The Making of
PAUL KLEE'S CAREER
1914–1920

The Making of
PAUL KLEE'S CAREER
1914–1920

O. K. WERCKMEISTER

The University of Chicago Press
Chicago and London

The University of Chicago Press, Chicago 60637
The University of Chicago Press, Ltd., London
© 1989 by the University of Chicago
All rights reserved. Published 1989
Printed in the United States of America

98 97 96 95 94 93 92 91 90 89 54321

Paul Klee's works reproduced by permission, © by ADAGP, Paris,
and COSMOPRESS, Geneva, 1984.

Library of Congress Cataloging-in-Publication Data

Werckmeister, O. K. (Otto Karl), 1934–
The making of Paul Klee's career, 1914–1920 / O. K. Werckmeister.
p. cm.
Bibliography: p.
Includes index.
ISBN 0-226-89358-8
1. Klee, Paul, 1879–1940—Criticism and interpretation.
I. Title.
ND588.K5W47 1988
759.9494—dc19 88-27423
 CIP

⊗ The paper used in this publication meets the
minimum requirements of the American National
Standard for Information Sciences—Permanence
of Paper for Printed Library Materials, ANSI Z39.48-1984.

For Charles Haxthausen and Wolfgang Kersten

Contents

vii

Contents

Contents

Contents

Notes
259

Bibliography

Index

Preface

This book is intended as an attempt to present in a continuous form a stage in Paul Klee's career, which as a whole forms the subject of my continuing studies. It incorporates texts and materials first published in several articles, most of which were in turn collected in my earlier book *Versuche über Paul Klee* of 1981, and are now superseded. I must take responsibility for this bibliographical recycling, which was originally prompted by the publisher's wish to make my Klee studies available in English, but which in a more profound sense is due to the expansion of material and revision of perspectives experienced in dealing with a historic figure such as Klee over a protracted period of time.

While *Versuche über Paul Klee* was dedicated to Christian Geelhaar and Jürgen Glaesemer, then the leading European Klee scholars, in gratitude for their support, the present book is dedicated to Charles Haxthausen and Wolfgang Kersten, Klee scholars of two successive younger generations, who have done as much as anyone to carry on and deepen the study of Paul Klee according to standards of critical scholarship. Their trenchant critical commentaries on the draft of this book, fully worked out on many printed pages, should have been published as book reviews in their own right; instead, both have written them for the benefit of my own, thorough revision of the book before it went to press. Although I have heeded most of their advice, I do not wish to imply that they now subscribe to everything I finally wrote. Rather, they might subject the book to a renewed, detached scrutiny in critical reviews of their own. In the end, their help has confirmed my confidence in yet a new phase of Klee studies, now ready to move beyond sequential or pluralistic additions of individual viewpoints and interpretations toward a shared body of results.

I also wish to thank a number of other Klee scholars for all kinds of help over the years: Magdalena Droste, Marcel Franciscono, Stefan Frey, Christian Geelhaar, Justin Hoffman, Joan Weinstein, and Armin Zweite. Institutions to which I am grateful include the Paul Klee Foundation in Bern, the Robert Gore Rifkind Collection in Los Angeles, the Bauhaus Archiv in Berlin, the Städtische Galerie im Lenbachhaus in Munich, the Guggenheim Museum, and the Museum of Modern Art, both in New York City.

Most substantial of all has been the continuing help and friendship of Felix Klee. Most meaningful of all has been my friendship with Jürgen Glaesemer, whose untimely death of AIDS on May 5, 1988, I can accept with none of the equanimity he achieved while facing it.

Work on this book was started under a Guggenheim Fellowship in 1982–83 and completed while I was a fellow at the Wissenschaftskolleg in Berlin in 1986–87. To both these institutions, I express my gratitude.

Evanston
June 1988

Introduction

Success and Socialization

When Paul Klee headed for Munich in 1898 to undergo academic training as a professional painter, he was well prepared through years of meticulous landscape drawing, which he may have learned in high school or may have taught himself. However, four years of professional study, including a sojourn in Italy, left him stranded with the conviction that he was incapable of painting and with a concomitant resentment against established visual culture and tradition. To break off his studies and return home meant giving up on making a living with his art and instead falling back on economic dependency on his father, who in 1898 had mortgaged his home in order to underwrite the professional education that his son was now abandoning.

In the reproachful but secure family home, Klee embarked on a second, more tenacious, technical and literary self-initiation into art on terms that were entirely his own. He systematically channeled his efforts into the creation of a major work with which to go public when he was ready. In 1906 he exhibited that work, the etching series *Inventions,* married, and moved to Munich to set up a home of his own. When *Inventions* failed to attract public attention, Klee was obliged to change his source of support from his father to his wife. A reversal of traditional family roles—Lily Klee provided most of the income, while he tended to the household and their small child—enabled Klee to engage in yet another round of private efforts at artistic self-perfection.

It was not until 1911, when Klee joined a group of avant-garde artists who were equally hardheaded but more adroit at ceaseless public self-promotion, that he was at last able to make his idiosyncratic art acceptable to a small but growing public in the German art world. This was his third attempt to turn his art into a professional activity by which he would be able finally to support himself and his small family, a goal which he, the son and son-in-law of well-salaried civil servants with a traditional sense of upper middle-class working ethics, had not lost sight of during the years of an uneventful, steady life devoted to nothing but work.

Like other artists of the modern tradition whom he joined in 1911, Klee had started out with the ambition of personalizing his art to the point of maximum subjectivity regardless of the professional consequences. Klee's

quest for an art all his own had been directed with particular determination against the prevailing culture of his social environment. Throughout the years of his protracted formation as an artist, he had developed a sense of disapproval, critical rejection, resignation, and introspective self-assertion amounting to a fundamental opposition to society as single-minded as it was vague. Yet, simultaneously, to become an artist meant for him not just to make a mark but to make a living, that is, to make the public appreciate his art as valid on general principles, over and above a mere acceptance of idio-syncrasy. This was a fundamental contradiction[1] that could only be resolved through compromise, and Klee reflected on it in November 1905: "Farewell, present life which I am leading. You cannot stay that way. Dignified, that's what you were. Pure spirit. Silent and lonely. Farewell, honor, at the first public step."[2] In spite of such hypothetical counter-recriminations, up to 1911 Klee had held out for uncompromising self-development. His lack of success at self-promotion had never tempted him to throw his experimental drawings aside and try some artistic formula that would more easily bring him recognition.[3] After holding out that long, Klee joined the modernist art movement just when that movement was beginning aggressively to claim, and receive, a share of the German art market. In the last three years before the First World War he started to become known through participation in the provocative publicity campaigns in which "expressionism" was launched in this environment. Now at last it must have seemed to him that he could be-come successful on his terms.

However, at the beginning of the First World War, a market slump co-incided with a resurgence of nationalist attacks on modern art and proved a setback for Klee's newly gained self-confidence. Thus, starting in 1916, he presented his work in a different light. Instead of a testimony of individual creative freedom, it was styled as the illusion of a mystical, timeless message, transcending into the metaphysical.[4] Klee himself worked at contriving this illusion after his first endeavors to reassert an uncompromising modernist intransigence through the year 1915 had met with no success. The change brought him to prominence in the canon of modern art, but its premise can-not stand the test of time.[5] In this book I will attempt to show that in the years of the First World War and the German Revolution Klee's rise to public suc-cess entailed a process of social adaptation to changing economic conditions and to ideological trends of prevailing culture, accelerated, in the end, under political pressure. This adaptation compromised his original ideal of artistic self-determination, no matter how exalted the posture of cultural leadership that he acquired in return.

Economic and social historians of Germany have defined the time span from 1914 to 1920, when Klee's career finally took off and culminated in his appointment as a state employee, as one continuous period, that of the Ger-man inflation.[6] It was a time when German industry was launched on a course of recovery and expansion regardless of the political costs, first the defeat of the German Empire and then social income redistributions fatal in

the long run to the Weimar Republic, which succeeded it. Thus, while inflation marks the economic trajectory for Klee's financial success, the First World War and the German Revolution mark the permanent political crises under which it was achieved.

Social historians have called for investigations that abandon schematic class analyses and focus on "small groups that can be exactly circumscribed," investigations "about how not just lawyers and doctors, but also writers and artists . . . were coping with the economic, social, and moral problems of inflation."[7] Klee's career, as it unfolded through the years 1914–20, is an example of the "learning process" by which individuals, groups, and institutions in German society adapted to inflation and shaped the particular course it took.[8] The present book is an attempt to follow this perspective, although its monographic focus lacks the strength of comparative group analysis required by social history. And, as the historian Hans Mommsen has said with reference to comparative biographies of Ruhr industrialists, "Generally one will succeed in ascertaining the most important personal and career data. Yet it is doubtful whether one will be able to uncover motivations for action to such an extent as to be able to draw conclusions about distinct learning processes."[9] Similarly, to place the making of an artist's career into its social and economic setting is not to say that whatever is significant about that career was prompted exclusively by historical circumstances. Nevertheless, in the case of Klee, it can be shown that in his third career attempt he was watching these circumstances with an accuracy, sensitivity, and shrewdness different from his two earlier withdrawals and different from the posture of such a withdrawal which he struck again in 1920, at age forty, the moment when his career was secure.

Klee and the Klee Literature

In 1920, Klee's dealers Hans Goltz and Paul Westheim brought out the first two monographs about him. Admiring critics Leopold Zahn and Hermann von Wedderkop wrote the texts. Klee, keeping his distance, called them "advertising" but nevertheless assisted in their preparation (see p. 236, n. 61). Both authors in fact derived their interpretations in part from texts Klee himself had just published. One was a short autobiography in the catalog of his first great retrospective exhibition with Goltz, which appeared in May 1920 as a special issue of *Der Ararat,* Goltz's house journal; the other was the summary of his artistic concerns published in the fall of the same year by Kasimir Edschmid in the collection of statements by artists and writers entitled *Schöpferische Konfession (Creative Confession.)* In addition, Klee furnished Zahn with excerpts from early parts of his diary, which were printed verbatim in an appendix. For Wilhelm Hausenstein, who wrote a third Klee monograph in 1920, Klee even compiled a lengthy autobiographical digest from his entire diary. Hausenstein did not, however, confine himself to elaborating on Klee's ideas. Instead, he placed the artist in the center of daring

critical reflections about the precarious position of modern painting after the experience of the First World War. These reflections were at variance with the posture of transcendental remoteness from the world that Klee assumed in public at this point in time. As a result, he courteously disqualified Hausenstein's book as "poetic fiction." The three monographs by Zahn, von Wedderkop, and Hausenstein mark the beginning of Klee's efforts at a supervision, or even guidance, of the art-critical literature written about him. These efforts were not always successful, since as soon as Klee became a public figure, he also became a controversial one. But, the most important monographs published about him after the Second World War, written by personal acquaintances who during his lifetime had acted as promoters of his work—Will Grohmann, Max Huggler, Carola Giedion-Welcker—by and large perpetuated his self-presentation.

A new phase in the Klee literature,[10] that is, the transition from art criticism to art history, was inaugurated in 1973 and 1976 by Jürgen Glaesemer. The first two volumes of his catalog of Klee's works in the Klee Foundation at Berne, which appeared during this time, are comprehensive scholarly endeavors and as such decisively surpass the previous literature. Glaesemer's meticulous "comparative analyses" of Klee's works and his careful use of "unpublished source material"[11]—that is, Klee's own autobiographical and pedagogical texts, as well as letters unpublished at the time—were based on his conviction that Klee's pictures speak for themselves if they are removed from arbitrary, time-bound commentary and are subjected to an exact formal analysis according to Klee's own instructions. Glaesemer expected these analyses to reveal a largely autonomous significance of Klee's art, intended by the artist and still visible today. As the scholarly executor of Klee's artistic heritage, he was still honoring Klee's own claims to an absolute validity of his art over and beyond the historical circumstances of its making. Thus, Glaesemer's first two volumes can be read as attempts at a scholarly ratification of Klee's public self-presentation for posterity, not yet as a detached historical analysis.[12]

Oeuvre and History

By and large, the chronological concept underlying all these monographs was based on the notion of an artist's "development" only superficially touched, perhaps deflected, but never determined by historical circumstance. It is the concept that Klee himself, in his diary, constantly used to interpret his own life and career. Like his contemporaries Proust and Joyce, he envisaged the conscious or even deliberate synchronization of a personal maturing process, encompassing both life experience and moral self-clarification, with the progressive elaboration of an oeuvre. This synchronization guided the writings he addressed to the public, directly or indirectly, and acolyte authors from Zahn to Grohmann faithfully observed its premise. Glaesemer may have ceased to reaffirm it explicitly, but it still shapes his account, whose

time frame is merely biographical, not historical. This convergence of subject and author is an example of an approach that used to be common in German writing about great artists. It recalls Gundolf's and Dilthey's biographies of Goethe, where the life of the poet was construed by analogy with his work and thereby styled into a coherent, symbolical work of art in its own right.[15] Walter Benjamin has criticized this approach as "just a perpetuation of the myth started by the [artist] himself."[14]

Such a personalized synchronization of biography and art history has engendered two guiding ideas of the Klee literature published to this day.[15] The first is the convergence of Klee's protracted autodidactic formation as a painter with the systematic buildup of painting from its elements, which he later codified in his Bauhaus teaching. According to this scheme, the young Klee started out as a draughtsman and first mastered the line as a "pictorial means" (*bildnerisches Mittel*); years later he would master tonal composition with dark and light; finally, on his trip to Tunisia in April 1914, he discovered color and became a true painter.[16] The second guiding idea is that of a biological polarization of the forty years of Klee's creative life between the notions of childhood and death. Just as his early work was prompted by the effort to recapture a childlike spontaneity, so was his late work conditioned by reflections on approaching death in the certainty of an incurable disease. The deceptively simple clarity of this scheme has preempted any but perfunctory reflections on historical time as the fundamental category of Klee's biography.

Klee's Diaries

The numerous conventional accounts of Klee's so-called development were able to claim the authority of the artist's own diaries, published posthumously in 1957, as incontestable source material. Here indeed the record of an exclusively private biography, which up to the war contains no reference to historical events of any kind, is laced with continuing self-assessments of both moral and artistic growth, making for an image of hesitant but consistent self-determination. Hence, any new historical assessment of Klee's career is bound up with the critical reevaluation of these diaries as a primary source.[17] Apart from the subjective viewpoint, which must be taken into account when using anybody's diary for historical purposes, Klee's diaries present the added problem that the artist repeatedly rewrote and edited those from before 1916 at later points in time. In a fundamental article of 1979, Christian Geelhaar has drawn the consequences from this fact.[18] In April 1904, Klee had already rewritten his diaries up to that date "in order to use them at a later time as material for an autobiography,"[19] and during the years 1913–21, he again made a clean transcription of three of his four diary notebooks, which ranged from 1898 until the end of 1915.[20] In this transcription he recast into coherent form the flow of reports and reflections that he had originally recorded and then had already transcribed once before, at least in part. After he was done,

he seems to have discarded the earlier versions. Only the fourth and last notebook, which covers the time of his military service from 1916 to 1918, contains, with two exceptions, the original version of the text, spontaneously recorded with so much intellectual assurance that Klee must have felt he could let it stand, as he was bringing the other three up to the level of articulate reflection he had finally reached. Only in the fourth notebook was he able to invest the immediate transcription of letters to his wife with instant, implicit or explicit, self-interpretations, which he then matched with retrospective autobiographical reflections in the transcription of the earlier three. It is this composite text, the result of two successive transformations of a diary record, but still clinging to the diary format, which ever since has conditioned art-historical accounts.

The preprogramming of the Klee literature by Klee's own potential autobiography began as early as 1919, at a time when he had stopped keeping the diary and was working on the revision and when he made a digest available to Hausenstein for the latter's book about him. In those passages of the earlier diaries that Klee incorporated into the digest in late 1919, it is still possible to discern two successive stages undergone by the autobiographical material on its way from the running diary to the final transcription. The first version of this autobiographical digest was drafted into the so-called Supplementary Manuscript, a notebook containing a collection of texts directly or indirectly destined for publication. This version still includes the numbering of the diary entries on which Klee drew. Several entries are not even transcribed, but simply referred to as "to be quoted" (*zitieren*). When Klee copied this digest from the Supplementary Manuscript over for Hausenstein, he omitted the numbering system, altered the text in many places, eliminated many passages, and added some others. Compared to these two versions of the digest, the extant diary transcript appears as a literary text honed to publishable poignancy. An entry of December 1908, for example, underwent the following transformations:

Supplementary Manuscript
843 [inserted: Komposition] Die Harmonie im Bild aus disharmonischen Einzelheiten.

Text for Hausenstein
Erkenntnis des kompositorischen Wertes an sich disharmonischer Faktoren.

Fair copy of Diaries
844 Gut komponierte Bilder wirken vollendet harmonisch. . . . Denn ein erster Teil erfordert nachdem er zu einem zweiten Teil in Harmonie gebracht ist überhaupt keinen dritten Teil mehr. Nur wenn eins und zwei hart zueinander stehn, so ist drei an der notwendigen Reihe, hinzutretend diese Härte in Harmonie zu verwandeln. Diese neue dreiteilige Harmonie überzeugt dann viel kräftiger.[21]

In the two successive digests, Klee confined his thought within a two-part antithesis between disharmonic detail and harmony of the whole. To call the solution "composition" seems to have been an afterthought at the stage of the supplementary manuscript. In the text for Hausenstein, the term "composition" is made part of the argument, but the antithesis remains the same. Only in the diary transcript did Klee introduce an intermediate possibility. The resulting "new tripartite harmony" cannot have been conceived of in the original diary at the time when Klee wrote and then copied the digest, since he hardly would have gone back to the simpler antithesis for the purpose of Hausenstein's publication. Long-term reworkings such as these make it impossible to rely any longer on Klee's diaries as instant historical records of his self-understanding at the time to which they refer. To do so would mean to succumb to Klee's own retrospective autobiographical guidance of how he wished the story of his life and career to be read and retold.

From Diaries to Publications

Klee's move from private to public texts, marked by the rewriting of his diaries, began in the fall of 1918, when he wrote his essay "Graphic Art." The publication for which it was destined had the telling title *Creative Confession,* which intimated that expressionistic artists were letting the public in on previously hidden, private thoughts about their art.[22] Conversely, just at this point Klee seems to have abandoned the private recording of his current thoughts on art and life. Yet even in the carefully crafted publications that Klee in subsequent years occasionally issued on his own art, he affected a deliberately subjective, personal attitude. From the time he authorized Zahn to reprint seemingly verbatim copies of his diary texts, he cooperated with those who wrote about him on the task of transfiguring a resolutely private concept of artistic creation, seemingly remote from the business of culture, into the posture of a leading master of modernism.

Christian Geelhaar's thoroughly documented and extensively annotated critical edition of nearly all texts published by Klee himself, which appeared in 1976, is, along with Glaesemer's catalogs, the second work that marks a new phase in the Klee literature. Geelhaar has started to put Klee's printed self-presentations into perspective as a deliberate public posture, distinct from his private thoughts,[23] and thus his edition is the first step toward an understanding of Klee's art in terms of its interaction with a changing public. This understanding must encompass Klee's art production as a whole, of which artworks and publications were interrelated components. Geelhaar has observed, for example, that the exhibition reviews from Munich which Klee published in the Berne journal *Die Alpen* in 1911 and 1912 were with only one exception devoted to galleries with which Klee himself did business sooner or later.[24] Klee's thoughts about modern art, particularly his well-known review of the *Blaue Reiter* exhibition at the Thannhauser gallery, were thus part of his strategy to place himself within the modernist

Fig. 1. Klee, Calligraphically written text "On this side . . ."

Munich art scene. His active participation in the promotion of modern art, which he intensified and diversified throughout the years of war and revolution, contradicts the image he later propagated, the image of an introspective concentration on his work unconcerned with its success: "The great success fell into his lap like a ripe fruit. He enjoys it in the silence of his industrious withdrawal. Dreaming, creating, playing the violin."[25] This is how Klee concluded his autobiographical sketch, which was printed in the catalog of his first retrospective exhibition at the Goltz gallery in May 1920. Here he proclaimed for the public an equation between art and private life that made his unwordly art appear to be the result of a withdrawal from society. "In this realm I cannot be grasped at all" (*Diesseitig bin ich gar nicht fassbar*)—these famous lines in Klee's handwriting were printed in facsimile at the beginning of the same catalog, blown up to double size (fig. 1) and captioned "From the Diaries." Since they do not appear in the extant transcription of the diaries, however, their ostensible privacy is most probably fictitious. This is a public statement in disguise, perhaps even calligraphically penned for the purpose of the catalog, the slogan for a recognized, successful posture.[26]

Toward Radical Historicity

The antirational affect that contributed to Klee's popularity during such times of economic and political crisis as the end of the First World War and the German Revolution of 1919, the Depression of 1929–36, and the collapse of the German state after the end of the Second World War regains some of its actuality in the currently emerging political crisis of capitalist culture. The mere critique of technical rationality which calls on Klee as a supportive witness obviates a political critique of the functions to which rationality and

technology are being applied in late capitalist society. Klee and his advocates were aiming at this kind of popularity when they presented him as a magician and metaphysical sage. Such a posture, however, appears at variance with Klee's own, ironically sharpened rationality, his critical distance from grandiloquence and self-delusion, which he maintained in the nonpublic realm, particularly in his teaching.

Such an ambivalence of posture and personality is socially conditioned. Historical research on Klee is bound to move away from the unquestioned acceptance of Klee's art on his own terms. Any independent assessment of how that art was historically conditioned means questioning its apodictic premises. This kind of radical historical inquiry, radical in the sense of an uncompromising application of historical scholarship to culture, aims at a historical critique of culture as ideology. With Klee, whose promise of art as "a summer resort" (see p. 136), as a refuge from the depressing or oppressive historical present, has been gratefully accepted by so many, such an inquiry may lead to debates like those waged earlier about Kafka or Benjamin, German-speaking authors who for a long time were admired as existential models for intellectuals. For the tendency toward relativism inherent in any historical inquiry blends into today's ever more trenchant skepticism toward modern culture as a whole.

The Scope of This Book

My historical inquiry into Klee's career is intended as a critical challenge to the myth of his art, to the hagiography of his artistic personality. As an enterprise of cultural critique, it follows a tradition of which Theodor W. Adorno's essay on Wagner is a famous example. However, today, in contrast to the time when Adorno wrote, the task of cultural critique can no longer be accomplished by negative theoretical reflections on the aesthetic experience. It has to proceed to an extensively documented assessment of the conditions under which Klee's art was produced, an assessment which precedes and conditions any visual understanding of his works. Such an approach takes Klee's career itself as a historical process enacted between the artist and his public, a process in which the works were not ends but functions.[27]

True, today's expansive historical scholarship, with its boundless possibilities of documentation, its swollen bibliographies, and its potentially unlimited interdisciplinary references, would seem to hinder rather than help my project. A complete, comprehensive Klee monograph is bound to be a task of so many years that it would miss out on its contemporary purpose as an effort at cultural critique. Such a monograph could only be the end result of the career of its author long after he or she has lived through the historical moment that motivated the undertaking. And the required complexity of rigorous historical scholarship would tend to make it a purely academic venture, out of reach for a general public thrown back on glossy color plate collections and weighty, incoherent exhibition catalogs.

Hence this book is itself a transitory token of an ongoing process, rather than an end result. It is meant to present Klee's career from the available record in such a way that its modular chronological and topical subdivisions can be shared, challenged, corrected, and supplemented by other writers. The bibliographical range of the book is limited accordingly. It pulls together the results of the previous Klee literature, which is noted in the bibliographical appendix. It does not, however, explore all the issues that are raised in light of what has been written about them in the literature on twentieth-century art in general. Within these limits, the book is intended to become a cooperative contribution to the Klee literature in progress.

1914

The Slump of the German Art Market

In the fall of 1914, the German art market was so bad that the art journal *Kunst und Künstler* discontinued its regular reporting of auctions and art sales.[1] By November, the trade journal *Der Kunstmarkt* summarized the situation: "Supply as well as demand have stopped almost completely, and one recalls no time of an even approximately similar stillness of the entire art trade."[2]

The reason for the slump was not just the outbreak of war, as was generally assumed at the time, although in the spring the art market had still held up.[3] The outbreak of war merely exacerbated the general economic recession in which Germany found itself in 1914, with weak demand, lagging sales, lack of liquidity, shrinking production, and unemployment.[4] The first war loan, issued in September 1914, absorbed still more money from the capital market, and thus production continued to decline to the point of a full-blown depression.

The slump of the art market was everywhere perceived as an emergency. The author of the lead article in the trade journal *Der deutsche Künstler* of August 15, entitled "The Artist in the German War of Liberation," saw the war as nothing but an adversity for artists, which he hoped would soon subside so that the artistic culture of peacetime might be restored.[5] The journal's editor, Georg Jahn, writing from the front, did not hesitate to call art a luxury that in wartime could be done without and argued for stable prices to avoid a total crash.[6] By October, however, the journal began to advocate the relevance of art for a war that was being waged in the defense of German culture against foreign barbarism.[7] And by December, one of the contributing editors ascribed the perceived crisis of German art to "charlatanism and adulation of the French," which he declared to be a dangerous political influence on the public that he expected the war to resolve.[8] These three interrelated issues—the slump of the art market, the claims of art to contribute to wartime culture, and the resurgence of nationalist opposition to modern art—determined the prospects for Klee's career as it stood at the beginning of the war.

Klee's Initial Attitude toward the War

When the German government declared war on Russia on August 1, 1914, Klee was in neutral Switzerland, in Berne, his native city. Here he received a letter from Kandinsky, the leading modern painter in Germany and a decisive influence on Klee during his own breakthrough toward international modernism after 1911. At the outbreak of war, Kandinsky had immediately left Munich for Switzerland, where he was preparing for his eventual return to his native Russia. From the border town of Goldach, he asked Klee for help in changing foreign currency. When Klee answered him on August 18, he took the opportunity to clarify his attitude toward the war for the first time:

> As far as I am concerned, I would, on the one hand, rather be there right now, for in spite of everything—these times have a certain grandeur. It does hurt that they appear reactionary from the standpoint of our further aspirations. . . . But who knows whether Germany's national uplift may not also bring us opportunities (courage and money from the side of supporters and publishers) for which under the pressure of recent years the courage was lacking. . . . And it was a mistake not to count any longer on a war between the big powers. It was a kind of effeminacy.[9]

On balance, Klee the modern artist was looking at the war with cautious confidence. True, he foresaw a hardening of chauvinistic opposition against modern, that is, internationalist, art under the impact of belligerent patriotism. But he also shared the view of many German artists and intellectuals that the war might imbue German culture as a whole with greater assertiveness. Still, his status as a German citizen subject to the draft gave him cause for concern:

> My wish to return to Germany now will probably be fulfilled in the coming days, although not in the imagined free fashion, but under the compulsion of continued mobilization. I belong to the Bavarian Home Guard, First Levy. Since I have never had military training, a belated recruit drill may well be in store for me. But I will be able to accept and appreciate it from the ironic side.[10]

The expectation of artistic opportunity and the fear of being drafted rendered Klee's attitude toward the war contradictory from the beginning. After his return to Munich, throughout the following eighteen months, the expectation of being called up remained on his mind until, on March 11, 1916, the notification finally arrived.[11]

Kandinsky, in his belated reply dated September 10, implicitly rejected Klee's optimism: "What a good fortune it will be when these terrible times have passed. What will come afterwards? I believe a great release of the inner forces, which will also bring fraternization. Hence also a great unfolding of art, which now has to stick to hidden corners."[12] With his "terrible

times," Kandinsky contradicted Klee's assertion that "these times have a certain grandeur," just as his prediction of art's precarious subsistence "in hidden corners" contradicted Klee's expectation of "opportunities." Klee was no less eager than Kandinsky for a speedy peace in the interest of the international community of artists, but, unlike Kandinsky, he expected it from a speedy German victory. On September 30, shortly before his return from Berne to Munich, Klee wrote to his old friend Ernst Sonderegger: "But everything will pass, and probably in the desired way, so that the calm central power will remain unshaken. Then nothing much more will happen to the others than that a peace of long duration will be dictated to them. And that is what we need, an unthreatended peace, nothing else.[13] Klee's evocation of "a certain grandeur" in his letter to Kandinsky thus matched his confidence in German arms, which he expected to protect his ideal of a community of modern artists.

Klee's cautious confidence paled next to the war enthusiasm of his and Kandinsky's friend Franz Marc, who at that time was already serving at the front. On August 6, 1914, Marc, who had undergone training as an artillerist in 1900, had volunteered for service in the First Bavarian Artillery Regiment. In September, he was moved to Alsace and thereafter continuously took part in actual fighting.[14] On November 16, 1914, he began to relate his war experience to Kandinsky's prewar abstract paintings. He wrote to the Russian painter: "During the first, very bad engagements in the Vosges mountains, I was often unable to separate dream and action. . . . And I thought often of your paintings, which accompanied me like formulas of such a situation. . . . my heart is not angry at the war, but profoundly grateful, there was no other [conceivable] transition toward the times of the spirit."[15] Ignorant of Kandinsky's current view of the war as a calamity for modern art, Marc asserted in effect that the war was inaugurating the "Epoch of the Great Spiritual" envisaged by Kandinsky back in 1911. On October 24, he wrote him of his conviction that the war was bound to "purify Europe."[16]

What made these reflections so important for the German modern art world is that Marc soon set out to write them down and send them home for publication. His first article, "In War's Purifying Fire," was written by the middle of October 1914 and published on December 15 in one of the most widely read national newspapers, the *Vossische Zeitung*. The second, entitled "The Secret Europe," was written by the end of November 1914 and appeared in March 1915 in the magazine *Das Forum*.[17] In both articles, Marc elaborated on the thoughts he wrote first in his letter to Kandinsky. Time and again, he reiterated his conviction that "this great war is a European civil war, a war against the inner, invisible enemy of the European spirit," and "[it is] the very ancient remedy of the blood sacrifice . . . for the cure of our European disease."[18] Marc greeted the war with that tragic pathos of fate which distinguished some circles of the German liberal bourgeoisie, including artists and intellectuals, from the patriotic war enthusiasm sponsored by the government. But no matter how much distance he tried to put between his

thinking and what he called "the raging and undignified national bark,"[19] his welcoming of war objectively formed part of the patriotic consensus prevailing in the German art world during the fall and winter of 1914. What he wrote was particularly effective since he addressed himself to those intellectuals who had adhered to an internationalist modern culture in the years before and whose sense of a scathing cultural critique was largely derived from Nietzsche's condemnation of materialism in all of Europe, not just Germany.

When Klee wrote his first letter to Marc at the front on October 17, he had already had a face-to-face conversation with Kandinsky, in the course of which the latter must have made their differences of opinion clear to him.[20] Their mutual friend August Macke was missing in action and presumed killed since September 26. In this situation, Klee's attitude was changing, and he found himself in an evolving disagreement with the war enthusiasm Marc was expressing in his articles.

> "From the little articles which your wife had me read I could gather how your mind was able to adapt quickly to the unheard-of change.
>
> Actually we are just now particularly severely affected in our most tender hopes. And yet you compensate the loss with the boldest expectations. And how few of us Germans are still there—and nevertheless?! Now we have had to lose August Macke. . . .
>
> Moreover, I have to miss the enormous sensations which you are experiencing. To gather everything in the form of reading. If tomorrow all the papers were saying it was not true, no war, nothing—I would also have to believe it.
>
> Hence I envy you![21]

Now Klee was already reacting to the hard times that during the first year of the war seemed to be in store for the internationalist avant-garde in Germany: the patriotic backlash revealed its minority position, and the death of some of its members on the battlefield decimated it even more. Yet he was still conceding that Marc's immediate experience of action at the front might credit his posture with an authenticity that Klee at home was unable to match or verify. Thus the "envy" he expressed at the end of his letter refers to the unhesitating assurance of Marc's views compared to his own growing indecision.

Marc for his part was prepared to make historical sense of Macke's death in action. On October 25, he published Macke's obituary where he wrote: "The blood sacrifice which nature exacts from the nations in great wars is being offered by them with tragic, remorseless enthusiasm. The community joins hands in loyalty and proudly bears the loss to the sounds of victory."[22] Four days later, on October 28, Klee wrote again to Marc regarding Macke's death, in order to assure him of his friendship. He concluded, "when the war will finally have been decided we will perhaps be less lonely than it now appears to you."[23] The passage acknowledges no sacrifice. It re-

calls Kandinsky's hopes, in his letter to Klee of September 10, for "fraterniza-
tion," that is, for a reestablished community of modern artists, once "these
terrible times have passed."

Klee's First Images of War

"Outbreak of the World War," Klee wrote into his oeuvre catalog after entry
number 124, thus marking the start of a historic period in his artistic produc-
tion. The oeuvre catalog is the fundamental documentation of Klee's work up
to January 1920, for aside from the numbered list of his works, it also contains
extensive notes about his exhibitions, sales, and other business activities.[24]

Under number 130 Klee had already recorded the first title thematically
related to the war: *Fortified Place*. Between August and December 1914, he
created altogether twelve works (six watercolors and six drawings) bearing
war-related titles, four of them actually including the word "war" or "war-
like."[25] Since 1911, Klee had pursued his concept of a resolutely subjective
art that was both abstract and expressive with increasing self-assurance,
regardless of its unresolved ambivalence between pattern and caricature.
Hence he ventured into statements about the war despite his political indeci-
sion. However, his intransigent subjectivity made the war-related drawings
and watercolors in effect testimonies of the change from cautious optimism
to skepticism which Klee underwent in those four months.

The first group of watercolors, from *Fortified Place* (fig. 2) to *Thoughts
of the Battle* (fig. 3) and *Thoughts of Mobilization* (fig. 4), was no doubt
painted in August or early September, while Klee was still in Switzerland. If it
were not for the titles, one would be at a loss to discern any visual allusions
that would make the war theme recognizable.[26] This is all the more striking
if one recalls the unequivocally illustrative significance of works bearing
such titles from the year before, that is, *The Battlefield* (1913, 2),[27] *The War
Begins* (1913, 37), and *Belligerent Tribe* (1913, 41; fig. 43). The new water-
colors seem rather to be specimens of Klee's ongoing pursuit of pictorial ar-
chitecture and abstraction in the wake of his trip to Tunisia in April 1914.
Fortified Place is a structurally consolidated multiple color composition of
triangles, squares, and arches which may pass for the image of a fortress;
Thoughts of Mobilization is a more loosely balanced square composition
with a partially detached linear design evoking no pictorial associations of
any kind. Thus in both watercolors, the war-related titles appear not as refer-
ences to any content, but rather as portentous allusions, superimposed to
counterpoise the abstract memory of the Tunisian experience with thoughts
of the historical threat.

After his return to Munich in early October,[28] Klee gave *Fortified Place*
on commission to his dealer, Hans Goltz. He also deposited with Goltz a new
set of four watercolors and drawings whose titles refer to the theme of war:

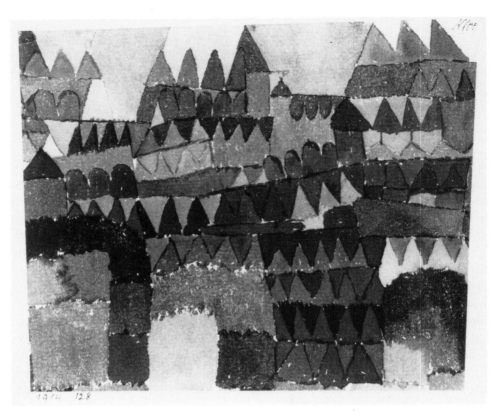

Fig. 2. *Fortified Place* (*Befestigter Ort;* 1914, 128)

Fig. 3. *Thoughts of the Battle* (*Gedanken an die Schlacht;* 1914, 140)

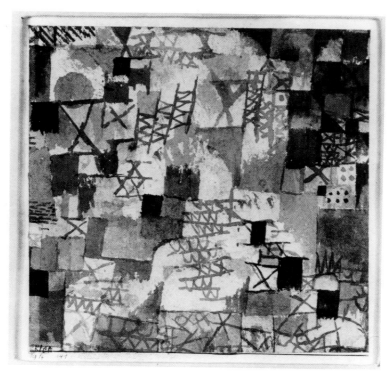

Fig. 4. *Thoughts of Mobilization* (*Gedanken an den Aufmarsch;* 1914, 141)

War Which Destroys the Land (1914, 166; fig. 5), *The German in the Brawl* (1914, 167; fig. 6), *Portents of Difficult Destinies* (1914, 178; fig. 8), and *War Striding over a Locality* (1914, 179; fig. 9).[29] With this collection, Klee joined several of his colleagues from the New Munich Secession who contributed to an ongoing exhibition in the Goltz Gallery under the heading "The War."[30] He may have made them for the purpose, since compared with the earlier group, from which this one is separated by twenty-five numbers in the oeuvre catalog, the thematic reference is more apparent. It is also downright negative. *The German in the Brawl,* in particular, is a thinly veiled persiflage of contemporary pictorial propaganda drawings illustrating Emperor Wilhelm II's exclamation: "Now let us thrash them!" (fig. 7).[31] It even recalls the contemporary antiwar drawings of Ludwig Meidner (fig. 10), although these were published somewhat later in *Die Aktion.*[32] The watercolor *War Striding over a Locality* and the drawing *War Which Destroys the Land* are unequivocal, serious denunciations. In the watercolor, the fragmented composition confronts a house torn open at the side and a tumbling tower, suggesting a devastating sweep toward the right. The drawing vaguely suggests a ravaged ground with signs or objects that are indefinable, except for a small ruined house in the bottom left-hand corner. Amorphous, scribbled lines covering the ground enhance the impression of chaotic formlessness. *Portents of Diffi-*

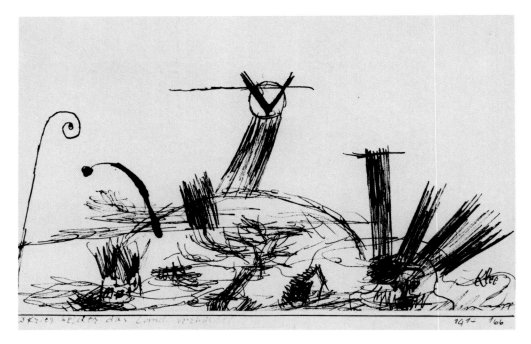

Fig. 5. *War Which Destroys the Land* (*Der Krieg welcher das Land zerstört;* 1914, 166)

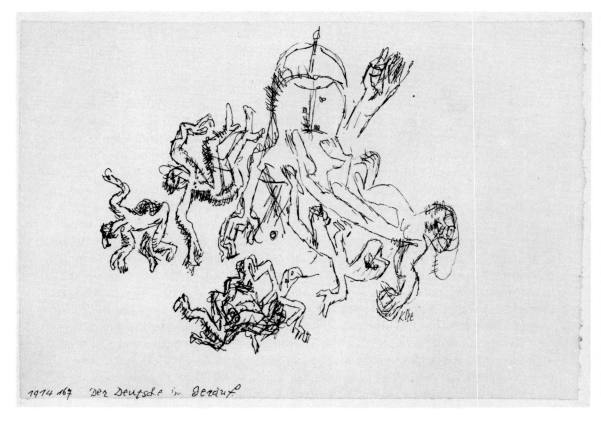

Fig. 6. *The German in the Brawl* (*Der Deutsche im Geräuf;* 1914, 167)

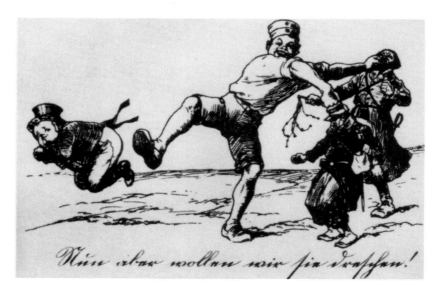

Fig. 7. "Now let us thrash them!" ("Nun aber wollen wir sie dreschen"), postcard

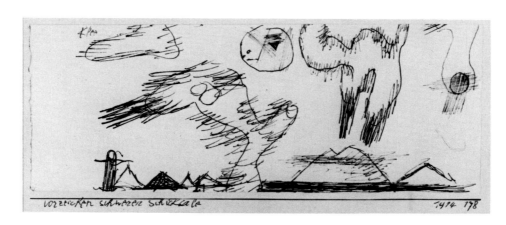

Fig. 8. *Portents of Difficult Destinies*
(*Vorzeichen schwerer Schicksale;* 1914, 178)

Fig. 9. *War Striding over a Locality*
(*Der Krieg schreitet über eine Ortschaft;* 1914, 179)

Fig. 10. Ludwig Meidner, *Battlefield* (*Schlachtfeld*), from *Die Aktion*, 1915

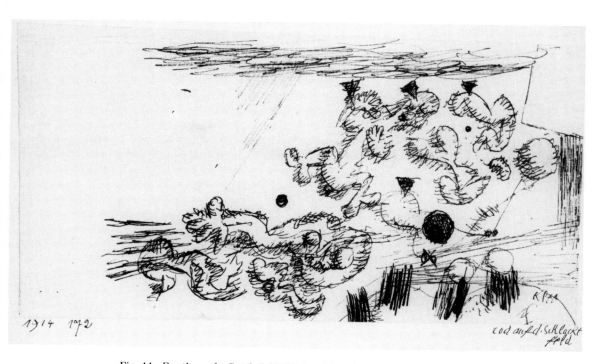

Fig. 11. *Death on the Battlefield* (*Tod auf dem Schlachtfeld;* 1914, 172)

cult Destinies, finally, shows giant nondescript shapes in heaven, clouds or constellations, hovering over a tiny mountain landscape, their outlines obscured by formless, scribbled hatchings. The whole collection would have amounted to the most decidedly antiwar statement by any Munich artist at the time had not its hermetic abstraction obscured its meaning. Compared to the first group of war-related watercolors, it expresses the change in Klee's position toward the war, which is documented in his letters to Kandinsky of August 18 on the one hand and to Marc of October 17 and 28 on the other. Goltz could not sell a single one of these works. According to a note in the oeuvre catalog, he later returned them to Klee. Apparently Klee's images about war were both too negative and too cryptic. In spite of his efforts at thematic actuality, he had confined himself so much to his idiosyncratic form that he could not overcome the public's lack of interest in his art of subjective, "abstract" expression.

However, Klee had not included in the collection for Goltz two drawings that, according to the oeuvre catalog, were done at about the same time: *Death on the Battlefield* (1914, 172; fig. 11) and *War up High* (1914, 173; fig. 12). These drawings pertain to the more figurative, caricaturistic mode in Klee's ongoing work. They form a pair of images of explosions, ostensibly

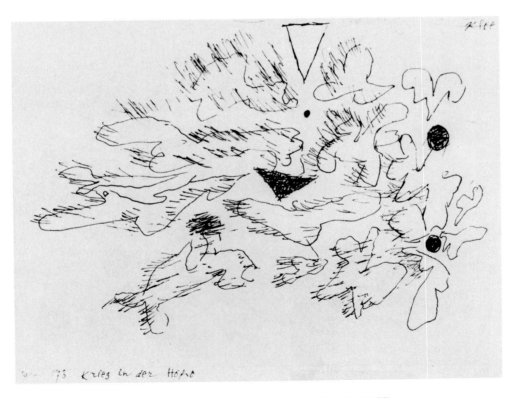

Fig. 12. *War up High* (*Krieg in der Höhe;* 1914, 173)

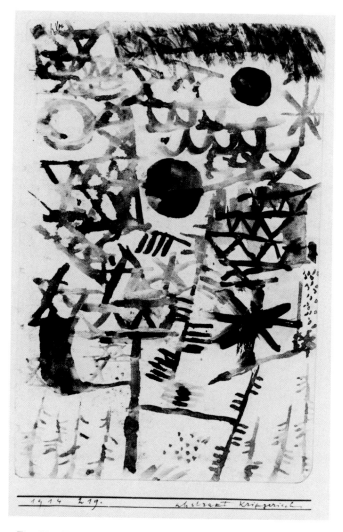

Fig. 13. *Abstract-Belligerent* (*abstract-kriegerisch;* 1914, 219)

brought about by black triangular wedges and round cannonballs, one on the ground, one in the air. In the first drawing, human figures are torn apart and tossed about; in the second, nondescript cloudlike shapes are centrifugally blasted away. In both, narrow, formless hatchings overcross the outlines. These two drawings are the most outspokenly critical war images that Klee made in 1914. Had he given them to Goltz along with the others, he would have clarified the significance of the collection. He must have had his reasons for holding them back.

The last of Klee's works whose titles refer to the war, *Abstract-Belligerent* (1914, 219; fig. 13), was entered two numbers before the end of the oeuvre catalog for 1914 and hence may date still later than the two drawings

just discussed. The term "abstraction," of central concern for Klee at this time and included in the titles of ten works from 1914, is here linked for the first time to the term "War."[33] The watercolor may be seen as a version of *War Which Destroys the Land* (fig. 5) which has been stripped of all representational features. It marks the point in Klee's work where war and abstration were beginning to be construed as opposites.

The Lithographs for the *Zeit-Echo*

When Klee brought his small, edited collection of drawings and watercolors about the war theme to Goltz's shop, he joined several of his colleagues of the New Munich Secession who were also contributing war images to Goltz's publishing branch. In the fall of 1914, the war was a subject of burning actuality on which hosts of German writers and artists rushed to express themselves. Goltz was busy putting out *Die Kriegsbilderbogen Münchner Künstler* [The War Broadsheets of Munich Artists], a series of portfolios each containing twelve lithographs by different artists, and, in addition, lithograph portfolios by individual artists under timely titles: *1914, Behind the Armies, Combats, The Victims.*[34] In addition, several of the New Secession artists joined in one of the new art-and-war journals which in August 1914 were launched all over Germany. It was published by the Graphik Verlag under

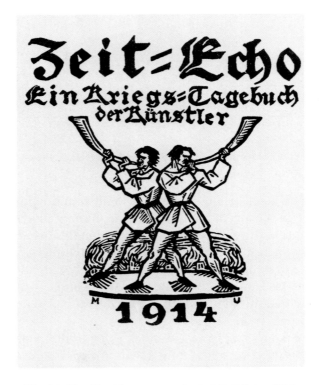

Fig. 14. Max Unold, cover woodcut of *Zeit-Echo,* 1914

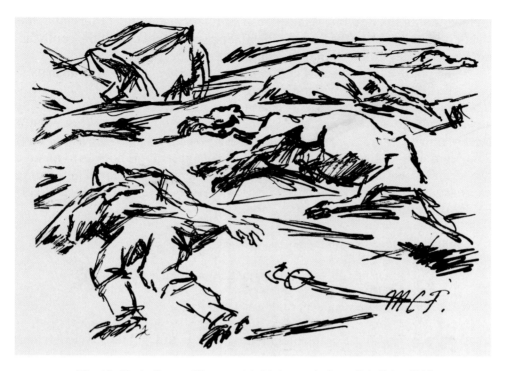

Fig. 15. Maria Caspar-Filser, untitled lithograph, from *Zeit-Echo*, 1914

the title *Zeit-Echo: Ein Kriegstagebuch der Künstler* [Echo of the Times: A War Diary of Artists]. This well-produced, bibliophile biweekly combined literary texts with original lithographs. The title vignette (fig. 14), a woodcut by Max Unold, depicts a pair of husky trumpeters, well-dressed in late medieval fashion, standing back to back, turned outside, before a horizon lined with burning houses. Raising their trumpets in both directions, they blow with fierce determination, not just announcing the news of war, but actively contributing to the fall of the city behind them, like the biblical trumpeters of Jericho. The woodcut is a visual rendering of Thomas Mann's patriotic definition of "the artist's fate," printed in the second issue of September 1914, "to live like a soldier although not as a soldier."[35] However, the journal's line was by no means just belligerent. The editor, Otto Haas-Heye, pursued a pluralistic program admitting diverse points of view.[36] "What matters now is only to collect and reflect the war sentiment, precisely in its differences and diversity of interpretation."[37] The editor's main concern was to demonstrate the historical actuality of contemporary art and literature, whatever its political persuasion. In fact, despite the seemingly patriotic image of the artist embodied in Unold's title vignette, the first lithographs published in the journal were decidedly negative in content: a fallen cavalryman next to his dead horse by Maria Caspar-Filser (fig. 15) and, most startling, Adolf Schinnerer's fallen soldiers of uncertain nationality being lowered into a mass grave (fig. 16). These were extremes of a sentimental, but nonetheless affirmative

imagery about the grandiose sacrifice of war, lacking, on the other hand, the strident jingoism professed by the Berlin Secession artists in their contributions to Paul Cassirer's similar journal *Kriegszeit* in Berlin.

The political pluralism of opinion, however, did not extend to an artistic one. All the lithographs printed during the first year of the *Zeit-Echo* were figurative, or even illustrative, in character. There were no contributions by any artist of the abstract or expressionist avant-garde. That this was a deliberate editorial line was brought home to Klee when he also was asked for a contribution. For the third issue, some time in September, he was to make a lithograph to be juxtaposed with a poem by Theodor Däubler. The leading expressionist poet and modern art critic was ready to focus his stock of verbal imagery on the new subject:

> In the morning dew, on the narcissus meadow in the valley,
> children are singing;
> Their song glorifies the heroes emerging from another valley far
> away;
> In silver armor they came to vanquish giants.[38]

Klee's lithograph (Fig. 17) appears incongruous with Däubler's lyrical transfiguration of soldiers into shining knights. Its rectangular field is cubistically splintered into loose diagonals and hatchings. An open circle at the top may denote a rising sun, and to the right may be discerned the vague contours of a leafy plant. The lithograph remained untitled in the *Zeit-Echo,* where the lack of titles was a matter of editorial policy, and Klee did not list it in his oeuvre catalog. Only at a later point in time was it labelled *Battlefield,* hardly by Klee himself.[39] Does it express "war sentiment" in line with the journal's program? The editor must have doubted that, since he printed the lithograph in only a few copies of the issue. The run of copies printed for distribution carried only Däubler's poem, with the bottom of the page left blank.

Klee reported what had happened in a letter to Marc of November 22, 1914:

> Your wife has sent you the first issues of the new little war milk-cow, or rather milk-goat, "Kriegs Echo" or "Zeitecho." As a first contribution, I was asked to draw a vignette for a rather abstract poem by Däubler. . . . When already 5,000 copies had been printed, the editors became fearful, probably that the harmless piece would be taken for seditious francophile art, something that the subscribers were bound to reject. The 5,000 [copies] were withdrawn and issue number three was reprinted without me.[40]

Two points emerge from Klee's explanation. First, he excused his cooperation with the *Zeit-Echo* as a cynical way to make money, to the point of pretending uncertainty about the title of the journal. The designation of his lithograph as a "harmless piece" places it along with the watercolors *Fortified Place* and *Thoughts of Mobilization* of August and September, where

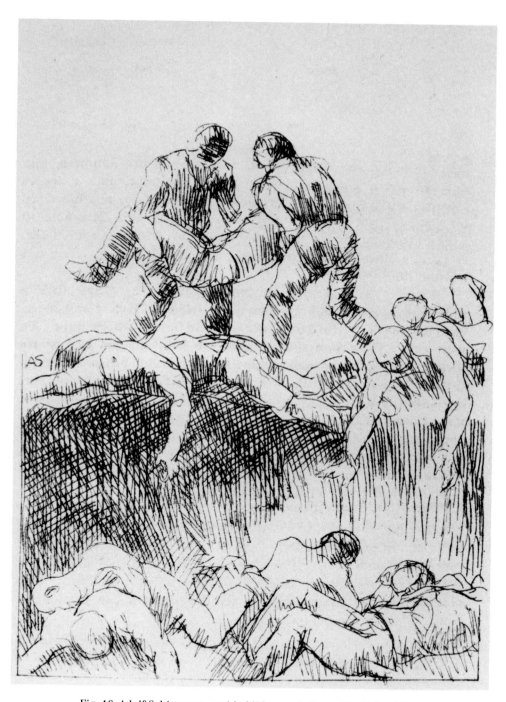
Fig. 16. Adolf Schinnerer, untitled lithograph, from *Zeit-Echo*, 1914

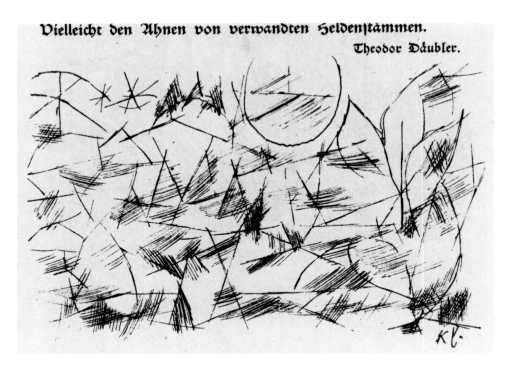

Vielleicht den Ahnen von verwandten Heldenstämmen.

Theodor Däubler.

Fig. 17. *Battlefield*, lithograph from *Zeit-Echo*, 1914

the relationship of the manifest contents to the title had been tenuous at best. Second, Klee was sensitive to the new vulnerability of modernist art as it was confronted by the patriotic wartime culture now being promoted. Since the Vinnen controversy of 1911, when Marc had felt compelled to defend modern painting against the charge that it was lacking in patriotism, Munich had been the center of a public debate about this issue. Meanwhile in Berlin, Franz Pfemfert systematically published modernist French artwork in his journal *Die Aktion* with the all-but-stated purpose of a muffled political opposition to the war. Klee must have feared, or experienced, a resurgence of chauvinist resistance against modernist art, for in the same letter he counselled Marc against an exhibition at the Thannhauser gallery at this time: "Just for the sake of opposition it would be fun, but then again the pictures are too good for that purpose."[41] Whether the suppression of the lithograph was really based on such political grounds, and not just on its unintelligibility, remains uncertain. The lithograph by René Beeh that faced Däubler's poem on the opposite page in the final printed copy (fig. 18) depicts a pile of corpses thrown into a ditch, the opposite of Däubler's emergence of the heroes from the valley and certainly no war acclamation. In any event, Klee's failure to be published in the *Zeit-Echo* matches the oblivion to which his little war collection of drawings and watercolors was consigned at the Goltz Gallery.

Marc, in his answer of December 11, did not conceal a certain satisfaction: "I had always hoped that the spirit of this good company would become

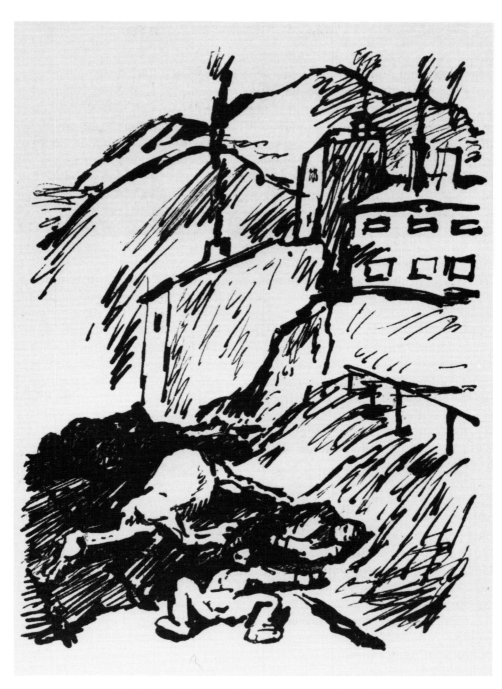

Fig. 18. René Beeh, untitled lithograph, *Zeit-Echo,* 1914

too motley for you in the long run—what do you have to do in this emergency circle anyway?"[42] His disdain for the *Zeit-Echo* probably stemmed from his skepticism toward the New Munich Secession, which he had refused to join when it was founded on November 27, 1913.[43] Now, however, he did not just insist on the exclusivity of the modernist avant-garde, he also reacted against the pluralistic lack of viewpoint in the journal's editorial line, falling short of his own, painfully severe, efforts in his writings to reach an integrated understanding of the war in his capacity as a soldier, artist, and intellectual.

When Klee replied on December 16, he only defended himself against the charge of cooperating with uncongenial artists. He emphasized that it had been for practical reasons, entailing "no concessions." "For all this I am no less isolated as an artist but have a guaranteed support base in practical matters."[44] Within the diversity of contributors to the journal, Klee placed himself among the "people who stand on the left."[45] The ambivalence of conviction and adaptation, to which he confesses here for the first time, was to haunt him throughout the pursuit of his career during the war and revolution.

Actually, Klee was justifying to Marc his continued cooperation with the *Zeit-Echo,* in spite of his initial failure. When in December 1914 he once again received a commission, he created an image where, by contrast to that of September, the war theme was unmistakable (fig. 19). The full-page lithograph shows a huge nondescript composition fusing architectural parts and trees. At the bottom, there lies a small, prone figure with the German spiked helmet. Below, the large, neatly handwritten title: *Death for the Idea.* Once again, the lithograph was juxtaposed with a poem, which here appears on the opposite page: *Night* by the Austrian expressionist poet Georg Trakl, who "succumbed to his wounds in the field hospital at Cracow on November 3, 1914," the caption asserts.[46] The picture is just as incongruous to the text as Klee's earlier "vignette" for Däubler's poem had been, but as an image, it is clearly readable.[47] Possibly Klee had an understanding with the editor that he would not repeat the obscurity and lack of thematic reference which had made his previous contribution to the *Zeit-Echo* unacceptable. The title *Death for the Idea* suggests that the reference is not to the poem, but to the death notice below the author's name.

However, Klee's attitude toward the war, as can be gathered from his correspondence with Marc in the previous two months and as expressed in his somber, satirical or even critical drawings and watercolors of that time, would not have lent itself to a glorification of Trakl's supposed death in action by calling it a sacrifice for a patriotic idea. Trakl had, in fact, not fallen on the battlefield at all. On November 15, 1914, the Austrian Field Hospital No. 15 at Cracow had informed Trakl's brother Wilhelm in Munich that the poet "had been under treatment in this hospital for mental derangement (Dement. praec.), that during the night of November 2 he undertook a suicide attempt by means of cocaine poisoning, and that he could not be saved in spite of every possible medical effort."[48] Although Trakl's death notice, issued by his mother on November 16, ambiguously proclaimed that he "had

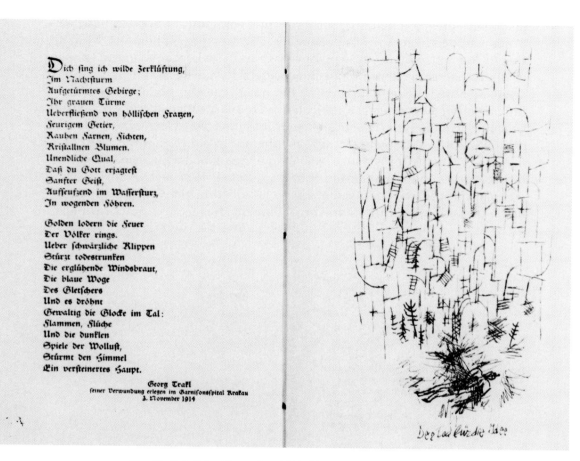

Dich fing ich wilde Zerklüftung,
Im Nachtsturm
Aufgetürmtes Gebirge;
Ihr grauen Türme
Ueberfließend von höllischen Fraßen,
Feurigem Getier,
Rauhen Farnen, Fichten,
Kristallnen Blumen.
Unendliche Qual,
Daß du Gott erjagtest
Sanfter Geist,
Aufseufzend im Wassersturz,
In wogenden Föhren.

Golden lodern die Feuer
Der Völker rings.
Ueber schwärzliche Klippen
Stürzt todestrunken
Die erglühende Windsbraut,
Die blaue Woge
Des Gletschers
Und es dröhnt
Gewaltig die Glocke im Tal:
Flammen, Flüche
Und die dunklen
Spiele der Wollust,
Stürmt den Himmel
Ein versteinertes Haupt.

Georg Trakl
seiner Verwundung erlegen im Garnisonsspital Krakau
3. November 1914

Fig. 19. *Zeit-Echo,* December 1914: Klee's *Death for the Idea*
(*Der Tod für die Idee;* 1915, 1), printed opposite Trakl's poem *Nacht*

died in the . . . garrison hospital . . . for the fatherland," it is likely that the true story was known in Munich's art circles.[49] Trakl, like Marc, had hailed the war as a "cleansing thunderstorm" and had immediately volunteered as a medical officer, but he broke down under the extreme pressure of his service in field hospitals. His suicide during a drug-induced spell of mental derangement was one of the earliest instances of nervous breakdowns which German and Austrian artists serving at the front suffered under the impact of their experiences. Thus, Trakl's death, as it had actually occurred, was a confirmation of Klee's emerging sense of a potentially mortal contradiction between art and war. If he saw it as meaningful for any "idea," it must have been this. The reclining figure with the spiked helmet and the surrounding ground are rendered in the unstructured, scribbled form of some of Klee's war-critical drawings of autumn. The soldier almost appears crossed out by the lines scratched over his body, helplessly obliterated.

Within the December issue of the *Zeit-Echo,* the deceptive juxtaposition of Trakl's poem and Klee's lithograph stood in the center of an apparently

planned sequence of texts and images whose common subject was the glorification of death in war. The sequence began with a lithograph by Willi Geiger (fig. 20), who in subsequent years was to make war a central subject of his art, showing three mourning women in heroic, classical postures. There followed a rhapsodic text by the noted cultural philosopher Martin Buber claiming a mystical identification on his part with death in war: "From your fiery conflagration the events pour into my bloodstream, the impact of assault and the stiffness [of death], calling and gasping, and the smile of a mouth over the shattered body." [50] The sequence ended with an article by another famous philosopher, Max Scheler, entitled "War and Death": "Whoever sees death sees his person transcend death in the very act of seeing it. . . . Metaphysics is the heroism of thought. Heroism is practical meta-

Fig. 20. Willi Geiger, untitled lithograph, from *Zeit-Echo*, 1914

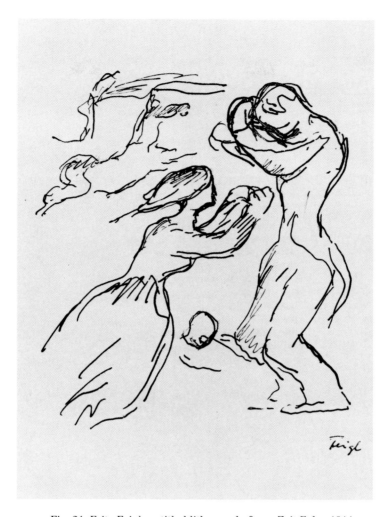

Fig. 21. Fritz Feigl, untitled lithograph, from *Zeit-Echo*, 1914

physics. . . . As on a scale of steps, the genius of war leads his apprentice to the knowledge of immortality."[51] In the second section of the same fascicle, the editor, pursuing his pluralistic policy, had lined up four testimonies of a more negative attitude toward war: a lithograph by Fritz Feigl (fig. 21) showing the desperate leavetaking of a couple, a poem by Gottfried Kölwel featuring a child crying out for his father among departing soldiers, and, as an extreme, "Letters to Someone Who Died," by the German-French writer Annette Kolb, openly deploring the war between her two native countries and ending with the exclamation, "It is we who should have died!"[52] On the last page of the fascicle there appeared a nostalgic lithograph by Richard Seewald (fig. 22), another member of the New Munich Secession, a street view from Marseilles, dated 1914, depicting the newspaper bureau Soleil du Midi. On the bulletin posters the words "Russie" and "Berlin" can be deciphered, headlines announcing the outbreak of war.

33

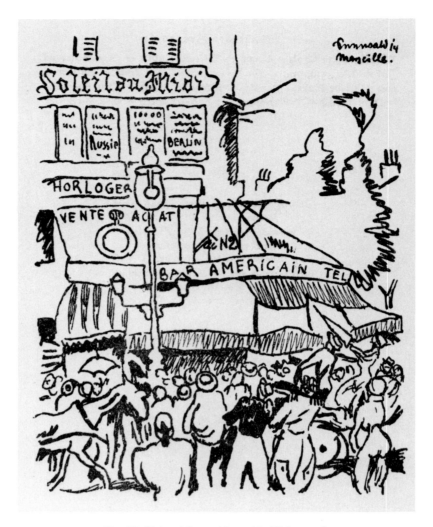

Fig. 22. Richard Seewald, untitled lithograph,
from *Zeit-Echo*, 1914

In the politically balanced December issue of the *Zeit-Echo*, Klee found himself unequivocally placed, not on "the left," as he had claimed in his letter to Marc, but on the side of those liberal artists and writers who in the fall of 1914 had joined in the prevailing war enthusiasm. His surreptitious, potentially subversive commemoration of Georg Trakl's suicide had gone unnoticed. While he was complaining, in a letter of December 4 to his collector Hermann Rupf, that the "shame of the destruction on both sides" was repugnant to his sense of friendship with French artists,[53] the seeming identification of the artist with the dead soldier in his published lithograph confirmed, for the readers of the *Zeit-Echo*, Thomas Mann's definition of "the artist's freedom and the artist's fate" by the formula "to live like a soldier but not as a soldier."

1915

The Incipient Recovery of the German Art Market

In the course of the year 1915, the German art market started to recover. Still in January, *Der deutsche Künstler* had to report that sales at the annual Munich Glass Palace Show were down to 6 out of 156 works exhibited, with the result that the Munich corporation's special show in the Kunstverein was cancelled and all of the corporation's available funds were committed to the support of needy artists.[1] However, by February, the journal *Der Kunstmarkt* noted the first stirrings of a recovery:

> all signs suggest that even during the war, and despite the loss of international trade relations, the art market possesses enough receptivity for regular auctions. . . . In the first weeks or even months of the war, one would not have easily foreseen such a situation of the art market. Everybody believed that a general price crash would be unavoidable. At the very least one expected an absolute standstill of the entire art trade for the duration of the war. . . . This initial standstill, and the general fear of the great price crash just seem to have resulted in maintaining the German art market on a healthy basis.[2]

And in April *Der deutsche Künstler* was able to report:

> Just like economic life in general, the art market, too, is beginning to revive in a gratifying manner. After the art auction houses have again announced their auctions, the symptoms of a market recovery are multiplying. Everywhere demand already exceeds supply. . . . The brisk demand is helped, of course, because at the moment, due to the war, liquidity is fairly high, and then also because this year money is remaining entirely within the country.[3]

This conclusion pinpointed the two fundamental facts of money circulation in the German war economy, although it addressed neither its economic reasons nor its effects on the market chances of current artwork. In the summer of 1915 the growing war production began steadily to increase the money supply.[4] It was the German government's stated policy not to subject the

arms industry to any production or price control or, initially, to any special tax. As a result, that industry achieved ever larger returns on its capital outlay, steadily increasing domestic wealth and purchasing power.

The resulting recovery of the German art market benefited old artworks and current art production in different ways. It seems that the former took the lead and that the latter trailed behind. And here the various camps—academic artists, secessionists, and "expressionists"—fared differently. As far as one can tell in the absence of research about this issue, the first were disappointed, the second fared the best, and the time for the third had not yet come. Modern art had not been broadly established on the art market in the years before the war. Now it was threatened by a resurgence of competitive attacks couched in nationalistic terms that recalled the great debate in the wake of the Agadir Crisis of 1911. By June 1915, the trade journal *Der deutsche Künstler*, representing the camp of academic artists, launched vigorous broadsides against what its writers perceived to be the press's predilection for French-inspired modernism.[5]

At a time when the Secession artists in Berlin had publicly staked out a patriotic wartime posture in their journal *Kunst und Künstler* and in their broadsheet *Kriegszeit*, the expressionist camp belatedly felt called upon to face down these persistent chauvinist attacks against their perceived francophilia. The *Zeit-Echo*, which had thus far been reticent in this regard, now published in short sequence two articles by the leading national critics favoring expressionism, Paul Fechter and Adolf Behne, who both turned their timely but mild interpretations of expressionism as a German style of the year before into a belligerent wartime posture. First Fechter, in "Confirmation of the War," proclaimed the expressionist emphasis on feeling to be in tune with the wave of national enthusiasm that had buoyed the German war effort in the summer of 1914. In a poignant fusion of avant-gardism and chauvinism, he positioned the expressionists in the forefront of the claims to German leadership in art which was to be the cultural achievement of the war.[6] Later in the year, Behne, in "Organization, Germanness, and Art,"[7] evoked the Gothic, which he presented as an intrinsically German style, as a precedent for the compositional firmness and spiritual determination of expressionism. His terms "willpower" and "fantasy" provided an equation between the productivity of the German war economy and the creativity of modern art.

In this situation, Klee acted with intransigence. Although his sales, contrary to market tendencies, dropped below subsistence level in 1915, he would have no part of the current political vindication of modernism.

Klee's Stance of Withdrawal from the War

The lithograph *Death for the Idea* suggests that by December 1914, Klee had come to a point where he perceived modern art as a war casualty. This perception went beyond the cautious doubts to which he had still confined him-

self in his letter to Marc of October 17. In a letter to Kubin of December 29, Klee went even further: "Now I have already become quite accustomed to the war. It no longer stimulates me. I am entirely with myself, somewhere, beyond, below, but very much alive."[8] By that time, Kubin had already published in the fourth issue of *Zeit-Echo,* dated sometime in October, an unequivocal lithograph depicting the war as a deathlike woman who brandishes the torch of destruction (fig. 23). Klee could count on his sympathy for his own growing aversion to the war and hence wrote to him more openly than he did to Marc. The crucial passage of the letter, which Klee eventually used for the literary formulation of his new stance in his diary, confirms that initially the war had had a "stimulating" effect on him, at least to the point of prompting him to deal with it in his drawings and watercolors. However, as the months of war wore on, he began to share the weariness and disillusion-

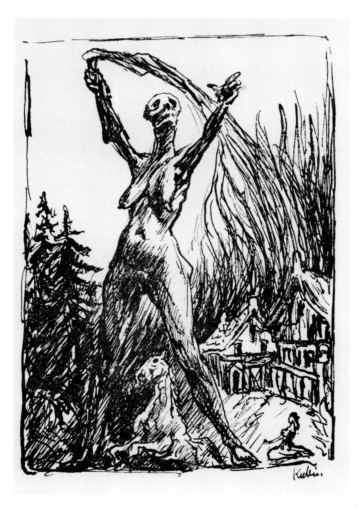

Fig. 23. Alfred Kubin, untitled lithograph,
Zeit-Echo, 1914

ment that some members of the German art world were beginning to feel already at this time. Klee's failure to elicit any public response with his war-related images from the autumn must have added to his disillusionment with wartime culture.

The increasing intransigence of Klee's position between January and April 1915 can be retraced in Maria Marc's letters to her husband at the front. This correspondence touched all the notions of art and war which Marc was pondering at the time, and it fuelled a discussion continued at Munich and Ried in conversations between Maria Marc, Klee, and the composer Heinrich Kaminski.[9] None of the three shared Franz Marc's acceptance of the war as a welcome if tragic destiny. Maria Marc in particular never tired of explaining to her husband her own rejection of the war. Nonetheless, in her reports about the discussions at home, she took exception to Klee's refusal even to consider the issue of art and war as significant. These reports are important for two reasons. First, they document and date the attitude Klee expressed in his diary entries of early 1915, which are not dated to the month and which he rewrote sometime in 1920–21; second, they show that this attitude was hardening in the course of the four months from January to April 1915.

When Maria Marc first mentioned Klee's indifference to the war, on January 14, she was still impressed by the assurance with which he was pursuing his work.[10] Five days later, she reported: "Klee is odd—he found your article II very beautiful—and then he said—he was having *no* such thought[s] *at all;*—he is very glad that somebody [else] should have them and write them down! . . . The war does not touch him inside at all. . . . All the more odd since his artistic sensitivity is so completely assured and very rich."[11] Maria Marc recognized Klee's artistic achievement as long as he was ready at least to admit that the issue of art and war was relevant. However, by March 15, Klee had reached the point where he denied "that the war should have even the slightest influence on the spirit of men,"[12] and by April 11, Maria Marc was charging him with "lack of clarity."[13] On April 26, she made a final assessment of how Klee's attitude came across in their discussions: "Klee does not strive, does not torment himself, does not suffer."[14] At the same time, her judgment on Klee's artistic prospects turned negative.[15]

The Controversy about the Spring Exhibition of the New Munich Secession

In the New Munich Secession's spring exhibition, which took place from February 20 through March 1915, Klee showed a collection of fourteen recent works, all from the year 1914. Among them were the two war-related watercolors *Thoughts of the Battle* (fig. 3) and *Thoughts of Mobilization* (fig. 4). Not a work was sold. Worse still, the exhibition provoked a political controversy in which Klee was one of the targets. A predominantly conservative art public attacked the paintings by some of the more modernist group

members as internationalist and francophile.[16] In the first war year, the patriotic terms of this attack rang with particular stridency. The critic of *Die Kunst für Alle* commented:

> The spring exhibition of the New Munich Secession, which was altogether misplaced in the rooms of the Kunstverein with its predominantly conservative attendance, was widely inferior in importance and value to the first great event of the Kunstverein in the summer of 1914. . . . The kind of art which is concentrated in the New Munich Secession is problematical; at least a rather substantial part of the artists who are united here have received impulses from the most recent Frenchmen and Russians, and today, as we are remembering again our German identity in all matters of external and internal culture, we are altogether disinclined to validate such models as worthy of emulation.[17]

The critic of *Deutsche Kunst und Dekoration* even reported that the exhibition "unleashed a storm of indignation with protest lists, noisy scenes, and lampoons. The exhibition had to be closed earlier than had been announced at the time of the opening."[18] Klee's fears, voiced in his letter to Marc of November 22, 1914 (see p. 26), that modernist art was in for hard times amidst the patriotic fervor of the first wartime culture, had been borne out. Both critics condemned the excesses but agreed that the controversy as such was justified. They separated a minority of modernists out from the bulk of the group, and of the former, in their judgment, Klee was the extreme. The more conservative critic of *Die Kunst für Alle* found it unlikely that "Klee's fantastic, pointillistic compositions" could "induce the impression of satisfaction on the part of an art lover with normal sensibilities."[19] The more liberal critic of *Deutsche Kunst und Dekoration* gave a laudatory illustrated survey of the exhibition in order to refute the charges that had been voiced but wished to avoid "provoking [such charges] through a polemical emphasis on the most extreme aspects of our modern art tendencies."[20] Hence, he did not even mention Klee.

In a postcard to Kubin, Klee scoffed at his critics and declared "the historic deed to publicize 'enemy art' at this time" to be a defiant gesture.[21] "In those rooms, my *abstracta* come off as very telling," he wrote, equating, in effect, abstraction with political subversion.[22] The New Munich Secession as a group, on the other hand, defended itself against the charge of being "fellow travellers of the art of our enemies"[23] by means of a printed broadsheet (fig. 24), which concluded:

> We reject this senseless pretension, the insults bounce off of us. As German artists who, like all other citizens, comply in every respect with their duties toward the state, we have of old a hereditary right to freedom of thought. [Any efforts to (illegible passage)] infringe upon the freedom of the artist and to patronize him will be in vain.

Fig. 24. *Striding Figure (Ausschreitende Figur;*
1915, 76 [reverse])

Fig. 25. *Striding Figure (Ausschreitende Figur;*
1915, 76)

> We are convinced of our aspirations, and it is in token of being Ger-
> man that we fight for them and do not let ourselves be misled.
> We continue to work.
> March 1915
> The New Munich Secession.[24]

Klee, the group member most affected by the attacks, expressed what he
thought of such a loyalist declaration in a drawing on the back of the broad-
sheet, which he kept in his own collection.[25] At a right angle to the lines of
patriotic Gothic boldface, which shows through in mirror reverse, he drew a
Striding Figure (fig. 25) who hastily walks through a door as if about to leave
the room. In its antithetical relationship to the turned, reversed broadsheet,
the figure appears as a countermanifesto, both private and programmatic,
about Klee's intention to walk away, as it were, from the patriotic defense of
modern art in the face of the war. "All of this is terribly important despite the
greatness of the time," he commented sarcastically to Kubin.[26] It was at just
this time that Maria Marc began to notice his absolute refusal of the notion
"that the war should have even the slightest influence on the spirit of men."

The Literary Formulation of the New Stance in the Diary

The Correspondences with Kubin and Marc

Early in 1915 Klee wrote down some of his evolving thoughts about the theme of art and war in a series of literary reflections which in the fair copy of his diary of 1920–21 he transcribed in the following form:

> One abandons the region here and builds beyond, into a transcendent region which is permitted to be entirely positive. Abstraction.
>
> The cool romanticism of this style without pathos is unheard of. The more terrifying this world—as is the case especially today—the more abstract the art, whereas a happy world brings forth an art of the here and now.
>
> Today is the great transition from past to present. In the huge pit of forms lie fragments to which one still clings in part. They furnish the stuff of abstraction.
>
> . .
>
> I thought I was dying, war and death. [But] can I die, I the crystal?
> I the crystal.
>
> I have had this war within me for a long time. Therefore it does not concern my innermost self. In order to work myself out of my ruins, I had to fly. And I did fly. In that shattered world I remain only in memory, as one thinks back sometimes. Thus I am "abstract with memories."[27]

With the exception of the line "I the crystal," which Klee cut out of the original notebook and pasted into the final transcription (fig. 26),[28] these texts are by no means immediate reactions to the historical situation of early 1915, but rather the final literary summation of Klee's wartime stance in 1915 as he wished to record it in 1921. At the time to which they are dated, Klee was just beginning to work out these texts. He seems to have kept revising them in an intermittent process of reflection that extended over several years and ended only on the date of the transcription. Still on June 8, 1915, he maintained in a letter to Marc that he had confined his diary to biographical notes.[29] The finalized texts about art and war, on the other hand, are the result of Klee's responses to positions taken by a number of artists and critics of importance to him.

Fig. 26. Diary transcription for early 1915, detail: "I the crystal" ("Ich Kristall")

Characteristically, the protracted dialogical process of formulation evolved out of Klee's correspondence around the turn of the year. The two crucial statements about internalization and memory respectively are matched in two letters from this time.

Letter to Kubin, December 29, 1914

Now I have already become quite accustomed to the war. It no longer stimulates me. I am entirely with myself, somewhere, beyond, below, but very much alive.

Diary Transcription

I have had this war within me for a long time. Therefore it does not concern my innermost self.

In the fair copy of the diary, Klee stylized the straightforward process of mental withdrawal from the war and ensuing introspection into a tense alternation between introversion of the war and its emotional rejection. He transfigured his new lack of concern and concentration on his work into a mystical brush with death.

To Marc, Klee conveyed the same conclusion differently. Here he represented it as a confirmation of feelings of a cultural crisis already experienced in the years before the war which Marc himself had experienced:

Letter to Marc, February 7, 1915

For me, a war was really not necessary any more, but perhaps it was for the others, all those who are still so backward. For me, the present had already mauled and destroyed itself. . . . There was only one salvation, a turn away from this world. Abstraction. Relapses do not become us so badly that one would have to avoid them forcibly. One has been a child and has one's memories of that.

Diary Transcription

I have had this war within me for a long time. Therefore it does not concern my innermost self.
One abandons the region here and builds beyond, into a transcendent region which is permitted to be entirely positive.
Abstraction.
In that shattered world I remain only in memory, as one thinks back sometimes.

This letter is the first testimony of a debate about the issue of art and war which Marc and Klee pursued by correspondence and in conversations

during the reminder of the year. Klee knew all of Marc's writings before they were published, as soon as Marc had sent them home. On November 23, 1914, Marc sent the manuscript of "The Secret Europe" to his wife Maria, asking her explicitly to work it over together with Klee.[31] On January 7, 1915, he sent her a second article, again in order to pass it on to Klee for a critical reading.[32] On February 21, 1915, finally, he sent her the most comprehensive, most profound, and most literary formulation of his ideas about art and war, a collection of exactly one hundred aphorisms.[33] Here he did not stipulate that Klee was to read them, but Klee did so anyhow, as the correspondence testifies. Klee's letter of February 3, where he advances his position in a tentative, not yet literary form, was written about three weeks before Marc's aphorisms arrived. In his next letter, dated April 28, 1915, Klee already acknowledged that they had sharpened his own thinking. "Your aphorisms have already exercised strong effects, even before they have gained a definitive shape for publication. I found in them a host of successful thoughts and poetic pieces, so that I can only wish you might soon find the spare time and the distance in order to finish them. Then it will be possible for me, more than at present, to define what they say which agrees with me. Surely very much."[34] At a later point, Klee acted on his stated intention to clarify his thoughts by comparison with Marc's. In the final version of 1921, his texts take on a similar aphoristic form. However, far from determining what was akin to his own thought, Klee used the literary similarity in order to establish a common level on which to distance himself from Marc. His own aphorisms can be read as explicit replies to some of Marc's.

First War Experience

MARC: "From the first moment of the outbreak of war all my thinking was aimed at releasing the spirit of the hour from its roaring noise. I plugged my ears and sought to look the war specter in the back. All the signs of the war were struggling against me. Its face blinded me wherever I turned. The thinker avoids the face of things, since they are never what they appear to be."[35]

KLEE: "What the war was telling me at first was more of a physical nature: that blood was flowing nearby. That one's own body could be endangered, without which the soul could not do! The reservists at Munich, chanting stupidly. Wreathed sacrificial victims. The first sleeve tucked up, with the safety pin. The one long leg in Bavarian blue, striding widely between two crutches."

The Heart Stops

MARC: "In the Great War, in one hour and second or another, every heart stopped one time, a short, single time, only to slowly start beating again with a faint new heartbeat toward the future.
This was the secret hour of the old time's death."[36]

KLEE: "Within me, the heart that once beat for this world, has been hit, as if mortally.
I thought I was dying, war and death."

The Coolness of Memory

MARC: "Many who do not have the inner glowing fire will be cold and feel nothing but coolness and will escape into the ruins of their memories."[37]

KLEE: "The cool romanticism of this style without pathos is unheard of. In that shattered world I remain only in memory, as one thinks back sometimes."

Flying Away

MARC: "How beautiful, how singularly consoling is it to know that the spirit cannot die. . . .
To know that makes departure easy.
With Mombert I sing:
 'I would like to do one wingstroke only,
 A single one!'"[38]

KLEE: "Can I die . . . ?
In order to work myself out of my ruins, I had to fly. And I did fly."

The fundamental difference between Marc's and Klee's respective positions is that for the former, the war prompted the transition from the rejected material world into a spiritual realm, whereas for Klee, it had no spiritual sense whatever, but was only part and parcel of the self-destructive world. Hence, Marc recalls his first reaction to the war experience as one of introversion, Klee as one of repugnance.

Klee most probably did not reach this fundamental distinction all at once in the spring of 1915. As of June 8, he had not yet formulated his own text in response, for on that day he wrote to Marc that he did not care for what he called "theoretical" debates. In fact his texts were the end result of a protracted effort to come to terms with Marc's position, lasting throughout the years of the war.

However, there is one crucial idea which Klee did formulate as an instant response to Marc's aphorisms, in his letter of April 28: "I can just as well admire those who passed away in silence and now are no more, as justify those who want to preserve their lives for other struggles. Accordingly I am ready to take upon me any fate, either not to be called up or to witness or suffer the greatest hell."[39] This is how Klee tried to come to terms with the continuing possibility of being called up and at the same time to "justify" the exemption he had enjoyed thus far: to Marc's alignment of art and war, he implicitly opposed an ambiguous alternative with claims to an equivalence.

The Reference to Texts of the Munich Avant-garde

However long it took Klee to put his position into final literary form, its premises were derived from what amounts to a composite theory formulated by the participants of the modernist art scene in Munich in the two years before the outbreak of the war.

Klee derived the notion of abstraction as a "crystalline" antithesis to re-

ality, from a text familiar to the *Blaue Reiter* artists, Wilhelm Worringer's *Abstraction and Empathy*. In 1907, the twenty-five-year-old art historian had submitted this work as a dissertation to the University of Berne; in 1908, it was published in Munich as a book; by 1910, it was in its third printing. The author was the first renowned academic art historian in Germany who publicly took the part of modern painting. More than any other text, his book had made the notion of abstract art respectable to an educated art public. Its references were not to suspicious theosophical authors such as Madame Blavatsky, Annie Besant, and Rudolf Steiner, as in Kandinsky's *On the Spiritual in Art*, but to celebrated German philosophers, Kant, Schopenhauer, and Nietzsche, as well as to art-historical authorities, Heinrich Wölfflin and Alois Riegl. It was Philipp Lotmar, the left-leaning law professor in Berne and father of Klee's classmate Fritz Lotmar, who had drawn Klee's attention to Worringer as early as July, 1911.[40] Back in 1904 and 1905, Professor Lotmar had shared and encouraged Klee's passing sympathy for socialism and the February revolution in Russia. Now their reading of Worringer suggests a transition from socialism to modernism on the part of both the established scholar and the aspiring artist.[41] "All of this has been my achievement for quite some time, but it is highly gratifying as a scholarly utterance," Klee had commented when he received the book,[42] pleased to see the claims of the avant-garde backed up by academic scholarship. Marc had read *Abstraction and Empathy* only in February 1912, three months before the *Blaue Reiter* appeared, and immediately recommended the book to Kandinsky on the assumption that the latter did not yet know it.[43] Soon both planned on enlisting Worringer as a contributor to the projected second volume of the *Blaue Reiter*.

Geelhaar has shown to what extent Klee drew on Worringer's book already in his diary reflections of 1913.[44] No doubt Klee had by then accepted Worringer's principle of an abstract form which the human spirit devises in order to oppose it to the sensory world, a form which, by contrast to nature-oriented "empathy," is aimed at metaphysical absolutes. However, only when he set out to formulate a position adequate to the historical moment of the war, did he take seriously the pessimistic premises of this principle, which had their origins in the philosophy of Schopenhauer and Nietzsche. "The more terrifying this world—as is the case especially today—the more abstract the art, whereas a happy world brings forth an art of the here and now."[45] An art theory where positive aesthetic values such as abstract, lawful, necessary, and crystalline, were founded on a negative feeling for life circumscribed by terms such as skepticism, fear, disruption, worry, and even agoraphobia,[46] suited the intransigence with which Klee sought to justify the purity of his concept of abstraction in response to the threat of the war.

The pessimistic ambivalence of abstraction had already been voiced by Kandinsky and Marc at the beginning of 1914, when the pronouncements of both these publicity-conscious painters had taken a somber turn. In late 1913 or January 1914, for the opening of his exhibition at the Circle of Art in

Cologne, Kandinsky wrote a lengthy speech which he never delivered. Here he renounced his earlier claims that his paintings could be understood by anyone with an "open soul."[47] Now he "only wished to paint good, necessary, living pictures that will be correctly experienced at least by a few beholders." At this point Kandinsky referred to Worringer. "For my way of feeling, still completely unconscious at that time, the highest tragedy took the form of the highest coolness, so I saw that the highest coolness is in fact the highest tragedy. And that is the cosmic tragedy where humanity is merely one sound, merely one single participating voice, and where the center is shifted into a sphere that approaches the divine."[48] The new, "cool" transfiguration of abstract art into a divine realm where men experience their own insignificance as tragedy, follows Worringer's pessimistic understanding of abstraction as a mode of experience caused by the fear of threatening reality. The characteristic mixture of lone self-exaltation and gloomy detachment which Kandinsky derived from this understanding was the opposite of his confidence in mankind's "spiritual" participation in the occult "sounding cosmos," heralded three years earlier in his treatise *On the Spiritual in Art*. Klee adopted this stance, centered as it was on the key term "cool," from Kandinsky's speech, or at least from conversations with him. In the fall of 1914, he had already sided with the exiled Russian painter's expectation that during the "terrible times" of war the few artists of the internationalist avant-garde could hope for no more than survival in hiding (see p. 15).

Marc, in an essay of early 1914 entitled "Critique of the Past," unpublished during his lifetime, went even further than Kandinsky in his metaphysical pessimism: "Everything is one. Space and time, color, sound, and form are just ways of perception which originate from the mortal structure of our minds. . . . The dead man does not know space and time and color, or he knows them only to the extent that he still 'lives' in the memory of the living. He himself has been delivered from all partial sensations. With death there begins that kind of being properly speaking, around which we, the living, restlessly swarm, like the moth swarms around the light."[49] For the first time, Marc conceived the avant-garde's characteristic "spiritual" alternative to physical life as a longing for death itself. In April 1914, this may have been little more than an artistic conceit, yet by August it suited the attitude with which the painter greeted the outbreak of war, although no testimony from before that time suggests that he already then thought war was inevitable or desirable. By actually facing death at the front, Marc had given his stance a compelling authenticity. When Klee imagined his own hypothetical brush with death—"I thought I was dying, war and death"—he transfigured his escape from this historic test of abstraction, as he had stated in his letter to Marc of February 3, 1915. Marc himself, in a letter of March 1, 1915, had quoted to him Mombert's verse "I am the rock that cannot die" on which Klee's metaphor is modelled.[50]

Finally, when Klee proclaimed the absolute separation of art and war, he sided with Munich's most influential art critic of the modern scene, Wilhelm

Hausenstein. For several years, Hausenstein had been both a leftist and an advocate of modern art. A member of the Social Democratic Party since 1907, he had taught in a workers' night school and edited the cultural section of the *Sozialistische Monatshefte.* In his writings on art, he had conceived of a "sociological" approach based on the writings of Marx. At the same time, he was promoting modern painters, including Kandinsky, Marc, and Klee. On November 27, 1913, he had organized the foundation of the New Munich Secession with Klee's participation, but without Kandinsky and Marc.[51] In his book *Die bildende Kunst der Gegenwart* of 1914, Hausenstein had given Klee an ambiguous accolade: "one has the feeling of a corruption which is sublimated to the point of childlikeness, which, however, does not remain for a moment in the realm of the material, but immediately translates itself into artistic intuition with the greatest intensity. . . . Concepts such as decadence make no sense here: in the end the intensity and sharpness of form overcome every disruption."[52] With negative terms such as "the last . . . reflex of sensual experiences," "extreme dilution," "absolute vagueness," and "disintegration," Hausenstein characterized Klee as "the most boundless deformer witnessed in the history of the more recent graphic arts."[53] His praise of Klee's formal precision was summary by comparison, hardly counteracting the impression that for him, Klee was one of the purest representatives of expressionism which he defined as "the conscious principle of artistic deformation."[54]

In the fall of 1914, Hausenstein, in a long article entitled "For Art," challenged the war-committed art now being rushed to the public. He presented a balanced critical survey of the issue "art and war," whose positive sense was being taken for granted by so many patriotic artists and writers, and concluded the two were incompatible, or even polarized like life and death. "In war, the artist has no function any more. . . . If he is honest to some degree, he senses that there is no so-called aesthetic relationship to war."[55] According to Hausenstein, war and abstract art were particularly incompatible:

> The war is something monstruously concrete. The art with which we went to the threshold of the war was not concrete. In the summer of 1914, we lived a moment when art had blossomed to a—seemingly—unheard-of abstract formalism. The artist's experiences were no less vehement and intimate than ever. However, these experiences were entirely rooted in a speculative view of form which was all but severed from anything tangible and substantial. . . . every affect, every situation was translated into pure form equivalents. . . . Will the war cancel this tradition?[56]

These were the terms with which Hausenstein had characterized both Kandinsky and Klee in his earlier writings. After Kandinsky had left Munich, only Klee remained to be addressed in that way. Thus, in addition to drawing from the pronouncements of his two *Blaue Reiter* colleagues, Klee could reassure himself of critical sanction for the wartime stance he was elaborating in 1915. By that time, though, Hausenstein had carried his thesis of the polar-

ity of art and war still further. In the summer or early fall, he published a new article on the issue in the *Zeit-Echo*, where he insisted on the primacy of politics, explicitly rejecting a stance of mere withdrawal: "If war and art are brought into a too immediate connection, they become polarized. . . . However, it makes no sense and has no dignity, but is just extremely helpless, if artists who recognized this . . . tried to close off their lives against the event of war . . . , as if there were today any valid notion at all which could compete with the war, and as if they were the guardians of this notion."[57] In line with his Socialist convictions, Hausenstein had begun to move in the direction of the political radicalization of the avant-garde. Klee, although he had counted himself among "the left" of the *Zeit-Echo*'s contributors in the fall of 1914, did not follow him in this direction (see p. 30).

The Images of Flight and Death

The diary text in which Klee pictures himself as flying away from a world of rubble can be read as an allegory about the achievement of the artistic self-sufficiency he had sought for years. Although it appears here as a response to Marc's enthusiastic quote from Mombert, the image of flying had been for Klee a metaphor for the triumphs and failures of the artistic imagination almost from the beginning of his career.[58] As early as 1902 he had started one of the fantasies about artistic success in his diary with the exclamation "A flying man!"[59] In 1905, he had personified the notion in his etching *The Hero with the Wing* (fig. 28). One wooden leg of a nude man is rooted in the soil, and from his right shoulder has grown a short, stubby, unusable wing. Klee explained the etching with these words written in the corner: "Especially endowed by nature with one wing, he has therefore formed the idea of being destined to fly, whereby he perishes."[60] In his transcription of the diary for 1905, Klee elaborates: "This man, born, in contrast to divine beings, with one wing only, makes constant attempts to fly. That he thereby breaks arm and leg does not prevent him from remaining faithful to his idea of flying. The contrast of his monumental and ceremonious attitude with his already ruined state had to be especially underscored."[61] The final literary version of the diary entries for 1915 declares the "ruined state" to be that of the world, no longer that of the artist, and Klee writes of a successful flight, not of a crash. His evocation of a tortuous emergence from ruins differs from Mombert's and Marc's soaring flight, but is no less confident. The past tense in which the last sentence of the diary entry is written suggests that Klee saw his confidence in the artistic validity of his stance confirmed in retrospect, after that stance had been vindicated through his career success during the First World War. It is unlikely that he would have anticipated it with so much assurance in 1915, at a time of uncertainty about its prospects.

Actually, Klee's text about the flight of abstraction suggests an experience of the war itself which was still before him at the time to which it is dated. The imaginary break is not a clean one, for through memory the artist

remains conscious of the shattered world. It was this ambivalent, dynamic process between recollection and rejection of reality which Klee called abstraction and declared the appropriate attitude for the transition from past to present. Elements of memory incorporated by the artist in his abstract images testify to a historical situation, no matter how self-sufficient their subjectivity, but they do so in a negative, critical way, as the metaphor of rubble suggests. Klee inserted into his account a recollection of the mood of deliberate but disoriented skepticism with which he initially countered the war craze of fall 1914: "What the war was telling me at first was more of a physical nature: that blood was flowing nearby. . . . The reservists at Munich, chanting stupidly. Wreathed sacrificial victims. The first sleeve tucked up,

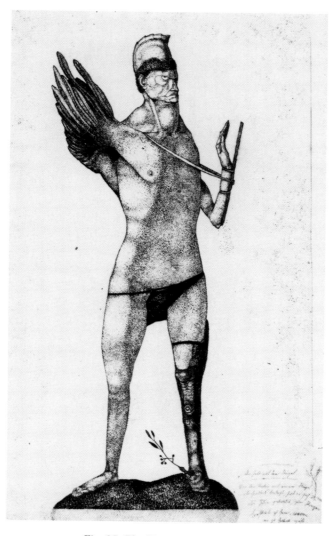

Fig. 27. *The Hero with the Wing*
(*Der Held mit dem Flügel;* 1905, 38)

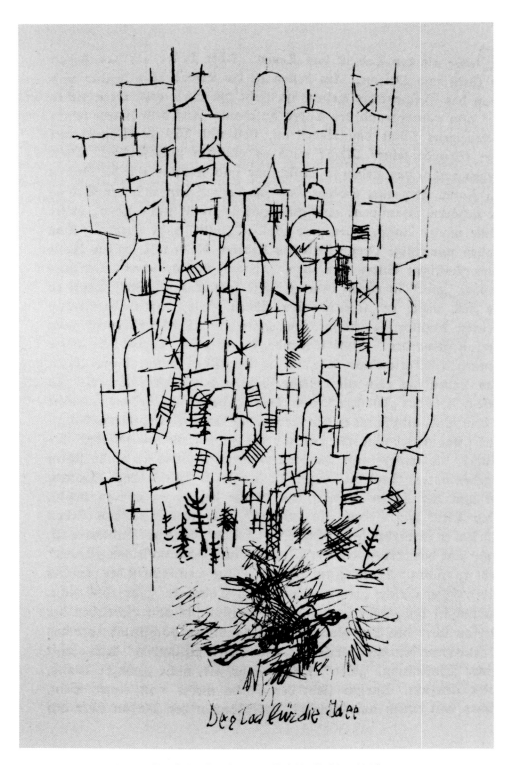

Fig. 28. *Death for the Idea* (*Der Tod für die Idee;* 1915, 1)

with the safety pin. The one long leg in Bavarian blue, striding widely between two crutches. The letterprint in the history book turned real. Old picture sheets confirmed."[62] Klee here disclaims the historical authenticity of his immediate physical sense of war calamity. From the sidewalks of Munich he was watching historical actuality as if it were staged as a play in conformity to discredited images and texts. The terms of audience and spectacle allowed for easy disengagement. Klee was on his way to wartime culture by contradiction.

The lithograph *Death for the Idea* (fig. 27) had appeared in December 1914, and yet Klee recorded it, in his oeuvre catalog, as the first work of the year 1915. Through this redating, it corresponds to the first diary entry for the year 1915, "Within me, the heart that once beat for this world has been hit, as if mortally," as well as to Klee's thoughts about artistic destiny as an alternative to death in war, as he had voiced them in his letter to Marc of February 3, 1915 (see p. 42). The synchronization appears to be intentional, as if Klee had wished to sever the image, at least for himself, from the context of its publication in the preceding year, which had compromised him against his own intent. When he wrote, "I thought I was dying, war and death" into his diary, he figuratively complied with Annette Kolb's equally figurative demand "It is we who should have died!" in the *Zeit-Echo* of December (see p. 33). Such a projection of artistic experience as an act on the brink of death was no doubt written in response to Max Beckmann's letters from the front, published in *Kunst und Künstler* of December 1914. Here the painter, who had volunteered to serve as a field orderly, wrote: "my will to live is stronger now than it ever was, although I have been through terrible things and have already died on behalf of others a few times myself. But the more often you die, the more intensely you live. I've been drawing, and that keeps you safe from death and danger."[63] In adapting the thought from the well-known realist painter who had gone to the front for the ultimate raw experience of life and death, Klee staked out high claims for his homefront abstraction.

"Crystalline" Images of 1915

In 1915, Klee produced seven works with titles relating more or less clearly to the war, although in no case as directly as in 1914.[64] Six are drawings and one is a black-and-white watercolor. The word "war" itself occurs in only one title from the very beginning of the year. After that Klee never used it again for the duration of the war. In 1915, unlike 1914, he exhibited none of these works, nor did he offer them for sale to dealers or collectors. He thus drew the consequences from the failure of his efforts of the year before to impress his statements about war upon the public. The seven war-related works of 1915 remained private reflections.

The first of these works, *Crystalline Memory of the Destruction by Navy* (fig. 29), bears the number 11 in the oeuvre catalog and must therefore have

been done very early in the year. The title combines three of the key terms of Klee's conceptual polarization of art and war which recur together in the diary transcript of 1921. The drawing's theme refers to submarine warfare, the overriding issue of public debate in early 1915 (fig. 30). The outlines of the composition vaguely suggest fragments of the hull of a ship, gun turrets, and staircases. The ship has literally been shattered and rebuilt into an abstract composition resembling the background of *Death for the Idea*. It is as if the cubistic form procedure[65] had reversed the result of the destruction of war, in a subversive defiance which confirms the diary entries dating to that time.

The new "crystalline" form of this wartime image contrasts with the fuzzy, scribbled appearance of the satirical drawings of late 1914 such as in *War Which Destroys the Land* (fig. 5). The compositional pattern with its characteristic diverging and converging verticals is similar to that of the watercolor *In the Style of Kairouan* from the fall of 1914, which is completely abstract. In the watercolor *With the Brown Camel* of early 1915 (fig. 31), this abstract composition is taken up once more; here the small, simplified but obtrusive pictorial sign denoting the camel evokes the memory of Klee's trip to Tunisia as the reference point for the otherwise nonrepresentational picture. It connects with the same sign in the watercolor *In the Desert* (1914, 43; fig. 32), which was actually done during that trip. In *Crystalline Memory*, the relationship between abstraction and reality is not confined, as in the Tunisian works, to the spontaneous transposition of a private travel experience to visual and conceptual memory. In line with the dialectics of cubism, with its ambivalence of fragmentation and reconstruction, the "crystalline" form as applied to the destruction of war contradicts a historical reality out of reach for Klee's perception.

Probably at the same time, Klee made the lithograph *Conquered Fort* (fig. 33), whose war-related title ties in with that of the drawing. Only in October 1916 did he issue this lithograph, with hand-colored additions, under the new title *Destruction and Hope* (see below, p. 82).[66] Franciscono has shown how Klee took the pictorial idea from Gleizes's painting *La ville et le fleuve* of 1913 (fig. 34). Klee emphasized the negative, fragmented, but not the positive, consolidated aspects of Gleizes's cubist composition. "Gleizes's picture remains a landscape of perception, which has been dissected into fragments and subsequently reassembled in a kaleidoscopic manner. . . . Klee, on the other hand, ironically applies the fragmentation and discontinuity of cubism, so to speak, literally, in order to evoke the image of chaos or collapse."[67] Pursuing his own "crystalline" form concept, Klee did accomplish a reordering of the image fragments together with the abstract shapes. However, that concept was not static, as in Gleizes's orthogonal coordinates, but dynamic, diagonally activated according to Klee's sense of subjective, moving pictorial form.

With this cubist pictorial reflection Klee ventured for the third time into publishing war-related lithographs, after *Battlefield* and *Death for the Idea*.

Fig. 29. *Crystalline Memory of the Destruction by Navy*
(*Kristallinische Erinnerung an die Zerstörung durch Marine;* 1915, 11)

Fig. 30. Claus Bergen, *Submarine Attack,* watercolor, 1915

Fig. 31. *With the Brown Camel* (*Mit dem braunen Kamel;* 1915, 39)

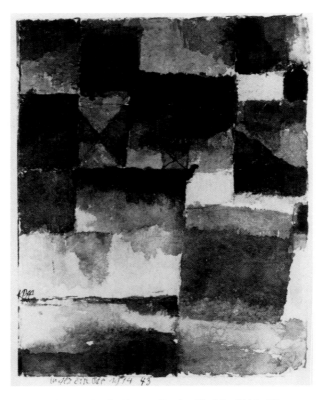

Fig. 32. *In the Desert* (*In der Einöde;* 1914, 43)

Fig. 33. *Destruction and Hope (Zerstörung und Hoffnung;* 1916, 55) stage of early 1915

Fig. 34. Albert Gleizes, *La ville et le fleuve,* 1913

Goltz, however, who at this point was unable to sell anything of Klee's, ran no sales edition of the print. The block remained packed away until October 1916, when the lithograph was finally issued, adapted to the changing circumstances of that time (see p. 84).

Indeed, with his new concept of abstraction, Klee was even less successful on the art market than before. After he had received his collection back intact from the New Munich Secession show of March 1915, his only effort at a public showing in that year was a collection of eleven works put up for sale with Goltz, who sold none of them until the war was over. Thus Klee was thrown back on a few chance purchases by a handful of collectors who were already acquainted with him. They, however, were reluctant to follow him up to the heights of abstraction he had newly reached in his watercolors and his cubist drawings. To be sure, these were not the only kind of work Klee produced in 1915, but their correspondence to the programmatic diary entries of that year suggests that he regarded them as his most advanced work.

In February, Dr. Hermann Probst bought three watercolors of 1914, all landscapes, one from Tunisia.[68] "Dr. Hermann Probst owns some of my watercolors and loves them rather much, it seems," Klee ironically noted in his diary.[69] "At his suggestion, Rilke was sent a small collection of mine and brought it back to me in person." Rilke visited Klee toward the end of April, 1915. He, too, preferred Klee's earlier watercolors.[70] "To the graphic work, where I have advanced the most, he paid less . . . attention." In July, the painter Lotte Wahle in Dresden bought two drawings from 1913 with fantastic, illustrative subject matter.[71] In autumn, the painter Alexei von Jawlensky and the collector Dr. Röthlisberger did show interest in more recent works, but only those with Tunisian themes.[72] And the architect Alfred Bürgi in Berne, who bought three black-and-white watercolors at once, wanted only landscapes from Berne, whereupon he received, as an additional gift, an eight-year-old charcoal drawing of yet another landscape.[73] Only the collector Kissling bought an abstract oil painting from the current year.[74] "A small public of fine minds is what I wish for myself," Klee had written to Kubin on April 29, 1915, after Rilke's visit.[75] Now that public held him to recognizable themes, particularly from Tunisia. The lack of adequate response confirmed the failure of his new work in the exhibitions. Klee was left alone with his sense of artistic and conceptual innovation reached in the course of 1915.

The Debate with Marc

"Today I love all human beings whose hearts tremble in sympathy with our lives and with the will of destiny in this war," wrote Franz Marc on January 29, 1915, in a letter from the front to the widow of August Macke, who had been killed in action on September 26, 1914.[76] "Strangely enough there are, however, many who timidly avoid everything which might draw their souls into the war, the 'neutrals' in our land." With these words Marc was almost cer-

tainly alluding to Klee, who was just now coming to the conclusion that the war did not matter to him anymore. Four weeks after Macke's death, in a letter of October 23, 1914, Marc had proposed to Klee: "Let us become brotherly friends,"[77] but as soon as the two artists attempted to clarify to each other their opposing views of the war, a protracted, severe argument ensued, which remained unresolved until Marc's own death in action.

In March 1915, Marc's essay "The Secret Europe" appeared in *Das Forum*.[78] In the same month, in a letter to his wife, he called his large painting *Animal Destinies* of 1913 (fig. 37), of which he had received a postcard reproduction from Berlin, a "premonition of this war,"[79] thus retrospectively declaring his wartime stance to be the outcome of his prewar thinking. In a small-size sketchbook which, during the months of March through June, 1915, he filled with pictorial ideas for large compositions to be painted after his return, he drew a variation of this composition, with its splintering interpenetration of crystalline diagonals, and gave it the unmistakable title *Struggle* (fig. 35).[80] The drawing is a direct if unintentional counterpart to Klee's lithograph *Conquered Fort* (fig. 33). Both artists referred the destructive connotations of cubism and futurism to the theme of war in a different manner. Whereas Klee was reaching for a synthesis of "destruction and construction," Marc made only the explosive, negative side of cubism the rationale for his composition. His counterimage in the sketchbook (fig. 36), an inviolate, paradisiacal landscape complete with horses, was realistic by comparison.

It was during this time when Marc formulated his principles that he and Klee joined a debate about them in their intermittent correspondence. For Marc, the debate was merely a side line to the intense, often daily exchange of letters that he carried on with his wife Maria, in which she related to him her conversations with Klee and Kaminski at Munich and Ried. For Klee, on the contrary, it was his only opportunity to clarify his stance by way of dialog. This difference in the degree of commitment increased the ensuing conflict, the more so since both painters were bent on developing metaphysically charged art theories out of their different life situations as a soldier and as a civilian.

The debate by letter was kindled by Klee's responses to the essays Marc sent home for publication. Marc was not interested in an exchange of views on equal terms, but only in Klee's reaction to his own views, of which he was less certain than their self-assured literary formulation would lead prospective readers to believe. This is why Klee's emphatic letter of February 3 (see p. 43), remained unanswered. After curtly announcing, in a postcard of February 11, that he would send his completed aphorisms in March,[81] Marc stopped writing to Klee altogether.[82] But as soon as Klee had formulated his first response to Marc's aphorisms in his letter of April 28, Marc wrote back on May 10, instantly and at length. To Klee's seemingly light-hearted, diffident insistence: "Perhaps a warrior on the battlefield will find it puzzling how one should be able today to paint watercolors and play the violin. And [yet] I find both so important! Anyway the Ego! And Romanticism!"[83] Marc gave a heavy-handed moralistic rebuttal: "But the question of conscience—

Fig. 35. Franz Marc, *Struggle* (*Streit*), from the war sketchbook, 1915

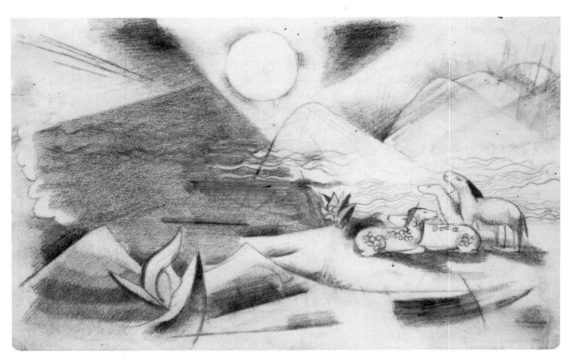

Fig. 36. Franz Marc, untitled, from the war sketchbook, 1915

the question, for the fact of the matter, of the essence—still remains the last and unavoidable question, and not your 'Ego and Romanticism'! . . . How in the world are we to eradicate this egocentricity, this root of our European impurity and impiety?"[84] And he countered the egocentrism of modern art with a medieval ideal of religious inspiration: "Wherever the ego is taken for important, more important than the *substance*, there is bad, impure art. The artist is a tool and creates selflessly. . . . the Ancients called it inspiration, or transfiguration . . . [the artist] stands behind his work, just as the Evangelist stands behind his Gospels."[85] Thus, the debate between the two artists focused on the issue of individuality versus collectivism, which Marc evoked with his references to the tradition of William Morris and the Nazarenes. After some hesitation, Klee answered on June 8 with a clarification of what he had meant. He tried to play down the one-sided subjectivism of his insistence on individuality, by relating it to both the idea of the divine and a community with others:

> As to my "Ego and Romanticism" I do not want to go on being unwise and saying things that may sound false. Of course what I mean is the divine Ego as a center. It is this Ego which for me is the single reliable being, and my confidence in it rests on parts of common ground. Your circle and mine appeared to me to have relatively much common ground. Approximately like this: [here follows a small drawing of two intersecting circles] and I believed I could rely on this until I got frightened. Now I have calmed down again completely.[86]

Klee had taken the figure of two intersecting circles from Hebbel's published diaries, where Hebbel had used it to characterize "the relationship of most human beings to one another."[87] Moreover, with the figure of the circle, he reminded Marc of a continuing artistic dialog dating back to 1913. This dialog concerned precisely the picture which had now assured Marc about the continuity of his prewar art with his current sense of war as destiny. In the late spring or early summer of 1913, Klee, who in those days was spending much time in Marc's company,[88] had proposed to Marc the title *Animal Destinies* for the just-finished painting.[89] At the same time, he had made a drawing (fig. 38) which may be viewed as his own response to the large composition. Klee translated Marc's dynamic interpenetration of diverging diagonals into a black-and-white composition of dynamically propelling wedges with enclosed circular forms. By contrast to Marc's representational symbolism with its literary associations, no rudiment of imagery mars Klee's abstraction.[90] In *Animal Destinies,* Marc had fitted perspectively distorted circles into the angles of form intersection so as to visualize the sentence "the trees show their rings" written on the back of the canvas. He thus symbolized the transparency, behind appearances, of an apocalyptic fate to which all life is subject. Klee, in his drawing, composed only one circle into an angle of intersection but placed a large number of other larger and smaller circles on the diagonal lines of the composition itself. Here they turn on various axes in

Fig. 37. Franz Marc, *Animal Destinies* (*Tierschicksale*), 1913

Fig. 38. *Circles* (*Some Freer, One Controlled*) (*Kreise [freiere u gebundener]; 1914, 89*)

movements of their own, not unlike little wheels, released from the con-
straints of their angular enclosure. Klee entitled the drawing *Circles (Some Freer, One Controlled)*,[91] apparently in order to oppose his own ideal of a re-
laxed mobile composition to Marc's conflict-ridden web of energy lines.
Marc, for his part, must have been aware of this reference, since in an ex-
change of pictures with Klee he selected this drawing, together with another
one, now lost, whose title *An Eye That Sees, Another One That Feels (Ein Auge welches sieht, ein anderes welches fühlt*, 1914, 100) also suggests an artistic
alternative between the two painters.[92] Thus, the circles of whose partial
intersection Klee wrote in June 1915 had always been polarized, in line
with Klee's habit of achieving self-definition by contrasting himself to his
friends.[93] Even the metaphor of shared territory in his letter sounds static
and final, excluding any movement of one subject toward the other.

Marc seems always to have respected or even appreciated the artistic
distance that Klee maintained toward him. On April 13, 1915, he wrote to his
wife, "I am more than ever in love with flowers and leaves. . . . With human
beings you can almost never have this kind of company; there, the egos
always collide; the least perhaps with Klee."[94] Klee, on the other hand, was
suffering to some degree from his resolute self-centering, no matter how
clearly he may have felt it to suit his temperament. When he transcribed the
letter into his diary, perhaps from a draft, he intensified the expression of
worry: "Your circle and my circle appeared to me to have common ground *in between them* [sic!]. And I *relied unshakably on this,* since I feared *the ulti-
mate solitude.* Now, *after a temporary shock,* I am completely calmed again."[95]
The words "in between," incongruous for intersecting circles, which Klee
here used to elaborate on the metaphor of common versus separate "ter-
ritory," inadvertently reveal that he was no longer concerned with any inter-
sections, but actually with a separation of the "circles." And the anxious
words of the transcription reveal the emotional stress in Klee's resolve to
force the distinction he needed to assure himself of his own artistic posture.

In his final reply, an undated postcard which turned out to be his last
written communication to Klee, Marc refrained from pursuing the argument
any further, looking forward to his home leave in July, when he would be
able to talk to Klee in person. Only in anticipation of the dialog, Marc took
up the metaphor of the intersecting circles once more: "Rest assured: our
circles still intersect considerably. However, your pictorial representation is
still too inflexible. One has to imagine the circles in turbulences and trajec-
tories, with necessary temporary estrangements, intercrossings, divisions,
and at times also beautiful romantic darkenings. Our sun always remains the
divine ego as the center."[96] With unequivocal symbolic realism, Marc trans-
formed Hebbel's and Klee's existential sign into a cosmic scenery where the
two artists are orbiting like planets.

In July and November, Marc came home to Munich on leave from the
front. On both occasions, he met Klee for long conversations, of which Klee
in his diary rendered account to himself. These passages must, as always, be

read with caution, since they are Klee's final assessment of his relationship with Marc as he saw it at the time he wrote the fair copy, that is, in 1921. According to this retrospective view, Klee's attitude remained inflexible, while Marc's underwent a deep if transitory change, and Klee's response to him, in between the first and second visit, changed accordingly.

On the first visit, Klee described Marc as "talking incessantly," no doubt about his reflections on art which had become inseparable from his war experience. Klee reacted with revulsion against Marc's appearance as a soldier. He "hated" his uniform, "the damn outfit," which later hung from the clothesline "like squeezed-out entrails in order to dry."[97] Marc for his part, after his return to the front, wrote on July 21 about his feeling "why it gets so much on our nerves if we see someone who pretends as if the war, even as an event, did not matter to him."[98] This reads like a literal quote from Klee's diary text, which Klee must have expressed in their conversations and which is thus already on record in its extreme form at this time. Klee most probably reacted to Marc's war pathos with the same resistance, no doubt tactfully subdued in conversation, but all the more stridently expressed in the diary. Here he called Marc's efforts to fuse his notion of art with his war experience "burning fermentations," which Marc "was really much too advanced already" to have.[99] The metaphor suggests that Klee was unable to see an artistic position as anything but the result of a natural self-development, not as a response to historical reality, no matter how overwhelming. He called Marc's acceptance of the war a "soldier's game," which "ought to be more hateful to him, or even better: indifferent."

Four months later, on Marc's second home leave from the front, his attitude vis-à-vis the war had changed in just this direction. Already on October 5, he had written to Macke's widow that he was now "filled with hate against this war," yet was "a better and better soldier," "soon to be an officer." He now felt "the grotesque quality of my present life"; his "thoughts were really nowhere, unsteady, unproductive. . . . Often I do not recognize myself."[100] Klee immediately picked up on the change. "I am not sure whether he was his old self or not," he wrote in his diary.[101] On the last evening before Marc's departure for the front, he and Marc jointly viewed a number of works by Jawlensky, and Klee experienced a feeling of profound harmony with him.

However, Marc did not stick for very long to his new, pessimistic view of war. On February 2, 1916, he wrote to his wife that he was struggling "constantly against the prevailing thoughtlessness of hating . . . the war as such."[102] Time and again, he tried to explain to her his efforts at understanding the "war as a natural *consequence* and hence a just, unfailing atonement."[103] In the last weeks before his death, new doubts befell him. "My glance has *for a long time completely turned away from the war,*" he now wrote. However, far from being drawn to Klee's position, he went on to write that he wanted no part of "Klee's indifference."[104] Since his last home leave he no longer exchanged letters with Klee. "He was now aware of my disinclination to theorize," Klee surmised.[105]

1916

The Upsurge of the German Art Market

In the first six months of 1916, German arms production rose in speed and volume to such an extent that the regular war bonds were no longer sufficient to finance it. A deficit in the federal budget ensued, and a new manner of augmenting the war budget by means of taxes was introduced.[1] Profits of war-related industries rose fast as a result. Between June 1915 and June 1916 Krupp's gross earnings doubled. By the fall of 1916 the accelerated and enlarged arms production initiated by the Hindenburg Program of August 31 had already led to yet another increase in the money supply.[2] The returns benefitted industrialists and shareholders exclusively, while workers' real wages declined.[3] Since many consumer imports were cut off, the German domestic market was forced to feed on itself. The resultant accelerated circulation created a surplus of available money, which in turn prompted a general rise in prices. The reduced production of consumer goods directed this surplus money supply to nonvital luxury items. This kind of spending began to create a budget problem for the state, since it tended to draw money away from the annual war bonds crucial for funding the war effort. The first special war tax was imposed in 1916, not only in order to raise money for the state budget, but also to reduce the oversupply of money and stem demand.

In June 1916, *Kunst und Künstler* was able to report, "Money seems to be no problem in Germany at this time. The overall result of the auction [Cassirer's on May 22, 1916] had been estimated by optimists at 600,000 marks, but it yielded over 100,000 Marks more."[4] "War-profits investment hardly plays any part in this," the reported added appeasingly. And in December 1916, another report in the same journal read, "The auction yielded the surprisingly high total result of one and a half million marks. . . . The lack of supply increases prices on the art market, and those who now have merchandize can sell to clear their inventory."[5] The spectacular recovery of the market in old art was matched by that for current production. The journal *Der Kunsthandel* cited as representative "the Munich Glass Palace Exhibition of 1916, where one had been prepared for a giant deficit, but

which in its result was surpassed only by two or three of the best peacetime exhibitions."[6]

At this point most participants in the German art market realized that its resurgence had to do with the touchy political issue of war profits, which was discussed time and again in the art-critical literature. Most writers tended to minimize the impact of war profiteering on the art market, although everybody recognized its existence. War profits were on the minds of those Reichstag deputies who already in 1916 moved unsuccessfully to impose a tax on luxury consumption, in which art was to be included.[7]

The Pacifist Revalidation of Expressionism

Marc's death in action on March 5, 1916, was a turning point in the nationalist revalidation of expressionism. Although his wife launched a press campaign in order to establish him as the leading painter of expressionism on nationalist terms, Walden and Hausenstein, Marc's most influential advocates, in their publications left no doubt that Marc's patriotic assent to war was no longer perceived as the platform for his success. Whenever Walden had to print in his *Sturm* yet another obituary for one of his contributors killed in action, he took the opportunity to deplore what the war had done to the international community of modern art. When in November 1915 a conservative critic of the *Kölnische Zeitung* wrote against the "idiocy" of seeing the war as a confirmation of expressionism, Walden retorted that war was no argument for or against art of any kind.[8] In Theodor Däubler, who in the summer of 1916 became the regular art critic of the *Berliner Börsen-Courier*, Walden found a nonaggressive expressionist author who was willing to laud his artists in the daily press. Däubler's new book of collected essays, entitled *The New Standpoint*,[9] did not touch the issue of war with as much as a word. It was on this platform that Klee in 1916 rose to prestige in the expressionist art world.

Klee's Conscription

"1916. A fateful year. . . . On March 4, my friend Franz Marc was killed in action near Verdun. On March 11 I was drafted into active service, a recruit of thirty-five years." With this retrospective diary entry,[10] Klee related the following stage of his wartime career to the death of his friend, a hypothetical commonality of fate, the awareness of which never left him for the rest of the war.

He received his call-up papers on March 11, together with the telegram bringing the news of Marc's death.[11] The coincidence may have appeared to him like a historic changing of the guard, as if he had been called upon to assume the military identity of his friend, after a year and a half of deferments. Actually he had been declared fit for active service already at the beginning of February 1916.[12]

Up until the end, Klee held on to his aloofness from the war, even under the conditions of military service, conscious of the contrast to Marc which this stance entailed. He resented his "masquerade," first in the old uniforms of the home guard (fig. 39), then in new, field-grey combat uniforms (fig. 40), even more than he had resented Marc's (see p. 62). In his last drawing of 1916, *When I Was a Recruit* (fig. 41),[13] which he made after his transfer to the airfield at Schleissheim, he retrospectively caricatured himself[14] and his uniformed superiors and comrades at Landshut with an acrimony recalling his satirical war drawings from the fall of 1914.

In the letters Klee wrote from Landshut, which he transcribed with few changes into his diary,[15] he underscored both his revulsion against the routine of military service and his resolute arrangements for pursuing his life and work as a civilian. Only six days after his conscription, on March 17, he rented a furnished room for his time off and for visits from his family.[16] After four more days, on March 21, his wife sent him his box of watercolors,[17] but he hesitated to resume his artistic work immediately. On March 28 he wrote to his wife: "Last night I played the violin until late. . . . This afternoon perhaps I will paint. A natural aversion has held me back from it thus far, also I

Fig. 39. Photograph of Klee in the old uniform of the home guard, 1916

Fig. 40. Photograph of Klee in new, field-grey combat uniform, 1916

must first of all adjust myself to a lighter 'occasional style.'" [18] In the diary transcription of this letter, Klee enhanced the contrast of music and painting: "I play the violin now and then. A great aversion holds me back from painting." [19] The aversion coincides in time with Klee's first one-man show of watercolors at Walden's Sturm Gallery in Berlin, which had opened on March 1. [20] While he was still in Munich, the exhibition seemed to result in failure, like all his business ventures of 1915. Immediately after the opening, Walden must have written to Klee that he had sold nothing yet and, accordingly, must

Fig. 41. *When I Was a Recruit*
(*Als ich Rekrut war;* 1916, 81)

66

have advised him to reduce his prices, especially in view of the small format of his watercolors. By March 3, Klee, "accepting the increased tragic burden of the miniature format," heeded the advice and reduced his net prices of over 100 marks by 20 percent.[21] On March 29, at last, he was able to record in his diary a sale for 260 marks from this exhibition,[22] and on April 4, he resumed his painting.[23] Soon he introverted the balancing act between artistic work and military service into a two-track sensibility. On April 10, he wrote to Kubin of a "dream world," of "things of the second sight," of "moments when the eye stumbles at reality." The beginning professional reassurance focussed the concentration of the painter, "trotting along in the column with heavy boots, tanned and sugar-coated with dust," on a counterworld of visual sensibility, on a second, spiritual existence.[24] Not until May 19 did he receive the news that Walden had sold another watercolor for 160 marks net. "I am to send him replacements, since he wants to land still more sales."[25] A reversal of Klee's fortunes on the art market seemed to be in the offing. Taken by themselves, the two sales were minimal, but Walden sensed from them a growing demand for works by Klee and encouraged the painter to produce.

On the day Klee received Walden's encouraging letter, his captain was asked by the New Munich Secession to grant him a leave so that he could attend the opening of the group's summer show on June 1. The captain balked at first, but on May 30 permitted Klee to leave for four days.[26] From then until the end of the war, Klee was allowed to go on short leaves for the installation or opening of his shows.[27] Thus, between the end of March and the beginning of July 1916, his conscription coincided with the first, tentative signs of success with the public, which in turn stimulated his resolve to work. The principle of an uncompromising withdrawal from the war, on which he had based his "crystalline" art of 1915, had initially been rejected by both Marc, the avant-garde artist closest to him, and by the small public which cared to see his work. Now it began to be validated at just the time when Klee had become a soldier.

Walden's Commemoration of Marc and Promotion of Klee

In the German art press, Marc's death in action made him an instant hero. From Munich, on the very next day, several versions of a press release were launched, each one calling Marc, in superlative terms, the leading German expressionist painter.[28] Moreover, within days of the news, the Munich art critic Alfred Mayer launched several versions of an obituary in the national press, each one designating Marc as an essentially German painter.[29] As a complementary part of his campaign to style Marc as Germany's foremost modern painter, Mayer also placed suitable excerpts from Marc's own essay "In War's Purgatory" into the national press.[30] The Munich-based press campaign tied in with the national revalidation of expressionism the year before (see p. 36). However, it no longer caught on at the core of the expression-

ist art movement. The leading writers of that movement, Hausenstein and Walden, had never been very patriotic. While he was alive, Marc had kept his distance from both these men, in spite of their admiration for his art. He had refused to join the New Munich Secession, the modern artists' group founded under Hausenstein's aegis; as for Walden, he had regarded him "unfortunately still a necessary evil."[31] Now, as Hausenstein's and Walden's circles, who remained essential for the career of any expressionist artist in Germany, promoted the work of the fallen painter, they ignored the posthumous amplification of his patriotic message by his wife and friends.

For Walden, Marc's death in action came at a particularly dramatic juncture in his wide-ranging campaign to establish expressionist art on the market. In late fall of 1915 he had exhibited Marc's work in Berlin, Geneva, and Stockholm. On March 1, 1916, he opened his first Klee show in his Sturm Gallery in Berlin. A few days later he must have received the notice of Marc's death, for on the title page of the March double issue of *Der Sturm*, he published a pathetic obituary, a hymnic text that ended with the exclamation "How I love you, Franz Marc!"

> How through you the miracle comes down to the earth, . . . that now looks with big, astonished children's eyes into the world extended over the eyes of all fighters. Visible only for big, astonished children's eyes.
> Artists and children find what they seek. They see, they hear, they feel. They tumble around in the valley, see the mountains, hear the voice and feel God. . . . that bird there lifts their spirits, and they are one with the earth, because they feel themselves to be part of the world.[32]

Walden did not relate Marc's art to the war at all. And he characterized it not by its animal subject matter, Marc's trademark, but by the more universal idea of an artist at once childlike and of a cosmic universality. On both these counts, his obituary reads like an evocation of Marc in terms of Klee's art, or even as a cryptic characterization of Klee under Marc's name. Did Walden thus attempt to promote Klee, whose exhibition was on view in the Sturm Gallery when the obituary appeared, as Marc's successor, to transfer Marc's quickly rising prestige onto the less well-known painter? Such a strategy may have been less cynical than it would appear. Walden was hardly aware of the profound divergences between the two artists, as they had clarified them to one another in their private correspondence and conversations. Still, his interpretation of Marc was at variance with the one that had prevailed so far, based on the artist's own publications.

On the day his exhibition opened at the Sturm Gallery, on March 1, 1916, Klee suggested that Walden publish some of his drawings in *Der Sturm*, insisting that they be "something new from 1915."[33] Walden complied and reproduced one of the drawings he had on commission, *Dream Aboard* (fig. 42), on the title page of the first April issue, although the Klee exhibition

DER STURM

MONATSSCHRIFT FÜR KULTUR UND DIE KÜNSTE

Redaktion und Verlag	Herausgeber und Schriftleiter	Kunstausstellung
Berlin W 9 / Potsdamer Straße 134 a	HERWARTH WALDEN	Berlin / Potsdamer Straße 134 a

SIEBENTER JAHRGANG BERLIN APRIL 1916 ERSTES HEFT

Paul Klee: Traum zu Schiff / Zeichnung

Fig. 42. *Der Sturm,* April 1916, title page with *Dream Aboard* (*Traum zu Schiff;* 1915, 106)

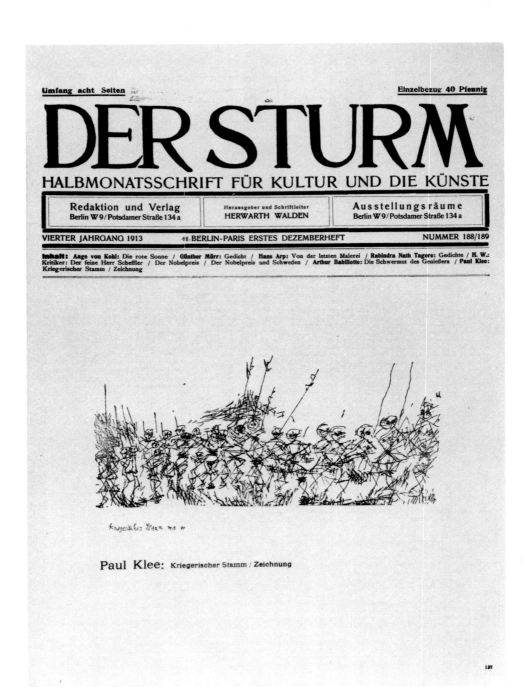

Umfang acht Seiten

Einzelbezug 40 Pfennig

DER STURM

HALBMONATSSCHRIFT FÜR KULTUR UND DIE KÜNSTE

Redaktion und Verlag	Herausgeber und Schriftleiter	Ausstellungsräume
Berlin W 9 / Potsdamer Straße 134 a	HERWARTH WALDEN	Berlin W 9 / Potsdamer Straße 134 a

VIERTER JAHRGANG 1913 18.BERLIN-PARIS ERSTES DEZEMBERHEFT NUMMER 188/189

Inhalt: Aage von Kohl: Die rote Sonne / Günther Mürr: Gedicht / Hans Arp: Von der letzten Malerei / Rabindra Nath Tagore: Gedichte / H. W.: Kritiker: Der feine Herr Scheffler / Der Nobelpreis / Der Nobelpreis und Schweden / Arthur Babillotte: Die Schwermut des Genießers / Paul Klee: Kriegerischer Stamm / Zeichnung

Paul Klee: Kriegerischer Stamm / Zeichnung

127

Fig. 43. *Der Sturm*, December 1913, title page with *Belligerent Tribe* (*Kriegerischer Stamm*; 1913, 41)

70

had closed by then. Perhaps he had already intended to print it in the second March issue, but postponed its publication in order to make room for the Marc obituary. This was Klee's first published drawing in *Der Sturm* since 1913, when his *Belligerent Tribe* had appeared on the journal's title page just after the opening of Walden's First German Autumn Salon (fig. 43). The new drawing carries a message different from that earlier self-satirical image of the avant-garde as a tribe of aggressive savages.[34] On a vertically projected water surface hover above each other an open boat and a ship with mast and streamer. The water surface reflects a host of moons and stars above, creating a mirror continuum where the floating boats appear projected into the sky. In the boat below, the dreamer is reclining, half-submerged in the water which fills the boat and on which he himself appears to float. Giant crablike tongues snap shut around him from below, both menacing and protective. The drawing is a work from 1915 as Klee had requested, but it is neither a "crystalline" cubist abstraction nor a caricaturelike grotesque, as are so many drawings from that year. It is serious, romantic, imaginary. Most important, the small, reclining figure of the sleeper is the counterpart of the dead soldier below the "crystalline" dream forest in the lithograph *Death for the Idea,* Klee's last previous publication in a journal (fig. 19). The two figures, both washed over by scribbled water surfaces, circumscribe the ambivalence of death and dream in Klee's imagination. Their historic sequence points the way from the memory of war into the imaginary dream world which Klee now presented to the public in anticipation of success.[35]

The suggestion of a continuity between Marc and Klee, which Walden had proffered in the previous issue of *Der Sturm,* was here expanded upon.[36] Inside, Walden reprinted Marc's essay "In War's Purgatory," next to a commemorative poem "On the Death of Franz Marc" by Sophie van Leer. In Marc's text, the notion of dreaming figures prominently: "we cannot think. We can only experience in a primitive fashion; often our consciousness wavers between two questions: Is this crazy war-life but a dream, or is the dream the thoughts from our home-life brushing us sometimes? It seems that both are a dream, rather than reality. . . . thus we lie well-protected below the zenith of the great shell trajectory. . . . We are asleep, wrapped in our cloaks. . . . Now everyone is for himself and is able to dream."[37] Any sensitive reader was bound to relate Klee's drawing *Dream Aboard* to these reflections as a fantasy equivalent of the front soldiers' precarious balance between rest and danger, dream and death, and it is more than likely that Walden intended it that way. The typography of the title page, with the titles of the two texts by Marc above, and the caption of the drawing by Klee below, reinforced the equation. Klee, of course, had made the drawing and submitted it to Walden long before Marc's death, so that, from his perspective, the juxtaposition would have been fortuitous. Still, the resemblance to the lithograph *Death for the Idea* suggests that thoughts about dream, death, and war were on his mind when he made the drawing. And since Klee had read and edited Marc's essay at the time it was first published (see p. 43), he may himself have re-

lated his image to Marc's text. In any event, at the time the drawing was printed, it publicly suggested the association.

Klee's First Sturm Exhibition

In their exhibition, Klee and Walden were offering a total of thirty-five water-colors, fourteen from the year 1914 and twenty-one from the year 1915. They were emphasizing Klee's most recent production, as was to be expected, but they were also drawing the consequence from the public failure of the abstraction concept of 1915. According to the printed sales catalog, no fewer than eighteen of the works exhibited carried titles that had been changed significantly[38] from those Klee had assigned to them in his oeuvre catalog.[39] At least seven of these changes were in the direction of greater thematic legibility of the subject matter. Thus, Klee changed *With the Brown Points* (1914, 102) to *Park Composition; Memory of an Experience* (1914, 111) to *Oriental Experience; Abstraction [made] after 1914 114* (1914, 119) to *Motor Nerve of a Landscape; Cheerful?* (1915, 31) to *Laughing Gothic; Composition* (1915, 173) to *Architecture of Altitude, Bluish-Reddish.* On the other hand, six other changes went in the opposite direction, from vaguely suggestive titles to precise but abstract form descriptions. Thus Klee changed *Transparencies ⟨orange-blue⟩* (1915, 70) to *Composition of Transparent Orange and Blue Tones; Transparencies ⟨red and green⟩* (1915, 72) to *Composition of Transparent Red and Green-blue Tones; Small Black Door* (1915, 116) to *Black and Diverse Reds; With the Blue Triangle of Heaven* (1915, 118) to *With the Blue Triangle; Medieval Town* (1915, 219) to *Urban Composition; Emerging and Darkening Town* (1915, 223) to *Town, Extending Itself Upward.* Similarly, Klee changed five loosely descriptive titles twice to more poignant, representational ones but in another case, conversely, omitted a title altogether (see note 39: 1915, 102, 131, 178, 224, 230; 1914, 127).

This adaptation of titles for the purpose of sales is but one aspect of the relationship of Klee's pictures to their titles, an issue which in numerous respects is fundamental for his art as a whole at every stage of his career.[40] The question was to what extent Klee's works were realistic or abstract, illustrative or constructive, symbolic of content or paradigmatic of form. Klee's increasing public exposure during the first three years of the war forced the issue to the point of decision. The artist was confronted with the potential contradiction between devising pictures according to an abstract form procedure which in and of itself was not targeted to any content and continuing to follow his lifelong literary inclinations evident in his copious reading and writing. Klee never conceived of abstraction as devoid of literary content, but he was faced with the necessity of promoting his works on a market which, even within the confines of expressionistic culture, was ready to accept abstraction only as the expression of thought or feeling, however idiosyncratic or distorted. How critical the war years were for Klee in this respect is suggested by the increasingly numerous distinctions between ink and pencil en-

tries in his oeuvre catalog. While he continued to enter the majority of the titles in ink, he entered more and more of them in pencil. The distinction could mean two things. Either Klee was not ready to title certain works at the moment when he recorded them in ink by number and technique, or whenever he entered the titles in pencil, he regarded them as less than definite, perhaps subject to change. Indeed, for some works, he never entered a title at all; for others, he corrected in pencil titles originally entered in ink. Thus, the question of the readability of his pictures was becoming a matter of concern for Klee himself. The accompanying table shows that these concerns were most acute in the first two years of the war, were being resolved in the years 1916 and 1917, and were gone by 1918.

	1914	1915	1916	1917	1918
Total Works	220	255	81	162	211
No title	16	3	4	5	2
Title in pencil	35	92	3	5	0
Total provisional entries	51	95	7	10	2
Percentage	23.1	37.25	8.64	6.17	0.94

In 1915, when Klee had reached a maximum of self-assurance about his concept of abstraction, he was not ready to give a title to over a third of his works upon their completion, although the titles he finally chose were suggestive enough. Klee's sense of the titles must have allowed for some flexibility in determining them once he was ready to show the works. In any event, the decrease in titles written in pencil after 1915, suggestive of an increasing assurance on Klee's part about the definitive title of a given work, coincides with the time when his career took off.

In the case of one watercolor in the Sturm exhibition of 1916, the change of title amounted to a change of program. In *Thoughts of Mobilization* (1914, 141), which Klee had received back unsold from the politically controversial New Munich Secession exhibition of March 1915 (see p. 38), he erased the title and replaced it by *Ordered Pathos,* words which were both more abstract and more poetic. With the new title, the watercolor was reoffered in the Sturm exhibition and promptly sold. Klee had abandoned his thematic allusions to war toward the end of 1915 at the latest, and Walden the pacifist did not address the war on principle. Their detachment was beginning to be shared by a growing segment of the German art public, whose enjoyment of art as an escape from wartime horror was just now being encouraged in the art press. One month after the Sturm exhibition opened, the Secession art dealer Paul Cassirer changed the title of his art journal *Kriegszeit* to *Der Bildermann* and advanced this program: "The strain of war has taught us to look horror calmly in the face, but it has also reawakened our longing for higher and purer things."[41] In their own way, Klee's watercolors were such "higher and purer things" that distracted from the war. The sale of *Ordered*

Pathos in particular must have impressed on him that the public tended to accept projections of a world-transcending sentiment more readily than imaginary war recollections. The change entailed an explicit recanting of Klee's own ideal, conceived the previous year, of a "cool" art remote from the war experience, which he had expressly designated as "without pathos" (see above, p. 41).

The exact timing of the sales is not always apparent from Klee's entries in the oeuvre catalog.[42] On October 17, 1916, when Walden had informed him of the sale of two more watercolors, he felt in a position to partly revoke his price reductions of March 3. "May it go on like this (which I don't doubt at all any more)," Klee confidently wrote to the dealer.[43] The final sales result must have appeared as a confirmation of the principles by which he had assembled his collection. Out of thirty-five watercolors, twelve were sold, or slightly more than a third. Of this total, seven, or half, of the fourteen watercolors from 1914 were sold, but only five, or less than a quarter, of the twenty-one watercolors from 1915. That the production from the year 1914 was twice as successful as that from the year 1915 confirmed to some extent the lack of acceptance which the style of 1915 had encountered in that year. Apparently the public of the Sturm exhibition still preferred, as had the private collectors the year before, compositions with small-scale, approximately square subdivisions, boxed into one another, with obfuscated, fuzzy borderlines, and with a superimposed, diverging linear pattern, as exemplified by *Tapestry of Memory.*[44] Such compositions could still be read as landscape allusions. Less successful were the pictures from 1915 with their larger, more regular, and more transparent color compositions, where Klee had put forth his concept of "crystalline" abstraction.

By changing the titles, Klee had redressed some of the inaccessibility of those later pictures. Five of the twelve works sold had had their titles changed, and out of these, three were from 1915; thus, out of the five works from 1915 that were sold, more that half were sold with changed titles. To be sure, in his far-reaching readjustment of titles, Klee had gone in both directions, that is, toward poignancy of suggestive content as well as of abstract form. However, the buyers' response to these changes was telling, since works sold with changed titles belonged only to the former, not to the latter category.[45] The two pictures sold from 1915 whose titles were not changed, *Aphrodite's Anatomy* (1915, 45) and *Bird Collection* (1915, 190), had a clearly defined subject matter. Walden, in his Marc obituary, had evoked the bird as the leitmotif of the childlike, abstract, cosmic artist. Soon this motif came to loom large in Klee's production, as well as in his public success.

Klee's New Exhibition Strategies

In the spring of 1916, the director of the Folkwang Museum at Hagen, Karl-Ernst Osthaus, had staged a programmatic show of modern art under the title "Art in War," in order to demonstrate the historic topicality of modern

art in wartime. Sometime in June, Klee ventured to send him a sample collection of twenty-nine drawings and watercolors. On June 22, Osthaus, probably counting on what it meant for an aspiring modern artist to be represented in his museum, replied with a minimal offer. For a total of 300 marks, he wished to select five drawings and watercolors.[46] Klee agreed, despite his beginning sales success,[47] and Osthaus by return mail informed him of the following selection:

> 1914, 140, *Thoughts of the Battle*
> 1915, 183, [no title]
> 1915, 192, *With the Four Riders*
> 1915, 212, *Landing at Salonica*
> 1916, 10, [no title][48]

Of the three titled drawings, the first and the third openly refer to the war, and second may at least be understood that way. The two untitled watercolors, on the other hand, were visual fantasies centered on recognizable images but with no unequivocal significance, as Klee confirmed to himself when he titled them in his oeuvre catalog after the sale:

> 1915, 183, *Plant, Tonal, Animated in Yellowish Hue*
> 1916, 10, *Violet-Yellow Sound of Fate with the Two Spheres* (fig. 44)[49]

With his selection, Osthaus had correctly ascertained Klee's antithetical interrelation of war and fantasy. With the portentous private title of the most recent work, the artist suggested to himself how charged with meaning and emotion this antithesis had become for him.

For the 1916 summer exhibition of the New Munich Secession, Klee put together a collection which differed from the one he had shown in the Sturm Gallery, although it included some unsold works from there. Aside from an earlier tempera painting of 1912, he presented only his most recent production from 1915, seven colored works, for a total of eight. However, he also changed the titles of three of these to make them sound more fantastic. Thus, he changed *Daisies* (1915, 167) into *Composite Flowers* and went back from *With the Blue Triangle* (1915, 118) to *With the Blue Triangle of Heaven.*[50] Nonetheless, just as in the previous year, Klee sold not one picture to the public.[51] He was quick to draw the consequences. When the exhibition travelled on to Frankfurt and Wiesbaden, he changed the titles of three more of the works from 1915.[52] Now the title change administered to *Urban Composition, Emerging and Darkening Town* (1915, 223), which Klee, emphasizing formal precision, had called *Town, Extending Itself Upward* for the Sturm exhibition of March 1916, went in the opposite direction of organic fantasy: *Growth of the Houses.* The most telling title change was that for the watercolor 1915, 175. In the Munich exhibition it was still called *Abstract Watercolor,* but in Frankfurt it was offered as *Grave Pathos.*[53] The change

Fig. 44. *Violet-Yellow Sound of Fate with the Two Spheres*
(*violett-gelber Schicksalsklang mit den beiden Kugeln;* 1916, 10)

confirmed the recantation of Klee's earlier program inaugurated by the re-
titling of *Thoughts of Mobilization* into *Ordered Pathos* for the Sturm exhibi-
tion of March (see p. 73).[54] All three watercolors with the newly changed
titles were now sold. Thus, by late 1916 Klee would have been able to discern
that his hermetic abstraction of 1915 could be made palatable to the public if
he imbued it, by means of new titles, with a suggestive literary significance.

Klee's Text on Marc

Soon after Marc's death in action, the New Munich Secession started plan-
ning a commemorative exhibition of his work, disregarding Marc's hostility
to the group (see pp. 29 f.). Marc's widow Maria was prepared to cooperate,
perhaps because the group provided the greatest exposure for modern art in
Munich.[55] The exhibition was held from September 14 to October 15, 1916,
"and brought Mrs. Marc great material success," as Lily Klee reported to
Gabriele Münter.[56] Klee took an active part in the preparations.[57] The pub-
lisher Reinhard Piper, who was to produce the catalog, charged Klee with

writing a biographical foreword of six printed pages at the most, without, however, informing Maria Marc about his choice of author. Klee, for his part, belatedly wrote to her in the hope of obtaining biographical materials.[58] However, if he expected any support from her on this venture, he was mistaken. Since the beginning of their three-way discussions about art and war by mail and conversations, Maria Marc had never taken seriously Klee's withdrawal from the issue—as her husband had done in spite of all his disagreements—but had rejected it outright as "lack of clarity," thoughtlessness, and "complete callousness," "a mental stagnation" that was going to stifle him for the rest of his life.[59] Accordingly, by July 17, Maria Marc had already enlisted Wilhelm Hausenstein, an unconditional admirer of Marc's, to write the preface. On receiving this rejection of his own contribution, Klee replied: "If you like Hausenstein's article [better], I will gladly stand back. At first, I regretted it a little, but now I recognize that I would have had to restrain myself somewhat on this occasion."[60] Hausenstein, on the contrary, could voice with unrestrained enthusiasm his acclaim of Marc as a socially concerned modern artist. He began his text with the words: "The painter who was killed in action this spring as a Bavarian artillery lieutenant was no friend of Mars. But he was even less an artist in that narrow sense which secludes the aestheticists from the general topicality of our times and abandons them to the sentimental cultivation of charming things."[61] Thus, Hausenstein characterized Marc's art expressly by contrasting it to Klee's withdrawal from topicality, without, however, mentioning the latter's name. He may have reached an understanding with Marc's widow on this point.

When Klee received Maria Marc's rejection, he answered her on July 17 that he would let Walden have the text he had begun to write,[62] in all probability for publication in *Der Sturm*. Now he no longer felt obliged to "restrain himself," but freely proceeded to one of his customary self-characterizations by antithesis to a friend.[63] Since his call-up on March 11, 1916, he had reflected on his artistic identity by reference to a commonality of fate with Marc. "Sometimes the word Marc occurs to me, then I am stunned and see something collapse."[64]

On July 20, 1916, the moment seemed to have arrived when Klee himself was about to see action. He was transferred to an "emergency weapons drill" at Munich-Freising, where the recruits were being prepared for front-line service. "Shooting more accurate. Serious fighting exercises."[65] It was here that Klee located the comprehensive literary formulation of his relationship to Marc. The text is written with pencil on a verso page in the diary of that year, not part of the running entries, but the transcription of a draft.[66] Here Klee styled the rejected catalog preface as a spontaneous meditation while on military duty: "When I, on one of several occasions, stood guard at the munitions depot of Frötmaning, several thoughts about Marc and his art occurred to me. Circling the few munitions magazines really provided a good opportunity to concentrate at leisure. Besides, during the day, a fabulous high summer flora created an especially colorful mood, and at night and

just before sunrise a firmament spanned above me and before me, which drew the soul away into large spaces."[67] Klee transfigures the landscape into a microcosmic scenery where the painter circles the highly explosive center of the firmament in a rhythmic alternation of colorful summer days and starry nights. He could hardly have devised a more suitable metaphor for the precarious balance between cosmic harmony and threat of war which he had set out to define, and in which he now polarized Marc's artistic identity and his own. The circular scenery refers back to the figure of the circle in his letter of June 8, 1915 (see p. 59), acknowledging Marc's own dynamic transformation of that figure into cosmic orbits (see p. 61). However, Klee's circular path of the solitary soldier making his rounds intersects with none other, only returns upon itself. The metaphor just serves, as it did for Hebbel, to distinguish common and separate "territories": "When I say who Franz Marc is, I must at the same time confess who I am, since many things in which I take part also belong to him."[68] However, whereas in the previous year's correspondence Klee had still attempted to assure himself of common ground, he now deepened the territorial demarcation. His comparison was aimed at distinguishing Marc as the more human, earthly artist from himself as an artist who was more remote from humanity, but all the more profoundly intent on cosmic perspectives. The diary entries of early 1915 about withdrawal from the world and "crystalline" abstraction, at least in their final form, were still written with reference to Marc's own aphorisms. The new text no longer took note of any of Marc's thoughts or writings, but referred point by point to Walden's obituary for Marc in *Der Sturm:*

Love for human beings

WALDEN: "Franz Marc, if they only knew how the artist loves them, these blind ones to whom he gives light, all the fire would consume them before it devours the one man who is to all of them father and mother, lover and loved one."[69]

KLEE: "He is more human, he loves more warmly, more explicitly. No wonder that he found more love. [His] noble sensuality attracted a good number of people and warmed them. My love is of a religious kind."[70]

Animals, Plants, Stones

WALDEN: "For him, the earth shone, to him the animals, the forests, and the rocks talked.
Man did not attract him, he had to divest himself of man. He who stood only behind things. He saw things as they are, which others have to construct for themselves. He stood before the rocks, and the rocks formed themselves for him. He walked between the trees, and the forest assembled around him."[71]

KLEE: "He bows to the animals in a human way. He raises them up to himself. He does not first dissolve himself as a part of the whole in order to then see himself on a level not just with animals, but also with plants and stones."[72]

Earth Versus World

WALDEN: "His realm is not of this world. But the earth was home to him.
[Artists and children] are one with the earth, since they feel [their being]
in the world.

To you the earth was home, but your realm is the world." [73]

KLEE: "With Marc, the idea of the earth comes before that of the world. [74]
[With me] the idea of the earth recedes before that of the world." [75]

Glow

WALDEN: "How Being glows through you who glow.
How I love you, Franz Marc.
How you glow toward me.
How I glow toward you." [76]

KLEE: "My glow is more of the kind of the dead or unborn." [77]

God

WALDEN: "Artists and children find what they seek. They . . . feel God.

· ·

To you, God's artist." [78]

KLEE: "I seek a place for myself only with God, and if I am related
to God . . ." [79]

From these high-flung comparisons, Klee derived a concluding "formula"
for his own self-definition: "In this I seek a more remote point, one that is
closer to the origin of creation, where I divine a kind of formula which ap-
plies to the animal, plant, man, earth, fire, water, air, and all revolving forces
at once." [80] Here only the claim to "my glow" still refers to Marc's counter-
position of "inner glow" and "coolness" in his aphorisms (see p. 44). For the
rest, Klee must have studied Walden's obituary, which his wife had imme-
diately sent him on March 15 to the Landshut barracks, [81] with a view to de-
riving from it the criteria according to which he wished to present himself to
the readers of *Der Sturm*. In the end the text was never published there. [82]

For the analytical differentiation of Walden's text Klee took recourse to
Worringer's complementary prewar notions of abstraction and empathy. [83] In
doing so, he claimed the notion of abstraction for himself, as if Marc had
been a nature-observing realist. He disregarded Marc's own development, in
the spring of 1914, toward a purely abstract and symbolical form, away from
the animal themes to which Klee now held him just as did the critics in the
art press. However, Klee did not just resume the polarization of abstraction
and empathy on the level of abstraction itself, in order to emerge, so to speak,
as the master of a cosmic superabstraction. He used Worringer's pair of
terms as the weapon for a self-defense both moral and historical, involving a
decision about death or survival. "With Marc, the idea of the earth precedes
that of the world (I do not say that he would not have been able to develop in
this direction, and yet: why then did he die?)." [84] The question Klee enclosed
in parentheses is really his deciding conclusion. In his way of thinking,

which identified art and life, artistic production and human development, an artist of Marc's stature could not be conceived as subject to "external" chance. Thus, Klee presented Marc's death as if the latter had met his deserved artist's destiny at Verdun. Following this train of thought, he could conceive of his own survival as a no less compelling consequence of his opposing stance. Styling himself as a "neutral creature" devoid of "passionate humanity," he adopted an attitude of forced coldness, distance, and moral indifference, ultimately derived from Nietzsche. "I was dreaming that I slew a young man and called him a monkey as he died. The man was outraged, [objecting] that he was breathing his last. All the worse for him, I replied, for then he cannot evolve any more!"[85] Klee had recorded this dream in his diary already in 1906. Walter Benjamin understood the underlying attitude well when, in 1931, he called Klee's *Angelus Novus* (see p. 241) "a mixture of child and cannibal" and recognized it as a figure symbolizing a kind of "humanity . . . which proves itself through destruction."[86] In his art-theoretical scheme, Klee carried the apotheosis of abstraction into a reversal of death and life. When he wrote, "My glow is more of the kind of the dead," he seemed to imply that Marc by contrast was still too much attached to life. As in his lithograph from the end of 1914, Klee played "death for the idea" off against death in action. Over and beyond justifying his own survival, he defended his attitude as appropriate for the historical moment. Just as Hausenstein had done in his preface to the commemorative catalog, Klee, too, posed the question of the artist's public social engagement, perhaps in response to Hausenstein's implicit attack on his own position.[87] But he answered it to the contrary: "The transition of time depressed him, he expected people to join him. For he was still human himself, and a remnant of strife tied him down. The last state of affairs, when goodness was a common good, the bourgeois Empire, appeared enviable to him."[88] At this point, Klee's continuing, posthumous argument with Marc became a historical critique. No matter how little Marc may have had to do with the German public's war enthusiasm, his work and his memory had been placed at the disposal of German wartime culture. And Klee doubted that Marc's self-sacrificing humanity made any historical sense for such a cause.

The Transfer to the Airfield at Schleissheim

However, the dangerous moment Klee chose for recording his most decisive reflections on Marc's memory passed by, for at the last minute he was exempted from combat duty and transferred to a homefront unit.[89] A few days later, he wrote into his diary an account of the transfer in the form of a comic scene:

> Long after I slept at home [i.e., was given leave to spend the nights at home] and started to like it in this unit, once my name was called out all of a sudden on the training field during a break in one of the innumerable combat exercises. Present! Go immediately to the battalion doctor, [but]

first to the sergeant. This immediately struck me as rather significant. The sergeant received me in a very good mood. Don't you want to fly? Who, me? Yes, since you have signed up for the air force! Excuse me, sergeant, I know nothing of that! Well, so that you know what is going on, we have signed you up.[90]

Since this entry is part of the original diary, not of the transcription of 1921, it carries a particular poignancy. Klee leaves no doubt as to how irregular the transfer appeared to him: "God bless you, Klee, have a good time!! The other desktop soldiers were also smirking. The writing clerk shook my hand with a smile."[91]

Klee's old acquaintance Max Pulver, in his recollections of 1949, has related what had really happened:

> One evening his old father came to me, breathlessly. Paul Klee was reassigned to field duty, as it was called, that is, he had been found to be fit for active service and was to be shipped to the front within a few days. Nine thousand of the "Leiber"[i.e., the so-called Leibregiment in whose replacement battalion Klee was serving] had been killed in action by that time. . . . The king or his son Rupprecht had given secret orders to the effect that the talented Munich artists were to be spared, for Weisgerber, Franz Marc, and others had already been killed in action. . . . I knew of this directive. Fortunately I was acquainted with several young relatives of the king, and, what was even more important, with a sergeant of the "Leibregiment," precisely the one who was charged with assigning men for combat duty. He was himself a sculptor. A few visits and suggestions were sufficient. The day before his transfer to the field, the painter Paul Klee was detached for Dachau.[92]

In a letter to Osthaus of August 31, 1916, Klee still reported his transfer with apparent surprise.[93] Yet whenever he was informed of Pulver's machinations, he must have sensed a profound significance in a sequence of events where Marc's death in action had indirectly caused his own exemption. Like an unintended sacrifice, it had prompted the home front to spare artists from the war.

In his diary account, Klee ironically counterpointed his deadpan show of ignorance by literary metaphors which reveal his reflections on the events. "In order to work myself out of my ruins, I had to fly. And I did fly," he had written in his programmatic diary entries of early 1915, if the transcription of 1921 preserves the wording in this respect. The sergeant's ironical question "Don't you want to fly?" should he really have announced Klee's prearranged transfer to the air force in these words, takes the artist's metaphor literally with historic irony. Throughout the rest of the war, Klee remained conscious of this ironic relationship between his service at the airfields of Schleissheim and Gersthofen and his self-understanding as an artist.

His superiors at the airfields also recognized him as an artist, and, perhaps with an irony of their own, gave him seemingly appropriate things to

do: "Now that we were feeling secure we were no longer [regarded as] just painters, but as painter-artists. With this we caused some headshaking. Only the writing clerk of the company was happy. Now, [he said,] we would be given work where we would be able to prove our art."[94] On October 23, Klee specified this kind of work: "Varnished two blackboard stands. Touched up old numbers on airplanes, stencilled new ones in front."[95] As early as 1905, Klee had depicted the inconclusive alternation of flight and crash in his etching *The Hero with the Wing* (fig. 28). Now, on the military airfield, he was able to observe crashes in reality. On November 10, 1916, he wrote to his wife, and into his diary, with obvious fascination: "Today I helped to clear away the damaged airplane where, the day before yesterday, two airmen lost their lives. Badly mangled engine etc. A rather sentimental kind of work? . . . Then at least I have had the experience with the crashed machine."[96] The ironic sense of remote curiosity Klee expresses here differs from the romantically alienated frustration of his recruit days at Landshut. Significantly, in his letters and diary entries from the airfield, Klee links his reports about bad treatment on the part of his superiors with the resumption of his work, as if his resentment against the military had prompted him to paint again:

> At about four o'clock the rumor of an imminent drill was spreading. Then I grasped a propitious moment and escaped from the [marching] column. Thereby gained a pretty stretch of free time. We'll see whether it will have consequences. Up to now I was a well-behaved recruit, tame and obedient. In return, my leave was messed up. Consequence: no longer a well-behaved recruit. Started to tackle the coloring of the lithos for Goltz.[97]
>
> Otherwise I am fine, always at the ready for military hassles. But the time will surely come for a compensation . . . Tonight (Saturday) I will work, there is some petroleum and a warm room.[98]

The Lithograph *Destruction and Hope*

Does the diary entry of October 23 about the hand-coloring of "the lithos for Goltz" (fig. 45) mark the point in time when Klee started to work regularly during his service as a soldier? On October 12 he had already received the commission from Goltz. Apparently he planned to devote "a short leave" on the next day to carry out the job,[99] but did not get around to it. Since Klee's oeuvre catalog lists only 81 numbers for the entire year of 1916, by contrast to 220 for 1914 and 255 for 1915, he must have stopped drawing and painting for a considerable time. At Landshut, he may have occasionally overcome his "great aversion" to painting (see p. 66), but he cannot have produced much. If Klee resumed his regular production at Schleissheim with the coloring of the lithograph, which is entered under number 55 in the oeuvre catalog, he would have started his artistic work as a soldier with a programmatic image that suited his situation.

Apparently Goltz, now that Klee slowly started to sell in Berlin, thought the moment had come to put the lithograph from early 1915 (see p. 52) on

Fig. 45. *Destruction and Hope* (*Zerstörung und Hoffnung;* 1916, 55)

the market at last. Three days before he commissioned Klee to hand-color the prints, on October 9, he offered it for subscription to the director of the Folkwang Museum at Hagen: "In my publishing branch there appears a new[!] original lithograph by Paul Klee, *Conquered Fort.* . . . Paul Klee, whose importance is becoming apparent to ever wider circles, is one of those artists who go their way, unconcerned about hostility and misunderstanding."[100] Goltz must have sent this announcement also to other institutions and collectors, but the projected title of the lithograph specifically suited the connection between modern art and the war which Osthaus had advanced in his spring exhibition of 1916 and which he had confirmed for Klee in June by his selection of purchases (see above, p. 75). At this time, the title *Conquered Fort* was likely to be associated with the battle for Verdun. Goltz may have believed that he would finally be able to market Klee's work as a contribution by a modern artist to the actuality of war.

However, the dealer had not reckoned with the reasoned withdrawal from any such topicality which the artist had enacted for himself in the meantime. When Klee resumed work on the lithograph, he also changed the title. On two trial proofs, the title is given as *Ruins and Hopes*,[101] referring to Marc's "ruins of their memories," and to Klee's contrary notion of abstraction as a transition from rubble to crystalline creations. The final title, *Destruction and Hope*, directly refers to the formal ambivalence of cubism which Klee, in an exhibition review of 1912, had succinctly cast in the question: "Destruction, for the sake of construction?"[102] In his letter to Marc of February 3, 1915, he had used the term in a similarly antithetical fashion in order gently to mock Marc's belief in regeneration through the war: "This state of destruction is lasting a long time. They proceed with it thoroughly, just in order to be whole again in the end."[103] In a letter of March 20, 1917, to Maria Marc, Klee wrote about the fire damage to Marc's painting *Animal Destinies* as it was about to be shipped to Marc's commemorative exhibition at the Wiesbaden Kunstverein, and then he added: "You have decided that Franz shall no longer lie in his soldier's grave, especially since it may still perhaps also fall victim to the general destruction. How much strength is in you, that you undertook this initiative! Also my heartfelt thanks for the beautiful drawings. How good it is that there is still hope of creating something positive and not just destruction everywhere."[104] The last sentence applies the two terms from the final title of Klee's lithograph to the antithesis between war and art. Klee relates Maria Marc's efforts to save her husband's remains from the shelling to which his makeshift grave was exposed in the embattled front zone to the repair of Marc's masterpiece which he himself was about to undertake. Maria Marc's own drawings apparently confirmed his conviction that art could be a meaningful response to war.

Klee completed the lithograph by adding to the minute, precise cubist line drawing simple, large color silhouettes, figures of a half-moon, two hexagram stars, and a circle which in the context appears to denote the sun. He pencilled the outlines of these shapes by means of a stencil and filled

them in with yellow, green, and blue watercolors. It is the same technical procedure that he used when painting airplanes during his hours of service as a soldier, and it is hardly without deliberate irony that he reports about both painting jobs in the same diary entry. The historic ambivalence of his artistic stance relating abstraction, flying, rubble, war, and art to one another was no doubt on his mind as he was practicing this technique on both the planes and prints. Franciscono has interpreted the finished lithograph. "as a symbolical expression of the contrast between 'destruction' and 'hope'—between the crumbling elements of the drawing and the inviolate geometrical color forms" (chap. 2, n. 67). However, the uncolored print of early 1915, which Klee himself considered finished (chap. 2, n. 66), already carried this ambivalence. It is the dynamic composition of the drawing itself which balances destructive and constructive features. The new, hand-colored shapes represent a different antithesis to the composition as a whole, a straightforward emotional contrast between despondency and confidence, as suggested by the new title. These are the simplified signs for the sun, moon, and stars, which Klee had used time and again in his drawings and watercolors of 1915.[105] He had displayed them prominently in *Dream Aboard* on the title page of *Der Sturm* (fig. 42). For the composition of the lithograph, they were not required. Their coarse symbolism contradicts the aesthetically refined rationality of the cubist drawing just as crassly as does their form. Yet they provided the "cosmic" illumination of the fairytale landscapes to which Klee's public now began to respond.[106]

1917

The Boom in the German Art Market

In 1917 the German government, in response to pressure from the Supreme Army Command, pursued the Hindenburg Program of increased arms production uninhibited by price or profit controls. Unrestricted competition by industry for scarce manpower led to wage increases, which in turn were recovered by higher prices, resulting in a wage-price spiral that fueled the black market and began to impoverish the lower middle class.[1] Under these conditions, the government could no longer balance its war budget for 1917, although at this time, the deficit was only caused by growing interest payments on the annual war loans.[2] In response, the government raised the war profits tax of 1916 and imposed several new war taxes on banking, coal, and transportation.[3] However, these taxes did not reduce, but increased the social disparity caused by the German war economy. For while taxes to service the war-loan debt could at least in theory be spread over all income categories, the recipients of the war-loan interest payments were for the most part the wealthier social groups.[4]

Under these conditions it is not surprising that by January 1917 the upsurge of the German art market had become a veritable boom. An auction report in *Kunst und Künstler* read: "The auction, . . . with its total of almost one and a half million marks, surpassed all expectations. . . . The big dealers, for whom import has been made very difficult and who fear the lack of merchandise in these times of extremely high demand, stocked up without regard for normal price levels."[5]

Current production was also benefitting from the boom. Sales at the Glass Palace summer show at Munich, a sure indicator of general demand, reached an all-time high, surpassing even the record year of 1888.[6]

Finally the increasing demand began to extend to modern art as well. As soon as prices for older art and even for Secessionist art soared out of reach for small and middle-range collectors, a market niche for modern art began to open. On June 5, 1917, the collection of the dealer Alfred Flechtheim was auctioned off in Berlin, the first modern art auction to take place in Germany. This auction was advertised as an opportunity to establish the market

value of modern artworks in a verifiable, public fashion. Some critics remained skeptical about such a new market strategy on behalf of modern art,[7] but others acknowledged that for the first time modern artists were participating in the upswing of the market and that an auction such as this provided an opportunity to stimulate interest among a new collecting public.[8] Collectors of modern art were indeed often newcomers, distinct from established collectors who continued to prefer more traditional, and more expensive, artists.[9] In 1917 the dealer and writer Paul Westheim launched a new journal, *Das Kunstblatt,* which was devoted to modern art and addressed to the new collectors' public. It entered into an open competition with the established journal *Kunst und Künstler,* which continued to hold the line of traditional and impressionist versus modern art in the interest of the high-priced market segment.[10]

At the Flechtheim auction, prices for modern German artworks remained far below those for the more established, more conventional ones, ranging for the most part between 800 and 300 marks. A few high-priced modern masters such as Picasso and Marc remained the exception. However, sales themselves were multiplying. Walden's Sturm Gallery, which handled many of the expressionist artists, at last became financially successful.[11]

The coincidence of the booms of the war industry and the art market was not lost on the German art world. In November 1917, Wilhelm von Bode, director general of the Berlin Museums, published a polemical newspaper article entitled "Picture Prices and War Profiteers."[12] Since the state's financial resources were tied up in war production, he lamented, museums and public collections were cut off from the flourishing art market. For the same reason, private owners and shareholders of war and war-related industries, the main recipients of state expenditures, along with the recipients of interest on the war loans, disposed of ever higher sums for the purchase of art works.[13] The journal *Kunst und Künstler,* which represented the interests of the free market for high-priced old and traditional art, rejected Bode's attacks.[14] Ever new arguments were advanced in its pages against the assertion that the art market was being stimulated by war profits. *Das Kunstblatt,* for its part, refrained from reporting about the art market, but in a telling fashion glorified the "private collector in the grand style" as the guiding force for a coming artistic culture.[15]

The charge of war profiteering on the art market was one of the reasons why, in the spring of 1917, the Finance Ministry moved for an extension of certain provisions of the special sales tax of 10 percent on luxury goods to artworks, on top of the general sales tax of 0.5 percent. Predictably, the German art world unanimously protested this legislation. Yet in spite of its outcries, the Reichstag approved the extension of the luxury tax to artworks for fiscal 1918. In this tax debate, no matter how divergent their interests, all groups in the German art market advanced the argument that art was a needed spiritual compensation for the misery of war. Ernst Waldmann, the editor of *Kunst und Künstler,* in an article entitled "The War and the Prices of

Pictures" advanced this defense: "What is the reason for this strong preponderance of demand over supply? For one, it is . . . the circumstance that for many people art has become a necessity. In the encounter with artworks one seeks spiritual recreation, perhaps also forgetfulness. It seems that during the hours spent with art one forgets the distress of the war and the madness of these times."[16]

In the spring of 1917, when Waldmann wrote his article, the political situation was ripe for the sentiment he voiced. Soon afterwards, on July 19, 1917, the Reichstag voted the peace resolution, responding not merely to the deteriorating military situation, but also to the increasing war-weariness of ever wider segments of the German people. Now the German art press, to the extent that it still addressed the issue of art and war at all, turned full circle from war enthusiasm to a longing for peace.[17] And with this turn, the established artistic culture finally converged with that of the avant-garde. The war economy of 1917 provided the financial conditions for the convergence. The standpoint of a 'spiritual' withdrawal from the war, which Klee had taken, rather lonely, as early as 1915 (see p. 36), was now embraced by nearly everyone in the German art world. At this time, Klee reached the first high point of his public success.

Klee's Sturm Exhibition of January 1917

From the airfield of Schleissheim, Klee was sent several times on rail journeys as a guard for airplanes shipped to the front. One of these trips gave him the opportunity to visit Walden in Berlin on January 9. "We talked about plans for a book and about business," he noted in his diary.[18] On his return on January 15, Klee found the order for his transfer to the air force training school at Gersthofen, near Augsburg, where he moved the following day and served until his discharge after the end of the war.[19]

The second Klee exhibition in the Sturm Gallery was to open on February 1. By now, Klee and Walden must have realized that Klee's most recent work had its best sales prospects in Berlin and hence should be shown there first. Their selection for the upcoming show differed markedly from the smaller collection of Klee's works which was being offered at the same time, from February 1 to April 1, within the Sturm exhibitions at Zurich and Basel. The latter collection comprised six of the watercolors not sold during the Klee exhibition in Berlin the previous year, of which five dated from 1914, one from 1915; in addition, it included four drawings from 1913. Apparently Klee and Walden had concluded from the divergent sales results of the 1916 exhibitions at Berlin and Munich that it would be best not to present Klee's most advanced production outside Berlin. But for Berlin, they made a bold selection. From the year 1914, they presented one coherent group of four watercolors from the Tunisian trip, a theme which purchases by individual collectors during the year 1915 (see p. 56) had proven to be popular. From

the year 1915, they presented three drawings and four watercolors, two of them thematic reminiscences from Tunisia. The bulk of the show, twenty-three works, was from the year 1916. Of these, a series of six watercolors with texts from Chinese poems was not for sale. Thus two small, thematically focussed groups of works from the years 1914 and 1915 were juxtaposed with a large series of most recent works.

For the occasion, the February issue of the journal *Der Sturm* appeared with a Klee drawing on the title page (fig. 46) and four more inside.[20] The March issue, which appeared after the exhibition had closed, also featured a drawing by Klee on the title page (fig. 47). Both are suggestive of how Walden wished to present Klee to his public at this time. The drawing *Moonrise* from 1913 on the first title page shows three nude women under a large sickle moon on the horizon, dropping to the ground in swooning attitudes of rapture, accompanied by the chant of a nightingale. The drawing may originally have been meant as a satire on the nudist romanticism of Fidus or even Hodler, but now its satirical edge must have been perceived at most as the customary expressionistic device of self-ironic, grotesque exaggeration. Sexual satire is hardly noticeable here;[21] instead, the drawing seems to suggest a cosmic world sentiment similar to that of the later drawing *Dream Aboard*, which had been printed on a *Sturm* title page in the previous year (fig. 42). The bird whose chant appears to prompt the human figures' emotional contortions had been the leitmotif of the childlike, cosmic artist evoked in Walden's Marc obituary of March 1916 (see p. 68). The sickle moon was one of the celestial bodies which Klee, in the fall of 1916, had stencilled into the sales edition of the retitled lithograph *Destruction and Hope* (see p. 85). Accordingly, the publication of the drawing *Moonrise* was a presentation of newly popular motifs from Klee's prewar repertoire. Klee had made the drawing at approximately the same time as *Belligerent Tribe* (fig. 43), which Walden had immediately used on the title page of the *Sturm* issue following the debates about his provocative "First German Autumn Salon." Here it mocks the avant-garde's appearance to a hostile public.[22] Four years later, the Klee title page of *Der Sturm* was no provocation anymore, but an invitation to the public to share in the expressionist sentiment. The Klee drawing reproduced on the March title page of *Der Sturm, Acrobats* from 1914, presented a circus act both dangerous and playful. One year later, it inspired Däubler, in a text on Klee, to celestial transfigurations (see p. 129).

On February 3, 1917, Klee was granted a "short leave" in order to attend the opening of the show.[23] Only nine days later, on February 12, he was able to note in his diary: "Walden sold a couple of things. . . . An article by Däubler in the *Börsencourier* was sent to me. He writes that the exhibition is heart-stirring, and that [my] recent gain in profundity is incredible."[24] Two days later Klee received from Walden himself an offer to buy six works, of which four were from the current exhibition, for his own private collection.[25] And by February 22, one week before the exhibition closed, he could strike an

DER STURM

MONATSSCHRIFT FÜR KULTUR UND DIE KÜNSTE

Redaktion und Verlag	Herausgeber und Schriftleiter	Kunstausstellung
Berlin W 9 / Potsdamer Straße 134 a	HERWARTH WALDEN	Berlin / Potsdamer Straße 134 a

SIEBENTER JAHRGANG	BERLIN FEBRUAR 1917	ELFTES HEFT

Inhalt: Herwarth Walden: Weib / Komitragödie / Kurt Heynicke: Gedichte / Hermann Essig: Der Wetterfrosch / Sophie van Leer: Gedichte / Paul Klee: Zeichnungen: Mondaufgang / Gefangene Tiere / Tierseelen / Drama in der Kuhwelt / Schiffe, ein Schiff, Fisch Bastard

Paul Klee: Mondaufgang

Fig. 46. *Der Sturm*, February 1917, title page with *Moonrise* (*Mondaufgang;* 1913, 57)

DER STURM

MONATSSCHRIFT FÜR KULTUR UND DIE KÜNSTE

Redaktion und Verlag Berlin W 9 / Potsdamer Straße 134 a	Herausgeber und Schriftleiter HERWARTH WALDEN	Kunstausstellung Berlin / Potsdamer Straße 134 a

SIEBENTER JAHRGANG	BERLIN MÄRZ 1917	ZWÖLFTES HEFT

Inhalt: Herwarth Walden: Weib / Komitragödie / Adolf Knoblauch: Die Kirche / Kurt Heynicke: Zwiesprache / Ich entgegne / Sophie van Leer: Knaben-
stunde / Wilhelm Runge: Lieder / Paul Klee: Akrobaten / Zeichnung / Campendonk: Holzschnitt / Vom Stock gedruckt / Jacoba van Heemskerck:
Holzschnitt / Vom Stock gedruckt / Inhaltsverzeichnis des siebenten Jahrgangs

1914 *113. Akrobaten

Paul Klee: Akrobaten

Fig. 47. *Der Sturm*, March 1917, title page with *Acrobats* (*Akrobaten*, 1914, 113)

intermediate balance: "My Berlin exhibition is becoming a financial success. Walden is buying for 800 marks, and in addition 12 works have been sold for 1830 marks. To the tune of two thousand six hundred and 30 marks."[26] On March 19, Klee struck the final balance: "The latest sales at Walden's amount to 540 marks, the first sale he reported was for two hundred ninety marks, hence there are now 3460 marks. Thank God one does not have financial worries on top of all the others!"[27] Walden's calculation had succeeded. Däubler's press review of the Klee show was merely five sentences long and was only one of two that appeared in the daily press,[28] but his decisive sentence, "Paul Klee is, after Marc's death, the most important painter of the expressionist tendency,"[29] confirmed the change of guard suggested in Walden's Marc obituary (see p. 68). And in an even more enthusiastic gloss published in *Die weissen Blätter,* Adolf Behne addressed the hallmark of Klee's new public appeal: "Paul Klee loves the world of the stars, and each one of his drawings, each one of his pictures touches the stars from afar. . . . That we have an artist of this sincerity, of this devotion to the stars, that is a deep happiness!"[30] The strategy of emphasizing Klee's most recent work had also proved successful. Of the four works from the year 1914, none had been sold, of the seven works from 1915 only two, but of the sixteen works for sale from 1916 no less than fourteen had been sold, that is, all four drawings and ten of the twelve watercolors. Similarly, when on April 1, the Sturm exhibition closed at Zurich, not a single one of the earlier works by Klee offered there had been sold. This was a failure of the cautious strategy, and a confirmation of the bolder sales pitch adopted for the exhibition in Berlin.

Apparently Klee's most recent works were successful because they either featured illustrative figurations or bore descriptive and yet enigmatic titles suggesting mysterious contents. The six works purchased by Walden himself were masterpieces of the new, literary line. By contrast, the only two works from 1916 that were not sold—*Watercolor* (1916, 15) and *E (Emma) Watercolor* (1916, 18)—bore nonsuggestive, neutral titles. The profundity of meaning evoked through the titles was enhanced by a new ambivalence of form. Just as in the year before, the public did not go for the clear, transparent, and constructive color composition of the three watercolors from 1915. Compared to that style, many of the new works featured a forced, ragged simplicity. Essentially pure color compositions are advanced with contrived technical crudity on shreds of airplane canvas with irregularly torn edges. Seemingly awkward image-signs for "constellations," of the same kind as the stencilled shapes enhancing the lithograph *Destruction and Hope,* visualize uncertain meanings suggested by mysterious titles, such as *Feast of the Ship-Stars* or *Constellations over Evil Houses.* Behne, in his review, felt compelled to affirm the sincerity of trademarks such as this.

In another group of works from the second half of 1916, Klee reactivated a childlike, seemingly primitive form of drawing. These were finely detailed scenes with angular mannequins which he had developed in 1912 and 1913 following Kerschensteiner's notions of schematic childrens' draw-

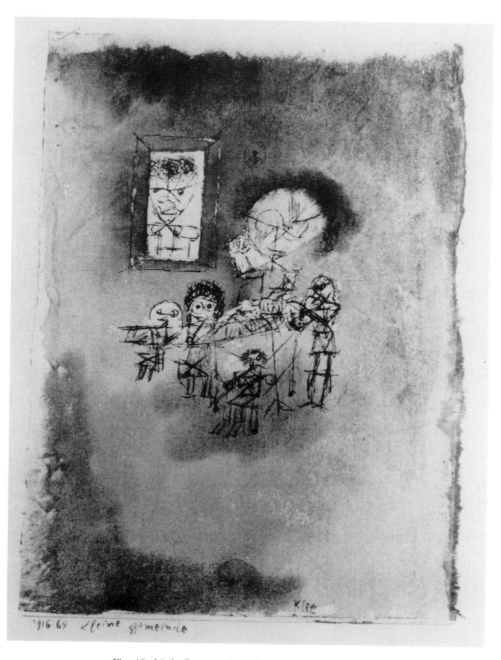

Fig. 48. *Little Community* (*Kleine Gemeinde;* 1916, 69)

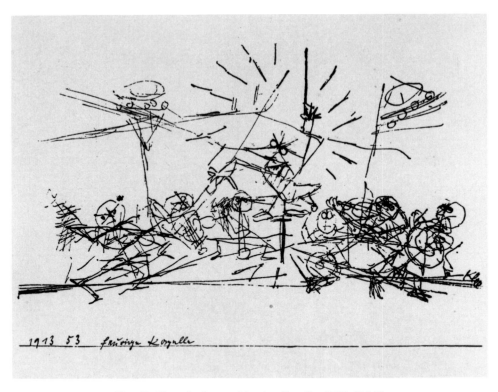

Fig. 49. *Fiery Orchestra* (*feurige Kapelle;* 1913, 53 [A])

ing.[31] In 1914 and 1915, he had rarely used this scheme. Walden's sentences in the obituary for Marc about "artists and children" who "find what they seek" (see p. 68) may have encouraged him to take it up again. Almost all the works from this group were sold. Walden himself acquired one, *Little Community* (fig. 48), for his private collection. Here, a giant master at the piano presides over a chamber orchestra consisting of four little, childlike players. They are performing a wind quintet under the fierce gaze of a framed portrait on the wall. The four little musicians appear to perform in perfectly docile coordination with the beat that the master-pianist is signalling with his raised hand. The triangular schemes of their bodies are neatly strung out along the triangular extensions of the piano. The concentration of the group in the center of the otherwise empty colored piece of rag adds to the compact consolidation. The image appears all the more suggestive if it is compared to the drawing *Fiery Orchestra* from 1913 (fig. 49),[32] which Klee and Walden included in the Sturm picture book to be published in late 1917 (see p. 107). This earlier drawing is related to *Belligerent Tribe* from the same year, where the provocative ideal of modernist primitivism was advanced (see p. 89).[33] *Fiery Orchestra*, like *Little Community*, shows a giant conductor leading a group of childlike mannequin-musicians. Here, however, everyone is per-

forming at an absolute pitch of frenzy. The conductor himself leaps over his music stand into the air and raises his huge baton straight up with a defiant grin, as an officer would raise his saber to fire up his troops for the attack. In the time between the two images of childlike art from 1913 and 1916, calm assurance seems to have replaced aggressive provocation. The term *Gemeinde* in the title of the latter work suggests, not without irony to be sure, a religious acceptance of the primitive ideal.

Cultural World Peace

For some in the expressionist movement, the achievement of success produced a defiant self-assurance, as if their anarchistic opposition to official wartime culture had been vindicated. In his book *Insight into Art,* which appeared in 1917, after the catastrophic crop failure of the fall of 1916 and the excessively hard winter 1916/17 with its hundreds of thousands of civilian victims, Walden proclaimed a "time of art happiness."[34] His exclamation, "It is a happy time in which we live,"[35] was seconded by Däubler in an article in the newly founded *Kunstblatt* on the eighth anniversary of the Sturm Gallery. Here, Däubler declared the art championed by Walden to be "a movement leading back to order," setting the pace for a new style. "In this process, the ego stands authoritatively in the world of its dreams and designs for realization. No escape from reality, but a visualization of the transcendent . . . : this is the new metaphysics."[36] In a bold turnaround, Däubler adjusted the validation of modern art from subjective freedom to metaphysical authority, from the right to disregard visual reality to the claim for a reality of its own.

Walden now openly worked at reestablishing the international community of modernist artists, the disruption of which had been Klee's and Kandinsky's greatest worry at the outbreak of the war (see p. 14). The consignment of works from the Sturm Gallery which he had been circulating in Switzerland since early 1917 ended up in the first exhibition of the Dada Gallery, opened by Hugo Ball and Tristan Tzara at Zurich on March 17. It was followed up, in August, by an official exhibition of recent German art mounted at Zurich on behalf of the German Foreign Office by Paul Cassirer, carrying the title "Regierungskommissar," presumably as part of the German peace feelers extended through neutral Switzerland at that time. In this exhibition, a third of the painters represented were expressionists.[37]

On November 16, 1916, Tzara had asked Klee directly for a collection to be included in the exhibit,[38] but it seems that his request was fulfilled through Walden. Here, the anarchist provocations of the Cabaret Voltaire had given way to serenity. The new gallery was "to give artists from countries at war the opportunity of an understanding. Politics and art are different things. Art has a pure and moral effect, if it intensely and directly gives to the beholder joy and goodness."[39] In the publicity program of the exhibition, Waldemar Jollos, on March 31, delivered a lengthy lecture on Klee.[40] Placing him in an all-encompassing context of world art history which culminated in the Gothic

as the crucial precedent, Jollos hailed Klee's achievements in both abstract and expressive art. A summary of the last part of the lecture, dealing with Klee in particular, was printed in the *Neue Zürcher Zeitung* on April 17.[41] This was the first completely positive, in-depth "art-historical" analysis of Klee's work. Klee must have seen the lecture as a fulfillment of his own internationalist ambitions, even though the Dada Gallery was unable to sell any of his works.

On June 30, 1917, Klee had already been so much encouraged by his successes in Berlin that he suggested to Walden that he adapt the *Sturm* journal to the new cultural acceptance of modern art:

> About the *Sturm* as a journal I should like to add that it is quite excellent as a forum for emerging artists, but no longer as representative of the new [art] which is already established. Your *Sturm* is for the most part merely the supplement of the [kind of] journal I would wish for. Everything that is only relatively good, which you publish often enough and with good reason, would find its place there. All the polemical material of the literary part would also look better there. I am afraid I have to protest against the name, too, which is already obsolete. Culturally we already have world peace now, and it is only to the elderly gentlemen that our creed [still] seems like a tempest. (Thus, again, the realm of polemics).[42]

By designating the success of modern art in 1917 as a sign of cultural world peace, Klee was in tune with the cultural politics of the time. The change of appeal in his own drawings on the title pages of *Der Sturm* between 1913 and 1916–17 already suggested the advance from the "polemical" to the "established," which he now wanted to see adopted for the journal as a whole. Technically, this meant a step up to the lavish printing to which readers of established art journals such as *Kunst und Künstler* or *Die Kunst für Alle* were accustomed: "The positive part of the journal would require a make-up for all possibilities. Different sorts of paper for all kinds of reproductions (original and photomechanical). No issue should lack the unheard-of newness of *color*."[43] In a two-year-long campaign, Klee, with Walden's help, had channelled his personal withdrawal from war of 1915 into the "cultural world peace" of 1917.

Klee's Munich dealer, Hans Goltz, immediately responded to the idea. When in October 1916 he had commissioned Klee to complete the lithograph *Destruction and Hope,* he had still advertised it under its old title *Conquered Fort* (see p. 84). In 1917, he offered it in his print catalog under the new title, with the following explanation:

> In his bizarre, romantic fashion, which renders experience in a purely subjective, psychic fashion through a structure of linear signs, runes as it were, Klee has here provided a "war print." To the viewer who wishes to penetrate it, it yields a profound perception. A seemingly irregular multiplicity of circles and lines without representing the total turbulence of

war's destruction as a comprehensive sentiment. The sun, the moon, and
the stars are shining over the destruction and give to that sentiment the
upsurge toward a hope for the end.[44]

The last sentence summarized the public appeal that Klee's notion of modern art as a counterposture to war had acquired at this point in time.

The First Slowdown of Sales

Klee's successful pictures at the Sturm exhibition of 1917 were a far cry from his "crystalline" abstraction of 1915. As he was reviewing the sales results from the Sturm exhibitions, which were available by March, he must have recognized that the new style was going over with the public, whereas that of the year before remained unappreciated. In addition, by March 21 at the latest, he learned of the sale of the three watercolors from the 1916 summer exhibition of the New Munich Secession, whose titles he had changed for the subsequent show at Frankfurt toward a greater literary suggestiveness.[45] However, Klee was still hesitant to show his most recent work outside Berlin. As replacements for the three watercolors that were sold, he sent three older works, two from 1914 and one from 1915, to the show which by now had moved to Wiesbaden, raising their prices in the process.[46] In July he had to mark all three as "returned."

It is likely that Klee already knew about his failure to sell at Wiesbaden when he began in June to put together his collection for the summer exhibition of the New Munich Secession that opened on June 10. He included in the collection one work of 1915, following his habit of recalling earlier stages of his art, but otherwise he offered only his most recent works, ten from 1916 and seven from 1917, and raised almost all his prices to 400 marks per watercolor.[47] For this price increase he had not only been encouraged by his own sales at the Sturm Gallery, but probably also by the results of the Flechtheim auction on June 5, 1917 (see p. 87), which were widely felt to have established the price range for contemporary artists. Works from Klee's generation had fetched prices ranging from 300 to 800 marks. Although no works by Klee himself had been offered at the Flechtheim auction, he now adjusted his prices accordingly, no longer conceding prices of 150 and 200 marks, as he had done earlier under the constraint of his lagging sales. By contrast, the Flechtheim auction had propelled Franz Marc into the price class of the French modern classics such as Picasso and Matisse, one of his paintings fetching 3,400 marks. After his death in action, Marc's reputation had soared to that of the leading German master of expressionism. "Franz Marc fell in March of 1916, and the prices of his pictures rose," wrote Nell Walden in her memoirs.[48] His price range remained unattainable to Klee throughout the war years, and the difference was magnified by the small-scale watercolor format to which Klee confined himself.

Although critics dismissed Klee's collection in the New Munich Secession show as "aimless, decorative prism experiments,"[49] or as infantile and

routine at once,[50] the sales results of the exhibition seemed to indicate a modest improvement in a city where Klee had had no success thus far, and to confirm his exhibition strategy. Six of the eighteen works were sold, three from 1916 and two from 1917, as well as the lone watercolor from 1915. However, the sales did not indicate a public success, for not a single work had found a new buyer. One had been acquired by Klee's old collector Dr. Probst, the other five by his Munich dealer Goltz. With this kind of supportive buying, Goltz was now beginning to follow Walden's assessment of Klee's sales prospects in Berlin. Within the range of Klee's new, technically simplified style, Goltz seems to have preferred the more minutely subdivided architectural compositions recalling the Tunisian watercolors of 1914 and 1915. The three works *Place of the Holy Riddles* (1915, 50), *Serene View* (1917, 3), and *Urban Jewel* (1917, 4) are similar in form despite the time lag between them. The other two works purchased by Goltz, *With the H* (1916, 77) and *Demon over the Ships* (1916, 65), are figurative or even narrative. Dr. Probst's choice was similar. Klee had exhibited side by side two watercolors which follow the same formal scheme: *Two Miniatures* (1916, 14; fig. 50), purely abstract, and *Trout Brook* (1916, 71; fig. 51), with an additional layer of representational motifs denoting fish, grass, mountains, and constellations. The numbering of the two works in the oeuvre catalog suggests that the more abstract one was painted in early 1916, before Klee's conscription, and the figurative one in late 1916, at the Schleissheim airfield. By opting for the latter version, Dr. Probst, who in February 1915 had been unable to follow Klee's abstraction (see p. 56), now responded positively to his figuration.[51]

Fig. 50. *Two Small Watercolors* (sold as *zwei kleine Aquarelle;* 1916, 14)

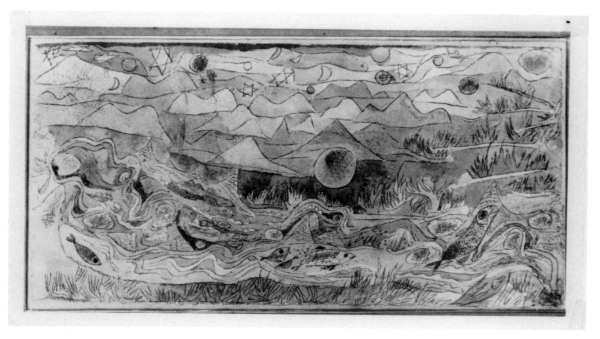

Fig. 51. *Trout Brook, in the Way of a Miniature (Forellenbach miniatürartig;* 1916, 71)

The New Concept of Illustrative Painting

In July, 1917, while sitting "near the open window of the accounting office," Klee noted in his diary a principled reflection which is not a transcription of a letter but a carefully edited text:[52]

> We investigate in the formal realm for the sake of expression. . . . Philosophers have a penchant for art, [and] in the beginning I was astonished about all that they saw [in mine]. For I had only thought of form, and the rest had ensued by itself. However, the awakened consciousness of this rest has been very useful to me and has made possible a greater variability in my creative work. After I had struggled through in the realm of form, I could again become an illustrator of ideas. And now it was no longer abstract art that I saw. Only abstraction from what is transitory remained. The object was the world, although not this visible one.[53]

Klee here deliberately distinguished his new conception of painting from that of 1915. Others had perceived a "philosophical" content in his art which he, bent as he was on abstract form, had not intended. He had then incorporated such a "philosophical" perception into his conscious working process. The abrupt decline in pencil-written titles in favor of titles recorded in ink, which can be observed in his oeuvre catalog between 1915 and 1916 (see p. 73), goes to show that he now tended to relate images from the very beginning to their elucidation by words. It is still an open question how and when

he began to adjust the formal appearance of his work to the new direction.[54] In any event, moving from the abstraction of form to the illustration of ideas, he had moved from an unsellable art to one that was proving successful on the market without delay. In his exhibition strategies of 1917 he had started to take the change into account. In the diary Klee describes the change as the result of a purely introspective reflection. "The formal element has to blend with the world view." Whose world view? That of "others," of Walden, of Däubler? Or his own? Soon Klee began to feel the need to come to a decision on this point, to take the lead in determining how his work was to be perceived (see p. 131).

When on September 9, 1917, Klee returned from an outing where he had painted no fewer than five watercolors, he wrote a letter to his wife in which he attempted to relate his new productivity to the historical situation: "Times are not easy but revealing. Would my art have shot up as quickly as in 1916–17 if I had gone on as usual with my life? A passionate drive toward transfiguration is certainly in part the product of external experience."[55] When Klee copied the letter in his diary, he changed the last sentence slightly but significantly: "A passionate drive toward transfiguration is certainly related to the great change in the conduct of life."[56] Thus, upon further reflection, Klee intensified "the external experience" into "the great change in the conduct of life," but at the same time reduced the historical determination suggested by the term "product" into the more cautious "is related." Such emendations show how critical the reflection was for him. What did he understand by "the great change in the conduct of life"? Was it only his military service? Was it the seeming paradox that in the middle of war an artistic ideal had become successful whose romantic subjectivity transfigured the withdrawal of a homefront soldier from the world around him? Or was it the recognition that in the third year of the war a growing public was becoming ready to follow the "passionate drive toward transfiguration"?

The Theme of Birds and Airplanes

On July 10, 1917, shortly before he wrote down his thoughts near the open window of the accounting office, Klee transcribed into his diary a long letter to his wife reflecting about an anticipated transition in his work toward "something new":

> Last night I was able to paint well. A watercolor of the sort of the "miniatures" came into being, nothing new, but an enlargement of the series. Something new is preparing itself, the diabolical will be merged into a simultaneity with the celestial, their dualism will not be dealt with as such, but in its complementary unity. This conviction is already present. The diabolical is once again peeking forth here and there and cannot be suppressed. For truth requires that one consider all elements together.[57]

Just as in his statements about "crystalline" abstraction from the beginning of 1915, Klee formulated his newly gained insights by means of a polarization of opposites. However, he no longer construed them as a "transition from yesterday to today," from reality to abstraction, but as an ambivalent alternative with moral connotations suggested by words such as "the diabolical" and "truth." Within this alternative, abstraction and figuration remained in balance.

The passage in the diary can be related to a recurrent theme of Klee's imagery at the time: singing and flying birds. The watercolor mentioned there immediately precedes in the oeuvre catalog an interrelated group of works which have that theme in common: *In the Way of a Miniature*, (77; new version of *Creative Head*), *Airy Birds' Home* (80), *Chanting Nightingale* (81), *A Piece of the Moon's World* (82; fig. 52), *Lover's Death* [corrected from *Thief's Death*] *of the Persian Nightingale* (83), and *Three Black Nightingales* (84; fig. 53). In the drawing *A Piece of the Moon's World*, the schematic silhouette of an upright-standing, chanting bird in profile, which recurs in all three pictures bearing the word "nightingale" in their titles, is juxtaposed with a different kind of bird, seen not in profile but from above, which appears to crash head-on in the bottom left-hand corner. In contrast to the standing nightingale, whose silhouette is barely suggested by a thin line drawing, this bird's body is solidly modelled with dark hatchings. Apart from the head, which is identified by the pair of eyes, the figure lacks any characteristics of a bird. The entire body is drawn with straight lines by means of a ruler. Feet are lacking. Without the head, this body, with its straight, narrow wings and symmetrical tail fins, looks rather like an airplane.

This is the first example of the juxtaposition of birds and airplanes which Klee pictured several times in the following months. In the drawing *Bird-Airplanes* of 1918 (fig. 77) he openly identified the two. In all of these images, Klee alluded to the allegorical association of birds and airplanes current in wartime graphic propaganda (figs. 54 and 55).[58] He thereby related the new dualist concept of art, of which he was writing in his diary, to one of the fundamental visual allegories of his artistic self-reflection, the idea of flying. However, in contrast to the confident projection of a soaring flight away from reality, which he had formulated in his diary entries of early 1915, Klee now returned to the ambivalence of flight and crash which he had depicted in 1905 in his etching *The Hero with the Wing* (see p. 49; fig. 27).

Shortly afterwards, Klee made the motif of the chanting nightingale the subject of an enthusiastic poem about the cosmic exaltation of the abstract artist:

"Because I came, blossoms unfolded,
Plenty is around because I am.
Chant of the nightingale
brings to my heart the spell for my ears.

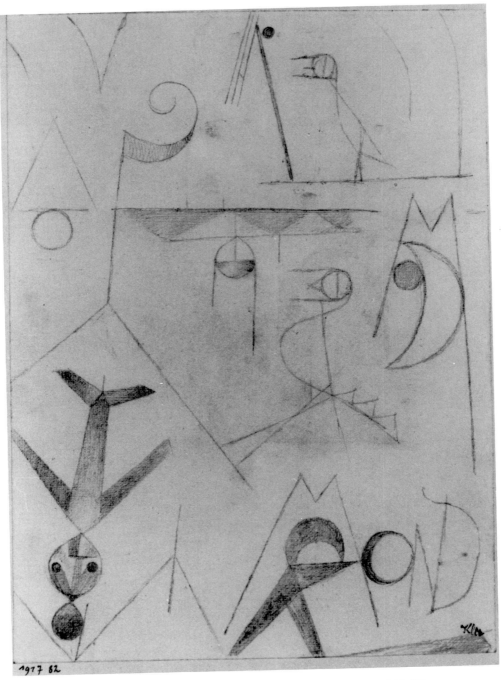

Fig. 52. *A Piece of the Moon's World* (*Ein Stück Mondwelt;* 1917, 82)

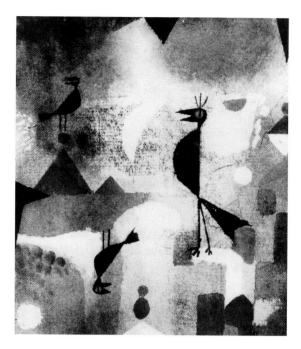

Fig. 53. *Three Black Nightingales*
(*Drei schwarze Nachtigallen;* 1917, 84)

Fig. 54. Poster by Max Mandl

Fig. 55. Poster by Julius Gipkens

I am a father to everything,
to all who live on the stars,
and in the remotest regions[.]"[59]

The motif of the airplane crash, on the other hand, was based on observations Klee made during his service on the military airfields.[60] At Schleissheim, on November 10, 1916, he had already written with fascination of his "experience with the crashed machine" (see chap. 3, note 66), without, however, relating this experience to his artistic work. Now, at Gersthofen, Klee was occasionally charged with taking photographs of airplane crashes, even at times when he should have been on leave.[61] In a letter to his wife and in the diary of September 24, 1917, he complains for the first time that he had to remain on duty on a Sunday, "because I was replacing Baumann as a photographer, and would have to take the picture in the event of a crash."[62] The time conflict between the private production of modern art and the official photography of airplane crashes cannot have been lost on his ceaseless self-reflection. By the time of his transfer to Schleissheim airfield, he had encapsulated the grotesque similarity between his artistic ideal and his military service in the sergeant's apocryphal question "Don't you want to fly?" (See p. 81.)

On October 27, Klee once again had to spend the weekend on duty in order to photograph crashes should they occur, but he did not let it distract him from his painting. "Yesterday and today I was rather productive, was working as usual, just confined to the drawer [where Klee used to hide his artwork during office hours]. For the flying school it was a bad day, in the morning one [pilot] crashed and broke several bones, and in the afternoon another one fell to his death from a high altitude (Lieutenant Geuth). Good luck for tomorrow's Sunday flying. I, of course, am not concerned, I am sitting here warmly and securely," he wrote to his wife.[63] When he transcribed the letter into the diary, he enlarged upon the last sentence: "I am of course sitting here warmly and securely and know of no war within me."[64] At this time, Klee's efforts to keep painting while on duty prompted him to engage in his most articulate reflection so far about what his experiences of airplane crashes meant to him. For, unlike the earlier letter of November 10, 1916 and its diary transcription, the last sentences of both letter and transcription are complementary quotations from his programmatic formulation of early 1915, which in the fair copy of 1921 reads: "I have had this war within me for a long time. Therefore it does not concern my innermost self." Following as it does the report of the crashes, the restatement acquires an ironic uncertainty which contrasts with the assurance of the earlier phrase. The complementary wording suggests that Klee himself was mindful of the correlation. Either he rewrote the earlier entry with reference to the later one, or he wrote the later entry as a straightforward allusion to the earlier one, in which case the earlier one would at least have been transcribed in that form by then and would most likely be the entry in its original form. Whatever the

sequence, in the later entry the fundamental antithesis of war and art, which Klee had asserted in 1915, appears both put into practice and put in doubt. It was only with such reservations that Klee now represented the transition from historical experience to artistic abstraction as accomplished. The new, dualistic conception from July 1917 that he had developed in the meantime required him to insist on a simultaneous, that is, contradictory, awareness of the real experience, the crash to death and ruin, and the opposing, abstract allegory of an ascent to enduring art.

The Sales Slump

In the fall of 1917, Klee must have become aware that the spectacular sales success of the January Sturm exhibition was not being sustained. The near failure at Munich in June, which Goltz had alleviated to some extent with his purchases, could still be ascribed to Klee's continuing lack of resonance in his own city. However, in other German cities he was not selling either, although his work was offered through newly founded modern galleries or associations of modern art collectors. In October he sent a collection of three watercolors to two of these associations, first to the Kestner Society at Hanover, then to the New Circle at Dresden. The sales success of his most recent works prompted Klee to raise these watercolors higher than the earlier ones: two watercolors from 1915 he offered for 300 marks, one from 1917 for 500 marks. However, none of them was sold at either place.

Klee may already have known of this disappointing result when in a letter to his wife of November 28, 1917, he registered for the first time reservations about the wartime art boom: "The Dresden group calls itself the New Circle, in Hanover it is called Kestner Society, in Frankfurt New Association, in Munich Das Reich ("The Empire"). Everywhere the same mushrooms of the new times shooting up. . . . In any event, one satisfaction appears to emerge for me from all of this: complete economic independence. Not that all obstacles will cease from now on. After all, the spirit needs them!"[65] Klee's doubting reflections about "the mushrooms of the new times shooting up" recall his earlier letter where he had characterized his new artistic productivity with the same words and related it to the "times" of "anno 16/17" (see note 55). The failure of three watercolors to sell could hardly be regarded as a setback, but it signalled to Klee that his career was not moving on the pattern of steady growth which was so fundamental for his self-understanding in every respect. This is what the metaphor of the ephemeral growth of mushrooms suggests. Did Klee begin to sense the problematical nature of an art boom which was not only incongruous with the historic emergency of wartime, but whose unexpected fluctuations he was beginning to experience without being able to fathom their reasons? In the last year of the war Klee strove ever more keenly to devise exhibition strategies with which to counter these fluctuations, but until the end of the war he was never to recapture the spectacular success of February 1917.

On September 4, 1917, Klee urged Walden to put on another show of his

work in the Sturm Gallery, "and I mean, as soon as you wish! Perhaps it is even possible to show one collection in the fall and another in the spring."[66] Walden scheduled the next Klee exhibition for December. Klee selected thirty watercolors for it. Of these, he sent nine to Däubler as early as October, "as a loan for study purposes,"[67] that is, as material for Däubler to write about, and Däubler forwarded them to Walden in time for the opening. This was the first time Klee actively cooperated with the prominent critic. *Chanting Nightingale* and *Three Black Nightingales* (fig. 53) were among the watercolors he sent, and Däubler responded to them with particular enthusiasm. In his review of the exhibition, which appeared in the *Berliner Börsen-Courier* of December 7, 1917, he wrote, heedlessly mixing up the titles: "Thus [Klee] calls one watercolor, which has a particularly melodical sense to it, *Three Chanting Nightingales*, or another one *Black Nightingale*."[68] Däubler also reproduced *Three Black Nightingales* as the sole illustration for his long article on Klee which appeared in the *Kunstblatt* of January 1918.[69] And in another article on Klee, which he wrote somewhat later for the May issue of the new journal *1918: Neue Blätter für Kunst und Dichtung* at Dresden, he once more singled it out for comment (see p. 120).

The new Klee show at the Sturm Gallery opened on December 2 and lasted until the end of the year. Of the thirty "new watercolors" exhibited, two were from 1915, two from 1916, and the remaining twenty-six from 1917. Klee was now concentrating his offerings entirely on his most recent production. The small group of four watercolors from the two preceding years served as a preamble, no doubt in order to put his new "development" into perspective. In setting the prices, Klee and Walden again took into account that the most recent works were more in demand than the earlier ones. The two watercolors from 1915 were offered for 200 marks, the two from 1916 for 250 marks; of the twenty-six from 1917, only four were offered for 250 marks, nineteen for 300–400 marks, and *The Three Black Nightingales*, already in press at the *Kunstblatt*, for 500 marks. Klee, perhaps encouraged by Däubler, may have expected the bird theme to carry a particular appeal, for he changed the title of *Mountain Landscape* (1917, 43) into *Bird Landscape* for the occasion.[70]

When the exhibition closed at the end of December, Klee was faced with a result which differed sharply from that of February. Only four of the thirty watercolors had been sold. And yet, the scant sales confirmed Klee's exhibition strategy. They comprised only the most recent pictures, all of them with birds as their subject, including the top picture, *Three Black Nightingales*, as well as *Chanting Nightingale, Bird Landscape*, and *Warning to the Ships* (1917, 108). It surely helped that Däubler had singled out three of them in his review in the *Berliner Börsen-Courier* (see note 68). However, these pointedly selective sales did not add up to a public success, and hence Walden did not heed Klee's suggestion to show another collection of his works in the following spring. The next Klee exhibition in the Sturm Gallery did not take place until after the end of the war, in January 1919.

The Sturm Picture Book

In the last days of 1917 the *Sturmbilderbuch* devoted to Paul Klee was published, with full-page reproductions of twenty-two of his drawings. How this publication was accomplished is suggestive of both the rise and the limitations of Klee's success during this critical year of the war.

It was probably the breakthrough of Klee's January exhibition at the Sturm Gallery that prompted Walden to launch the album. In a letter of May 14, 1917, Klee asked him for the first time how it was progressing.[71] He must have supervised the selection, for in a later letter he enjoined Walden not to sell the drawings used for the reproductions, so that he could eventually put them together in an album of his own.[72] Apparently on this occasion, free of concerns for any sales, he wished to stress what he felt was the achievement of his drawings from 1915 (see above, p. 56). Already a year earlier, one of these, *Dream Aboard*, had been reproduced, at his own insistence, on the title page of *Der Sturm* (see p. 68), and now it was reprinted in the album,[73] along with ten other drawings from the same year. The playful or otherworldly subjects of 1915 were interlaced with four exceedingly aggressive ones from 1913, including a murder and a suicide. The fifth drawing from 1913, *Moonrise*, was the one that had appeared on the title page of *Der Sturm* in February 1917. Only one drawing was from 1916. Klee's handwritten titles for all drawings but one were included in the reproductions and listed in a table of contents. The exception was one drawing from 1914. Its title, *Conquest Machine*, alluded to the war theme which had been on Klee's mind in late 1914, when he made the drawing (see pp. 15 ff.), but which was out of place in the pacifist Sturm environment of 1917.[74] It would have been easy for Klee to exclude the drawing altogether from the album, but instead, for unknown reasons, he chose to include it and omit the title.

When Klee, on August 3, 1917, wrote to Walden again about the album, he was under the impression that it was to be printed in facsimile, in a two-color technique that would recreate the effect of the tone of Klee's original yellowish drawing paper, set off by the white ground of the matlike margins.[75] His expectations were consistent with his suggestions of June 30 that modern art should be reproduced with suitable technical lavishness now that its acceptance by the public was assured (see p. 96). However, Walden, without consulting Klee any further, had the album printed with a simple technique, similar to that used for the *Sturm* journal.[76] Klee's stagnating sales hardly encouraged Walden to offer more costly reproductions of his work, as he did for other artists. When Klee wrote him on January 6, 1918, about the disappointing results of his December exhibition, he also had to inquire whether the album had appeared at last.[77] Two weeks later, the printed book was in his hands. In his reply, Klee voiced his disappointment: "With regard to my own [picture book], I had not imagined it would look so poor (in its makeup)." After reiterating his own technical proposals, ignored by Walden, he concluded: "But if all of this is not feasible, one just has to

make do with that kind of war edition. Perhaps it would be good to point this out, if now there is no longer time to wait for better circumstances." [78] Within a matter of six months, Klee's expectations about the technique to be used for publishing his art had been readjusted in his mind from what was appropriate for "cultural world peace" to what was necessary for "war editions." Yet these technical limitations had nothing to do with peace or war. When Cassirer, also in 1917, published Max Slevogt's resolutely antiwar *War Diary*,[79] he had it printed in an almost bibliophile edition, with many of the famous painter's frontline watercolors from 1914 reproduced on choice paper in exquisite color technique. Like so many other members of the German wartime art world, Klee mistook specific market circumstances for general political conditions.

1918

The German Art Market under the Luxury Tax

During the first six months of 1918, the boom of the German art market seemed to have reached its highpoint. In the February issue of *Der deutsche Künstler*, Georg Jahn, the economist and editor, surveyed the situation. He wrote of an

> extraordinary liquidity brought about by the war economy. In selling off extant inventory as well as in producing and selling war-essential goods, numerous merchants and industrialists were making in part unheard-of profits, which could be spent only with difficulty. Investment possibilities in industry and commerce were slight. Because of the scarcity of machines, materials, and labor, only industrial plants for immediate war demand could be expanded, and in the commercial sphere, circulation of capital accelerated quite substantially as a result of increased demand, coupled with diminished production and shrunken inventory. Since war bonds did not completely absorb profits, it was possible to indulge in increased luxury. . . . war profiteers appeared at art auctions as bidders and buyers, partly in order to create collections for themselves in all seriousness, partly in order to hide their profits in objects of value and thereby escape taxation to that extent, or even occasionally in order to make speculative profits with [their art acquisitions].[1]

Several of the big summer exhibitions, Jahn observed in a later article, "had achieved sales returns such as had hardly ever existed in any exhibitions." The Munich Glass Palace show, whose complete failure in the summer of 1914 had appeared to be the most telling symptom of the crisis prevailing at the time (see p. 11), but which by 1916 had recovered in excess of prewar standards (see p. 63), "could book sales of approximately 1,960,000 marks, a sum thus far unmatched in the history of the Munich exhibitions, overshadowing all earlier results, even last year's, the highest thus far" (see p. 86).[2] And on November 22, 1918, the journal *Kunstchronik und Kunstmarkt* reported: "On November 9, when the confusion of the revolution days started

in Berlin, the Great Berlin Art Exhibition in the Academy of Arts was closed. Originally it was to last until November 17. This time, its economic success was especially great."[3]

In this situation of affluence, the Reichstag finally adopted the 10 percent luxury tax, including artworks, which had been previously proposed, in July 1918. The war effort had rapidly augmented the government's long-term and short-term indebtedness. Moreover, at the beginning of 1918, the yield from the annual war loan dropped for the first time. The finance ministry attempted to offset the resulting budget deficit with various tax increases of which the luxury tax was one. The war profits tax also became law in July. Taxes had to be raised all the more drastically since they were needed not only for arms procurement, but also in order to curb the demand that had been stimulated by the war profits of 1917 and that was driving up all prices.[4]

The special sales tax of 10 percent on luxury goods exempted the works of living German artists[5] on the condition that they be sold by the artists themselves, their next of kin, or their own professional associations and exhibition groups. For this reason the reaction of *Der deutsche Künstler* to the adoption of the tax was mild[6] compared with the strident protests of *Kunst und Künstler*, with its ties to the big dealers. This journal decried the so-called art tax and predicted a stagnation in the art market, which indeed soon occurred to a certain extent, but only in the area of old art. As a result of the tax and the financial uncertainty of art collecting in the future, private collectors began to sell, and a general decline in prices ensued.[7] By July 1, 1918, *Kunst und Künstler* reported that the returns from an auction had amounted to only half of the estimates and expressed doubts that conditions on the auction market would improve again.[8]

It is unclear how the tax, which seemed to favor the work of living artists, affected the sales of conventional and expressionist artists. Even *Der deutsche Künstler* had to recognize that artists would also suffer, since the dealers were likely to pass the tax burden on to them by way of lowering their net prices, just as collectors who were buying directly from artists would attempt to get a cheaper deal from them.[9] In these market conditions, Klee's sales for 1918 did not reach the record heights of the year before. He soon took note of the new uncertainties of the art market and attempted to counter them by taking a higher public profile.

The Turn to Religion

Klee probably knew already of his setback in the Sturm exhibition when on January 3, 1918, he returned to Gersthofen airfield from his Christmas leave in Munich. He wrote to his wife that as he was looking out of the train window through the snowstorm at the town of Gersthofen, "more serious thoughts arose, influenced by the grim snowy desert and the chaotic darkness which ruled [outside] . . . Kyrie eleison was my leitmotif. . . . The crucifix stood at my right, black and unfriendly."[10] Three days later, Klee wrote two letters,

one to Walden, the other to Kubin, speaking in both of "hard times." To his dealer, he wrote:

> Aside from the one sale, apparently nothing more has materialized. It seems the prices are being perceived as somewhat high. But that does not matter. I am satisfied already now with the result and can only welcome the fact that no sellout occurred this time. If I am earning just as much as I need, now in these hard times, to make the life of my loved ones easier, and at the same time to reserve a collection for myself and for later times, I like that much better than being drawn too much into fashion and speculation. For our time has not arrived just yet.[11]

Klee's self-consolation, that modern art was not quite established yet, is a retrenchment from his confidence in cultural world peace as the reason for the success of modern art in his letter to Walden of June 30, 1917 (see p. 86). Unable to assess the change in the economic conditions of the art market, he ascribed the slackening demand to the time lag in the public acceptance of the modern movement. Once again, in his view, his art had to count on the future for complete acceptance.

In his letter to Kubin, Klee used the term "hard times" to give his sentiment of crisis a seemingly religious exaltation: "The hard times have strongly influenced my art in an ethical sense. There has been a complete breakthrough of the religious."[12] Here, "hard times" seems to mean more than just a period of declining sales and may refer to the whole of the war situation. Still, Klee cannot possibly have meant to say that as a result he had become religious. Rather, he was alluding to a newly emerging turn toward the religious in his work, whereby he was linking up with a general tendency in the modernist German art world. In June 1917, Gustav Hartlaub, a curator at the Municipal Gallery in Mannheim, had already included him in a long article that appeared in the newly founded *Kunstblatt* under the title "Art and the New Gnosticism." Hartlaub noted in modern German art of recent times "a half-conscious, half-unconscious striving" to "renew the intimate merging of religious and aesthetic imagination" found in the Middle Ages and other earlier cultures,[13] but drew a firm line between such sentiment and the genuinely religious cultures of the past.[14] Similarities that he perceived between the new turn to religion in modern art and para-religious movements such as theosophy and anthroposophy made him skeptical. He attempted to trace influences from, or at least correspondences with, these movements in the works of artists as diverse as Marc, Munch, Kokoschka, Klee, and Kandinsky.[15] Despite such reservations, Hartlaub organized in the Mannheim gallery an exhibition under the affirmative title New Religious Art, which opened in January 1918. It included works by more than thirty German artists,[16] although none by Klee. It is with this trend that the religious "breakthrough" in Klee's art was synchronized to the month.

On January 31, Klee received a confirmation of his new attitude at the airfield itself. He reported to his wife: "Today in the office a Lieutenant Oester-

reicher addressed me, a nice man whom I have liked for quite some time. He wanted to see some of my work. But I could only show him the reproduction in *Das Kunstblatt*. I then immediately broached the question of world view, and he revealed himself to be a rather well-informed man. Then we came to religious questions and to the [topic of the] war as the realization of the collapse of Europe. Astonishing for a technical officer and airman!" [17] Precisely the successful picture *Three Black Nightingales*, which Klee had painted in the course of his first critical reflections about the ambivalence of modernist wartime culture (see p. 101), now became the occasion for a conversation with an air force officer about the subject of war. Klee would also have been able to draw the lieutenant's attention to the earlier issue of *Das Kunstblatt*, where he was mentioned in Hartlaub's article. The ensuing conversations must have recalled to him those with Marc, the combat soldier and artist, in the summer and fall of 1915.

New Versions of the Airplane Crash

On February 21, 1918, Klee was obliged to photograph yet another airplane crash (cf. fig. 56).[18] In his diary, he described it with a critical irony exceeding that in the earlier entry of October 27, 1917 (see p. 104).

> Yesterday we were . . . on duty, again with the appropriate crash. . . . This week we have had three dead, one clobbered to death by the propeller, two came to pieces in the air! Yesterday a fourth raced onto the roof of the repair hangar. Flew too deeply, caught into a telegraph pole, bounced once on top of the hangar roof, somersaulted and remained lying upside down, like a heap of rubble. People running from all sides, the roof at once black with mechanics' smocks. Stretcher, ladders. The photographer. A man disentangled and carried away unconscious. Yelling insults against spectators. First-class movie effect.[19]

Just like the earlier diary entry about an airplane crash, this one also refers back to the programmatic diary texts from the first months of 1915, including all three of their key terms: flying, crash, rubble. Klee, "the photographer," describes the crashing airman as if he had been the *Hero with the Wing*. He must have perceived the actual crash as a counterimage of free flight, his personal allegory for the effort and ascent of artistic subjectivity. Now, the overwhelming impression of the wreck contrasts with the assurance of achievement which that allegory, in 1915, had seemed to promise as long as the war could be ignored.

Somewhat later, in the spring of 1918, Klee resumed in a group of three pictures the motif of the bird in the shape of a crashing airplane, which he had used for the first time in the drawing *A Piece of the Moon's World* of July 1917 (fig. 52). They are the three watercolors *Flower Myth* (82), *The Tree of Houses* (83), and *With the Eagle* (85; figs. 57–59). A fourth watercolor, entitled *With the Ascending Lark* (1918, 92), missing today, may have contained

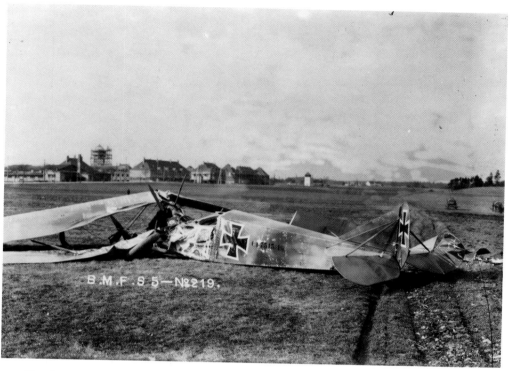

Fig. 56. Photograph of the fatal crash of Private Georg Schmidt, Gersthofen, March 8, 1918

the same motif. In *Flower Myth*[20] and *The Tree of Houses* a small bird flies downward head first into a fantasy landscape of little houses, trees, a moon, and stars. It has the form of a folded paper airplane (fig. 60). The construction pattern of a child's toy fits into Klee's childlike fairy-tale landscape. In *The Tree of Houses* it appears above a couple of tiny mannequins, which Klee had derived, in 1913, from schematic children's drawings. The paper airplane, which children throw into the air and which hovers a few seconds until dropping head first to the ground without being damaged, was Klee's imaginary antithesis to the airplane crashes he saw happening in reality.

Flower Myth shows how Klee took up the idea of childhood in full consciousness of what it meant for his view of his own development. The small bird is headed down, like a butterfly carrying pollen, toward a huge flower which extends its opened leaves toward him.[21] The image combines the ideas of flying, childhood, and sexuality, all three fundamental to Klee's self-reflection. The picture relates back, no doubt explicitly, to a text Klee had written in his diary in January 1906, which reads in the transcription of 1921: "Dream. I flew home where the beginning is. It started with brooding and nail-chewing. Then I smelled something or tasted something. . . . If now a delegation came to me and ceremoniously bowed before the artist, pointing thankfully to his works, I would hardly be surprised. For I was there, where the beginning is. I was with my adored Madam Primordial Cell, that means

Fig. 57. *Flower Myth* (*Blumenmythos;* 1918, 82)

Fig. 58. *The Tree of Houses* (*Der Häuserbaum;* 1918, 83)

Fig. 59. *With the Eagle* (*Mit dem Adler;* 1918, 85)

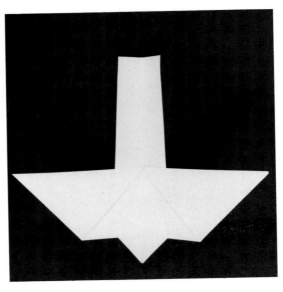

Fig. 60. Photograph of paper airplane

as much as being fertile."[22] The dream of an artistic productivity through regression to "primordial origins of art," that would be gratefully accepted by the public no matter how provocative, appeared to have come true in February 1917. The childlike fairytale landscape with the bird was just what Klee's dealer Walden had sketched out as the scenario for cosmic pretensions of the expressionist artist, in his Marc obituary of March 1916, at the time of his first Klee show (see p. 68, n. 32). In his book *Insight into Art*, which appeared in 1917, Walden generalized his ideal of a naive beauty of which "children or artists" partake, into one of an aboriginal art as practiced by peasant painters, blacks, and children.[23] In a collection of reprinted essays, *Expressionism: The Turn of Art*, which appeared in September 1918, the dealer restated these ideas.[24] And Theodor Däubler, the poet and art critic who since 1917 had pushed Klee's work in the press, followed Walden's lead when, in a long article on Klee in *Das Kunstblatt* of January 1918, he characterized him as "a painter who in his adult age perceives like a child."[25]

Däubler's was the first unreservedly enthusiastic appreciation of Klee's "childlike" traits in the critical literature. Back in 1912, when Klee had begun to concern himself with the idea of childhood in his art, his friend Hans Bloesch, in the first published review of his work, had still felt it necessary to defend him against the charge of childish clumsiness.[26] Still in 1914, Hausenstein, in his book on modern art, had granted Klee the rather ambiguous praise of "corruption sublimated to the point of childishness."[27] Now Däubler celebrated Klee's "seemingly fumbling works made out of hair-fine lines" with a quote from the cultural philosopher Martin Buber: "Supreme simplicity has been achieved."[28] However, like Hausenstein in 1914, Däubler recognized Klee's forms as deliberate: "nothing has remained a childlike at-

tempt! On the contrary, . . . all that Klee gives, has to be called fully accomplished, virile art."[29]

In the spring of 1918, Klee painted a watercolor that made literal Däubler's judgment of him as "a painter who in his adult age perceives like a child": *Landscape of the Past* (fig. 61). As the title indicates, it refers to landscape watercolors that Klee had painted twenty-eight years earlier, as a boy of ten or eleven (fig. 62),[30] before, as an adolescent, he started to train himself in the elaboration of carefully pencilled, realistic landscape drawings. All the elementary motifs of the fairy-tale landscapes of 1918—little trees made up of vertical and diagonal strokes, gabled houses, little towers, the big sun and stars, blotted flying clouds—were already assembled in those landscapes of Klee's childhood. When Klee revived them in his most advanced production, he did what he had not done in 1912, when he had first deliberately attempted to recall his childhood and ascertain the artistic potential of children's picture-making: imitate his own childhood works. Then, the recourse to childhood had been a principled provocation of the public, which Klee advanced with reference to Kerschensteiner's theory on children's art.[31] In 1918, the situation had changed. Walden's obituary on Marc and Däubler's article on Klee in *Das Kunstblatt* sanctioned the convergence of childlikeness and artistic vision as Klee's recipe for success in the Sturm Gallery. When Klee now adapted his own childhood pictures, he was conforming to Däubler's characterization of him.

In November 1918, Klee sent *Flower Myth* and *The Tree of Houses* to Walden, to be included in his next exhibition. From the sales results of December 1917, even though they were disappointing, he may have concluded that the public would respond to the bird theme and the seeming childlikeness of his form. Yet, the thematic reference to the earlier diary passage is also a token of the ironic distance which Klee kept vis-à-vis this strategy. And the thematic association with the airplane crash links the whole process, unrecognizable for the beholder, to Klee's personal experience of the war, which for him had become an allegory of his "tragicomic" two-track existence as an artist.

In Klee's polarized mode of thinking, the watercolor *With the Eagle* (fig. 59) represents a positive reaffirmation. Here the bird in the shape of a paper airplane appears standing upright on the apex of a huge arc, balancing on the point of his tail. Below, a giant eye surveys Klee's standard fairy-tale landscape with children, animals, trees, and rocks. Is it "the eye that feels" whereby Klee in 1914 had wished to distinguish himself from Marc's "eye that sees"? (See p. 61, n. 92.) The composure of his artistic abstraction appears triumphant, for a moment, in the paper airplane which neither flies nor crashes but maintains itself in a precarious, transitory equilibrium. Identified by the title as an eagle spreading its wings in order to fly, it visualizes Klee's allegory of the artist soaring above the ruins of war, as he had formulated it in early 1915. Klee did not send this self-reflection to Walden, but kept it for himself. It was never shown publicly until after his death.[32]

Fig. 61. *Landscape of the Past* (*Landschaft der Vergangenheit;* 1918, 44)

Fig. 62. *Summer Landscape, March 20* (*Sommerlandschaft, der 20. März;* 1890)

Exhibition Strategies of 1918

In March, the decline in Klee's sales continued. At Dresden, the Richter Gallery showed a new collection of his works in its exhibition The New Circle. Klee had balanced it chronologically: one work from 1914, four from 1915, six from 1917. Following the practice which had proved successful in 1917, he made the somewhat vague titles of two of these works sound more fantastic and articulate. Thus, *What a Girl Unknowingly Brings with Her* (1915, 229) became *Girl with Pathetic Glory*. The term "pathos" had already proven its pulling-power in two earlier retitlings (see pp. 73, 76). Nevertheless, by the end of May, nothing had been sold.

In the graphics exhibition of the New Munich Secession that took place also in the Caspari Gallery in March, Klee fared no better. In his oeuvre catalog he only noted that he submitted thirty works, without listing their titles or numbers. When he returned to the airfield from the opening of the show on March 19, he wrote triumphantly to his wife: "At the railway station [in Augsburg] I had bought newspapers and found Hausenstein's review of the graphic exhibition. The miracle that I am recognized there has come to pass and remains a miracle, in spite of the convoluted language."[33] When Hausenstein, in the fall of 1917, had succeeded the conservative Fritz von Ostini as art critic for the *Münchner Neueste Nachrichten*, Klee had greeted the appointment as "a miracle,"[34] surely because he was counting on good reviews from this author, who since 1913 had written favorably about him. This is what he meant when he now wrote that a "miracle" had come to pass. In his review, Hausenstein had singled out Kubin's and Klee's drawings as "the most essential impressions for me," but with a critical reservation: "This judgment is intended to be an entirely personal one; it does not oblige anyone [to agree with it]. In giving my assessment of Klee in particular, I remain conscious of the fact that I am neither able nor willing to give a generally valid norm of judgment. His drawing is so subjective and so full of fundamentally problematical features that it is impossible to match it against objective, general criteria of art."[35] Hausenstein thus ignored Klee's efforts of 1915 and 1916 to achieve an abstract style which was both aesthetically purified and historically relevant. In his lecture "On Expressionism in Painting," which he had delivered four days earlier, on March 14, 1918, in Berlin, and which he revised and expanded in September 1918 for publication,[36] he called Klee "the German classic master of cubism" and interpreted his treatment of reality as a "process . . . of ruin and new growth."[37] This pair of terms recalled Kandinsky's definition of abstraction as "ruin and transition" ("*Untergang und Übergang*") in his *Rückblicke* of 1913,[38] as well as the new title of Klee's colored lithograph *Destruction and Hope* (see p. 84). Still, in his assessment of Klee, Hausenstein did not pursue the constructive implications of the two interrelated terms. "However, the subjectivity of Klee's art is so hard to capture that it threatens to put an end to the nonnegotiable concept of the public existence of art."[39] It was this reservation which he

succinctly reiterated in the newspaper review. Klee, at a moment when his public success had again been put in doubt, was nonetheless reassured. However, the all but complete failure of the show was soon to disappoint him. Hausenstein had been right: his own "personal" approval neither corresponded to, nor did it prompt, any appreciation for Klee on the part of the Munich public. "Sold one drawing of a nude 100 [marks] gross," Klee laconically registered in his oeuvre catalog.

When on April 5 the hapless Richter Gallery in Dresden turned to Klee with new plans for a sales pitch for modern art, he reacted testily: "At Richter's yet another mushroom of a journal is supposed to shoot up. On Däubler's behalf he has turned to me with flatteries to make up for the lacking fee. At the same time my show there is to be expanded."[40]

Klee's uncertainty of his success, his awareness of strategies on the art market in which he himself engaged, and his resolve finally to prevail, all blended into one of his accustomed musings about tragic ambivalence. On April 21 he noted in his diary: "Oh, to only have come to be human, half-scoundrel and only half-god. A tragically rich, profound fate. May all of its meaning once lie before me, formed as a document. Then I can calmly face the black, void moment."[41] The gloomy thoughts on the last, desperate offensive of the German army with which the entry starts did not require Klee to turn them into airy but trenchant metaphysical self-incriminations. Gone was the high-handed self-assurance of having reached times of cultural world peace expressed ten months ago (see p. 96). Already then the war situation could have prompted such reflections on the historical or even moral incongruity of Klee's professional existence as an artist, but it took the experience of the shakiness of wartime culture to drive them home.

In May, the Richter Gallery opened its expanded Klee exhibition, meant to redress the failure of March. Klee had added twelve watercolors to the collection on view. Once again, he emphasized his work from the last two years. Six of the watercolors were from 1917, four from 1918, preceded by only one each from the years 1914 and 1915. The prices, too, were chronologically differentiated. Whereas all the works from the first two war years cost 300 marks each, three of the six works from 1917 and three of the four works from 1918 were priced at 400 marks. One work each from 1917 and 1918 even cost 600 marks. The latter two highest-priced pictures were fairy-tale landscapes, composed from the standard repertoire of half-moons, hexagram stars, and round "constellations." Klee slightly changed three provisional titles of his oeuvre catalog into unequivocal subject designations.[42]

In time for the expanded exhibition, Richter published the first issue of his new journal *1918*, for which Däubler had written a new Klee article. Once again the critic focussed on Klee's most successful motif, the nightingale: "There, a nightingale is chanting: pink love sentiments expand with incredible tenderness and care. A melancholy lilac tone resounds, dies down, its blue hue fading. A chant again! Decidedly pink. . . . Another, faster chant! Another nightingale? It came with so much light that the gold and green

spring twigs were visibly glowing. . . . It was the chant of a nightingale!"[43] With this kind of prose Däubler suggested that Klee's painting was conditioned by his musicality, as if it were the equivalent of the moody tunes of a color organ. Nothing could be more remote from Klee's own, strictly constructionist sense of music. When the artist got hold of a copy of the journal on June 3, he dismissed Däubler's contribution with a scathingly sarcastic note in his diary: "The article by Däubler is short, he tries to build his point on my musicality, and also spreads my international fame as a violin virtuoso. Engagement offers by leading concert institutions will be the immediate result. I shall however wire back: prevented by field-grey."[44] Klee's irritation with the art criticism being written about him, which he had already felt on the occasion of Hausenstein's "convoluted language," was now growing. In spite of his imaginary rejection of offers from "concert institutions," the next day he applied for a home leave in order "to listen to and make music."[45] After his return he wrote of the "intensity" and "concentration" he had experienced through his repeated playing of Bach,[46] in an obvious secret rebuff to Däubler. After Hausenstein, here was another critic who had ignored his constructionist notions of abstraction and instead reduced his work to personal lyrics.

However, when in July the sales results from the expanded exhibition at the Richter Gallery were in, Klee could not help but note that they confirmed his sales strategy, for which Däubler's text had been the propaganda. With the exception of one watercolor from 1915 which had already been shown in March, only works added in May had been sold, and of these only the ones from the last two years: three of the six from 1917, and two of the four from 1918, including the two most expensive pictures. But four of these five works had been bought by one collector at reduced prices,[47] and thus, the sales did not bespeak a wider public acceptance. Significantly, the works sold included *In the Realm of the Air* (1917, 138) and *Birds' Realm* (1918, 23), confirming the appeal of the bird theme.

For the summer exhibition of the New Munich Secession in June 1918, Klee once again limited his collection of twenty-four watercolors mainly to works from the last two years. Twelve were from 1917, six from 1918. The habitual chronological preamble consisted of one work each from 1915 and 1916, as well as four oil paintings of 1913. The oeuvre catalog does not list any prices. When the exhibition closed, two of the works from 1917 and five from 1918 were sold, that is, Klee had almost sold out his latest offerings. However, just as at Dresden, prices had been reduced,[48] and public acceptance had not grown. It was Klee's dealer Goltz who had bought four of the seven watercolors and three of the four oil paintings, for a total of 2,300 marks. This was only a slight improvement, compared to the Munich show the year before (see p. 75). Some buyers from the public had reacted more positively than before—Klee guessed in his oeuvre catalog ("Switzerland?" "Caspari?") who they might have been—but Goltz was helping out with his supportive stock purchases even more decidedly than in the previous year.

Fig. 63. *Garden at Night (with the Shadowy Mushrooms)*
(*Garten Nachts [mit den Schattenpilzen]; 1918, 55)*

122

The three unknown buyers of the Munich show had preferred unequivocally representational motifs, perhaps already on the basis of what they could read in the critical literature. They chose *Persian Nightingales* (1917, 92), *Experience in the Lechauen* (1918, 1), with similar profile birds distributed in a landscape, and *Boulevard Tunisien* (1918, 54), a repeat of Klee's well-known Tunis theme, advertised by lettering in the middle of the picture. Goltz for his part continued to pursue his predilection for Klee's seemingly untidy style of 1914, in the mode of *Tapestry of Memory*. The watercolor *Garden at Night (with the Shadowy Mushrooms)* (1918, 55; fig. 63) shows an extreme of coarse form as well as of illustrative directness. Little trees, a staircase, a half-moon, and constellations depict the Chinese landscape suggested by the hypertrophic title. This watercolor is a far cry from the aesthetically formalized expression of poetic sentiment in Chinese art which Klee had admired in 1916 and had attempted to recreate in his calligraphic letter compositions of Chinese poems.

Birds of Inspiration and Birds on the Ground

At this point, Klee took up once more the motif of the flying and crashing birds as metaphors for the artistic self-reflection. It recurs in a group of four watercolors that are recorded close to one another in the oeuvre catalog: *Landscape with Flying Birds, One of Them Pierced by an Arrow* (101; fig. 64),

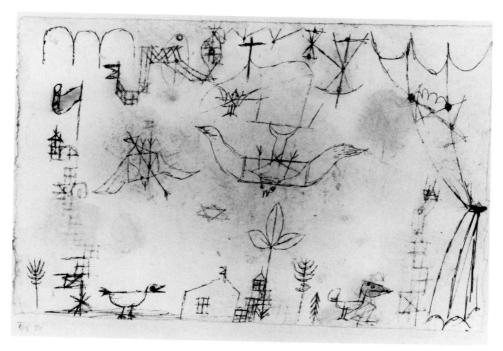

Fig. 64. *Landscape with Flying Birds, One of Them Pierced by the Arrow* (*Landschaft mit fliegenden Vögeln, einer vom Pfeil durchbohrt;* 1918, 101)

Chosen Boy (115; fig. 65), *With the Descending Dove* (118; fig. 68), and *Birds' Flights (Horizontal and Vertical)* (134; fig. 69).[49] These watercolors cannot be dated by external circumstances, but if the 211 works listed in the oeuvre catalog for 1918 were spread out over the year, the group would fall within the summer months.

Birds' Flights (Horizontal and Vertical) appears to be related to a diary entry of July 3: "The larks have grown silent, swallows are whisking over the ground here and there, like shadows."[50] Here, a huge bird, drawn in the scheme of *Flower Myth*, appears below an arch, soaring toward the sun with widespread wings. Before him, and encased within his outline, five smaller birds in profile fly from the left to the right in parallel formation. The position of the huge bird recalls that of the smaller one in *With the Eagle* (fig. 59). If the bird in the lost watercolor *With the Soaring Lark* (1918, 92) was similar, the correspondence to the diary entry of July 3 would be even closer,

Fig. 65. *Chosen Boy (Auserwählter Knabe;* 1918, 115)

124

confirming the approximate dating of the whole group. In any event, the op-
posing terms "horizontal" and "vertical" in the title emphasize the anti-
thetical pictorial thought that underlies the transformation of the crashing
paper airplane into the soaring bird, whereby Klee had earlier symbolized
the antithesis between the "internal" artistic uplift and the "external" reality
of war (see p. 105). Now he juxtaposed the bird figure with other birds in pro-
file, as he had done for the first time in *A Piece of the Moon's World* in July
1917 (fig. 52). This is the shape of the chanting nightingale, which in the in-
tervening year had proved so popular. Here it appears in fivefold repetition, a
compact group clinging to the ground even though in the air, constrained
within the soaring bird as within a cage.

In the watercolor *Chosen Boy* (fig. 65) a similar antithesis appears first
proclaimed but then satirized by means of a technical reversal. Originally
the picture resembled a devotional image. Here the frontal figure of the

Fig. 66. *Chosen Boy (Auserwählter Knabe;* 1918, 115), original state

125

Fig. 67. *Acrobats and Juggler (Akrobaten und Jongleur;* 1916, 66)

"chosen boy" appeared below an arch, encased in a transparent structure of interlocking buildings that ended in towerlets with fluttering little flags, suggesting a cathedral or a city. From the upper border, a bird in the shape of a paper airplane, perspectively distorted, appeared to be flying down, reminiscent of images of the Baptism of Christ, where the dove conventionally descends from heaven to hover over the Son of God. In *With the Descending Dove* (fig. 68), a similar bird is identified as a dove with an olive branch, the Old Testament symbol of salvation after the Flood. On the top left-hand margin of the original version of *Chosen Boy* a profile bird of the same type as Klee's nightingales stood on a treetop, looking up to the descending bird. The "chosen boy" spread his arms in a symmetrical prayer gesture, and in his opened hands the construction lines of the architecture intersected to form the shape of stigmata. In this original form, the picture was the result of the turn to religion which Klee had wanted to give to his art at the beginning of 1918 (see p. 110). Just like the watercolor *Bird Flights (Horizontal and Vertical)* (fig. 69), it included an antithesis of Klee's two bird types: the descending bird as the central symbol, the nightingale as a marginal figure, watching.

However, Klee did not stop at such an unequivocal assertion of religious sentiment. He cut the airplane canvas of the finished watercolor into two horizontal parts, one large, one small, reversed them, shifted them a bit horizontally against one another, and glued them, spaced apart, onto a piece of

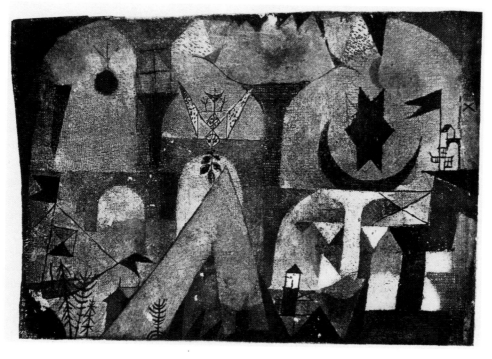

Fig. 68. *With the Descending Dove* (*mit der herabfliegenden Taube;* 1918, 118)

Fig. 69. *Birds' Flights (Horizontal and Vertical)*
(*Vogelflüge [horizontal and vertikal]*; 1918, 134)

cardboard.[51] And in the process of exchanging the upper and lower regions of the original image, he reversed all its meanings. The zone of heaven has become a predella, the separate area in composite altarpieces that traditionally displays small-scale scenes of earthly life or death and burial. The cut-off tower roofs of sacred architecture have become a row of isolated little houses on the flat earth. The profile bird stands on firm ground, and the descending bird with the spread wings carries no religious significance. Without its crowning towers, the rest of the architecture surrounding the "chosen boy" is broken up into a floating, interlocking form conglomerate. No doubt in the course of changing the picture, Klee painted into the new form ensemble an arc of coarse watercolor circles which contrast with the minute drawing, just as in the reworked lithograph *Destruction and Hope* of 1916 (see p. 85). These are balls which the "chosen boy" juggles in his stigma-marked hands. Deprived of his sacred housing and of the dove descending from above to confirm his sanctity, he now appears as a circus or *variété* performer, the traditional figure denoting the modern artist on the margins of society.

Klee had pictured the theme of juggling already in the drawings *Circus Artists* from 1915, which was reproduced in his Sturm album, and *Acrobats and Juggler* of 1916 (fig. 67).[52] Däubler, in his *Kunstblatt* article of January 1918, had used one of these images for a lengthy characterization of Klee's artistic identity, relating the pair of acrobats to some of Klee's key subjects, such as childhood and flight:

> "When Klee draws acrobats, he remakes children of the earth into constellations. It is nearly always two figures who work in the [circus] dome, for up there, on the trapeze, the human being will see his yearning for balance . . . fulfilled. . . . When the human being wants to fly, it is essentially alone, although he is moving toward a goal . . . yet it is as a pair that we are best able to perform toward a meaningful connection with the stars, as fixed points in the universe. . . . One has, as it were, to project [Klee's colors] . . . by means of a stylistic juggling act."[53]

Däubler's text is a close, imaginative interpretation of Klee's drawings. The cosmic perspective which the poet brought to the reading may have prompted Klee, in *Chosen Boy,* to transfigure the posture of juggling into a synthetic image combining flight, childhood, and color in a return reference to Däubler.

Klee's Cooperation with Hausenstein on a Book about Him

Sometime after his ambiguous acclaim of Klee in the *Münchner Neueste Nachrichten,* Hausenstein must have approached him with the plan to write a book about him, for on May 22, Klee promised him on a postcard from Gersthofen to provide him not just with drawings and watercolors, but also with "biographical material."[54] After this date Klee must have written this "biographical" text, a one-page manuscript signed "Klee 1918."[55] It consists merely of brief notes about the stages in the artist's professional development. Only at the end Klee wrote, in ever more complete sentences, a summary in which he represents that development as a path to synthesis: "In the Orient, in the spring of 1914, I developed—rather late—my [sense of] color. . . . The past appeared more genuine, the future clearer. Inferences from the ego to the cosmos in 1915. Positive religiosity, by contrast to the earlier pathetic element of negation (16/17). . . . My present intention is a unification of the different independent forces to form a whole."[56] By placing his definition of synthesis in a "contrast to the earlier pathetic element of negation," Klee implicitly contradicted the negative terms "corruption," "decadence," and "disintegration" with which Hausenstein had characterized him in his book of 1914 (see p. 47).

While he was writing his biographical summary for Hausenstein, Klee became conscious of his differences with the critic. On August 19, he wrote to his wife: "The article by Hausenstein, no matter how flattering it is for me, has nevertheless prompted a kind of opposition in me, and I painted a se-

verely organized piece *The Dream* [fig. 70], one of my most compelling sheets, on coarse paper linen with plaster grounding. It was immediately framed in white and hung on the wall. It completely filled my mind throughout the way home." [57] After his earlier mocking rejecting of Däubler's musical panegyric, Klee once again moved into "opposition" against the terms of his public recognition in the press. If in June he had withdrawn to the "concentration" of Bach's music, he now reacted by painting a "severely organized" picture. The disagreement with Hausenstein surely referred to the latter's opinion that Klee lacked the sense of firm composition which Hausenstein deemed to be the most essential feature of modern art with claims to public relevance. However, Klee's picture turned out to be no more than a formally tightened version of his ragged fairy-tale landscapes. The minute subdivision into color fields, enhanced by an intermittent grid of black lines, may distinguish it from other, more loosely painted watercolors of that time. However, the firmer structure was largely counteracted by the excessively coarse "paper linen," which determines the perception of the surface, in spite of the smoothing effect of the plaster grounding. Klee did not return to his sharp, transparent abstraction of 1915, but held on to the raw, provisional appearance of his most recent work. *The Dream* would still not have complied with Hausenstein's ideal of pictorial composition, which the critic had found fulfilled in

Fig. 70. *The Dream* (*Der Traum;* 1918, 121)

Marc's clean and colorful paintings. On the contrary, Klee fused his strengthened composition with features that he had no intention of giving up even though Hausenstein had judged them negatively.

The Essay "Graphic Art"

The First Draft

During the month of August, three publishing opportunities came Klee's way, involving two special editions of earlier etchings, and a commission to write a text for an anthology. All three ventures concerned his graphic art, not his painting. On August 7, Walden asked him for permission to print fifty copies of one of his etchings in a numbered "museum edition" of the book *Expressionism: The Turning Point of Art*, and Klee offered *Garden of Passion*, on the condition that he receive an advance.[58] The edition appeared in September. Somewhat earlier, Klee had given the copperplate of *Small World* (1914, 120) to Paul Westheim for publication in a collective portfolio. On August 12, he received from Westheim the complete run of 120 etchings for his signature, and on August 21 he sent it back.[59] It was during these two weeks, as he was watching the public dissemination of graphic works which thus far had been distributed only in individual copies, that he began to have second thoughts about the validity of Hausenstein's review of March 18 of his graphic art, where the critic had reiterated his opinion that Klee's art was too idiosyncratic to find general acceptance.

As it happened, on August 30, the writer Kasimir Edschmid asked Klee for a contribution to a collection of self-descriptive essays by modern artists and writers, which he eventually published under the title *Creative Confession*.[60] For the first time Klee was being offered a literary platform to clarify his artistic self-perception to the public. His lingering doubts about the public perception of his work, which his "thoughts near the open window of the accounting office" had brought into focus (see p. 99), as well as his increasing dislike for what others were writing about him, must have prompted him to seize the opportunity without hesitation.[61]

On September 19, Klee was able to write to his wife: "My essay for Edschmid is already extant as a first draft. However, now it is difficult to survey and order the thoughts that I have jotted down. Some things are said twice in different contexts, and an appropriate selection must be made."[62] Klee writes here that he intended to rework the "draft." In his correspondence and diary from the following six weeks, he does not mention it anymore. On October 17, Edschmid wrote to him again, urging him to send the manuscript.[63] On November 3, Klee wrote to his son that the essay would be "ready soon," and on November 5, he wrote to his wife: "The essay about graphic art is now approaching completion."[64]

Accordingly, in the manuscript,[65] two working phases can be discerned: first, a running text written in pencil, with numerous corrections and emen-

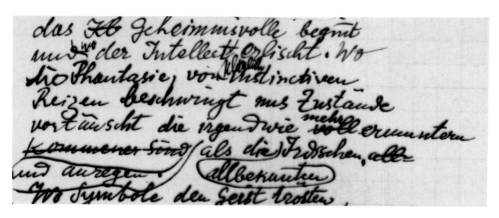

Fig. 71. Manuscript "Graphik," page G

dations, also in pencil; and second, penned in violet ink, additional deletions and displacements, new paragraphs, and a new final chapter. These must be the two versions, from September and November, respectively, about which Klee wrote in his correspondence. When the text was finally printed two years later, Klee had thoroughly reworked it once again.[66]

In his letter of August 30, Edschmid had set the condition: "The graphic arts will be dealt with by graphic artists themselves. You are to write about your drawing only."[67] Unlike other artists who wrote for the collection, such as Max Beckmann, Klee faithfully complied with the editor's request by limiting his contribution to graphic art and entitling his draft accordingly. Walden's and Westheim's publications of his etchings, and Klee's own doubts about Hausenstein's assessment of his graphic art, made the limitation timely. However, the essay is by no means focussed on the techniques of graphic art as distinct from painting, but amounts to a definition of pictorial art as such in terms of graphic art. Klee thereby reverted from the certainty that pure color represented the highest level of his artistic self-assurance, reached in April 1914 in Tunisia, to the earlier stage of a predominantly graphic definition of his work. His starting sentence: "Since [graphic art] in and of itself leads more appropriately to abstraction, it was bound to receive an increased appreciation in our age,"[68] took into account his failure to make the public accept abstraction in the medium of painting, where he had elaborated it so deliberately during the years 1914 and 1915. In attempting to explain abstraction by means of graphic art, Klee also tried to counteract the increasingly one-sided appreciation of his work for its illustrative, romantic, or even religious imagination. Nevertheless, he fell back on just the image of the fairy-tale landscape[69] that had proven so attractive to the public, in order to elucidate each element of form with an illustrative metaphor:

> Let us develop [our argument], let us make a little trip into the land of better knowledge. . . . A river wants to make difficulties for us, and we must avail ourselves of a boat (wave movement), higher up there would

have been a bridge (row of arches). . . . We traverse a freshly ploughed field (a plain with lines drawn across). . . . Basket weavers encounter us (mesh of lines). A little child is with them, with the funniest curly hair (the twisting movement). . . . Lightning on the horizon (the zigzag line). Above us one still sees stars (profusion of points). [Etc.] [70]

It is a far cry from January 1913, when Klee had written in his arbitrary translation [71] of Delaunay's essay "On Light": "As long as art does not detach itself from the object, it remains description, literature, it degrades itself to the use of faulty means of expression, condemns itself to the slavery of imitation." [72] In his Tunisian watercolors, Klee had subscribed to Delaunay's artistic ideal of a painting whose "sole and single subject matter" was to be the simultaneous harmony of colors. Now, he elucidated a process of graphic form-creation which the viewer was to recapitulate in time:

1913
"without the perceptive capabilities of the sense of sight, we would have remained with a successive movement, with the beat of a clock, as it were." [73]

1918
"The work grew from movement, is itself fixed movement (stereotypical) and is being perceived with an act of movement (eye muscles)." [74]

Delaunay had singled out the eye "as our preferred sense," [75] which, freed from the duty of recognizing objects, can perceive, through the harmony of colors, the simultaneity of the world process. Now Klee compared it to "a grazing animal," forced to "feel its way" successively along prescribed paths of the abstract image. [76] On his retreat from the ideal of pure painting to that of graphic art, Klee had turned the aesthetic emancipation which modern art could offer the beholder into the artist's claim to predetermine the viewing of his work. This is what Däubler had meant when he declared, in the spring of 1917: "In this process, the ego stands authoritatively in the world of its dreams and designs for realization" [77] (see above, p. 95). However, since the change toward illustration of ideas which Klee had undergone that year was the condition for his new claim, his text on graphic art was as much a response to the impact of his viewers on his public career, and perhaps on his creative work as well, as it was, conversely, an attempt to set the conditions himself for the public perception of his work.

The Completion

"The psychological moment is here," Klee wrote on October 2 in his diary, reporting about the sentiment of the imminent end of the war that was spreading at Gersthofen airfield. Military discipline began to slacken. Klee was assigned a room of his own right in the barracks. "No supervision, no 'Lights

out,' no reveille, nothing military, except for the noble costume. . . . I have a lot of space and a beautiful, big cupboard just for myself alone. Thus, nothing but work! The shining light with a hundred candles! Thus, descend, Holy Spirit!" [78] The ironic invocation of the Holy Spirit as a symbol of artistic inspiration recalls the equally ironic displacement of that symbol in the watercolor *Chosen Boy* (see p. 127). "We are about to go home, what a hymnic theme!" [79] However, the nonchalant mood Klee was trying to convey here did not last. When he wrote again to his wife about the approaching end of the war, four weeks later, on October 30, he appeared serious and preoccupied:

> A strange moment, with the German Empire standing so completely alone, armed to the teeth and yet so hopeless! I now see only the end, and one must hope that a certain dignity will be maintained at home, and that the idea of fate will prevail over everyday atheism.
>
> Perhaps an example is to be set of how a nation is supposed to bear a catastrophe. If so, the people will not act but will be an instrument. If they take matters into their own hands, ordinary things happen, blood flows, and lawsuits are brought. This would be trivial. [80]

Klee's un-ironical, even sentimental exclamation about "the German Empire" shows that he now began to be fearful for the order he still saw embodied in the state, no matter how little he cared for what the state meant to him politically. The imminent dissolution of that order was threatening the quiet existence as an artist which he had secured for himself in the middle of the war. In the fall of 1914, he had withdrawn from the awareness "that blood was flowing nearby" (see p. 43); in his forecast for 1919, the same event recurs as a "trivial" prospect. When Klee copied the letter in his diary, he stated his moral and political prescription for German society even more deliberately:

> What a moment, with the Empire now standing so completely alone, armed to the teeth and yet so hopeless! Will the hope also be shattered that dignity might still be preserved at home, and that the idea of fate will prevail over everyday atheism? Now we would have the opportunity to set an example of how a nation is supposed to bear its catastrophe. But if the masses become active, what then? Then very ordinary things will happen, blood will flow, and, worse still: there will be lawsuits! How trivial! [81]

In the transcription, the words "dignity" and "fate" are coupled with the words "preserve" and "prevail." "A nation" that could show how it "is supposed to bear its catastrophe" is contrasted with "the masses" who threaten to "become active." Klee was hoping for order, and dreading the conflict that revolution might bring.

Shortly after he wrote these words into his diary, Klee resumed his interrupted work on the essay "Graphic Arts" for Edschmid's *Creative Confession.* On November 3 and 5, he wrote to his son and his wife that the essay

was about to be finished.[82] On November 4, a sailors' revolt had started in Kiel, on November 7, Eisner proclaimed Bavaria a Republic of Workers' and Soldiers' Councils, and on November 9, revolution broke out in Berlin. During these days Klee completed the second version of his text.

Klee had halted in the first, pencilled version of September just where he was about to proceed toward a summary of the meaning of his art: "Art relates to creation in the manner of a parable, it is a paradigm, just as the earthly [corrected from: the earth] signifies a cosmic paradigm."[83] Thus he had started the sentence, no doubt aiming for the polarity of "cosmic" and "earthly," the scheme of his posthumous debate with Marc (see p. 79). At this point he had broken off. Now he crossed the two lines out and started over. After a more elaborate distinction between visible things "on earth" and "world totality," he proceeded to an aesthetic transfiguration of the political ideal which he had pondered in his diary a few days earlier: "The integration of the concepts of good and evil creates a moral sphere. Evil shall be neither a triumphant nor an embarrassed enemy, but a force which contributes to the making of totality."[84] In the moral definition of his art written on July 10, 1917, in a letter to his wife, Klee had already envisaged a "complementary unity" between "the diabolical" and "the celestial" as the goal of his new symbolic painting (see p. 101). In his first autobiographical statement for Hausenstein's projected book, written sometime in the summer of 1918, he had restated this goal as "a unification of the different independent forces to form a whole" (see note 129). Now he consolidated the undecided polarization of moral terms into a "state of ethical stability," an abstract alternative to the revolutionary conflict he was dreading.

Such ethical and political considerations led Klee back to Delaunay's ideal of simultaneity,[85] from which he had diverged in the first version of his essay: "Accordingly, a simultaneous joining of form, movement, countermovement. . . . (Coloristically: application of color analysis, as with Delaunay)."[86] Now Klee focussed the strictly guided sequential viewing process[87] onto the final attainment of simultaneous perception. Its designation as a state of "ethical stability" corresponded to the antirevolutionary ideal of order he had formulated a few days earlier. Following time-honored traditions of German idealism, Klee claimed no less than an ethical mission for his art. However, he did not conceal that the religious uplift he promised his readers at the end of his text was merely an escapade of the imagination: "Where fantasy, elated by instinctive attractions, simulates to us states of being which are more perfect than the earthly ones, all . . . ,"[88] he began (fig. 71), but before writing any further, he corrected himself: "Where fantasy, elated by *pitifully* instinctive attractions, simulates to us states of being which *somehow cheer up and stimulate more* than the *all-too-well-known* earthly ones."[89] The change from "perfect" to "simulate" undoes the metaphysical validity of the "other truths" which were to have made Klee's symbolical art superior to the "relativity of visible things." On the other hand, Klee remained intent on defusing his negative conclusions by means of ro-

mantic irony. He defined the relationship of art to reality as no more than playful reenactment: "Art . . . plays an unwitting game with things. As a child imitates us in his play, we imitate in [our] play the forces which created the world and are [still] creating it."[90] The definition of art as play is derived, directly or indirectly, from the same idealist tradition as its claim to an ethical mission is. Klee was thus able to connect his ideal of childhood with an accepted cultural value. He even transfigured it into cosmic universality, just as he did the childlike imagery of his paintings of that year. Walden, Klee's dealer, who in his obituary for Marc had first suggested this cosmic transfiguration of the childlike artist (see p. 68), restated it concurrently with Klee in his book *Expressionism: The Turning Point of Art,* which appeared in November, furnished with Klee's etching. This public acceptance of Klee's long-standing artistic ideal of childhood prompted him to make it the basis of his first public self-definition. Here at least the association of art and childhood suggests a carefree irresponsibility which makes its high claims tolerable. It is this ambivalence of seriousness and foolishness which Klee had visualized in his *Chosen Boy,* who juggles his balls with his eyes closed (fig. 65). The viewer who submitted to the artist's guidance for the sake of "ethical stability" was left with nothing but a self-avowed illusion. In conclusion, Klee recommended abstract art with this promise: "And to the human being [art] should be a summer resort where he can change his viewpoint for once and see himself transported into a world which distracts and offers only amenities, and from which he can return, newly invigorated, to everyday life."[91] It was the same ideology of art as a spiritual regeneration in the midst of the miseries of war that Waldmann had advanced in *Kunst und Künstler* of spring 1917 in opposition to the extension of the luxury tax on artworks (see p. 88). The market postures of conventional and modern art had coalesced.

Preparations for the Sturm Exhibition of January 1919

The collection Klee prepared during this time for Walden's next exhibition of his work in the Sturm Gallery was attuned to the ideas advanced in "Graphic Art." In October he had ten watercolors framed and forwarded to Walden, and in November he sent him another twenty. The first installment consisted of four works from 1917 and six from 1918; the second provided his usual preamble, one work from 1914 and two works from 1915, as well as seventeen additional works from 1918. At this point, then, Klee's offering was almost completely synchronized with his current production. Again, he changed some of the titles of the earlier works. Thus, *Abandoned Place* (1914, 8; originally *Abandoned City*) was retitled *Star of Abandonment,* in line with the exaltation from the "earthly" to the "cosmic" as postulated in "Graphic Art." The three watercolors *Flower Myth, The Tree of Houses,* and *With the Descending Dove* corresponded to Walden's bird-inhabited children's landscape and could now also be read as illustrations of Klee's own "land of better knowledge," his didactic scenery for the presentation of "cosmic" art as chil-

dren's play. Finally, in November 1918, Klee could be certain that his descending dove carrying the olive twig was bound to be viewed as a timely symbol of peace.

After the disappointing results from his previous Sturm exhibition in December 1917, Klee lowered his prices somewhat.[92] However, he topped the list with two programmatic pictures, each priced at 500 marks: *The Dream* (fig. 70), the "severely organized" picture painted in "opposition" to Hausenstein (see p. 130), and *Landscape of the Past* (fig. 61), the extremely simplified, "childlike" fairy-tale landscape painted in response to Däubler (see p. 117). The juxtaposition was no doubt intended to display Klee's reflection on the ambivalence of sophisticated form and simplicity as much as on the ambivalence of intransigence and accommodation. When the exhibition went on view in January 1919, the sales result confirmed the pairing as an alternative: *Landscape of the Past* was sold, *The Dream* was returned.

The Total of Klee's Sales during the War

The yearly totals of Klee's sales during the war varied considerably. They reached the following amounts:

1914	1,742 marks
1915	870 marks[93]
1916	3,320 marks
1917	11,585 marks
1918	9,455 marks[94]

These gross figures, compiled from Klee's individual notations of sales in the oeuvre catalog, would have to be adjusted here and there by various commissions and delays in payment, but their relative proportions are clear. In 1914 Klee was already making somewhat less than a minor civil servant (annual salary: 1,884 marks).[95] In 1915, the year of his "crystalline" abstraction and the low point of his public success, his income decreased by half. In 1916, the year of his belated conscription, his sales rebounded fourfold and now amounted to somewhat less than double the salary of a minor civil servant. In 1917, the year of his breakthrough at the Sturm Gallery and of his new concept of symbolic painting, they once again increased by three and a half times; Klee now made four and a half times as much as a minor civil servant, or one and a half times as much as a high-ranking civil servant (annual salary: 7,920 marks). However, in 1918, the year of art market fluctuations, his income went down by 18.4 percent.

Since the fall of 1917, Klee had begun to notice a decline of his sales. He counteracted by concentrating his offerings on his most recent production, the result of his change toward "symbolic" painting, which had proven relatively the most successful. In titling his pictures, he eliminated the last uncertainties, as the decline of provisional entries to a mere 0.94 percent for

1918 shows (see p. 73). Since Klee offered these new works at higher prices than the earlier ones, he recognized their higher market value. However, although the sales which Klee made confirmed his strategy, he could not altogether stem the decline of his sales total. His career depended on general economic conditions that could not be overcome by individual initiatives. His lagging sales were simply part of the momentary slump of the art market in the wake of the application of the luxury tax in 1918. And since Klee had just begun to establish himself, the recession appeared as an inexplicable setback in uncertain times. It was thanks to the supportive stock buying by Klee's dealer in Munich, Hans Goltz, that his sales slump remained within limits (see pp. 98, 121). Goltz bought on his own account in

1916 for 250 marks, that is, 7.5% of Klee's total sales
1917 for 1,900 marks, that is, 16.4% of Klee's total sales
1918 for 2,300 marks, that is, 24.3% of Klee's total sales

Without Goltz's purchases, Klee's total sales would have dropped from 9,685 marks in 1917 to 7,155 marks in 1918, that is, by 26 percent. As it was, they dropped by only 18.4 percent. Walden in Berlin, apparently lacking liquid capital,[96] was unable to match Goltz's Klee investments. Between May 14, 1917 and January 19, 1918, Klee had to write him on six occasions in order to request payment for past sales.[97] The oeuvre catalog for 1918 lists no sales to "Walden's private collection" anymore, as it did the year before. In the competition between Klee's dealers in Berlin and Munich, the latter prevailed. This was at variance with the public response, which up to now had been favorable only in Berlin and not in Munich. The better-funded dealer's investment soon paid off. In Klee's oeuvre catalog for the years 1919 and 1920 the entries "Sold through Goltz" were multiplying so fast that Klee had a rubber stamp cut for the purpose of marking off these sales. His business connection with Goltz was sealed on October 1, 1919 in a general contract (see p. 207). Thus, Klee's sales success toward the end of the war was increasingly based on calculations of future growth.

This financial future, however, was becoming more uncertain as inflation, which became noticeable during the year 1915, accelerated. If the currency depreciation is taken into account by measuring Klee's income against the gold mark standard of 1913,[98] Klee's annual sales balance, divided by the average inflation factor of each year, appears adjusted like this:

1914 1.05 = 1,659 gold marks
1915 1.42 = 613 gold marks
1916 1.52 = 2,184 gold marks
1917 1.79 = 6,472 gold marks
1918 2.17 = 4,357 gold marks

The two drops in Klee's earnings in 1915 and 1918 were magnified by particularly high annual inflation factors in those years. It remains an open

question to what extent Klee became aware of the depreciations as a result of noticeable declines in his own purchasing power. In any event, while in 1915 such a decline would merely have exacerbated his sense of glaring business failure, in 1918 he would have tended to see it as being at odds with his continually rising public stature as an expressionist artist. His prices, although somewhat on the rise, had by no means more than doubled between 1914 and 1918, so that he owed his growing sales figures to a continuing increase in the number of works actually sold. Thus, at the end of 1918, Klee, in spite of his successes, had to look with less than complete confidence at a career which so far had been conditioned entirely by free market forces.

The Memory of War

After the armistice of November 11, 1918, a soldiers' council assumed command of the Gersthofen airfield, and it became a rallying point for troops returning from the front. "Much commotion of arriving air force units. Hair-raising tales, partly true perhaps, partly lies. Doubly comfortable are now my digs, with the turmoil noisily raging outside," Klee wrote to his wife on November 19.[99] When he copied the letter into his diary, he stylized the last two sentences: "Hair-raising tales of the collapse outside. Doubly peaceful is now my little digs right in the middle of the turmoil."[100] In both variants, Klee contrasts, by means of his customary polarization, his artistic security with the "turmoil" of the war "outside." In his watercolor *Memorial Sheet* (fig. 72), which he entered in his oeuvre catalog as *Memorial Sheet of Gersthofen,*[101] he has depicted this room of his own in the barracks as a self-contained house with a roof and a chimney and transparent so as to reveal the inner space complete with the furniture. The artist appears reclining in his bed, drawing or writing. The telling term "my digs" (*meine Bude*), with which Klee designates this room in both the letter and the diary, relates back to the picture and floor plan of his room in his father's house which he had twice drawn, in 1896 and 1897, and labelled "My Digs."[102] In the floor plan drawing (fig. 73), the lengthy subscript inventories the furniture, culminating in the designation of the "working table (oh irony!)," which marks the spot of destiny for Klee's future as an artist. In *Memorial Sheet* of 1918, the inventory of the furniture is the same, with a few variations. Its panoramatic view combines the topographical exactitude of the floor plan with the suggestiveness of the interior. The imaginary viewer looks down, from a bird's-eye view, onto the open space, and the artist below appears tiny, as if seen from afar.

With the title *Memorial Sheet,* Klee was referring once again to a theme of world war pictorial propaganda. Memorial sheets were picture prints with a framed blank space in which to inscribe the name of a soldier killed in action, which army authorities sent as formal notifications to his relatives.[103] One of these memorial sheets, printed by the Munich publisher Callwey (fig. 74), shows a reclining dead soldier, his eyes closed, his face illuminated

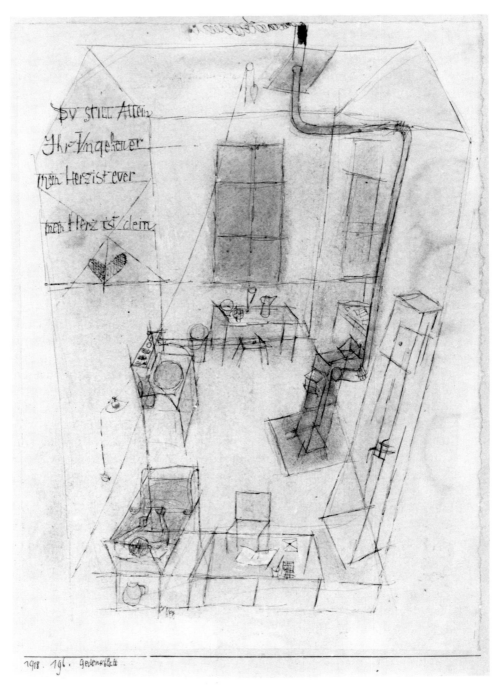

Fig. 72. *Memorial Sheet (of Gersthofen)* (*Gedenkblatt [an Gersthofen]*; 1918, 196)

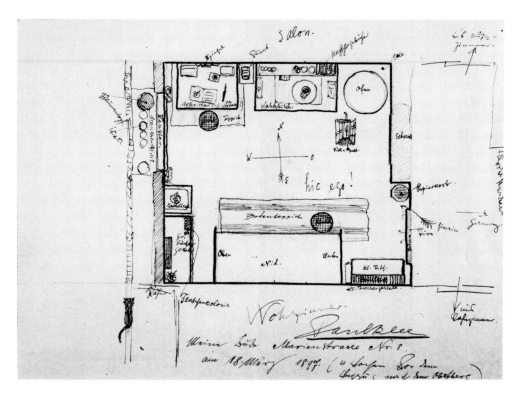

Fig. 73. "*My Digs*" ("*Meine Bude*"; 1897, 18.III)

Fig. 74. Robert Budzinski, Memorial Sheet for the Dürerbund

by rays of light from above, a direct illustration of the text below which reads: "Through the Night of Death, Everlasting Dawn is Breaking." Klee adhered to the concept of the memorial sheet, writing his own poetic device. The figure of the productive artist in bed below the light bulb—"No supervision, no 'lights out'!"—on the groundline of the "heavenly" perspective is like a somewhat blasphemous reversal of the whole idea.

With this reclining figure, Klee resumed the theme of the relationship between the soldier's death and the artist's destiny which had occupied him since he made the lithograph *Death for the Idea* of December 1914 (see p. 51). Through the historic intersections of his career with the war service and death of Franz Marc, this theme had acquired and retained for him a burning actuality. If the carefully executed colored drawing is compared to

Fig. 75. *Number Trees* (*Zahlenbäume;* 1918, 198)

the drawing *When I Was a Recruit* (fig. 41), which Klee had scribbled on the back of a note sheet at the end of 1916 in order to record his service period at Landshut, it becomes apparent how far he had progressed with his career since then. In the middle of the war, as a soldier, he had pursued, and publicly succeeded with, his program of art as an untouchable private alternative to historical reality. *Memorial Sheet* both transfigures and ironizes this success.

Two numbers after this watercolor, Klee entered in his oeuvre catalog the drawing *Number Trees* (1918, 198; fig. 75), an obvious doodle on a scrapbook addition of some payroll figures, done at an idle moment during service hours. From the standpoint of Klee the payroll clerk, the sheet can be seen as a flight of fancy from military duty into the fairy-tale landscape of the expressionist imagination; from the standpoint of Klee the successful artist, on the other hand, it can be seen as a self-mocking equation between the military pay figures and those of his picture sales. Klee's principled notion of artistic growth as analogous to organic nature here blends with a caricature of money totals which grow like ripe fruit from the branches of the tree, ready to be plucked.

At Christmastime, Klee made a formal application to the soldiers' council for home leave and returned to Munich. Not until February, 1919, was he officially discharged.[104] What he produced at home during the last week of the year is uncertain. In any event, Klee concluded his oeuvre catalog for 1918 with two works summing up the polarities he had outlined for his art. The last work entered is a drawing entitled *Constructive Connection of Earth and Heaven* (1918, 211; fig. 76),[105] a balanced, abstract composition where Klee's customary motifs of the sun and half-moon are sharply delineated and integrated into an even web of lines. It appears as if Klee had wished to express the cosmic fairy-tale landscape by means of his uncompromising abstraction of 1915. By contrast, the drawing *Bird-Airplanes*[106] (fig. 77) is a specimen of the illustrative pictorial concept Klee had developed in 1917. For the first time, the title directly equates the motif of the descending or falling bird with that of the airplane. Also for the first time, the motif is repeated several times. The four crashing birds no longer resemble the paper airplane with its slanting pointed wings, but are composed of staggered intersecting rectangles, reminiscent of the squarely compartmentalized wood-and-canvas construction of German interceptors (fig. 56).[107] The "bird-airplane" on the left appears most clearly as an axial machine structure, yet head and legs are drawn as diagonal variants over the axial composition, moving in their joints against the symmetry. The hyphenated title denotes this coincidence of mechanical and organic form. To the right there appears a small upright bird in profile, drawn nonconstructively, with a trembling line, perhaps deliberately "childlike." The counterpoising of the two types of birds is the same as in *A Piece of the Moon's World* from July 1917 (see p. 101) and in *Birds' Flights* and *Chosen Boy* from summer 1918 (see p. 127). However, unlike those earlier pictures, here the bird in profile is barely suggested, forms no part of the

composition. The theme of the nightingale which it embodies is no longer addressed. The sole apparent subject remains the airplane crash, which Klee, during his two years of service at the military airfields of Schleissheim and Gersthofen, time and again had observed, photographed, described in his diary, and conceived as an allegory for his artistic self-reflection. At the same time, Klee satirizes here, even more clearly than in the earlier versions of the motif, the conventional comparisons between birds and airplanes in war propaganda (figs. 54, 55). The figurative crash from heaven to earth is the opposite of the abstract "constructive connection of earth and heaven."

These two last drawings from the year 1918 are the kind of "documents" about Klee's historic situation as an artist which he had envisaged in his diary entries of July 10, 1917, and April 21, 1918 (see pp. 100, 120). Looking back on his war career, Klee here visually reflects upon its ambivalence, at least as much as he was able to within his self-serving concept of a dualistic pictorial form, both abstract and symbolical. He has complied with his intention of 1915, when he called himself "abstract with memories."

Abstraction's purpose, in Klee's understanding, was not to escape from historical reality into invention of pure form but was to retain the memory of history by way of a more or less hermetical antithesis. To that extent, Klee's was an art of contradiction. The shattered airplanes of Schleissheim and Gersthofen, and the corpses of their pilots, had provided him with a direct

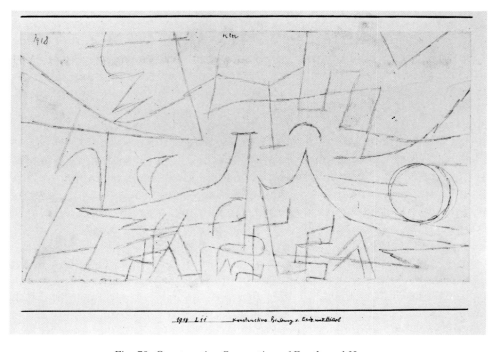

Fig. 76. *Constructive Connection of Earth and Heaven*
(*konstruktive Bindung von Erde und Himmel;* 1918, 211)

Fig. 77. *Bird-Airplanes* (*Vogel-Flugzeuge;* 1918, 210)

experience of the "rubble in the great pit of forms," which in 1915 he had wanted to make subject to abstraction. It was this dynamic process leading from recollection to rejection of reality which at that time he had declared appropriate for the transition from past to present. Abstraction was to be not just the result of the process, but the process itself. However, Klee's counter-images, the crashing and ascending birds, could not be abstract, just symbolical, testimonies of the "tragically" compromised imagination at this time in history.

1919
During the Revolution

The Realignment of the German Art Market

The German military defeat and the revolution of November 1918 prompted a temporary decline in economic productivity which lasted throughout 1919 but soon began to abate.[1] Politically, the German economy was stabilized by the Stinnes-Legien agreement between industrialists and trade union leaders; financially it was fueled by a policy of deficit spending on the part of the successive German governments with massive funding of demobilization programs and public works.[2] When exchange controls were abandoned in September 1919, and the exchange rate rapidly depreciated,[3] an "inflation consensus" emerged in German society in recognition of the economic and social benefits of this process.[4] The "inflation economy" of the years 1919 through 1922 not only proved beneficial for both the German export position and internal demand, hence making for continual growth of the gross national product,[5] it also deflected potential class conflicts inherent in postwar society, especially those between industry and labor.[6] Inflation acted in the way of a pacification policy, averting an overthrow of the social system following Soviet precedent, as had been demanded by the radical Left in the revolutionary struggles of winter and spring.[7]

The German art market stalled and rebounded similarly during this time. In January 1919, the journal *Der Kunsthandel* took issue with the *National-Zeitung*'s pessimistic survey of the situation. The conservative paper had reported: "In no other realm . . . have the after-effects of the upset made themselves felt so strongly and so incisively as in the realm of art. While [already] in the weeks before the outbreak of the revolution the old war boom prices could not be maintained any longer, since November 9 [1918] all interest for every kind of artwork has subsided completely on the part of the public with purchasing power. Just like in the antique shops, in the sales shops of modern art buyers are not showing up any more."[8] The trade journal retorted: "We find this view much too pessimistic. True, in the first two weeks after the start of the political upheaval, buyers' interest in the art market, just as in all other areas, slackened a great deal. However, the most recent auctions have again met a vivid response, and both old and new art

were sold at respectable prices, although so-called record prices no longer occurred."[9] At this point, the editor already judged the market decline to be temporary, due less to economic circumstances than to the political situation, just as in the fall of 1914.[10] By the fall of 1919, a profusion of sales and a rise in prices, accelerated by growing inflation, bore him out.[11] In the market for art reproductions, the Leipzig autumn fair proved to be such a success that one dealer graphically described his business as follows: "Every day brings reclamations for delivery, and one sits and schemes and bestirs oneself in order to increase production and distribute it evenly among the consumers."[12] While tax laws and the collectors' tendency to hold on to real values restrained the market for old art, that for current production was flourishing. The increased luxury tax imposed on the art market by the National Assembly,[13] as part of the new coalition government's sweeping new tax program,[14] was already a response to the recovery, and when it was retroactively repealed for the work of living artists in early 1920, business accelerated even more.

Since modern art was declared by its advocates to be in tune with the current political changes covered by the catchword "revolution," its position was strengthened further. At the Great Berlin Art Exhibition of fall 1919, no longer restrained by unsympathetic juries, modern art made such a mass showing the critic of the *Vossische Zeitung* lamented that the breakthroughs achieved by leaders such as Rousseau, Picasso, and Kandinsky were being trivialized into easy fashions.[15] And at the newly established Frankfurt Fair, a huge special exhibit brought together the booths of the entire spectrum of leading German art dealers, including champions of modern art such as Thannhauser, Cassirer, Neumann, and Flechtheim.[16] In his "Annual Balance" of December 1919, the editor of *Der Kunsthandel* summed up: "Business as such is still going so well that one might almost believe the [political] situation hadn't changed." He correctly ascribed both the brisk demand and the deceptive sales figures to the progressive devaluation of the German currency. "The truly bad consequences of the war will . . . become evident only later, when, perhaps within a few months, deflation will come and German money will regain its value."[17] This eventuality, however, did not present itself so soon, since throughout the years 1919 and 1920, the German economy as a whole was thriving on the basis of inflationary policies. In this business climate, Klee's sales soared so high that by October he contracted his dealer Hans Goltz to take over the bulk of his business activities.

Klee's Illustrations for Corrinth's *Potsdamer Platz*

During the last days of his military service at Gersthofen, Klee had already begun to illustrate a text whose subject was the revolution: Curt Corrinth's *Potsdamer Platz* (fig. 78). This novella is a literary grotesque about a rich young man from the provinces, the son of a war-profiteering millionaire,

who leads the prostitutes of Berlin to shed their lot as paid sexual workers and instead embark on the enjoyment of free sexuality, eventually joined by all the women of the world. In a persiflage of the Christian apocalyptic notion of a celestial Jerusalem, where the elect enjoy eternal bliss in the presence of the savior, the young "Messias" converts the luxury hotels around Berlin's Potsdamer Platz into a citadel of perpetual orgiastic feasting. This "modern-eternal communism of bodies flowering toward everyone,"[18] in defiance of bourgeois morality, prompts a counterattack by the forces of order. After police and army fraternize with the new society, the authorities call in foreign troops, but the liberated women incapacitate these soldiers by seducing them. The redeemer, his mission accomplished, ascends to heaven.

This novella was the work of an intense young writer[19] who in 1917, as a front soldier at Verdun, had published pacifist poems, following them up,

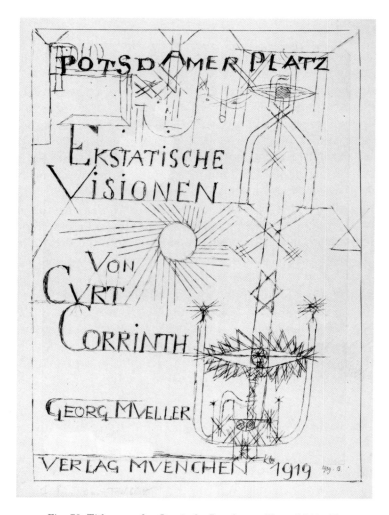

Fig. 78. Title page for Corrinth, *Potsdamer Platz* (1919, 13)

upon his return to Berlin in 1919, with a collection of utopian socialist verse. During the Weimar Republic, Corrinth was to become an active participant in Berlin's literary scene. *Potsdamer Platz* is a stylish piece of expressionist literature, combining thinly disguised, outrageously graphic sexuality, religiously exalted mystical hymnody, and deadpan banality of bureaucracy and press jargon. If it betrays a consistent political idea, it is an anarchist celebration of prostitution as a potentially revolutionary challenge to the bourgeois order. In the final showdown, Corrinth makes a mockery of the classical nineteenth-century image of the bare-breasted personification of liberty leading the struggle on top of the barricade, as a hundred thousand laughing women bare their bodies to seduce the attacking soldiers into submission.[20]

In a dedication he wrote on January 23, 1922, into a gift copy of his book, Corrinth asserts that he wrote it at the end of March 1918,[21] less than eight months before the German revolution broke out. Klee received the commission shortly before November 3[22] and made ten illustrations, which were photographically reproduced in two editions, appearing in 1919 and 1920.[23] In his oeuvre catalog, he listed these drawings not in sequence, but rather in two separate groups, one group among the last entries for 1918, the other among the first entries for 1919.[24] The Leipzig art historian and art critic Eckart von Sydow seems to have played a role in the commission, for, still at the end of 1918, Klee sent him for inspection the first drawing he had registered in the oeuvre catalog, *The Goal, My Goal,* to receive it back only in May 1919.[25] Hence the book cannot have been printed until summer 1919, well after the German revolution had everywhere subsided. Eventually von Sydow wrote a preface about Klee's illustrations, for the special edition which appeared in 1920.

The protracted chronology of the enterprise makes its political significance hard to assess. To write this kind of satire of a revolution would have been an act of cautious subversion under the threat of censorship in March 1918; to publish it in the fall of 1919 or even later would have been a convenient mockery of political failure. In between, from November 1918 to March 1919, the German revolution actually took place, and it is during these months that Klee drew his illustrations. Does Corrinth's story of foreign troops called in after the regular army has gone over to the revolution allude to the bloody suppression of the revolution in Berlin by Freikorps troops in January 1919? Did the author, in the course of these dramatic weeks, rework his text, and did Klee accordingly stop and then resume his work on the illustrations, as the interrupted sequence of the ten drawings in his oeuvre catalog seems to suggest? Neither text nor drawings seem to contain any certain reference to the historical events.

At any rate, von Sydow in his preface enthusiastically identified Klee's drawings with the idea of revolution: "These drawings of Paul Klee are full of a revolutionary paradox," he started his text, concluding with the exclamation: "Here's to the life-giving revolution! Here's to life-giving eroticism!!" For von Sydow, Klee's new drawings seemed to herald a surprising change in

the character of his art: "For: did we not love in him the one who polished the purest mirror for our pure soul-quality!: far away from the world we lulled ourselves into the rhythm of lines and in the sentiment of abnegation. And now: a dynamic will to live. . . . Only unproductive temperaments can bear a permanent life of resignation. The historic moment of expressionism certainly stimulates this kind of secularization. . . . Its magic wands are revolution and eroticism."[26]

In fact, Klee was able to carry over his earlier artistic concerns into the revolutionary frame of mind with no more than the grotesque exaggeration suggested by the story. In illustrating Corrinth's erotic fantasies (fig. 79), he gave a new, positive turn to his own obsession of many years' standing with the suppression of sexuality in "bourgeois" society.[27] Earlier, in his etching *The Virgin in the Tree* of 1903 (fig. 80), he had wanted to satirize sexual frustration and thus, as he noted in his diary, or at least in an excerpt made from

Fig. 79. *Finally Redeemed Femininity* (*Endlich erlöstes Frauentum;* 1918, 187)

Fig. 80. *The Virgin in the Tree (Die Jungfrau im Baum;* 1903, 2)

Fig. 81. *The Poisonous Animal (Das giftige Tier;* 1913, 34 [A])

Fig. 82. *You Strong One, oh—oh oh You!* (*Du Starker, o—oh oh du!* 1919, 14)

Fig. 83. George Grosz, *John the Woman Slayer,* 1918

it in 1920, express a "critique of bourgeois society."[28] The nude figure has her thighs wide open, but also closes herself off as she places one foot against her knee. During the following years, Klee had repeatedly drawn female figures as inviting but evasive targets of copulation (fig. 81), always symbolizing the male by aggressive, menacing animals. Now he used the same motif to illustrate Corrinth's sentence: "The bodies of finally redeemed femininity, unleashed after having languished for centuries in bourgeois prisons, raged in mad rapture."[29] Here Klee omitted the pursuing animal and transformed the seeming escape into a spontaneous, vertical leap of joy. He may have read Corrinth's phrase as an answer to his own commentary on the "bourgeois" *Virgin in the Tree* of sixteen years before.

Another illustration, *You Strong One, oh—oh oh You* (fig. 82), shows a woman enthusiastically submitting to violent treatment by a man. It refers to an episode in which the hero cracks the hypocritical coyness of a rich daughter of the bourgeoisie by giving her a beating. Corrinth had cast this sadomasochistic scene into anarchist political metaphors complete with barricade and bomb.[30] Klee adapted his illustration rather closely from George Grosz's oil painting *John the Woman Slayer* of 1918 (fig. 83), accessible to him in the Goltz Gallery, where the cubistic parcelling of the body is used literally to represent its physical dismemberment.[31] Klee not only took over from Grosz the reclining woman with her bulging breasts, but also the jagged contours

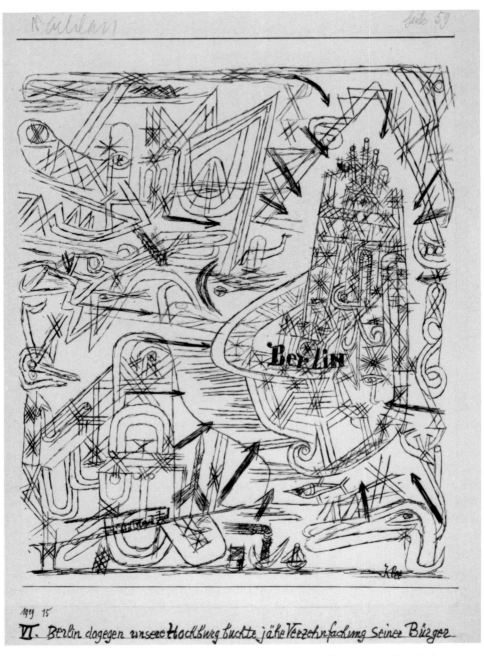

Fig. 84. *Yet Berlin, our citadel, recorded an abrupt decupling of her citizens* (*Berlin dagegen unsere Hochburg buchte jähe Verzehnfachung seiner Bürger;* 1919, 15)

Fig. 85 (opposite top right). *Cosmic-Revolutionary* (*Kosmisch-revolutionär;* 1918, 181)

Fig. 86 (opposite bottom right). George Grosz, drawing no. 14, from *Kleine Grosz-Mappe,* 1917

154

155

of the cubistically splintered interior, including the half moon in the window. He has dwelt on the crucial motif of the cut-off arms, which in Grosz's painting seem to deprive the murdered woman of the gesticulation suggested by her contorted body. In Klee's drawing the woman's body seems intact, except for the invisible hands. Conversely, of the man, only the "courageous hands" which Corrinth had apostrophized as revolutionary are visible in active motion (see note 30). By joining the two fragmented bodies into one complete set of limbs, and thus suggesting the shared sexual satisfaction of victim and attacker which Corrinth's text evokes, Klee satirically defused the violence of Grosz's picture, in line with his own cherished concept of complementary contrasts. Still, his adaptation bears the traces of Grosz's anarchistic medley of sexuality, revolt, and crime.[32]

In the sixth drawing (fig. 84), entitled *Yet Berlin, our citadel, recorded an abrupt decupling of her citizens,* Klee also used a motif from Grosz to relate his imagery to the big-city setting of the story. The drawing illustrates how Berlin, transformed into the city of eternal bliss, attracts the prostitute population from capitals all over the world, coming to seek redemption. Klee superficially adapted it from an earlier drawing of his, still without reference to the text, but with the explicit title *Cosmic-Revolutionary* (1918, 181; fig. 85).[33] Here the familiar ingredients of his fairy-tale landscapes of 1917 and 1918 are stirred up into a commotion within a space where the placement of ships, fish, birds, and stars has become indiscriminate. All of them are oriented toward a huge solid shape vaguely suggestive of a human profile. When Klee copied the illustration from this drawing,[34] he straightened the solid shape out into the image of a towering city, inscribed "Berlin," the target of converging arrows suggestive of population movements. Below, a little train, taken from George Grosz's Berlin cityscapes of 1917 (fig. 86),[35] races across an added bridge, carrying wagonloads of women.[36]

The Artists' Councils of Munich

In Prime Minister Kurt Eisner's Free People's State Bavaria with its constituent council of workers, soldiers, and peasants, numerous artists became politically active, if for no other reason than to advance their professional interests. Eleven days after the republic had been proclaimed, on November 18, 1918, twelve artists' groups in Munich joined to form the Council of the Fine Artists of Munich,[37] and two days later, forty-five delegates met to vote on guidelines and to elect the leadership.[38] The establishment of the council accorded with the program of the new Bavarian government as promulgated on November 16, 1918:

> Aside from the provisional central parliament and the revolutionary executive committee embodied by the government, all individual corporations and professions of the populace should be able to deliberate their own concerns in an entirely public fashion. We want to parliamentarize the

existing organizations. . . . The Deutsche Theater at Munich is to be the seat of this *Adjunct Parliament*. Organizations of civil servants, teachers, and private employees, the free professions, artisans, commerce, and industry, all of them are to congregate in councils, to deliberate in these parliaments their concerns independently and on their own, and to *assert* their wishes and suggestions both in the central parliament and in the government.[39]

Thus the council resulted from government decree, and was not spontaneously founded like those artist councils elsewhere in Germany, which were modelled on the revolutionary workers' and soldiers' councils. The Munich artists' council did not claim direct control of Bavarian institutions and agencies having to do with art, as was the original concept of the council system immediately after the breakdown of the monarchy in November 1918.[40] Rather, from the very beginning, its orientation was parliamentary, in accordance with Social Democratic policy:

The artists' community must break away from its unpolitical attitude. If the demands of art and of the artists' community are to become popular and find expression in the will of the people, the artists' community must take an active part in all political work. Some of us, perhaps most of us, may be reluctant to enter an area which has so little attraction, yet there is no other way. It is not [just] the right, but the duty of the individual to prove his share of the total will of the nation through collaboration. Artists must enter parliament, not only in order to take an informed position in the rare debates about art, but in order to take part in all political work."[41]

The council's program was therefore not revolutionary. In spite of its claims to a political representation exceeding professional interests, it stated no political goals of any kind.

However, already in late November a group within the council, described as "radical" by the press, worked out a program for art administration in the first council republic, aimed at far-reaching reforms: "The art administration of the peoples' state, which after the collapse of the old system has acquired a number of important tasks of patronage in precisely this area, envisages as its goal that art must not be a luxury and exception, but that on the contrary it shall pervade all of the people and everyday life, that it shall be attainable not just for a few, but for all."[42] The program then called for joining the academy, the architecture department of the polytechnic, and the school of arts and crafts in a new type of unified art school, which was to give impulse to the crafts and to industry.[43]

The New Munich Secession, to which Klee belonged, also joined the Council of Fine Artists.[44] Since 1918 Klee had been the New Munich Secession's corresponding secretary,[45] and he retained this office until his departure for Weimar in late 1920. It was hence inevitable that, upon his return from military service, he took part in the deliberations of the newly founded

council. By January and February of 1919, the politicization of the Munich art scene seemed to have been firmly established. On January 7, 1919, the Council of the Fine Artists of Munich counted no fewer than 1,500 members. On February 18, the Munich City Council recognized it as an advisory body on artistic matters. But already on January 17, in a tumultuous meeting of the artists' council, the more radical artists' group split off to the left, taking the name Action Committee of Revolutionary Artists of Munich.[46] In the course of the following months, Klee was faced with a choice between these two political directions.

Klee's First Contribution to the *Münchner Blätter*

In January 1919, Klee joined the editorial board of a newly founded art journal, the *Münchner Blätter für Dichtung und Graphik*. This new journal, aimed at collectors of original prints, was produced in rare-book fashion, large-sized, and printed on high-quality paper. Each issue contained several original lithographs interspersed throughout the text, and an additional loose-leaf lithograph, hand-colored and signed by the artist. At a price of 60 pfennig an issue, the *Münchner Blätter* amounted to an advertising gift on behalf of the participating artists. It mainly featured artists of the New Munich Secession, as had its predecessor, the *Zeit-Echo,* also a journal where literature and original prints were published side by side (see p. 24). Klee, in his capacity as the group's corresponding secretary, was joined on the editorial board by three other members: Karl Caspar, Adolf Schinnerer, and Richard Seewald. A fourth, Max Unold, made the woodcut logo on the cover (fig. 87), just as he had already done for the *Zeit-Echo* (fig. 14) in 1914. The new logo also depicted a pair of men symbolizing artists. In contrast to the husky, well-dressed late medieval trumpeters on the cover of the earlier journal, the two men on the cover of the later one are cruising in a boat, a variation of the New Munich Secession's group logo (fig. 88). No longer confident and erect, they are bent, hollow-eyed, dressed in simple, open shirts. One holds the rudder, the other lowers a net into the water, in order to draw his catch to the surface. Close behind them, instead of the wide horizon, is a riverbank lined by a few trees. The composition of the new logo expresses the difference in content: to the expansive upward gesticulation of his earlier trumpeters, Unold opposed the concentric, downward search of his new fishermen. In a scenery where untouched nature has replaced destroyed civilization, artists have turned from an active involvement in the world to an introverted pursuit of their goals.

In the first issue of the new journal, the managing editor, Renatus Kuno, expounded his program by way of a lead article entitled "The Saturnalia of War": "One thing appears certain: just as the war has proved to be the harbinger of a fate very different from that expected by all those who were busy bringing it about, thus likewise the revolution will probably come to be an entirely different unfolding of ideas than all those believe who today think

they represent the ideas and will master their realization. The revolutionary psychosis has lasted hardly as many days as the war psychosis lasted weeks."[47] Kuno recalled the passing ideological engagement of many Munich artists who had contributed to the *Zeit-Echo* in the first year of the war in the belief that the war could give art a new relevance. Unold's woodcut for the *Münchner Blätter* accurately illustrated this editorial program, just as his woodcut for the *Zeit-Echo* had illustrated the attitude which the program opposed. "Saturnalia of War" was Kuno's term for the revolution: "The revolution was in the first place a slave rebellion of those who had had to obey, an antimilitarist revolution. . . . it is against nature to lock up a people for four years within the absurd command tower of military hierarchy."[48] However, if revolution could be justified as a reaction to oppression, it could never lead to reconstruction. For this reason, Kuno rejected bolshevism in particular. Artists should not be tempted to commit yet another "confusion of spirit with action." Kuno concluded: "for us, only one thing remains: to stand guard and believe in the spirit. For that is our destiny."[49] In a similar vein, another member of the editorial board, the expressionist writer Hanns Johst, polemicized against what he called "the slogan of the politicization of the spiritual."[50]

To what extent did Klee share this editorial posture? For the first issue of the *Münchner Blätter*, he contributed a lithograph (fig. 90) copied from his drawing *Acrobats and Juggler* of 1916 (fig. 67). On the opposite page (fig. 89)

Fig. 87. Max Unold, cover woodcut of *Münchner Blätter,* 1919

Fig. 88. Max Unold, cover of New Munich Secession's exhibition catalog, 1914

was printed a lithograph by his coeditor and New Munich Secession colleague Adolf Schinnerer. Schinnerer and Klee had collaborated earlier for the *Zeit-Echo* in 1914. Schinnerer's depiction of a military mass grave in the very first issue (fig. 16), at that time at variance with the public's general war enthusiasm, was akin to the gloomy sentiment about the war which Klee had expressed in his cryptic lithograph (fig. 17) intended for the third issue (see p. 000). Neither Klee's nor Schinnerer's lithograph in the *Münchner Blätter* bears a title, but their juxtaposition suggests a common significance. Schinnerer shows the nude slaves of the "Saturnalia of War," which Kuno in his editorial had compared to the revolution, as they ride astride big, dressed human figures that are crawling on the ground. The figure in the background with his military boots is apparently a soldier, while the identity of that in the foreground remains unclear. The picture as a whole depicts the revolution as a foolish oppression of people by other people, nightmare and carnival at once. Klee's lithograph shows a similar configuration: two big acrobats, one holding the other upside down, jointly support a plank on which a small juggler stands, throwing and catching his balls. In 1916, when Klee

Fig. 89. Adolf Schinnerer, untitled lithograph, from
Münchner Blätter, January 1919

Fig. 90. *Acrobats and Juggler* (*Akrobaten u. Jongleur;* 1919, 10)

made the original drawing at the Schleissheim airfield, he may have intended it as a satire of his own artistic detachment from the war.[51] However, after Däubler, in *Das Kunstblatt* of 1918, had interpreted the image as a quintessential rendering of Klee's artistic concerns (see p. 129), it must have become for him even more of an image of self-identification and self-reflection. Republished as a lithograph in the midst of discussions about the role of the artist in the revolution, *Acrobats and Juggler* acquired the new sense of a caricature of the artist identified with the revolution, whom Kuno had disparaged as a slave emancipated by the "Saturnalia of War." At this point in time, Klee, in line with his diary statement of October 1918, was not yet ready to join a political cause.

Klee in *Der Weg*

In January, 1919, several of the artists and writers who shortly afterwards joined together in the Action Committee of Revolutionary Artists of Munich launched their own new magazine of art and literature, entitled *Der Weg*. Throughout the year 1919, after which it ceased publication, this magazine advanced a radical socialist position, far to the left of the *Münchner Blätter*.

Fig. 91. Aloys Wach, *Redemption,* title page of
Der Weg, February 1919

On the title page of the second issue, in February 1919, there appeared the well-known woodcut *Redemption* by Aloys Wach (fig. 91), soon to be a leading member of the Action Committee. The same issue carried a commentary on cultural politics by Kurt Bock, entitled "Forward!": "It is time for the revolution to create a revolution, a reformation. The moment cries out for the politics of fact. It is a sorry thing to believe in the independent force of the spirit. . . . The politician of the spirit is a fruitless term; dictatorship . . . alone enforces true politics."[52] This may have been written in express contradiction to Kunos' warning, in the editorial program of the *Münchner Blätter*, against the "confusion of spirit and action," just as Kuno's rejection of bolshevism was contradicted by the conclusion: "One may stand in whatever camp one likes, under the stormy pressure of necessity one will not escape socialism."[53]

Without regard for such political differences, Klee also contributed to this issue of *Der Weg*. His drawing *The Commander* (1918, 178; fig. 92) was reproduced full-page, without its title, but unmistakably a caricature of the deposed German emperor Wilhelm II, with his characteristic cuirassier helmet, and twisting his moustache. The drawing would still have been consistent with the limited acceptance of an "antimilitaristic revolution" against the "absurd command tower of the military hierarchy" voiced in Kuno's editorial program of the *Münchner Blätter*, Klee's own journal. But whereas here Klee had merely caricatured the artist as the juggler of revolution, he submitted to the more radical journal an image which was as revolutionary as he could give it without diverging from his own convictions. When he derided the deposed emperor, he attacked the one person whom modern artists and art critics of all persuasions had resented for decades as the absolute foe of modernism. All of them could agree that the upset of the imperial regime heralded the end of Wilhelminian art politics and promised recognition of artistic freedom by state institutions.[54] It was easy enough for Klee to identify with such aspirations. They entailed no reflection about the ideological consequences of revolutionary socialism for modern art as a whole or for his own art in particular, as advocated in *Der Weg*.

Klee's contribution to the February issue of *Der Weg* was no doubt prompted by Ernst Grünthal's article "Paul Klee," the first essay on the artist ever to appear in a Munich journal. Until then, Klee's public success had been largely limited to Berlin and Dresden, where the first monographical essays on him, by Däubler and Behne, had appeared. By contrast, in the New Munich Secession exhibition of summer 1918, Klee's collection had failed to attract any public recognition whatsoever, except for the rather dubious, two-sentence acclaim that Hausenstein published in the *Münchener Neuesten Nachrichten* (see p. 119). Thus, Grünthal's article in *Der Weg* signified a breakthrough of sorts, and Klee, whom the author, or the editors, had probably asked to make a graphic work available as an illustration for the article, submitted an image he thought would suit the political line of the journal. However, Grünthal in his text referred neither to politics nor to the drawing.

He addressed himself in high-pitched paraphrases to other motifs of Klee's art—"a herbarium," "protozoic bodies," "dolls," a "gallows' bird playing a flute heavenwards, as in a fairy tale"—the props of Klee's ascent to public success in Berlin during the last two years of the war. Grünthal probably just emulated Däubler's two articles of 1918. And he concluded: "Substanceless soul-quality of hard, painfully hard objects, grasped by extremely sensitive fingertips, shortly before they irretrievably slip away, losing themselves in dissolution. Visible still, but hardly to be retained any more: like soap bubbles which burst if one approaches them brusquely. Klee is allowed to get hold of them, for he embraces them lovingly and loves them with unspeakable tenderness, with a childlike shyness, almost just dreaming."[55] This was the opposite of the idea of a revolutionary, politically committed art advanced by the editors of *Der Weg*. Perhaps they did not find the discrepancy important or were not attentive to it in the haste of putting the issue together.

At about the same time, Klee published another caricature of the helmeted emperor Wilhelm II, the drawing *King of the Barbarians* of 1917, in a

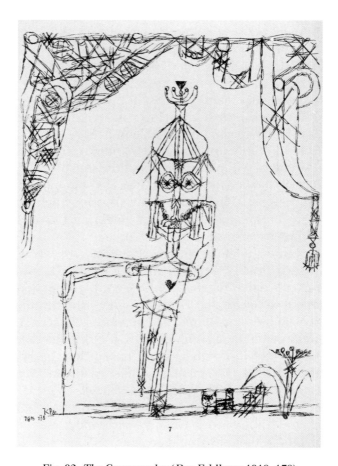

Fig. 92. *The Commander* (*Der Feldherr;* 1918, 178)

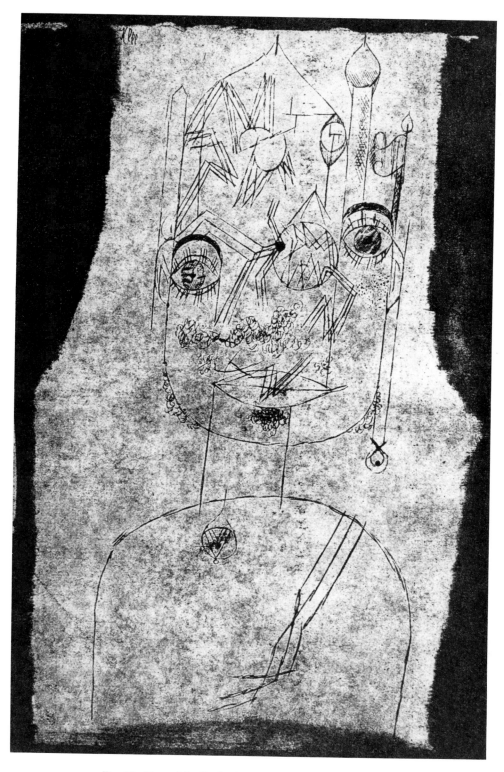

Fig. 93. *King of the Barbarians* (*Barbarenkönig*; 1917, 131)

radical journal, *Das Tribunal* (fig. 93). It was the issue advocating a reconciliation between France and Germany on the basis of socialism,[56] introduced by Edschmid's "Address to the Revolutionary Intellectual [*geistige*] Youth of France" and containing a memoir about the murdered socialist leader Jean Jaurès by Anatole France. In this program, socialist politics promised to sustain one of Klee's most firmly held ideas, that of an internationalist community of modern artists, which the war had shattered (see p. 14). However, Klee's name was lacking among the signatories of Edschmid's proclamation, which included such of his associates as Däubler and Eberz.[57] Whether by accident or by design, once again the record failed to show a political commitment on Klee's part.

King of the Barbarians was simultaneously reproduced in two other places, *Das Kunstblatt* and *Der Cicerone,* straightforward nonpolitical art journals, as illustrations for articles on Klee.[58] Here the caricature of 1917 was no more than a reminder that better times for modern art were now at hand. Still, at this point, Klee could not fail to notice that his art was consistently being favored by left-leaning writers or journals. After all, Hausenstein was a member of the Social Democratic party, and Behne, of the Independent Social Democratic party. Shortly after Grünthal's article in *Der Weg,* the *Sozialistische Monatshefte* in Berlin carried a positive review of his current exhibition at the Sturm Gallery by Lisbeth Stern, the friend of Käthe Kollwitz.[59] None of these authors attempted to interpret Klee's art politically. It was merely his "celestial serenity" that prompted Behne, in late 1918, to claim, rather disingenuously, that Klee personified the efforts of modern art "to cancel any connection with the life of bourgeois society."[60]

Klee's Second Contribution to the *Münchner Blätter*

Meanwhile, in Klee's own journal, the *Münchner Blätter,* opposition to the politics of revolution was growing. The February issue appeared with a masthead that showed an enlarged board of editors. One of the newcomers was Curt Corrinth, the author of *Potsdamer Platz,* who now published a story of downright antirevolutionary sentiment.[61]

On February 21, 1919, the first republican prime minister, Kurt Eisner, was assassinated, the deputies of the Bavarian Parliament took flight, and in its stead the Central Council of the Bavarian Republic constituted itself as the governing executive, with the active participation of the workers', peasants', and soldiers' councils. In the March issue of the *Münchner Blätter,* Hanns Johst published a poem alluding to these events and comparing the radicalization of the government to the wanton creation of a demiurgic human fantasy:

> "Whatever the boundless urge of your spirit
> Was bold enough to conceive as a thought
> —Now, without inhibition, without bounds

It is the world!—
It leapt
From the creator's lust of your fantasy
It became its likeness and yours—*beast!*"[62]

Juxtaposed with Johst's poem was an untitled lithograph by Klee (fig. 94) copied from his earlier drawing *Three Heads* (1918, 155). All three heads are grimacing caricatures. One, big and overtowering, with its furrowed countenance and enlarged eyes, resting precariously on a thin neck and angular, horizontal shoulders, appears to satirize Aloys Wach's expression-laden figures (fig. 91). This figure may be read as Johst's misguided revolutionary posing as creator, while two smaller figures below may be read as his offspring. The one on the right, in particular, appears as a bespectacled, mustachioed orator, his hand lifted in a demagogic gesture. Such readings would merely explain the choice, not the making of the drawing. However, at about the time Klee copied it for the lithograph, he drew a variant, entitled *Heads Come into Being* (fig. 95), where the theme of creation is addressed directly. Here the big head and the two small ones are twisted about, their physiognomies distorted even more grotesquely. As in the first issue of the *Münchner Blätter,* Klee's lithograph was juxtaposed with another by his coeditor, Adolf Schinnerer (fig. 96), which refers more clearly to the text. Schinnerer depicted Johst's demiurgic creator as a sculptor who is modelling the smaller clay figure of a fully grown nude man, perhaps Adam in accordance with traditional Christian iconography, who is looking downward with a terrified mien.

In contrast to the *Münchner Blätter, Der Weg* responded to recent events with increased revolutionary fervor. Its March issue was centered around a double-page epitaph for Eisner, the murdered prime minister, consisting of a poem by the editor, Eduard Trautner, and a full-page woodcut portrait by the art editor, Fritz Schaefler. In an article entitled "Revolutionary Artists," Hans Hansen denounced the Munich artists' council and its policies as having been prompted merely by professional self-interest:

> What are our artists' committees doing? They claim their basis in the revolution. Every one of them is assiduously concerned with his name and purse. . . .
> What is revolution? Overthrow—insurrection.
> What is art?
> Revolution—
> Revolution![63]

No doubt in direct reply, the *Münchner Blätter* printed in its April issue a "gloss" by the art critic August Mayer, entitled "Revolution and Art,"[64] arguing that in art the term revolution had nothing to do with politics. Referring to Kandinsky and Picasso, Mayer proclaimed: "We have had in art for fifteen years the strongest revolution, a world revolution of art. . . . artists have always been the greatest revolutionaries. . . . It is remarkable that most of

DER SCHÖPFER / VON HANNS JOHS

Du windest Brudermensch dich und du schreist —
Weltuntergang!! — Undankbar wie du bist;
Denn du vergißt
Daß diese Zeit, die du dein Leben heißt
Nur flammender als je lebendig ist!
Was deines Geistes uferloser Drang

Sich je erkühnte als Gedanke
— Jetzt ohne Hemmung, ohne Schranke
Ist es die Welt! —
Es sprang
Aus Schöpferwollust deiner Phantasie
— Es wurde ihr und dir zum Bilde — Vieh!

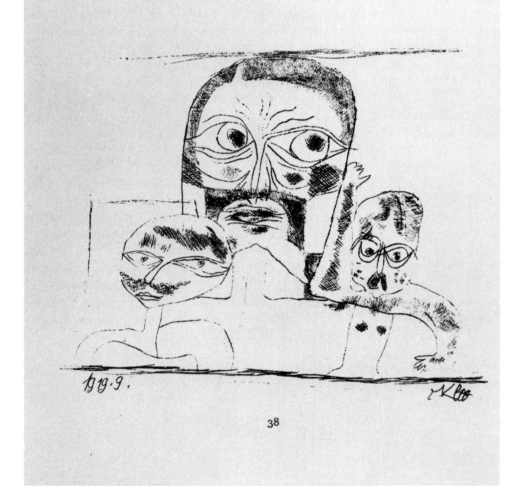

Fig. 94. *Three Heads* (*Drei Köpfe*, 1919, 9)

168

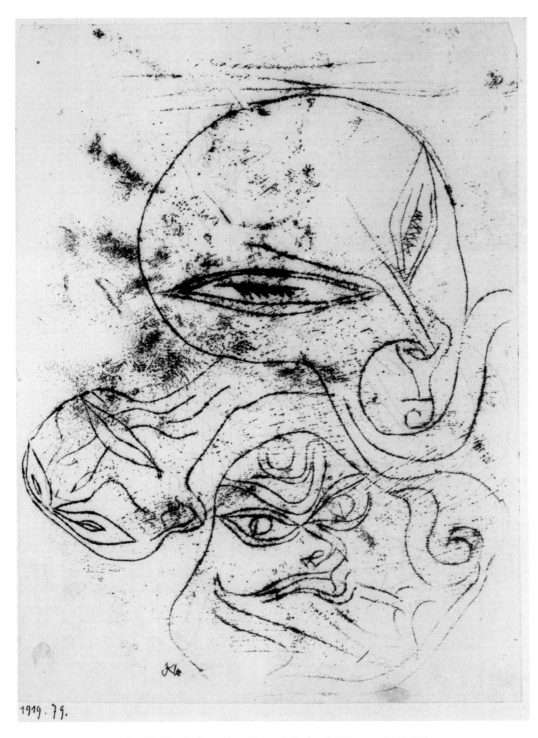

Fig. 95. *Heads Come into Being* (*Werdende Häupter;* 1919, 79)

these artists, as human beings, were firmly grounded in their respective social order, that they were correct, even philistine bourgeois. . . . Their art which moved everything was [nevertheless] unpolitical." [65] On these grounds, Mayer took his distance from the current Bavarian government: "It may well be the earnest intention of the new rulers to support art even more than before, to elevate and consolidate the artist's position; however, all this has fundamentally nothing to do with art as such." [66] Klee was not represented in the April issue of the *Münchner Blätter*. At this point, he had gone off on a political course of his own.

Fig. 96. Adolf Schinnerer, untitled lithograph, from *Münchner Blätter*, March 1919

The Invitations to the Artists' Councils

When the Council Republic of Bavaria was formally proclaimed on April 7, 1919, the organized artists of Munich were able to greet it with high expectations. The new education commissar in charge of the ministry for culture, the anarchist writer Gustav Landauer, appeared ready to grant all their demands. On April 8, the Council of the Fine Artists of Munich already felt in such a strong position with the new government that its executive committee formally demanded the suspension from service of all professors of the Academy of Fine Arts, and the government complied. Another day later, on April 9, 1919, the government issued a decree concerning the confiscation and redistribution of studio space. However, it was the small, radical Action Committee of Revolutionary Artists, not the large, mainstream Council of Fine Artists, which Landauer chose as the organization to enact his cultural program.[67]

In this situation, Klee received two simultaneous, and perhaps competing, invitations to join the steering committees of both artists' councils. The first was a letter dated April 11, 1919:

> Dear Sir!
> In order to strengthen the representation of progressive forces, the Working Committee of the Council of Fine Artists has co-opted Messrs. Karl Caspar, Jos. Eberz, Alex. Kanold, *Paul Klee*, Richard Seewald, and the architects Biber and Oskar Scharff. We ask you, in the interest of a real freedom of art, which in the present circumstances is in urgent need of such representation, to accept the election and to confirm your cooperation.
> Most sincerely
> By Order, [signed] Max Unold
> Schwind Strasse 29/IV
> We ask you to appear for sure at the next session, on Monday. April 14, at 5 P.M., in the House of Artists, at the Hoftor entrance.[68]

The initiative was at variance with the statutes of the council,[69] according to §§10–11 of which the executive committee was to be elected by the "small council" of forty artists from among its own members. It was to consist of at least twelve and at most sixteen artists, of whom at least two each were to represent, respectively, the branches of architecture, painting, graphic arts, sculpture, and crafts. Disregarding such allocations, Unold intended to draw into the executive committee five painters and two architects, all of them fellow members of the New Munich Secession. Perhaps he invoked the stipulation that "the executive committee may invite (*zuziehen*) to its deliberations artists who do not belong to the executive committee," although his own term "co-opt" (*kooptieren*) seems to mean that the artists he invited were to become members.

On April 12, the day he received Unold's invitation, Klee must already have had in his hands another one, written by Fritz Schaefler, to join the Action Committee, for on that day he replied to the latter:

Dear Mr. Schäfler [sic],

The Action Committee of Revolutionary Artists may dispose completely of my artistic capabilities. It is a matter of course that I regard myself as belonging here, since, after all, already several years before the war I was producing in the manner which now is to be placed on a broader public foundation. My work and my other artistic capabilities are at your disposition!

With best greetings,

Yours, Klee.[70]

Shedding the political hesitations he had expressed in the preceding months, Klee placed himself where he saw the greatest public chances for his art: on the Left. He made no claims to political convictions which might have corresponded to the Action Committee's politics. What he claimed was to have been a pioneer of abstract art, which in 1919 was espoused by German leftist intellectuals everywhere. Klee's acceptance letter was in fact a rather faithful response to what another member of the Action Committee, the critic Ludwig Coellen, had written three days earlier in the *Münchner Neueste Nachrichten:* "Before there was the political revolution, there was the revolution of art. Long before the end of the world war cleared the way for the spirit of the new times politically, this spirit had become alive in the new art. This is what today the working people must know: that the young artists and the young art are its allies. . . . The new art hails the world revolution. It knows that now the day of its own victory has come as well."[71] In his letter to Schaefler, Klee subscribed to the convergence Coellen had traced in his article: since modern art was a spiritual forerunner of political revolution, it was entitled to be adopted by the class which had carried the revolution out. Klee's words "already several years before the war" merely stake out this avant-garde claim which was by now as common as it was vague. His tentative sympathy for socialism in the years 1904 and 1905, which had culminated in his support for the February Revolution in Russia,[72] had subsided by 1911, the time of his commitment to the modern tradition. In 1914, he had placed himself among "the people who stand on the left" for no other reason than that of his modernist intransigence (see p. 30). Most important, in 1917 and 1918, he had had no part in the leftward politicization of expressionist culture with its opposition to the war and its sympathy for the Soviet revolution. Thus, in joining the Action Committee, Klee simply pledged himself to the group who had most determinedly championed his art in their journal *Der Weg* two months before and who now seemed to promise the political clout to "place it on a broader public foundation."

Klee's expectations seemed to be borne out after the Communist takeover on the following day, April 13, when the Action Committee continued in its ascendancy, retaining the functions that Landauer had assigned it, although he was no longer a member of the government. Consistent with the communist principles of the new regime, the Action Committee claimed authority not on behalf of any representation of Munich artists, but as a self-

proclaimed "authorizing body of an idea." [73] In a meeting the committee held on April 22 in the Landtag, an extreme program was proposed, whereby major state-owned art monuments and collections in Munich were to be sold off abroad, with the proceeds to go for social care. [74] In the same session, the painter Hans Richter's motion "to coopt Klee into the Action Committee" was adopted. [75] Then the Action Committee organized itself into various "commissariats" for painting, crafts, sculpture, exhibitions, and architecture. The minutes show the commissariat for painting to consist of the following artists: Richter, Schaefler, Klee, Eggeling, Campendonk, Laurent, and Holzer. [76] Thus, along with Richter, the acknowledged leader of the radical Munich artists, who had just come here from his Dada activities in Zurich, and Schaefler, the art editor of *Der Weg,* Klee emerged as a potentially active member of the radical Left in the Munich art world. The political grouping of Munich artists at this moment was consistent with their artistic orientation. [77] Unold, Caspar, Kanold, and the other members of the New Munich Secession active in the Council of Fine Artists were more conventional than Richter, Eggeling, and Campendonk, who opted for the Action Committee. Klee, who had often been counted the most extreme modernist among the New Munich Secession artists, was now called upon to choose sides.

The idea of a *Kunstkommissariat* working from the Ministry of Culture of the council government had already been proposed as early as March 1 by Ernst Toller, who had submitted a motion to that effect to the provisional National Council, where, however, it was never acted upon. [78] For chairman of this commissariat, Toller had proposed "Comrade Wilhelm Hausenstein," Klee's most influential admirer. [79] Klee was thus about to be drawn into political alignments far to the left of the more moderate Council of Fine Artists. Whether or not he actually followed suit remains unknown, since documents are lacking concerning his political activities in the council, the Action Committee, or as secretary of the New Munich Secession.

It was Hans Richter who acted as the spokesman for the leftist, revolutionary designation of what counted for "abstract" or "expressionistic" art in Munich at this time. At the April 22 meeting of the Action Committee which created the Art Commissariat, he submitted as a position paper his *Manifesto of the Zurich Radical Artists 1919,* [80] where he had stated: "The spirituality of abstract art (see executive program) signifies the immense extension of man's sentiment of freedom. . . . Art in the state must mirror the spirit of the entire people's body. Art . . . should belong to every individual and to no class. . . . Such work guarantees to the people the highest vital value." [81] Similar ideas recur in other revolutionary art manifestos issued in Germany in 1919; what is unique, however, is the decided identification of abstract art with political freedom. [82] It is in line with the *Proclamation of Russian Progressive Fine Artists to Their German Colleagues* of November 30, 1918, which the Action Committee had published on April 9. [83] The all-out support of abstract art by the Soviet government under the ministry of Lunatcharsky [84] assured nothing less than state patronage for this stance.

In the discussions about the reform of the Munich art schools, the Social Democratic *Münchner Neue Post* reported the arguments of "the spokesmen of the communist artist commission," headed by Richter: "The gentlemen spoke in the name of expressionism, announced the claims of the New Art and the young generation of revolutionary spirit which it has captured."[85] Consistent with these claims, Klee was nominated for a teaching post in graphic arts at the reorganized Arts and Crafts School.[86]

Conversely, in the position papers for the reform of art instruction which the Executive Committee of the Council of Fine Artists had discussed in March 1919,[87] among them two on painting written by Unold and Habermann, nothing was left of the far-reaching social changes espoused by the original program of the council in November 1918 (see p. 157). Neither painter addressed the issue of art for the people, nor did either one advance the cause of modern art in any way. On the contrary, Habermann, a conservative academy professor, unequivocally warned against the danger of "expressionist" or "futurist" art receiving too much recognition due to "external circumstances such as, for example, the momentary distribution of political power."[88] He, too, associated modern art with the revolutionary Left. To that extent, Klee was right in stating in his letter of acceptance that the direction of his work naturally led him to join the Action Committee; he would not have been able to give such an answer to the Council of the Fine Artists of Munich where his colleagues from the New Munich Secession wanted him.

1919

After the Revolution

The Escape to Switzerland and the Letter to Kubin

On May 1 and 2, 1919, the second council government of Bavaria was ousted through the military intervention of federal and Freikorps troops. Soldiers murdered former education commissar Gustav Landauer in prison. Artists and writers sympathetic to the council government were being tracked down. At least seven members of the Action Committee of Revolutionary Artists were arrested, and their leader Hans Richter was condemned to five years imprisonment.[1] Ernst Toller, a leading member of the council government, went into hiding in the city palais Suresnes, at the Werneckstrasse, the same building where Klee had rented an atelier (figs. 97, 98). On June 4, 1919, police entered and searched the building, including Klee's atelier, and arrested the writer.[2] In November 1919 the photographer Heinrich Hoffmann described the scene (fig. 99) with sneering doubletalk, associating modern art with subversion and crime: "The doorframe was covered with drawings and paintings. Detectives knowledgeable about art immediately recognized that there was more 'behind' these pictures than met the eye."[3] A week after Toller's arrest, on June 11, Klee left for Switzerland. The letters he wrote from there suggest his fear of the authorities, who had already detained his friend Hans Reichel, accused of knowingly hiding Toller and subsequently condemned to four months in prison on that charge. On the evening of June 11, Klee reported to his wife that he had made it across the Swiss border: "The boat for Romanshorn I could not catch anymore, the boat for Rorschach at 1:10 P.M. just barely. Otherwise I would have had to stay in Lindau until 4 P.M. My nerves were somewhat restless, and I made an effort to get as quickly as possible past the frontier. Everything went quite smoothly."[4] On June 24, Klee was still in Switzerland. "It seems we have peace now, better for me," he ventured in a postcard to his wife,[5] which crossed a letter of hers informing him that police had searched their apartment. He replied on June 28: "House search! What do they want at my place? To view pictures which they will not find beautiful anyway??"[6] On July 7, Toller was condemned to five years' imprisonment. Not until July 25, two and a half weeks after the conclusion of the trial, did Klee dare to return.[7]

Fig. 97. Klee's atelier in the Palais Suresnes

Fig. 98. Klee's atelier in the Palais Suresnes

Fig. 99. Heinrich Hoffmann, photograph of entrance to Toller's hideout

On the eve of his flight to Switzerland, Klee sent a long letter to his confidant Kubin, where he summarized his assessment of the Council Republic. The letter is dated May 12, 1919, when Klee had started to write it, but it was rewritten on June 10, just before Klee finally mailed it off.[8] Klee gives as his reason for the delay that he "had not been capable of bringing to a conclusion the various starts to a letter." Thus, the letter refers to events and thoughts spanning the entire period of crisis. Klee wrote:

> It was a real tragedy, a shaking collapse of a movement which was fundamentally ethical, but which was unable to stay clean of crimes, since in its overeagerness it set off wrongly. . . . However ephemeral this communist republic appeared from the very beginning, it nevertheless offered an opportunity for an assessment of the subjective possibilities for existing in such a community. It was not without a positive result. Of course a pointedly individualistic art is not suitable for appreciation by all, it is a capitalist luxury. We, however, ought to be more than curiosities for rich snobs. And that part of us which somehow aims beyond this, for eternal values, would be better able to receive support in a communist commu-

nity. . . . we would be able to channel the results of our inventive activity to the body of the people. This new art could then penetrate into the crafts and make them flourish greatly. For then academies would not exist anymore, only art schools for craftsmen.[9]

Klee takes up a subject which had been discussed time and again in the German art world since the beginning of the century: the postulate that modern art should shed its confinement as a luxury commodity for the wealthy bourgeoisie and make itself accessible to "the people," above all through crafts.[10] The demand, in particular, that artists should be form inventors for the production of useful objects was commonplace since the Darmstadt exhibition A Document of German Art of 1901. In late 1918 and early 1919, numerous revolutionary proclamations by artists and art writers radicalized that demand to envisage, as one of the benefits of freedom in a socialist society, a total emancipation of modern art from its economic dependency on the upper middle class. In late November 1918, the Council of the Fine Artists of Munich had already adopted such a program for academy reform; its preamble almost literally resembles Klee's ideals (see p. 157), although by March 1919 some members of the council's steering committee had reneged on those radical demands in the specific proposal they made (see p. 174). In its first program, published on December 18, 1918, the Working Council for Art in Berlin had proclaimed: "Art and the people must form a unity. Art shall no longer be the enjoyment of the few, but the happiness and the life of the masses."[11] And in his manifesto "What We Want," published in March 1919 in the Working Council's booklet *To All Artists,* Max Pechstein had written: "On the basis of . . . the crafts the dawn of the unity 'The People and Art' will shine forth. . . . Art is no plaything, but a duty toward the people."[12] Klee had many opportunities to become acquainted with these texts from Berlin, particularly since his critical mentor Wilhelm Hausenstein was a signatory to the December program.[13]

The art reforms envisaged in the November program of the Council of the Fine Artists of Munich continued to be advocated in the spring of 1919 by other, more radical artists under the first council government. Georg Wolf summarized them in the March issue of the journal *Die Kunst* under the title "Art and Revolution,"[14] Titus Tautz advanced them in the *Münchner Neueste Nachrichten* of April 9 under the title "Art and the Proletariat,"[15] and Hans Richter proclaimed them as policy when he reiterated his Zurich Manifesto in the session of the Action Committee of Revolutionary Artists in the Landtag on April 22, the same session where Klee was co-opted into the painting commissariat. Richter's key term "body of the people" (*Volkskörper*) recurs in Klee's letter to Kubin. Since by that time those points were no longer in evidence in the programs and discussions of the Council of Fine Artists itself (see p. 174), Klee's letter to Kubin confirms once more that he had sided with the left wing in Munich art politics.

In all those plans, complete freedom of artistic activity and an economically viable and socially responsible utilization of art were to converge, although the experience of the arts and crafts movement, from Darmstadt in 1901 to Cologne in 1914, had proven the two goals to be irreconcilable. For a brief spell of time, Klee may have shared the utopian expectancy that they might at last be brought to a synthesis, without the concomitant fundamental changes in both the art and the economy, merely through a vague confidence in "revolution" as a change of all conditions. Now, in his letter to Kubin, he was already reassessing the ideal with his customary skepticism. Yet he had subscribed to it, however hypothetically, and thus, in retrospect, the letter voices the political disappointment of a partisan, not the judgment of a disengaged observer.

After the suppression of the Council Republic, the director of the Arts and Crafts School, Richard Riemerschmid, who was also vice president of the Council of Fine Artists, still proposed a compromise plan for the "creation of a unified arts school."[16] This new institution was to comprise the reopened academy, the Arts and Crafts School, and the architecture department of the polytechnic. On May 15, 1919, the Executive Committee of the Council of Fine Artists publicly stated its support for this plan. The initiative failed, however, and only one day later, on May 16, all of the eighteen members of the Executive Committee—two in excess of the statutes—resigned. Klee summarized in his letter to Kubin: "Thus the Council Republic has brought for us [artists], too, more than one insight. [However] now less than ever can one think of a realization in practice."[17] When he continued, "My dear Kubin, perhaps [all] this does not interest you that much, but it has occupied me very much at times,"[18] it means not merely that he had pondered these issues in private, but that he had participated in policy discussions about them. And he added: "My [current] collection in the Secession would prove to you that in spite of all these matters I did not deviate from anything essential."[19] When Klee assured Kubin that those discussions, as well as his own ensuing reflections about the capitalist limitations of modern art and the need for making it accessible to the people, had had no effect on the production of his own art and on its public display, he was by no means being cynical. He simply had shared the confidence in the compatibility of modern art and radical politics professed by the leftist art world in the days of the revolution. His artistic intransigence stemmed from the conviction, "however ephemeral," that his art such as it was lent itself to public acceptance in a socialist society.

Klee's restrospective insistence on these issues is all the more significant since his dealer, Hans Goltz, advocated just the opposite position in the third issue of his house journal, *Der Ararat*, which appeared on May 19, two weeks after the occupation of Munich. From the time he started the journal in December 1918, Goltz had advanced a defiantly conservative political line.[20] Now he greeted the Freikorps as "our rescue troops" and condemned the November Revolution as "a crime against the German people."[21] Goltz

rejected the idea that modern art had anything to do with revolution, as "the proclamations of the revolutionary artists' council [i.e., the Action Committee of Revolutionary Artists] in the raped Munich press, worded in foul German language" might have led the public to believe. In opposition to their demand for an art for the people, he maintained "that art is open, maybe not for the people, but for everyone from the people," "whether dressed in workers' smock or cutaway." Goltz was convinced that in the year 1919 the distinction between "proletarian" and "bourgeois," between "exploiters" and "enslaved ones," was a futile one. "Where can one still draw the line today between the one who owns property and the proletarian? . . . Every nation will always consist of the fit and the unfit. Whoever has ability and willpower is the possessing one. The lazy and degenerate one must submit to him. There is no other world order. Wherever [a different world order] was established, conditions came about like those we have lived through in Munich."[22] Klee and Goltz must have written their politically discrepant texts almost at the same time, but Klee no doubt had the third issue of *Der Ararat* before him when he eventually rewrote his letter and mailed it to Kubin. His assertion that he "did not deviate from anything essential" in his current show may have been written in defiance of his dealer. Nevertheless, in the following months his utopian speculations about "subjective possibilities for existing" under changed political conditions were to be disproved by the objective possibilities offered his career under the social status quo acclaimed by Goltz.

The Self-Portrait *Absorption*

During the occupation of Munich, between May 1 and June 19, Klee drew a series of four self-portraits, entitled *Thinking Artist* (1919, 71), *Sensing Artist* (1919, 72), *Weighing Artist* (1919, 73), and *Forming Artist* (1919, 74).[23] The drawing that follows this series in the oeuvre catalog as 1919, 75, is entitled *Absorption* (*Versunkenheit*) (fig. 100) and hence is not expressly identified as a self-portrait or even as a picture of an artist. It is done in a different, minute pencil technique and on a larger scale. Nonetheless, it has been understood as a self-representation ever since it was reproduced as a lithograph in the *Münchner Blätter* of September 1919 (see p. 199).

The most conspicuous features of this self-portrait, the firmly closed eyes and the missing ears, refer literally to a postulate in Kandinsky's *On the Spiritual in Art* of 1912: "The artist shall be blind to 'recognized' or 'unrecognized' form, deaf to doctrines and desires of his time. His open eye shall be focussed on his inner life, and his ear shall always be directed toward the mouth of inner necessity."[24] The title *Versunkenheit*, on the other hand, recalls what Klee had written about his working mood in a letter to his wife in late February 1918: "everything around me sinks away (*versinkt*), and good works come into being by themselves before me. . . . My hand is completely the tool of a remote sphere. Neither is it my head which functions here, but something different, something higher, more remote, wherever it may be.

I must have great friends in these places, light ones, but also dark ones. That's all the same to me, I find them all to be of great benevolence." [25] Klee's claim to an introspective withdrawal from the world, or even to a mystic closeness to God, was of long standing. Early in 1915, he had affirmed it more insistently than ever in his diary entries about "crystalline" abstraction and in outspoken opposition to any involvement with historical concerns, which

Fig. 100. *Absorption* (*Versunkenheit;* 1919, 75)

Fig. 101. Photograph of Johann Lehner before his execution by Freikorps troops

then hinged on the artist's patriotic commitment to the war (see p. 41). Now, at the moment when the revolution was being suppressed (fig. 101), he pictured introspection with an expression so extreme that it borders on caricature.[26] It was probably just as deliberate as the self-reflection he had voiced in his letter to Kubin. The ambivalence of the caricaturistic mode embraces both privilege and resignation.

Klee's Show in the New Munich Secession

Klee's collection in the New Munich Secession, which he had assured Kubin would prove that he "did not deviate from anything essential" in his work, was indeed an uncompromising show of the kind of work that had been successful in the last two years of the war. Klee exhibited twenty-seven entries

altogether. Of these, ten were from 1918 and thirteen from the first five months of 1919. The usual preamble comprised a watercolor from 1915 with a motif from Tunisia and three watercolors from 1917. The titles of the works from 1919 in the exhibition show that in his most recent production, Klee had remained faithful to his themes with proven appeal, at times even intensifying them: *Fairytale with the Steamboat, Home-Garden-Labyrinth, Sphinx, Abstract with Moon Crescent, Oracle* (fig. 102). Twelve of the twenty-seven

Fig. 102. *Oracle* (*Orakel;* 1919, 98)

entries could be classified as fantastic landscapes, four as narratives, and three as completely abstract and constructive compositions.[27] Only one picture deviated glaringly from this range of themes: *Young Proletarian* (fig. 103). Within the collection, it belonged to a distinctive group of four oil paintings priced at 1,000 marks each, while all other works, watercolors with one exception, were offered for 500 marks. In the list of entries Klee recorded in the oeuvre catalog, he placed it at the end, and, judging from the number the picture bears here as well as in the signature, it was the most recent one, painted no doubt in May, that is, after the Freikorps troops had occupied the city.

As a concluding statement in the show, *Young Proletarian* evoked the ideal public which Klee had wished for his art in his letter to Kubin. This ideal association between "expressionist" art and a proletarian public was not new. In 1917, Gustav Pauli, director of the Hamburg Kunsthalle, had voiced the opinion that

> Artistic individuals seem to be once more longing for the anonymity of organized production. . . . We would then have once again, as in earlier centuries, an art of the people . . . for the people. . . . Impressionism was an art for connoisseurs, for sensitive epicures. . . . The new expressionist art seems to me instead an art of the aspiring, struggling popular classes. The works of these artists would fit better in a sober laborer's home than in a salon with silken wallpaper. This is proletarian art, and I mean this without any unfriendly second thoughts and in no way with a belittling intention.[28]

At about the same time, the Dadaists in Zurich had offered a guided tour for workers at one of their exhibitions, in accordance with their demand for a classless, "socialist" culture, but reportedly only a single worker had shown up.[29] In the early months of the German revolution, such expectations were seemingly being realized, but now the politically charged term "proletarian" was also advanced by left-wing critics who questioned the revolutionary claims of modern art with the argument that working people could never understand it. Thus, in the radical journal *Die Aktion*, Peter Bender characterized what he perceived to be a crisis of modern art after the war: "This crisis is first of all of an economic nature; but it also becomes an artistic one, since the place of the old public will be taken by the proletariat. However, the proletariat does not understand . . . bourgeois art and lifestyle, and thus faces uncomprehendingly or even with hostility the artist and the artwork as a characteristic piece of the class hostile to the proletariat."[30] On the other hand, in his report from Russia published in *Die Freiheit*, the paper of the Independent Social Democratic party, Kandinsky wrote of government-sponsored guided exhibition tours for workers (no. 171, April 9, 1919). Accordingly, the Working Council for Art in Berlin addressed its March exhibition Unknown Architects expressly to the proletariat. In his review of the exhibition, published in *Die Freiheit* on March 28, Bruno Taut wrote: "What would be useful

Fig. 103. *Young Proletarian (Junger Proletarier;* 1919, 111)

for all of us . . . would be if every proletarian . . . wrote on a slip of paper: 'I find that and that the most beautiful.'"[31] By that time, the urge to go directly to the workers had acquired a particularly radical edge, since it was voiced as a result of the Working Council for Art's disappointments about the lack of support from the Socialist government. It was in this sense that Behne had written: "There is nothing else left to us than to address ourselves to the proletarians, that is, to those human beings who spurn possessions, in whom the sentiment of the deepest community beyond all frontiers is alive, those without preconditions, those without prejudice."[32] At just the time when the New Munich Secession show was on view in Munich, on July 13, 1919, Walden's Sturm Gallery opened an exhibition of all of its expressionist masters, no doubt including Klee, in a working district in Berlin. According to *Der Cicerone,* this exhibition "enjoyed an extraordinarily large turnout and shows how surprisingly quickly the working class finds its way in the new art."[33]

Klee was referring to such aspirations when he placed the picture of a proletarian into his collection in the New Munich Secession show as a public reflection upon the precarious social position of his art after the counter-revolution. Characteristically for him, the reflection was as ambivalent as

ever. Seen in terms of the revolutionary programs of April which Klee had shared, the picture suggested that, in the words of Richter's manifesto, "the spirituality of abstract art . . . signifies the immense extension of man's sentiment of freedom. . . . Art . . . should belong to every individual and to no class."[34] On the other hand, seen as a response to the political disillusionment of May which Klee had expressed in his letter to Kubin, the picture may also suggest a self-critical counterpoint to the successful fairy-tale world of his current production as a "capitalist luxury." In any event, Klee must have intended the picture, sticking out as it did against all others in his collection, to be a programmatic statement, and this statement extends into its form. *Young Proletarian* presents the worried expressionistic physiognomy of Aloys Wach's figures (fig. 91) without any apparent trace of satirical intent, very different from *Three Heads* in the March issue of the *Münchner Blätter* (fig. 94). The centering of the frontal face complies with the principle of what Klee later called the "face of the picture," that is, of its balanced mirror relationship with the upright yet moving face of the observer.[35] Within the symmetrical composition, the primary contrast colors red and green are distributed in an alternate polarity. This double balance of form and color may be read as a visual equivalent of a public declaration, published under the headline "Appeal of the Outsiders," in the leading Munich newspaper, the *Münchner Neueste Nachrichten,* of May 9, 1919, and signed by many prominent figures of the Munich cultural scene, including Thomas Mann as well as Klee's admirer, the art critic Wilhelm Hausenstein. Here Munich's middle class was implored, at the moment of the Left's bloody defeat, not to forget that in the future, bourgeoisie and working class had to make their peace: "It is not sufficient, . . . to warn against the brutal use of force and a frivolous attitude of triumph at this terrible moment. Precisely now we find it necessary that the bourgeoisie seriously and sincerely direct its thoughts to the need to become aware of its community of fate with the working people. And that, together with the people, it begin the [necessary] fundamental transformation of the social order."[36] Klee was no outsider, but for a short while had ventured to become a partisan, or at least a fellow traveller. Still, the appeal was bound to remind him word for word of his own essay "Graphic Art" of November 1918 (see p. 135), where, in view of the imminent revolution, he had written: "The integration of the concepts of good and evil creates a moral sphere. Evil shall be neither a triumphant nor an embarrassed enemy, but a force which contributes to the making of totality."[37] As *Young Proletarian* evoked the defeated working-class just in the middle of a postrevolutionary art exhibition, it became a silent manifesto of Klee's far-flung metaphysical definition of an art aimed at balance rather than decision. Such a concept lent itself better to the apolitical, moralistic ideal of class reconciliation Klee had espoused in October 1918 than to the revolutionary ideals he had shared in April 1919. It was also in tune with the social accommodation between the classes now being encouraged by the inflationary policies of the first Weimar

coalition governments.[38] These policies were setting the conditions for Klee's continually rising financial success.

Overall, the New Munich Secession show brought Klee the breakthrough to success in Munich that had eluded him for years. Of the ten works from 1918 offered, five were sold, of the thirteen works from 1919, six, that is, almost half of the works from each year. Of the four earlier works, on the other hand, none was sold. Once again, Klee could observe the public's preference for his most recent production over that from earlier years. What sold consistently were pictures of the artificially coarse and ragged kind which Klee had started to paint in 1917 (see p. 92; fig. 104).[39] Equally consistently, the three abstract and constructive pictures (fig. 105) found no buyer.[40] In the New Munich Secession show of the year before, Klee had only been able to sell seven out of twenty-four watercolors offered, which amounted to less than a third. However, five of these seven works were from the current year 1918, and this must have encouraged Klee to concentrate his offerings for the exhibition of 1919 again on his most recent production. The sales of 1918 (see p. 121), though no great success, were part of a developing market strategy: only three out of the seven works sold were acquired by individual cus-

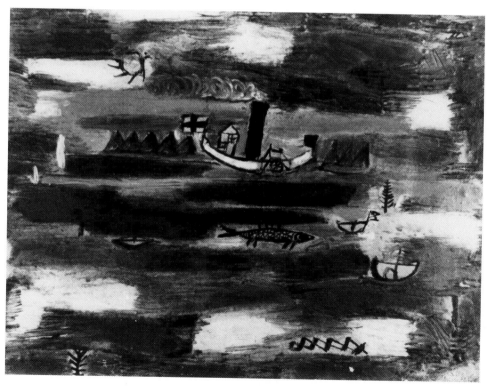

Fig. 104. *Fairytale Picture with Lake and Steamboat*
(*Märchenbild mit See und Dampfschiff;* 1919, 99)

Fig. 105. *With the Green Square*
(*mit dem grünen Quadrat;* 1919, 69)

tomers, whereas the other four had been bought for stock by Klee's dealer Goltz. In 1918, the total proceeds from the show had amounted to 2,400 marks. Now they amounted to 6,500 marks.

Of the four top-priced pictures in the show, three were sold, including *Oracle* (fig. 102), where a nude female bust, as figurative as the *Young Proletarian,* stares out at the beholder, surrounded by the telltale signs of hexagram, half-moon, and a Christian cross. Only *Young Proletarian* was returned. What the public expected and accepted from Klee were oracles, not historical reflections. In view of the overall success, the failure of his lone political painting must have struck Klee all the more clearly. When he wrote to Kubin that the exhibition would show that his political reflections had not made him deviate from what he called "essential," it was true of all his works but this. In the imaginary alternative which Klee had laid out for Kubin, the exhibition public ratified his art as a capitalist luxury.

Klee's Efforts at Professional Security

While Klee was biding his time in Switzerland, he kept intent on his pursuit of lasting professional security in Germany. He was seeking it in just those institutions from which he had hypothetically dissociated modern art in his letter to Kubin: the state academy and the capitalist art market. In the short term, both these initiatives led him into the kind of association between modern art and leftist politics that he had just escaped. In the long term, the two initiatives were aimed at the financial security Klee could not expect from his operations as a "free artist" on the open market, where fluctuating demand and inflationary risks inspired no professional confidence. Hence the attraction of a regular salary from an art school and a regular monthly payment from a dealer. The political economy of inflation conditioned Klee's two parallel efforts at professional security in the summer of 1919, which posed the alternative of free enterprise versus state employment. By the fall of 1919, one was successful, the other was not.

The Professorship at the Stuttgart Academy

On June 23, 1919, Oskar Schlemmer, then a student at the Stuttgart Art Academy, wrote to Klee in Bern regarding an appointment there. He and a group of other students wished to see a modern painter succeed their teacher Adolf Hölzel, the only modernist on the faculty, who had resigned his professorship on March 15. Schlemmer's letter refers to an earlier agreement of Klee's to be a candidate, given to the painter Schleicher, but it was Schlemmer who directed the campaign to push Klee's appointment through.[41] Schlemmer was then both an aspiring modern painter and a leftist student rebel. In November 1918, he had been elected chairman of the student body and as such was sitting as a delegate in the newly founded Council of Intellectual Workers of Stuttgart. By the end of January 1919, he found himself placed on the left of the politically polarized culture in a city where the goverment encouraged the formation of armed student squads at the academy to suppress "communist agitation," and where, as Schlemmer wrote to a friend, "painters who are just half-way modern are called 'Spartacusses.'"[42] After Hölzel's resignation, in the second half of March, Schlemmer led a group of students who petitioned the Ministry of Culture not only for Hölzel's reinstatement, but also for reforms at the academy, that is, democratization of the administration and modernization of the curriculum. By April 30, 1919, he declared the "grand idea" of the Russian revolution to be the promise of a "spiritual liberation" which would enable artists to feel united with the fighting proletariat.[43] Such thoughts recall Klee's own ideas as stated in the letter to Kubin. It seems that the group of students led by Schlemmer indeed expected him not merely to continue Hölzel's basic modern-form instruction, but also to advance the cause of academic reform.[44] The group launched a public campaign on behalf of Klee's appointment, of which the centerpiece

was to be a show of Klee's work, along with an exhibition of their own work which they planned for late October.

Schlemmer never met Klee personally. All their negotiations were carried on by mail. Schlemmer's first letter of June 23 only informs Klee about the procedures he intended to follow. Klee answered on June 28 on a postcard stating curtly that he was pleased to be available. But already on the same day Schlemmer, ahead of this answer, again wrote to Klee to inform him of "considerable resistance" to his appointment, which he intended to counter with "some fights." These initiatives were to include the exhibition of Klee's work and the demand for the resignation of an older professor to make room for Klee. Klee answered in a long two-page letter where he tried to make his bid for the appointment from the position of strength he felt he had attained by then. Pointing to his two current exhibitions at the Sturm Gallery in Berlin and the New Munich Secession, as well as to another planned for Zurich in July or August, he concluded:

> With regard to an exhibition of my works at Stuttgart, it is true that I am always for making my pictures accessible to wider circles time and again. . . . On the other hand, I must say to myself: Whoever has seriously concerned himself with art during the last, significant years, will presumably know quite well who I am.
>
> I could recommend to you to refer the persons, offices or authorities with whom you are dealing to several publications. Wilhelm Hausenstein. . . , Theodor Däubler. . . . Or refer to Dr. Hausenstein personally as an "expert," no matter how funny that may sound at first.[45]

Klee emphasized to Schlemmer the "altruistic motives" of his positive response: "My readiness to become active as an art educator at Stuttgart or elsewhere arises first and foremost from altruistic motives and the good will to help, as well as from the recognition that I will not be able in good conscience to withhold myself in the long run from a fruitful teaching activity. . . . Only one thing I ask you not to do, and that is not to think that if your plan should fail it would in any way affect my ambition or economic situation."[46] This is the first time Klee writes about his readiness or even eagerness to teach, after his appointment to the faculty of the Arts and Crafts School in Munich under the Bavarian Council government in April (see p. 174) had come to nothing. He implies that the Stuttgart appointment was only one of several prospects.[47] No word in the correspondence touches the direction that his actual teaching was to take. Since Klee and Schlemmer had never talked to one another, one can only surmise a tacit understanding on the grounds that Klee was now a renowned modern artist to whom an academy position was due and that if appointed he would work for institutional changes.

Both these arguments form the core of the official report which Schlemmer, in his capacity as student council president, addressed to the academy director, informing him about the students' vote for Klee's appointment.[48]

Here Schlemmer claimed that the "new art movement known as expressionism" was now so strong in Stuttgart that "only the appointment of an abstract artist" would be adequate to update the academy's program. Klee, he wrote, "upon an inquiry [on our part] declared himself ready to accept a teaching post at Stuttgart and to give it preference over offers from Frankfurt and Weimar which he had already received. The restructuring of the art school system which is underway throughout the country, and the concomitant new appointments . . . make it appear urgent to enact the appointment immediately."[49] Schlemmer singled out "the attraction of an [art] school program like that of the Bauhaus in Weimar," thus linking Klee's Stuttgart appointment to the cause of academic reform. By July 7, 1919, Klee had hardly already received a firm "offer" from the Bauhaus, as Schlemmer maintained—the official telegram with the call to the Bauhaus only reached him much later, on November 25, 1920 (see p. 242)[50]—but some tentative, informal negotiations must have been underway, for when Gropius finally offered Klee the position, he wrote that for a year he had been waiting for the moment when he would be able to do so (see p. 243).[51] It may have been for this reason that Klee already was familiar with the Bauhaus program by the time he wrote the letter to Kubin.[52] As to Klee's reputation as one of the outstanding masters of "the new art movement," Schlemmer described it in terms of an activist involvement in the art world: "In choosing Paul Klee, the students let themselves be guided by the thought that he is capable of being an *authority* to them, since they acknowledge him as an artistically superior mind, but also a *comrade-in-arms,* since as a pioneer of the new ideas, he engages himself completely on their behalf, and is therefore willing to represent the aspirations and interests of the students who declare themselves for him."[53] The expectation that Klee would "engage himself completely" as a "comrade-in-arms" confirms the evidence about his activist involvement in the Munich art scene during the revolutionary times. In any event, the prospect of appointing a professor committed both to academic reform and to support for left-wing students, which Schlemmer advanced with rather imprudent frankness, was likely to be felt as a threat by the conservative faculty at the Stuttgart Academy.

It is still an open question how Schlemmer could arrive at these expectations about Klee's role as a teacher, for in their correspondence Klee had written nothing of the kind. Thus, in retrospect, it is astonishing that Schlemmer, in his answer of July 9, 1919, expressed himself satisfied about Klee's letter,

> because in it you express yourself about how you conceive of your teaching activity. For one of the main aspersions against which we have to defend you here is the one that an artist who is so withdrawn from the world, so dreamy as you "supposedly" are, would hardly be a teacher who can lead the modern cause in a city such as Stuttgart with the necessary emphasis. Well, the *tender* manner may be the more striking one, and the agitation on behalf of modern art can be carried out by others of whom

there is no lack at Stuttgart, as in other places. "Playful," "feminine" are further words of doubt.[54]

Did Schlemmer mean to say that he himself was one of the agitators to whom he contrasted Klee's "tender manner"? In this spirit, he went on to describe the full-scale public campaign which he was mounting, involving student rallies, confrontations with academy professors, "the press," and lectures by the art historians Hildebrandt and Hausenstein. If in spite of all these ventures, Klee's appointment was still rejected, "we would publicly protest and eventually stage a strike." The two types of artists paired off in the initiative—the dreamer and the agitator—proved to be contradictory rather than complementary and eventually spelled failure for the initiative. For the moment, summer vacation intervened.

The Negotiations with the Flechtheim Gallery

Already as early as March 1919, Däubler had attempted to mediate on behalf of Klee for a general sales contract with an art gallery, Gurlitt in Berlin,[55] but nothing had come of his feelers. On June 3, 1919, the prominent modern art dealer Alfred Flechtheim in Düsseldorf, again on the suggestion of Däubler, among others, offered him such a contract and announced his visit to Munich for the middle of June.[56] Klee had "expressed his interest in the proposal," most probably still from Munich,[57] but was gone when Flechtheim was to arrive. So the latter wrote to him in Switzerland, on July 2, 1919, giving him the choice between two alternatives: "I have a number of contracts with artists. To the first group I guarantee a steady minimum income, and in these cases I charge a larger profit from the sales of their paintings, watercolors, and graphic works; to the other group I guarantee no amount, and then my profit share is smaller."[58] Why did Klee address himself to Flechtheim, not to Goltz, with whom he had worked for several years and who had backed him financially in the critical year 1918, when his sales were dropping (see p. 138)? In April 1919, the Düsseldorf art dealer had reopened his gallery, which he had been obliged to close when he was drafted in 1917 (see p. 87). For the occasion, Flechtheim published a sumptuous catalog, entitled *Easter 1919,* a double allusion to an anticipated postwar resurrection of both the gallery and Germany as a whole. The catalog was inscribed with a poem by Herbert Eulenberg which began with the lines: "Art and revolution! / This is an excellent match."[59] Klee's admirer, Hausenstein, as well as the art critic Hermann von Wedderkop, who was soon to write a popular book about Klee, both addressed the issue in long articles, entitled, respectively, "Art and Revolution"[60] and "Revolution in Art." Both authors asserted that the affinity of modern art and revolution could never be expressed by a political content, let alone enacted by a political mission, of the former. Hausenstein in particular insisted that modern art was revolutionary in and of itself, and for this reason must not be politically compromised:

It is not the worst artists who have renounced taking advantage of the moment of the revolution. As they staked everything on the significance of self-contained artistic achievement, it was just these artists who were more radical—as artists and probably also as human beings and as elements of society—than those others who expected salvation from the speedy foundation of artists' councils. Councils only touch the realm of the indirect. Power in the state is of indirect relevance for art. The essence of art [however] consists in the direct immediacy of achievement in each particular case, with each particular person. The primary concern is to do what is artistic, the secondary concern is to work on art politics.[61]

What both Hausenstein and von Wedderkop did expect from the political change of 1919 was a reorganization of public art institutions, a break with the restrictive state patronage of the arts which had prevailed under the imperial government, and unlimited support for modern art in general. This is no doubt what Klee had alluded to when he published his caricatures of Emperor Wilhelm II in the leftist journals *Der Weg* and *Das Tribunal* (figs. 92, 93; see p. 164). Flechtheim may have counted on Klee's sympathy for a program where modern art and revolution were related in this acceptable fashion, for in his first letter to Klee of June 3, he included a copy of the book *Easter 1919*.[62] No matter how vague, that program was the opposite of the militant hostility toward the revolution which Klee's politically conservative dealer Goltz had proclaimed in the May issue of *Der Ararat* (see p. 179). From a business standpoint, Klee's interest in Flechtheim made all the less sense, since in two letters written during his sojourn in Switzerland, he expressed satisfaction about transactions with Goltz while voicing skepticism about Flechtheim's business practices.[63] He may, nonetheless, have expected from the Flechtheim Gallery a public forum sympathetic to his own art-political views.

In the end, business reasons prevailed over ideological sympathies. Four months later Klee concluded the kind of permanent contract guaranteeing a regular monthly payment that Flechtheim had offered, not with him, but with Goltz (see p. 207). It seems, however, that he had already made some commitments to Flechtheim, for the contract with Goltz stipulated that Flechtheim was to continue to receive shipments of works from Klee directly.[64]

The Political Defense of the New Munich Secession Show

Meanwhile, *Der Weg*, the journal edited by writers and artists associated with the Action Committee of Revolutionary Artists of Munich, had moved to Berlin, where the editor, Eduard Trautner, had taken refuge since he was charged in Munich with briefly harboring the fugitive Ernst Toller in his apartment.[65] It is from this extraterritorial haven that the journal could afford to respond with unbridled outrage to the brutal suppression of the

Fig. 106. *Der Weg,* May–June, 1919, title page
with woodcut self-portrait of Felixmüller

Council Republic. The double issue for May and June began with a full-page printing of the short poem "Released Prisoners" by Ernst Toller, who was currently awaiting trial in the Munich jail. There followed a lengthy report, entitled "Terror," by the editor implicated in Toller's case, spelling out the new regime's repressive practices under martial law. The issue concluded with Felix Stiemer's article "Drawing the Line," which reiterated "every-thing amounting to a communist demand," that is, "six-hour day, council system, socialization of all . . . enterprises." In order to demonstrate that the white terror of Munich also threatened modern artists, the editors reprinted the anonymous postcard: "From a German! Woe to you, filthy Jewish swines! You Spartacists! Incompetents! Speculators! Dogs! Scoundrels! Woe to you, who are ruining the German fatherland and German art! . . . The same scoun-drels as Mühsam, Levien, etc., and consorts. Kokoschka! Heckel! Kirchner! Eberz! Unold! Seewald! Dawringhausen [sic]!"[66] As if to reassert the deter-mined resistance of the artist in the face of such threats, the journal's title page (fig. 106) showed a politically foreign figure: a full-page woodcut self-portrait from the year 1917 by the prominent Communist painter Conrad Felixmüller in the socialist-ruled city of Dresden, out of reach of the Munich authorities. The artist presented himself in half-profile, energetically turn-

ing forward, his rimless glasses stylized into dynamic extensions of his eye-sockets, his eyes squinting aggressively behind them.

The May–June issue of *Der Weg* staked out with implacable clarity the political field of conflict into which modern artists were being drawn at this moment. Ostensibly discrepant was the art-critical contribution, a laudatory review of the New Munich Secession show by Ernst Grünthal, who had already extolled Klee in the February issue (see p. 163). As if to refute the postcard "from a German," Grünthal praised one after the other of the New Munich Secession members, Unold, Seewald, Eberz, as "forces having a constructive effect in the higher sense, art at the foremost point of development." The current understanding of modern art as "merely revolutionary," as an expression of a "complete demolition of the old ways of life" was wrong, he asserted; what mattered was "the inner prophecy, the new fluctuations." Grünthal singled out one artist to represent these values at their purest: Klee, who at this moment was far away and safe in Switzerland: "Without any dispute it is *Klee* who will occupy the foremost point in the forward-driving wedge. . . . He catches cosmic things and forms a transcendent world with *compelling* necessity. Those colorfully blooming streamlets strike us as amicably familiar, as if we had already seen them once before. . . . This is the path to Being behind appearances, to the aesthetic thing-in-itself."[67] One might have expected that a critique of Klee's contribution to the New Munich Secession show appearing in the most intransigent issue of the leftist *Weg* should have dealt with *Young Proletarian,* the picture so meaningfully set apart in Klee's collection (see p. 184). Yet Grünthal did not even mention it. As in the February issue, his praise of Klee appeared at variance with the political line of the editors. While the self-portrait of the Dresden painter on the title page proclaimed the political engagement of the revolutionary artist, the exhibition review inside praised the Munich painters for their abstinence from any such ideal. The discrepancy was a telling one. After the postcard "from a German," Grünthal's review had to be read as a defensive plea against the political suppression now threatening modern artists in Munich.

The critic did not have to bend the truth, for the moderate turn of the New Munich Secession painters was a reality. The critic of the Leipzig journal *Der Cicerone,* sympathetic to modern art and writing from a distance, noted that "the development of the new Secession is increasingly adjusted to a conservative mentality, although it is here that the majority of Munich's progressive artists come together." He saw this as a recurring development among Munich artists, due to what he called "the atmosphere of this city."[68] There, the polemics were far from over. The critic for the conservative art journal *Die Kunst für Alle* confined himself to deprecating Klee, as the most visible member of the New Munich Secession's modernist wing, for what he perceived as the contrived pretense of an "elementary feeling for life."[69] It was the critic for the Social Democratic *Münchner Post* who based his attack on the memory of the unlikely connection between expressionist fantasy and

Communist culture claimed by leading artists and writers of the council republic. Recalling that under the council government Klee had been proposed as a graphics teacher at the Arts and Crafts School (see p. 174), he charged him both with "salon bolshevism" and with "acting out follies like a child."[70] He, too, ignored *Young Proletarian,* the one picture in the show that might have borne him out.

The Klee Issue of the *Münchner Blätter*

After the suppression of the Council Republic, the *Münchner Blätter* took the opposite political course from *Der Weg* and went completely antileft. Al-

Fig. 107. René Beeh, *Hermit,* from *Münchner Blätter,* September 1919

though the managing editor, Kuno, announced in the June issue as his program for the second half of the year, "We will not deny acceptance to any work because it might be too much to the left, too radical,"[71] the journal, if it ventured into politics at all, published no leftist, only outspokenly anti-bolshevist texts. Moreover, it emphasized even more the ideal of "the spirit," altogether remote from politics, which Kuno had proclaimed in his first editorial program in January (see p. 159). The September issue embodied this editorial line most clearly and was centered on the graphic art of Klee, one of its coeditors. Following the customary format, Klee was featured with three lithographs, including a hand-colored loose insert, and with an art-critical essay by Eckart von Sydow.

Fig. 108. *Portrait* (1919, 113)

The issue began with Gabriele d'Annunzio's poem *To the Mountains,* a hymnic call to the artist as harbinger of the "spirit":

> "Listen, my soul, if you don't hear
> A message from above!—Immortal mountains,
> Let come forth from your mystery
> The holy bard, wreathed with light!
>
> O unknown spirit! Descend from the purest of mountains,
> Bring down to us joy,
> From the virginal mountaintops which shine in the light of the
> stars
> From unexplored places,
> From wells that never dry up, that unconsciously sing . . .
> From the pure veins of the ice, from the holy silence
> Of unknown things . . .
> I call you down, o pure spirit."[72]

A lithograph entitled *Hermit* by another coeditor, René Beeh, illustrated the poem's conclusion (fig. 107).[73] It depicts a cowled monk kneeling in prayer before the mountains to which the poem is addressed, his face and hands raised toward heaven.

Two further poems by authors from Munich dwelt on the same theme, setting it off against the turmoil of revolution. Hans Schiebelhuth addressed a woman friend like this:

> " . . . a time that falls apart raves around you. Speeches
> Of reckless men like hand-harps touch your childlike heart.
>
> But once in the holy forests of columns
> You will also weep for God to come down and redeem the stones,
> You will be grateful, when his hand, forever invisible to you,
> Builds better constellations above the horizon."[74]

Ernst Otto Stählin, under the heading "Dream of the New Paradise," even offered a world-historical survey of the prewar era, the war, and the revolution:

> "Degeneration, plagues, the sigh of hunger,
> Error and mockery, the shattered consciousness
> Of imperfection and shame . . .
>
> Where does a light remain? Who knows when joy blossoms?
>
> Souls of prophets light up, the speech
> Of magicians roars . . .
>
> To love the earth! To divine the wonders of the stars!"[75]

These texts set the stage for Eckart von Sydow to present Klee to the readers of the *Münchner Blätter*. In his preface to Corrinth's *Potsdamer Platz*, written in January, but only now being printed, he had still applauded Klee for moving from introspection to revolutionary involvement (see p. 149). Now he precipitously retracted, praising Klee with these words: "The true psychographer, soul-writer, soul-disenchanter, god-charmer, here he is: Paul Klee!"[76] This sounded similar to what Grünthal had written in the February issue of *Der Weg* (see p. 164). However, whereas Grünthal's earlier text had been discrepant with the political line of his journal, von Sydow's was now representative. In his presentation, Klee offered instant fulfillment to the yearning for the artist as harbinger of the "spirit," expressed in the poems of d'Annunzio, Schiebelhuth, and Stählin, and illustrated in Beeh's lithograph.

Klee's own *Absorption* (fig. 108), drawn in the critical month of May 1919 (see p. 180), accompanied the text, meticulously transferred onto the lithographic stone. Although it was labelled merely *Portrait*, the reader could hardly fail to view it as a self-portrait. Since the time before the war,

Fig. 109. Egon Schiele, portrait photograph

Fig. 110. Klee's portrait photograph of 1913, offered for sale as a postcard by the Sturm gallery in 1916

Fig. 111. Max Beckmann,
lithograph portfolio *Hell*, 1919,
frontispiece with self-portrait

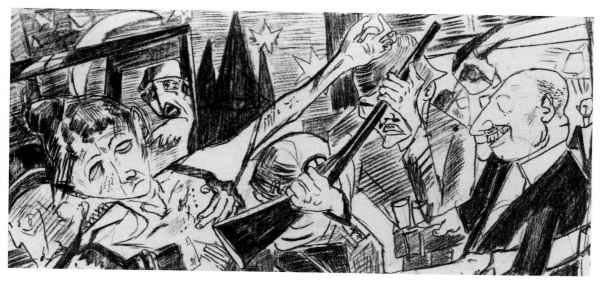

Fig. 112. Max Beckmann, lithograph portfolio *Hell*, 1919, Martyrium of Rosa Luxemburg

expressionist artists had been publishing graphic self-portraits, or even their own photographs, with programmatic intentions (fig. 109). To the connoisseur of expressionistic art, the lithograph was bound to recall Klee's own portrait photograph of 1913, offered for sale as a postcard in 1916 by the Sturm Gallery (fig. 110). Characteristic features of the lithograph looked like direct reversals of the photograph: the strikingly closed eyelids reversed the intense, dark-eyed gaze, and the strict, motionless frontality reversed the sideward movement of the slightly inclined head, as if the artist had retired from the space he no longer perceived. When it appeared in September, *Absorption* was the opposite of the frontispiece of Beckmann's lithographic portfolio *Hell,* which was also published in the fall of 1919 (fig. 111). Here, the artist charges forward from within the frame with wide open eyes and gesticulating hands, presenting himself to "the honorable public" he addresses in his preface, the sole witness of the revolutionary inferno, where killers and victims are equally blind (fig. 112). It is not known whether Klee, when he drew the original in May, already intended it as an illustration for von Sydow's characterization of him,[77] but its publication as a lithograph must have matched the text in the mind of any reader:

> He listens, quite motionlessly, to the inner voice which becomes audible within him; as if trembling, this voice whispers: "Take the most sharp-ended pencil in your hand and the tenderest brushes, do not move, but wait, wait, until your hand moves by itself."
> . . . And his eyes tell of mystical practices—how often he must have attempted to aim his glance at the other side of the moon: thus looks only a man who has won the subtlest knowledge from abnegation. . . .

. . . Does Klee consciously concentrate that way? He probably renders the inner states of his soul as a copy-faithful imitator. And also the state of [transcendental] realities? Probably; for a clairvoyant who saw the drawing "Souls of the Deceased Approach a Table Set with Food" exclaimed in astonishment: "That is exactly how I also see these beings!" Is it a general human state of fantasy? Are supernatural phenomena really perceivable to certain men?[78]

Von Sydow merely reiterated in a melodramatic fashion what Klee himself had written to his wife in February, 1918, when he explained his working process in mystical terms as a passive attentiveness to "great friends" in "a remote sphere" (see p. 180).[79] Hence Klee most likely influenced this popularization of his own ideas, just as he made texts of his available to Hausenstein, von Wedderkop, and Zahn. The artist as a clairvoyant, a medium whose passive hand is guided by spirits in a state of trance: this was the posture which the readers of the *Münchner Blätter* were called upon to associate with Klee's presumed self-portrait. Klee's long-standing claim to a mystical withdrawal from the world, in opposition to times of historical crisis such as war and revolution, had been honored as a public posture since Walden's obituary for Marc of March 1916. In *Das Kunstblatt* of 1917, Däubler had sanctioned it as "the new metaphysics" (see p. 95). Now von Sydow restated it in coarsely parapsychic terms. As coeditor of the *Münchner Blätter*, Klee must have known and approved. The antiexpressionist critic Karl Scheffler lost no time in deriding Klee's new status as an artist "worshipped by several high priests in prostration."[80]

As in two previous issues of the *Münchner Blätter* (see pp. 160, 167), Klee's coeditor Adolf Schinnerer placed a lithograph of his own in a telling context with Klee's. *The Stiltwalkers* (fig. 113) depicts two men gesticulating like political orators, who address a crowd below them. Their stiltwalking betrays their futile, artificial claim to leadership. Their faces, one raised pathetically to the sky, the other lowered to the crowd with an expression of anger, reveal them to be demagogues. The heads of the crowd are for the most part lowered, their eyes closed, inattentive to the speakers. These are the "speeches of reckless men" evoked in Schiebelhuth's poem, the revolutionary delusions against which both he and Stählin had conjured up the redeeming "spirit." Taken together, Klee's and Schinnerer's lithographs lay out this alternative.

Embedded in such a context, Klee's self-portrait appeared as the answer of the *Münchner Blätter* to that of Felixmüller on the title page of *Der Weg* (fig. 106). Klee may himself have intended it that way. No doubt the May–June issue of *Der Weg*, which contained Grünthal's critique of the New Munich Secession show highlighting Klee in particular, was already in his hands. He could not fail to notice that his drawing *Absorption* of May visually confirmed Grünthal's characterization of his art, which contradicted the stance of political defiance advocated by *Der Weg*. Historically, it was Klee's, not Felixmüller's stance that prevailed.

In presenting this stance, however, Klee displayed no reckless self-assurance. On the contrary, the caricaturistic connotation of *Absorption* (see p. 182) was reinforced by its juxtaposition with the lithograph *Number Tree Landscape* (fig. 114), which Klee copied from the drawing *Number Trees* of 1918 (fig. 75). That drawing had been a historic testimony of his double activity as a payroll clerk and as an expressionist artist at Gersthofen airfield (see p. 143), and most likely also a self-satire about how at just that time his

Fig. 113. Adolf Schinnerer, *The Stiltwalkers*, from *Münchner Blätter*, September 1919

Fig. 114. *Number Tree Landscape* (*Zahlenbaumlandschaft;* 1919, 112)

home-front art-making was paying off with the public in Berlin. The drawing was Klee's most straightforward pictorial self-reflection on the economic conditions, or at least on the immediate financial circumstances, of his work. To reproduce it next to the artist's otherworldly countenance amounted to a comedown, in tune with the grotesque self-mockery inherent in that face.

The Hand-Colored Lithograph *Absorption*

The three lithographs for the *Münchner Blätter* follow immediately after *Young Proletarian* in Klee's oeuvre catalog and may have been the first works he made after this painting, that is, upon his return from Switzerland. Klee hand-colored a copy of the lithographed *Absorption*, mounted it on cardboard (fig. 115), and retained it for himself. The color composition of the primary hues blue and yellow, with variations toward violet and orange, complements the primary color contrast red and green of *Young Proletarian*. Circumscribing all four basic color contrasts, the two pictures complement each other thematically no less than formally. The worried physiognomy of the proletarian with his wide open eyes contrasts with the transfigured countenance of the introspective artist with his closed lids, so that the two heads form antithetical pendants in a complementary unity of opposites, the ideal of Klee's synthetic notion of painting. This is how the two pictures actually hung in his atelier or his apartment sometime in the fall of 1919. He had intended both as programmatic statements for the public, but they had come back to him in a contrary way: one as an ignored reject from an otherwise successful show (see p. 188), the other as a glorification of the artist in his own journal. The process visualized the hypothetical community of fate about which Klee had written in his worried diary entry of October 1918 (see p. 135), as well as the utopian community of the artist and the people which he had pondered in his letter to Kubin of June 10, 1919, when he himself felt threatened by a fate like that of the imprisoned or executed revolutionaries.

Klee's pairing of the images of artist and proletarian corresponds to a hypothetical equation which had been embraced in 1919 by modern artists who sympathized with the revolution. Thus, Pechstein and Meidner wrote in their manifesto *To All Artists:* "Is our position in society much better and safer than the proletarian's?! Aren't we, like beggars, dependent on the whims of the art-collecting bourgeoisie!"[81] And in a series of programmatic articles about art, society, and politics, the painter Curt Uphoff drew a radical conclusion: "The fact that art has the meaning of luxury now leads the art producers into an emergency. . . . So the artist is compelled to reckon with a deprivation which places him on the same level as the poorest proletarian. . . . For me, that artist is the most honorable one whose works find the most subtle understanding and devout, loving care in the living rooms of the working people."[82] Klee hardly ever harbored such ambitions, but after the counterrevolution, even the expectation that modern art could be understood by the working class, because its underlying spiritual ideal was essen-

tially class-transcending, could no longer be maintained. No matter where his political sympathies lay, Klee's financial success with the "bourgeoisie" had removed him from the deprivation on which the analogy between artist and proletarian was founded.

Accordingly, the juxtaposition of the two images of artist and proletarian can be seen in terms of both analogy and contrast, a hypothetical anal-

Fig. 115. *Portrait* (1919, 113), hand-colored

ogy and an objective contrast. The posture of resignation it entailed had been predicted, and justified as spiritual "autocracy," as early as March 1919 by the critic of *Die Kunst für Alle* in a note of caution against the cultural politics of the Council Republic which Klee had then still shared: "The artist is no proletarian, even if he has no money; he cannot become creative through organization, which always only pertains to something external and material. The powers of his soul are not turned outward, like those of the politician or the public speaker or the demagogue; they are turned inward, referring to the nucleus of his essence, from which he creates his works by means of concentration and condensation."[83] Klee was thus following a pre-formulated literary position, but the ambivalence of the systematic color contrast between proletarian and artist suited his dialectical notion of painting. In the privacy of his home or atelier, his self-reflection by way of images counterpointed his public self-representation.

The General Sales Contract with Goltz

No doubt the political radicalization of many Munich artists in early 1919 had to do with their poverty, which was compounded by the inflationary increase in the cost of living and of working materials. Klee, on the other hand, after sluggish sales in the first two years of the war, already by 1917 had done very well (see p. 137). In 1918, to be sure, his sales had gone down somewhat, but in 1919, when the art market resumed its boom, they soared even higher. In the first six months of the year, that is, during the time of revolution and counterrevolution, he sold for 18,447 marks, and in the following three-month period, from July to September, his sales again went up, to 24,105 marks, with 13,200 marks from the month of September alone, bringing his total income for the first nine months of 1919 to 42,552 marks. These growing figures were due not to an inflationary rise in Klee's prices, but to a net increase in the number of works he sold. Klee had become to some extent independent of market fluctuations, but only at the cost of selling more of his works. The spectacular nominal rise in his income lost much, though not all, of its real value if divided by the rapidly accelerating inflation factors:

January–June	$18,447 \div 3.08 = 5,989$ gold marks	
July–September	$24,105 \div 4.93 = 4,889$ gold marks	

Nonetheless, Klee stood apart from the mass of impoverished artists who may have harbored utopian hopes that a socialist state would provide them with a living independent of the vicissitudes of an art market catering to the rich. He had no objective interest of his own in the social change of conditions for modern art for which he had argued on moral grounds in his letter to Kubin. On the other hand, the art market offered Klee no real assurance. It cannot have escaped him that the drawings and watercolors he was selling in ever greater numbers at almost stable prices were depreciating under his

hands like paper money. In order to keep up with inflation, he would have had to raise the price of a watercolor which sold for 400 marks in 1918 to 600 marks in June 1919 and to 1,000 marks in September 1919; yet what he did was keeping his prices at an average of 400 marks throughout the year.

In this deceptive affluence, Klee attempted to regularize his business activity, obviously not because he urgently needed to sell, but because the growing business activities in which he found himself entangled must have distracted him more and more from his work. The methodical accounts of all exhibitions, sales, and other transactions which he had noted on the verso pages of his oeuvre catalog during the war years suggest how much attention he was used to devoting to these activities. Already on June 29, 1919, he had corresponded with Flechtheim about a general sales contract (see p. 192). Why he did not conclude it then remains unclear, but in the end he concluded such a contract with Goltz, without concern for the reactionary politics of that dealer. On October 1, 1919, he signed the contract, of which the most important stipulations read:

> §1. Mr. Klee grants to Mr. Goltz for the duration of this contract the exclusive right of sale for his entire artistic oeuvre, insofar as this contract does not stipulate any exceptions. Accordingly, Mr. Goltz, during the time of contract, is exclusively entitled to sell all paintings, watercolors, drawings, and graphic works which Mr. Klee has completed and declared ready for sale, as well as all those works which Mr. Klee completes and declares ready for sale in the future for the duration of this contract. . . .
>
> §3. As his compensation, Mr. Goltz receives the balance of his sale prices over and beyond the net prices as determined by Mr. Klee. As net price is to be regarded the amount, without any deduction, which Mr. Klee declares as the net price to be received. For the time being Mr. Klee will keep the net prices for *paintings* at 800 marks for the individual piece, the net prices for *watercolors* at 200 to 500 marks according to the kind of work (*Art der Arbeit*) for the individual piece. The net prices for drawings Mr. Klee establishes at a level not below 150 marks apiece. . . .
>
> §6. Mr. Goltz guarantees to Mr. Klee a net minimum annual income from the sales of his works effected through him in the amount of 15,000 marks, and commits himself to pay this guaranteed sum without regard for the volume of actual sales in monthly instalments of 1,250 marks, to be paid on the 6th of each month.[84]

The contract was an exemplary capitalist appropriation of an artist's work in terms of the advantages inflation offered to business in the first three and a half years of the Weimar Republic. At the end of 1919, in the time of accelerating inflation, the dealer guaranteed the artist, for the duration of three years, a nominal income in depreciating currency that was to remain stable at no more than roughly 20 percent over the nominal income that Klee had attained already two years earlier on the free market. Since the real value of the currency had dropped by 69 percent since then,[85] Klee was settling, in

real value, for a minimum income of 50 percent of his income in 1917. Since he agreed, on the other hand, to keep his net prices at the level of 1917, at least initially, his rise in nominal income was tied to the dealer's well-founded expectation that he would be able to sell a much larger quantity of works by Klee. The balance of what these works would actually fetch on the free market, went to Goltz, who was not even tied to a percentage commission of the prices he himself charged.

Klee's actual sales through Goltz, which he initially still noted on the back pages of his oeuvre catalog, show that by this time the dealer's calculation was more than borne out, while the artist's material gains were minimal. Goltz advanced no money any longer and in fact took no risk whatever. Already in the remaining three months of 1919 after concluding the contract, Klee sold through Goltz for the gross amount of 14,113 marks, that is, almost the entire yearly sum guaranteed by the contract.[86] In the month of January 1920 alone, his net income from Goltz was 8,400 marks, over six and a half times the monthly payment stipulated.[87] Goltz's own actual sale prices are unknown, but with inflation, and with this kind of demand, it is likely that he freely raised them as time advanced, while Klee's net prices remained more or less stable. By March 1920, Goltz's Klee sales had accelerated so much the dealer was boasting of a "run on Klee" in his house journal *Der Ararat*.[88] On February 5, 1920, Klee wrote to Kubin: "Up to now Goltz works very well. I am very happy about this solution. No exhibition worries any more. Hardly any business correspondence any more! That's very comfortable."[89] Less than seven months after his doubt-ridden reflections about the position of his art between relevance for the people and "capitalist luxury," Klee had opted for the latter. And he assured his friend: "You will believe me, won't you, that this relief makes me feel obliged to step up my performance?"[90] But how "comfortable" was the "relief" Klee enjoyed through his contract with Goltz? True, the dealer was managing a sales expansion which by the end of 1919 had netted Klee a total of 63,400 marks, 6.7 times the 9,455 marks of the year before. However, if the average inflation factor of 8.03 for 1919 was taken into account, his real income amounted to 7,895 gold marks, only 1.81 times the 4,347 gold marks income of 1918. For the time being, Klee had reason to be satisfied, although he had by no means struck it rich.

Yet, what were his financial prospects for the future? After all, the rationale of his contract with Goltz was to compensate the inflationary loss incurred by relatively stable prices with a volume of sales that would have had to increase continually beyond any reasonable expectations in order to keep up with the progressive devaluation of the currency! The 8,400 marks worth of sales in January 1920, divided by the inflation factor 12.56 measured for that month, amounted to a bare 668.78 gold marks in real value. Neither Klee nor Goltz could know that at just this moment, thanks to the recovery of the German economy, inflation was levelling off. Klee, who throughout his career was being told by his dealers to keep his prices down, could be under no illusion of having reached financial stability. Not surprisingly, he tenaciously

pursued his other career objective, an appointment as an academic teacher, that is, as a state employee.

The Publication of *Creative Confession*

Sometime in the fall of 1919, Edschmid's essay collection *Creative Confession* went to press at last,[91] about a year after Klee had completed the second version of his draft of "Graphic Art" (see p. 134). By that time, Klee had revised his text once more.[92] Extending the division from five to seven numbered sections,[93] he had shortened and streamlined the argument into a brisk-paced manifesto. At the beginning, he had added the programmatic sentence "Art does not render the visible but makes visible,"[94] a statement which he had written in a less categorical form in a letter to his wife of December 10, 1918, and recorded in his diary.[95] It corresponds to a similar statement by Oskar Schlemmer[96] and is ultimately derived from Däubler's dictum: "No escape from reality, but a visualization of the transcendent," whereby the poet, in *Das Kunstblatt* of early 1917, had sanctioned modern art as "the new metaphysics" (see p. 95). And in the third section, Klee had inserted a passage that bestowed a gospellike authority on the explication of his artistic procedures: "In the beginning, there may be action, but it is in turn subordinate to the idea. And since infinity has no determinate beginning, but, like a circle, is without beginning, the idea may count for primary. In the beginning there was the word, Luther translates."[97] What had prompted Klee to change the mode of his publication from a poetical introduction to his art of the viewing public, in line with the confessional title of the volume, to the pronouncements of a teacher?[98] On September 5, 1919, Edschmid wrote Klee of his intention to visit him "soon" in Munich in order to view his works,[99] and it is possible that on this occasion Klee discussed with him the final version of his text. As long as the manuscript he actually submitted to the printer or his correspondence with Edschmid of 1919 remain unknown, the question has to be tackled from the historical context of the publication.

The individual contributions to the volume *Creative Confession* do not betray any common concerns on the part of the authors. However, Klee found his text printed along those of four other artists and writers who had affected his career in various ways. Three unpublished aphorisms by Franz Marc—"thoughts . . . born . . . on horseback and under the boom of cannons"—recalled the posture of abstract art as a spiritual alternative to the war experience[100] which Klee had once attempted to contest and rival (see p. 80). A text by Däubler—"I have only one thing to express: the idea of the northern lights"[101]—insisted on that categorical retreat from the emergency of war to the spiritual imagination which in 1917 and 1918 had certified Klee's public success (see p. 95). Most dramatically, two texts by Toller, submitted, as the author defiantly wrote, "from the prison fortress of Eichstätt," were printed right next to Klee's. The first was a letter of 1917 to Gustav Landauer, since murdered by Freikorps troops, about love and spirit as ir-

resistible forces of liberation; the second contained Toller's current defini-
tion of the "political poet" as "a human being who feels responsible for
himself and for every brother of the community of mankind." [102] None of
these three texts were of relevance any longer for Klee's public position.
Rather, it was the fourth, by a man whom Klee had never met, which could
be read as a confirmation of what he had to say.

Adolf Hölzel, the abstract painter whose resignation from the Stuttgart
Academy had prompted the efforts of Schlemmer and his fellow students to
get Klee appointed as his successor (see p. 189), advanced in *Creative Confes-
sion* a long justification of the need for a theoretical and academic clarifica-
tion of modern painting:

> Theory, which supports and clarifies knowledge, and sensibility are polar
> opposites which condition one another, which cannot exist without one
> another, which need one another, but which repel one another time and
> again.
>
> Not all painters have to be theoreticians. Yet the wisest ones had to
> clarify everything to themselves. And these then said: Art is a science.
>
> Only on the path of a complete knowledge of the artistic means (*der
> künstlerischen Mittel*) can one strive for the development toward the high-
> est artistic sensibility. . . .
>
> And nothing happens at the academies so that young people learn in
> painting what they are yearning for: the essence of painting. [103]

Klee's text on graphic art could be read as a response to such demands, par-
ticularly since its poetic literary form provided the assurance that conceptual
clarification did not entail academic dryness. Klee's lengthy explanation of
the picture surface as a landscape where people are moving in space and are
experiencing events, seemed to comply with Hölzel's postulate: "The world
of the picture surface and the beings living there are something entirely dif-
ferent from the world of human beings breathing air and in need of ample
space. Here there are errors to be straightened out." [104] Klee's own "little
journey into the land of better knowledge" started with "a stop to catch
breath," and his whole text was a conceptualization of sensibility made light
through the ironic mode in which it was cast.

Although Hölzel's stand on Klee's appointment as his successor is not on
record, he was no doubt in favor of it. His former students who wanted Klee
to come continued to gather at Hölzel's home. [105] Moreover, in 1918 Edschmid
had solicited Klee's contribution on a postcard written while he was Hölzel's
guest at the latter's country house at Rothach near the Tegernsee, [106] surely
also the occasion when he solicited one from Hölzel himself. Hence, it is
likely that Hölzel was familiar with Klee's contribution in some form and that
he wrote his own in the awareness of Klee's candidacy at the Stuttgart Acad-
emy. The quote from Schlemmer at the beginning of Klee's new text confirms
that he worked on the revision in connection with the candidacy. Hence Klee

most likely framed the statement as part of his bid to establish himself as a prospective teacher of modern art.

This new purpose of the final, published version of the essay "Graphic Art" explains two of its deviations from the versions Klee had written in November 1918. The first is the new emphasis on planned, deliberate assurance. Klee amended the beginning of his story: "Let us develop [our argument], let us make a little trip into the land of better knowledge,"to read: "Let us develop, let us *map out a topographical plan and* start a journey into the land of better knowledge."[107] The "topographical plan" for the fairy-tale landscape became the metaphor for the pedagogical clarification of Klee's wartime style. Conversely, another key poetic sentence was shortened in the same direction. In the version of November 1918, it read: "Art . . . plays an unwitting game with things. As a child imitates us in his play, we imitate in [our] play the forces which created the world and are [still] creating it."[108] In the printed version, Klee changed this sentence to read: "Art plays an unwitting game with the last things and yet attains them."[109] "Last things" recall death and resurrection, "unwitting game," ambiguously, childhood and idealist aesthetics. The reorientation of the metaphysical perspective from creation to eschatology matches the popularity of Apocalypse and resurrection in German art and literature immediately after the end of the war. That Klee should also have suppressed the explicit correlation of art and childhood suggests that the ideal of uneducated spontaneity inherent in that correlation had become untenable in his projected process of reasoned education about the principles of elementary form. Childlike "imitation" was replaced by certainty that metaphysics was in reach.

The second deviation of the published version from the draft deepened the conceptualized detachment of painting from the cosmic realm to which it was attuned by mere analogy (*gleichnisartig*) in the first version. The contorted process of correction apparent in these sentences reveals, however, that Klee intended to retain in full the cosmic claims of imagination itself. Thus, he amended: "as abstract forms, becoming quasi-objects, or remaining pure symbols, such as numbers and letters, are being joined to become symbols of the cosmos, that is, religious expression"[110] to read: "Out of abstract form elements, beyond their joining into concrete essences or abstract objects, a formal cosmos is being created which displays such a similarity with creation at large that a gentle breathing is sufficient to activate the expression of the religious."[111] The change was subtle, but decisive: abstract forms are no longer flatly declared to be symbolical, but are reduced to elements from which both images and form composition must be assembled; they cannot in and of themselves become symbols or religious expression, but can only be incorporated into an autonomous artistic creation, which is in turn capable of serving as an expression of religious sentiment.

Through inconspicuous, but laboriously contrived emendations of his text, Klee now took pains to draw the line against the premature "spiritualization" of his art which in the writing of Grünthal and von Sydow had

placed him into the dubious vicinity of theosophy (see p. 202). Although in the draft he had unequivocally rejected what he called "secret sciences" in this connection,[112] his conclusion, "Where fantasy, elated by pitifully instinctive attractions, simulates to us states of being which somehow cheer up and stimulate more than the all too well-known earthly ones," must still have sounded equivocal to him. Now he added: *"One may well still be able to speak in a reasoned way of the salutary effect which* [art] *exercises in such a way that* fantasy, elated by attractions *borrowed from instinct,* simulates states of being which somehow cheer up and stimulate more than the all too well-known earthly *or conscientiously supernatural* ones."[113] This was no less than a revocation of the earlier claims. Klee downgraded "instinctive" to "borrowed from instinct" and made it clear that artistic fantasy was to serve as an alternative not just to everyday reality, but to the "conscientiously supernatural" as well. The accusations of theosophic leanings advanced against him by the opponents of his appointment at Stuttgart (see p. 216) must have impressed upon him the necessity to draw the line this firmly.

The self-confidence inherent in this authoritative, potentially pedagogical, clarification of Klee's first summation of his art is evident in the changed metaphor of its conclusion. In the version of November 1918, it was cast as a projection of what art should be: "And to the human being [art] should be a summer resort." In the printed version of the fall of 1919, it had become the kind of call to mankind affected by artists such as those who subscribed to the programs of the Working Council for Art: "Rise, human being! Appreciate this summer resort."[114] Whereas in the first version Klee had likened the natural development of art toward the spiritual to a river with many arms— "May all art end here, the broad streams as well as the charming, aphoristically multibranched graphic art"—he now offered to mankind at large a seaside panorama as a secure medium of passage to spiritual experience: *"Let yourself be shipped into this invigorating sea, on a wide stream* as well as *on* charming *brooklets, such as* the aphoristically multibranched graphic art."[115] The amended conclusion certified the imagery of *Dream Aboard,* whose reproduction on the title page of *Der Sturm* of 1916 (see p. 68; fig. 42) had inaugurated the public acceptance of Klee's imagination.

The Failure of the Appointment to the Stuttgart Academy

After his return to Stuttgart in September, Schlemmer had carried on with his campaign on behalf of Klee's appointment to the academy.[116] He had secured fourteen of Klee's works from Walden in Berlin to be hung in a separate room of the Fall Exhibition of New Art, which was to open on October 25. Earlier that month, however, Schlemmer and his wife were detained and imprisoned for alleged Spartacist connections. He failed to show up on time for his speech at the opening of the exhibition, which was opened instead by one of his friends. "Only after half an hour did Schlemmer appear in his worn-out suit, accompanied by two police detectives, and, pale as chalk, read his

opening in the grand hall. The next day he was released."[117] The political suspicions cast on the main event in Schlemmer's campaign to get Klee appointed to the academy could hardly have been played out more theatrically. As if to confirm them, he began the speech, prepared in the police jail, with these words: "The revolutionizing of art, international and comprising all the arts in equal measure, preceded the political revolution, long before the war. Art with its sensibility and spirituality seemed to anticipate and announce the great events of world history."[118] Schlemmer merely advanced the depoliticized, avant-garde notion of an affinity between modern art and revolution that was current in 1919, but in the counterrevolutionary situation prevailing in October 1919, he was liable to be understood as an advocate of modern art's leftist aspirations. It did not matter that he refrained from pursuing the idea when he went on to speak about his candidate: "Thus it would appear that German Expressionism is approaching a bright clarity. Its demonic character is receding before a mystical simplicity. The mystics! India! Hail, Paul Klee!"[119] In his diary of 1916, Schlemmer had already characterized Klee in similar terms: "With a minimum of line he can reveal all of his wisdom. This is how a Buddha draws. Quietly, at rest within himself, not moved by any passion, the most unmonumental line, because it is searching and childlike, in order to reveal greatness. . . . The acts of all important men are rooted in a simple, but all-comprehensive experience."[120] Had it not been for the beginning of the speech, Schlemmer's emphasis on Klee's mystical introspection, with its reference to Asian religion, would have removed him as far from any association with revolutionary politics as von Sydow had intended in his Klee-inspired article printed in the *Münchner Blätter* one month earlier. However, as Schlemmer's own diaries suggest, his radical expressionist mentality was capable of reconciling leftist politics with mystical postures, and hence his public acclaim for Klee could not detract from the political issue at hand.

The article "Concerning the Appointment of Paul Klee," which appeared on the day of the opening in the *Stuttgarter Neues Tagblatt* as part of Schlemmer's concerted press campaign,[121] was argued in similar, potentially contradictory, terms. It began: "In November, when the revolution came and hence the path appeared to be cleared for renewal and reform in all intellectual areas, there was talk at the Stuttgart Academy, too, about all kinds of promises and plans for the future."[122] The writer went on to argue for art instruction reforms of the kind now being discussed or implemented all over Germany. However, when he characterized Klee's own prospective teaching program, which he had gathered from conversations with the painter on the occasion of a visit to Munich,[123] he merely wrote that it would allow for maximum freedom of the students.[124] As far as Klee the artist was concerned, he recommended him simply because "Klee has been recognized as a leading personality in the modern art movement."[125] Thus, just as in Schlemmer's speech, Klee was rhetorically tacked onto a "revolutionary" art instruction program.

The opponents of Klee's appointment were not ready to overlook the political connotations of the initiative. The press published letters by anonymous readers who charged the exhibition with being leftist, and on November 12, the *Süddeutsche Zeitung* even carried a broadside under the heading "Art and Bolshevism."[126] The most substantial attack against Klee's appointment, however, came from the critic Hermann Missenharter, in a review of the exhibition which appeared as early as October 30, 1919.[127] With great acuity, the critic spotted and polemically distorted the contradictions in Schlemmer's, and by implication, Klee's position: "Is it a voluntary or an involuntary joke if Oskar Schlemmer . . . demands that Paul *Klee* be appointed as an academy professor in Stuttgart? What does he care for the academy, which according to his innermost conviction ought to be abolished the earlier the better?"[128] This judgment was not only correct with regard to Schlemmer's notorious political position, but also, unwittingly, with regard to Klee's, as expressed in his letter to Kubin, where he had ventured that in a Council Republic "academies would not exist anymore" (see p. 178). Six weeks later, when Klee, from his temporary exile, entered into negotiations about an academy professorship for himself, he had resigned himself to accommodation to the failure of revolutionary changes in the art world, unaware that he was dealing with a group of radical artists still bent on pursuing "revolutionary" goals.

There was a second argument in Missenharter's critique which pertained to the substance of Klee's art, such as it appeared to the public in the fall of 1919. Klee, he wrote, "has passed over to theosophy, like many rootless, sick-minded contemporaries, out of regard for what is fashionable, or perhaps also out of dilettantish fantasies, and he now paints abstractly, which is still the most comfortable thing to do. He lines up sweet little color squares, into which he sometimes draws a starlet or a little heart, and does good business with it."[129] No matter how hostile the tone, Missenharter aptly characterized von Sydow's presentation of Klee in the September issue of the *Münchner Blätter.* He also hit the point of the illustrative simplification which Klee had undertaken in his work since 1917 and which in 1919 still accounted for his rising sales, as demonstrated by the exhibition of June 1919 in Munich (see p. 187). The fancy of playful freedom, childlike and mystical, which Klee's art now evoked, may have suited the tastes of the gallery public, but it was no hallmark of an academic teaching program, even in a setting of academic reform. In his rewriting of "Graphic Art" for *Creative Confession,* Klee had attempted to correct the impression of a partly idiosyncratic, partly arcane individualism inherent in his art. However, for his case at Stuttgart, the clarification came too late.

On November 9, 1919, Schlemmer sent Klee a clipping of Missenharter's article and asked him for counterstatements to be used in a rebuttal, although by that time he already conceded that "the decision of the academy will be negative." By return mail, on November 11, Klee obliged with a text, which he had copied almost verbatim from a rough draft pencilled on the

Fig. 116. Letter from Klee to Schlemmer, November 11, 1919, detail

back of Schlemmer's letter. It consisted of five numbered points. Klee did not address either of the fundamental issues Missenharter had raised, except for the connection to theosophy, which he flatly rejected with the statement: "With theosophy I have never concerned myself."[130] This was not true. In October 1917, Klee had received from his wife, and carefully read, Rudolf Steiner's book *Theosophy* of 1904 which he described as "an introductory course in theosophy," although he mistrusted much of it.[131] In February, 1918, Lily Klee even seems to have approached Steiner in person in order to ask him what he thought of Klee, but without success.[132] Thus, what Klee would have been able to say in good conscience was that he never cared much for theosophy. Still, in September 1919, von Sydow, in a conspicuous article which Klee must have sanctioned, had compared his art with spiritism and clairvoyance (see p. 202). Klee's disclaimer of his personal convictions could not make up for the public image which he had allowed to stand and for which the hostile critic was now holding him accountable.

Three other points of Klee's rebuttal were directed against Missenharter's assertions that Klee had sought the appointment, that his early etchings were derived from Beardsley, and that he was Jewish. On November 15,

Schlemmer, who apparently had been unsuccessful in placing the rebuttal in the *Württemberger Zeitung,* printed it in a pamphlet,[133] juxtaposing Klee's responses point for point with Missenharter's assertions. He also printed passages from Klee's earlier correspondence in the matter, on the latter's authorization. What Schlemmer omitted was the last of Klee's five points (fig. 116), a rather evasive answer to Missenharter's charge that he was unable to maintain himself at Munich any longer: "From a business point of view, I *am not* tied to Munich at all, almost all sales are made elsewhere in Germany. For business reasons one does not move to Munich, the art market is originally international, and now at least national," Klee wrote at first. Then he corrected the first sentence to read: "From a business point of view, I *was never* tied to Munich at all, almost all sales are made elsewhere in Germany."[134] This is how the sentence had originally read in the draft on the back of Schlemmer's letter. Why these vacillations about past and present in Klee's business at Munich? Six weeks earlier, after all, he had signed his general sales contract with the Munich art dealer Hans Goltz, ratifying a business relationship that went back to 1911 and had become crucial in 1918, when Goltz had backed Klee financially (see p. 138). True, since 1917 Klee's success with the public and with the press was centered in Berlin, in Walden's Sturm Gallery, but since 1918, his sales there had lagged, and so had Walden's payments (see p. 106). So by the fall of 1919, it was Goltz at Munich who was managing Klee's fast-booming success. Why, then, Klee's proclaimed aversion to this city, which, moreover, did not counter but confirm Missenharter's allegation that he was eager to move elsewhere? Perhaps it was because of the contradiction in Munich between political opposition to the kind of modern art which Klee was making, and its simultaneous sales success. It is easy to see why Schlemmer omitted this part of Klee's self-justification.

As to Missenharter's charge that Klee's idiosyncratic art lacked any academic teaching potential, Klee found it confirmed from a rather unexpected side. Sometime in November 1919, Wilhelm Hausenstein sent him a carbon copy of a text he intended to print the next day in his paper, the *Münchner Neueste Nachrichten:*

> A Stuttgart correspondent for the "Kunstchronik" reports that in Stuttgart a campaign is underway which aims at bringing the Munich graphic artist and painter Paul *Klee* to the . . . Stuttgart Academy. . . . In the M.N.N. Klee's art has repeatedly been mentioned with words of deep sympathy. There is thus all the more an obligation to stress that the thought of such an appointment of Klee would be thoroughly mistaken. It would be mistaken for the reason that it straightaway bypasses Klee's essential value, that is, the absolute subjectivity and irrationalism of his way of working (which not only runs counter to anything didactic, but is almost beyond any interpretation). One should leave Klee in the one and only sphere where he is conceivable: in the remoteness of his unconditional and unbridled personal fantasy, and in the recondite, magical world of his violin.[135]

This was neither the first nor the last time that Hausenstein, Klee's most profound admirer among the critics, characterized Klee as idiosyncratic, in spite of the artist's own ambition to found his art on more generalized aesthetic principles. He had irritated Klee before with such a judgment (see p. 119), but now he took a public stand against the painter's plans, all the more disappointing since Klee had given Schlemmer Hausenstein's name as an "expert" to help his case with the Stuttgart authorities (see p. 190). Aware of the potential strains, Hausenstein wrote at the bottom of the carbon copy: "Dear Mr. Klee, I would like to bring this notice tomorrow (Thursday) evening in the paper. I regard it as my duty of loyalty to inform you in advance. Please phone me still tonight: 32729.—When will I receive the notes for the book? Most cordially! Yours, Hausenstein." [136] Hausenstein's opinion about Klee as an artist and prospective academy professor is understandable, at least at this point in the latter's career. It corresponded to his conviction that art, and certainly modern art, should have nothing to do with any state authority, a conviction he had already expressed at the end of 1918, at the height of his own speculations about the relationship of art and the revolution (see p. 192). [137] But why did he feel "an obligation" to state it publicly in the Munich paper? Whatever the reason, this did not prevent him from going ahead with his own plans to write what turned out to be an enthusiastic book about Klee and to reclaim the painter's continuing collaboration for that venture. On November 25, Klee answered Hausenstein with equanimity: "In any event I am always for your writing about me whatever suits your conviction. The vita is coming along. . . . It is almost exclusively a matter of inner processes, and it is hard to do that conscientiously." [138] Once again, Klee maintained the superiority of "inner processes" over political adversity.

When Klee's appointment was officially turned down, the reasons given closely resembled Missenharter's and Hausenstein's arguments. According to the letter of November 8 in which Director Heinrich Altherr informed Schlemmer, in his capacity as chairman of the students' council, of the decision, the faculty had voted negatively because "Mr. Klee's works bear, on the whole, a playful character and in any event do not betray the strong will for structure and for pictorial construction which is being justly demanded precisely by the most recent movement." [139] No political accusations were raised.

On November 29, 1919, Schlemmer wrote a letter to the *Münchner Neueste Nachrichten* as an answer to Hausenstein's notice, [140] informing the paper of the rejection with a verbatim copy of Altherr's letter. With singular misjudgment, Schlemmer went on to write that "this reasoning . . . expresses an evaluation which . . . is in contradiction to that of your staff writer." [141] In fact neither had Altherr devalued Klee's art, nor had Hausenstein, in appreciating it, conceded its structural solidity. Indeed, no matter where each man's sympathy lay, they were in agreement in their conviction that Klee's art was too subjective to serve as a model to be taught. Schlemmer, in his letter to Hausenstein, pointed out the writer's "opinion, that the plan to appoint Klee to an art school is thoroughly mistaken. I can counter with a pas-

sage from a letter by Klee which sufficiently shows how much he is striving for a teaching opportunity." [142] And he quoted Klee's statement of his "altruistic motives" in this regard (see p. 190). Naively, Schlemmer assumed that Hausenstein had inadvertently misrepresented Klee's position. In fact, he only confirmed to the writer how discrepant Hausenstein's strongly held views on Klee were to the artist's own.

On the same day, Schlemmer broke the news to Klee. Close to resignation, he pondered taking a last stand: "Shall we make revolution? A small minority will gather, and the academy and the government will show their strength and expel us. It will be a gruelling fight and a great loss of time. In addition, the burning urge to work. What do you advise us to do?" [143] Between April and November, the meaning of the term "revolution" had shrunk, in the young painter's view, from a world-historical "spiritual liberation" sweeping art along, into a minority student protest doomed to failure.

On December 9, Klee answered Schlemmer's request for advice with a program for retreat into a prewar avant-garde position: "Remain in opposition, attempt a separation between official and inofficial art, as has always existed in Berlin, and as also exists in Munich now that general reaction has again set in. Here things have come to the point that the whole New Secession is in opposition, although on average it is not at all radical." [144] When Klee described his group, which in its journal, the *Münchner Blätter,* had stayed aloof from the revolution well into the fall, as moving into "opposition," he no doubt was referring to the New Munich Secession's boycott of the constitution, on June 4, 1919, of the new Working Committee of Fine Artists (*Arbeitsausschuss bildender Künstler*), which was to replace the defunct Council of the Fine Artists of Munich as the official artists' representation to the new government. The boycott prevented the ministry of culture from granting exclusive recognition to the new body. [145] Klee, the New Munich Secession's secretary, must have participated in the decision to boycott and thus, in recommending "opposition," had more than just personal withdrawal on his mind.

On the same day, December 9, Klee also wrote to Hausenstein, who had sent him his own letter from Schlemmer as well as the printed pamphlet. [146] To the critic, he advanced no political conclusions, in line with the strict avoidance of all potential disagreements that prevailed throughout their correspondence:

> The Stuttgart affair is completely settled for me, and I wouldn't know of what use it might still be for the public. . . . And for you it's of course even more settled since you thought the appointment would be a mistake.
>
> For me only one thing mattered: that one should not teach against [the wishes of] the students. Since, however, at Stuttgart they presently teach against [the wishes of] the students, and since those same students, quite spontaneously, had turned to me in their distress, I could not say no." [147]

At the same time, without an apparent trace of resentment, Klee announced the second instalment of the "biographical sketch" he was writing for Hausenstein's use in the projected book about him. But, perhaps not without irony, he invited Hausenstein and his wife to hear him play the violin to which the critic had publicly wished to confine him.

The Last Issue of the *Münchner Blätter*

In the fall of 1919, when antileftist political trials were conducted in Munich,[148] numerous artists felt threatened and left the city, although it remains doubtful to what extent their fears were justified. The files of the military administration, which subjected Munich to a systematic, secret political surveillance, contain next to no evidence that the military felt modern artists or their associations were posing any danger.[149] By December 3, 1919, one of its field agents filed this report entitled "The Radical Movement of Intellectuals in Munich":

> With regard to the interrelations of radical currents in art itself, that is to say not in the directly political life of the artists' community, one observes that, for example, at the Munich Art Academy . . . relatively little has remained of revolutionary aspirations. [Some group] . . . still attempts to nurture expressionism (see the people around Scharff, Unold, etc.), but the overwhelming majority of art students regards the study of futurism and expressionism merely as an end in itself, as a reference for comparison with the old trends that still set the tone. . . . The coloring of political convictions by artistic radicalism has taken place here [only] in a few cases.[150]

Still, the political radicalism of "expressionism" was taken for granted, even if discounted as insignificant. As the only suspicious artists, the report singled out "Scharff, Unold, etc.," that is, the New Munich Secession, which as a body had gone into what Klee called "opposition" to any official collaboration with the new government (see p. 219).

It is therefore no coincidence that in the October issue of the group's journal, the *Münchner Blätter*, the critic Karl Konstantin Löwenstein published a gloss with the accusatory title "The Murder of Modernism." As so many defenders of modern art were now apt to do, he insisted that "the negative, destructive aims" of modern art could not and should not be related to politics and that the sympathies of modern artists for the November Revolution had been no more than a "cave-in" (*Umfallen*), just as their patriotic enthusiasm at the beginning of the war had been. Yet he felt compelled to lament: "How does modernism end? Not through sickness, weakness, old age, and dissolution. No! Its end is murder! . . . The *new tendency* has ostracized modernism, not as an opponent who can be overcome and conquered, but as a marked man who must be removed."[151] The following

issue of the *Münchner Blätter,* which appeared in December, was to be the last. The lavish double fascicle was exclusively devoted to the French poet Arthur Rimbaud. Through selections from his works and interpretative essays, Rimbaud was presented as the prototype of the persecuted, suffering modern artist, as the "marked man" of whom Löwenstein had written. The text selections read like transparent allusions to the situation in postrevolutionary Munich: "The Whites are landing. Cannon arrives! One has to get baptized, put on clothes, work. In my heart I received the blow of grace. Oh! This I had not foreseen!"[152] For the fourth and last time, the coeditors and New Munich Secession colleagues Schinnerer and Klee cooperated in the illustration of the journal. Both selected from their stocks of earlier works images they must have found appropriate for the occasion. Schinnerer's lithograph (fig. 117) shows a reedy river bank past which the nude corpses of a man and a woman drift. The similarity of the seemingly melancholic scene in antique guise to George Grosz's lithograph *I Serve* (fig. 118), a notorious caricature of Munich's white terror, had to be evident to anyone. Klee for his part reproduced in his lithograph one of his drawings of 1914, entitled *The Dreadful Dream* (fig. 119). A reclining woman with her eyes closed, apparently asleep, is haunted by a small, apelike monster, whose tongue, pointed like an arrow, aims between her spread-out legs. Here Klee took up once again a sexual configuration which had been on his mind for many years. Less than a year earlier, he had used it affirmatively in his drawings for Corrinth's *Potsdamer Platz* (fig. 79), in order to illustrate the enthusiastic identification between eroticism and revolution proclaimed in that text (see p. 153). Now the same configuration, with the evil male animal restored, stood next to this text of Rimbaud's: "Cheers! I called, and I saw on the sky a sea of flames and smoke; and to the left and right all riches in flames, like billions of thunderstrokes. But the revelry and the camaraderie of women was not permitted to me. I saw myself faced with an exasperated crowd, with the gang of hangmen. . . . 'Priests, professors, prefects, you are in error if you hand me over to justice. I have never belonged to this people here.'"[153] In September, Klee's portrait of himself with eyes closed had proclaimed a turn to the spirit as the alternative to revolution. Now the closed eyes of the female figure depicted revolution itself as a sexual nightmare. Just before his lithograph, these lines of Rimbaud are printed: "I no longer love gloomy broodings. Rage, debauchery, folly, of which I know all the fevers and defeats—all my burdens have been thrown off. Let us calmly state the extent of my innocence."[154]

On January 1, 1920, on the occasion of the new year, Klee wrote to Kubin a sarcastic, gloomy survey of his situation which seems to match this mood. "The low temperature of [his] workroom in the Toller chateau" kept the political winter on his mind.[155] With mordant skepticism, Klee wrote of the reports of a young artist visiting from the Soviet Union who had confirmed the stories about state sponsorship of modern art there, but who was nonetheless headed for "nonbolshevist countries," since the future of the So-

Fig. 117. Adolf Schinnerer, untitled lithograph, from *Münchner Blätter*, December 1919

Fig. 118. George Grosz, *I Serve* (*Ich dien*), 1919

Fig. 119. *The Dreadful Dream* (*Der schreckliche Traum;* 1919, 212)

viet state itself remained uncertain. Klee concurred: "They know quite well over there in what situation the Soviet Republic finds itself despite its 'victory.' We here in Germany possibly know even better what victories can mean at times. After all, of those we have had plenty." [156] The luxury edition of Corrinth's *Potsdamer Platz* with Klee's illustrations was yet to appear. Faced with the prospect of having von Sydow's characterization of himself as the embodiment of the revolutionary expressionist (see p. 149) come out in print long after von Sydow himself had changed the characterization to that of transcendental sage, Klee made light of the earlier venture: "Perhaps a certain sovereignty has saved me from platitudes." [157] In the course of a fast-moving political year, publishing delays were creating havoc with the timely adjustments of Klee's posture. Klee reacted by declaring his earlier expressionistic self-mockery as sovereign detachment. In the words of Rimbaud, he was stating his innocence.

CHAPTER EIGHT
1920

The Inflationary Upsurge of the German Art Market

By March 1920, the German economy was reaching its strongest period before its turn to hyperinflation in June 1922.[1] Thanks to the governments' policies of monetary expansion, "Germany in the years 1920/21 was offering a contrast picture to the economic development in the other important industrial countries." Compared to the severe recession in Great Britain and the United States, the German economy was thriving, to the point where stabilization of the currency was widely expected to be imminent.[2]

Now the art market returned to boom conditions. It was fuelled by the inflation which, along with a continuing scarcity of consumer goods, directed purchasers toward artworks as an investment for their rapidly depreciating money. Doubtlessly in pursuit of a policy which favored the inflationary domestic boom wherever it occurred, the Reichstag, on July 30, 1920, abolished the luxury tax of 15 percent on sales of original artworks, which had been passed by the National Assembly on December 24, 1919.[3] *Kunst und Künstler* commented with resigned sarcasm about the established dominance of modern art on this burgeoning market:

> On the art market there prevails feverish movement. One buys almost without looking, and merchandise is lacking everywhere. Whither with the paper money? . . . Now one recalls that pictures, works of graphic art, books, and antiques are valuables. Of fluctuating market value, to be sure, but for the time being of increasing art value. . . . In exhibitions every third picture boasts the label "sold." And since there is no reactionary art any more, since everybody paints and draws in the modern manner, the expressionist, still derided yesterday, becomes a public-minded artist and capitalist overnight.[4]

Foreign buyers dominated the market for older art with their hard currency. Despite protests, the government did not discourage art exports, since they brought in needed foreign exchange. Thus domestic demand was being directed toward modern German art. At the Leipzig Spring Fair, the corre-

spondent of *Der Kunsthandel* reported "extremely brilliant business" in reproductions of modern paintings and even took exception to the sales popularity of "Dadaist" postcards.[5] And at the Frankfurt Spring Fair, which was devoted to foreign trade, modern painting was "represented by first-class firms, even of international reputation."[6] When in 1920 an official of the Bavarian Ministry for Social Welfare reported on the general trend toward what he called the "proletarianization of the intellectual worker," he exempted modern artists:[7] "Art dealerships are springing up like mushrooms, the 'new' art lovers are more numerous than the old ones. Understandably: they prefer to hang on their walls, in the form of artworks, their life insurance, their stocks, their war and revolution profits."[8] In the first quarter of the year, Klee, made secure by his contract with Goltz, was riding the crest of this boom (see p. 209). Aware of its uncertain inflationary nature, however, he did not launch himself with confidence on the free market as an independent artist, no matter how promising the situation seemed to be. Instead, he kept himself available for an academic appointment and finally achieved one in October 1920. With his move to the Bauhaus in Weimar, the first phase of his career came to a successful conclusion.

The First Monographs on Klee

Shortly after Klee signed the contract with Goltz, he began to cooperate in the preparation of two books about him which turned out to be competitive, politically discrepant ventures. They were written by the art critics Wilhelm Hausenstein and Leopold Zahn.

Hausenstein

In a letter of October 21, 1919, Hausenstein, who had written favorably about Klee since 1914, informed the artist of his "hopes that my projected Klee book will come about with [the publisher] Wolff."[9] This book had been planned at least since May 1918, and from the start the critic could rely on the artist's cooperation (see p. 129). By providing his own selection of works to be reproduced, as well as a lengthy autobiographical text, Klee seemed to have been given a say in the critical presentation of his work, almost as in an exhibition. Between May 1918 and October 1919, the intermittent correspondence between Hausenstein and Klee no longer mentions the book project. Hausenstein had, in fact, not started writing,[10] perhaps because Wolff had not yet definitively committed himself to publishing the book. When Hausenstein resumed work on the book, the revolution had changed the cultural position of both artist and critic so thoroughly that their notions about modern art became discrepant to the point of controversy.

Klee's transitory commitment to, disappointment with, and disengagement from the revolution entailed no resignation. On the contrary, he was able to adapt to the course of events with a feeling of uninterrupted, rising

success. Throughout Germany, the new parliamentary democracy that had been installed with military force against workers' rebellions and left-wing local governments promised to realize some of the aspirations of modern art originally proclaimed under the catchphrase "art and revolution." Klee's efforts in the summer of 1919 to obtain a general sales representation as well as an academy professorship testify to his implicit confidence in a convergence of democratic politics, capitalist enterprise, and modernist culture. His contract with Goltz of October 1, 1919, and eventually his appointment to the Bauhaus on November 25, 1920, bore him out.

For Hausenstein, on the contrary, the revolution brought a painful reversal of his convictions, both artistic and political.[11] Initially, he had welcomed it as an opportunity to do away with the restrictive art policies of the Wilhelminian era and to create the political conditions for a free development of modern art.[12] However, he had been opposed to placing art or artists into the service of politics and for that reason had argued against artists' councils (see p. 193). His response to Ernst Toller's proposal to appoint him as chairman of an "art commissariat" in the second council government of Bavaria (see p. 173) remains unknown. In the end, both the failure of the revolution and the collaboration of the Social Democrats with the right-wing forces of order in Munich disappointed Hausenstein so much that he left the party. Within a year, he shed both his leftist political convictions and his enthusiasm for modern art and, accordingly, abandoned any expectations of a convergence between modern art and progressive politics. This change of heart occurred between the fall of 1919 and the spring of 1920. In April 1920, Hausenstein delivered a sensational public lecture in Munich, where he repudiated expressionism.[13] Despite this recantation, in July he had to resign his post as art critic for the *Münchner Neueste Nachrichten* under conservative pressure.[14] In the same year Hausenstein published a brochure entitled *Art at this Moment,* an embittered reckoning with his earlier beliefs.[15] It was based on a pessimistic evaluation of the present times. Hausenstein denounced expressionism for its lack of collective spirit and diagnosed socialism as bankrupt through the revolution. As a remedy, he recommended a return to "nature and God."[16] It was during this critical year of self-reversal that Hausenstein finally wrote his book on Klee.[17]

In a letter dated merely "Nov. 1919," the art critic could confirm:

Dear Mr. Klee,

Today I have concluded an agreement with Kurt Wolff about the Klee book. . . . I conceive of the book like this: You will be placed in the center, and around this center the problem of an art relevant to the present time (*Zeitkunst*) (and of the present time [itself]) will be developed. Perhaps the book will become a half-novel.—Once you gave me a good deal of factual data. But may I perhaps ask you soon to write down as *extensive* a vita as *possible* and also something in the way of a commentary on your development and on individual points of your art?[18]

In spite of Hausenstein's subsequent press note opposing his appointment to the Stuttgart Academy, Klee immediately set himself to the task of writing the "extensive vita." On December 2, 1919, he mailed the first part, which he considered to be "in any event the most difficult piece."[19] In the letter of December 9 where he meekly bore with Hausenstein's opposition to the Stuttgart appointment,[20] he announced: "Soon you will receive the final part of the *vita*." And on December 15 he finally sent him "the conclusion of the biographical sketch."[21] Klee had drafted his autobiographical text in the so-called supplementary manuscript, his collection of texts for eventual publication,[22] from excerpts of his diaries, which he had adapted and changed for the occasion. When he transcribed the draft, he changed it once again in many places.[23] The complete text comprises eight pages in folio.[24]

Klee complied with his announcement of November 25, 1919, that his autobiographical text would deal almost entirely with "inner processes" (see p. 218). About the years up to 1911, the time of his self-development as an artist, he wrote at great length. For the years 1911–13, covering the start of his public career, the text becomes progressively scarcer, although in his diaries Klee had continued to comment on it extensively during this period. Finally, for the years 1914–19, when Klee was formulating one artistic position after another, both in his diaries and in texts destined for publication, the autobiographical digest contains no more than a few, anecdotal lines. Klee also seems to have promised Hausenstein "a number of short analyses of pictures,"[25] but such texts have not been found. Furthermore, Hausenstein knew Klee's own first published statement about the principles of his art, written and rewritten since September 1918 at the request of Kasimir Edschmid for the collective volume *Creative Confession*, which appeared in the spring of 1920.[26]

However, if Klee had hoped, despite his "opposition" to Hausenstein's earlier writings about him (see p. 129), that his long autobiographical survey would at last induce the author to present him according to his own self-understanding, he was to be disappointed. Even before Hausenstein received the text, he had already written two long drafts of his own where the scheme of the book and its main propositions were all but finalized.[27] In the first of these drafts, he projected the new, pessimistic perspective on contemporary history from which he viewed modern art after his experience of war and revolution. It begins with the sentence: "Start with [Spengler,] *The Decline of the West*: no objects, no human beings." On the basis of Spengler's views, Hausenstein placed Klee's art in a direct correspondence to the historical situation, instead of hailing it as a "spiritual" alternative, as other authors had been doing: "Contents: the way of a European of 1914 and 1919, of a European from the most dreadful of wars; his way to experience the world. Contents enough."[28] In contradiction to the self-reflective detachment from the war which Klee had sketched out in his diary of early 1915 and was just now casting into final literary form, Hausenstein made Klee the abstract artist appear as the most historical of painters. In the process, he carried his

negative, subjectivist Klee interpretation, which he had been advancing since 1914 (see p. 47), to an extreme. Earlier, this interpretation had enabled him to set Klee and his art apart from social concerns and historic responsibilities. Now, on the contrary, Klee's art served him as the supreme testimony for the devastating judgment he had formed about society and politics after the experience of war and revolution. Such a presentation was the opposite of the otherworldly reputation on which Klee since 1917 had staked his public success, and which he had made von Sydow reaffirm in print as late as September 1919 (see p. 202). Hausenstein concluded:

> But now, among the anonymous horrors of the most dreadful of all wars, where the machine was not even the tool of men, but the power of men was there to serve the machine's absolutism—there it became impossible to view events, situations, objects, and persons in any other way than with the despair of nihilistic instincts. . . .
>
> In everything pertaining to history, event, man and object, or conviction, here was nothing that could be valid under these circumstances. The world was: nothing—nothing, once again and worse. Nothing with absurd scaffoldings of organization and machines. Manifold nothing. . . . Humanity retreated.[29]
>
> The painter-draughtsman who is to be consistent must draw and paint ruins. He is at best allowed to partake of the romanticism of the ruin-painter. . . . Irony of the spirit is also permitted to him who indulges in no more illusions.[30]

Hausenstein, for all his admiration of Klee, had always insisted on describing the latter as an idiosyncratic individualist. For just this reason, Klee felt uneasy with Hausenstein's praise, since it failed to acknowledge his claims for an art of general aesthetic or even metaphysical validity. Now this discrepancy touched upon his public reputation. Not only did Hausenstein omit the reassuring values of childlike spontaneity and cosmic harmony championed by the Sturm Gallery in 1918 and advanced by Klee himself as trademarks of his art in his text for *Creative Confession,* he also confronted Klee's art with a stark reality which made these values look like delusions.

True, the thesis implied in the title *Kairuan* was that the artist, when he travelled to Tunisia in April 1914, had searched and found a spiritual alternative to the depraved object-world of European civilization. Taking his cue from what Klee had written in his autobiographical digest about the possible oriental ancestry of his mother,[31] Hausenstein interpreted this trip as a profoundly meaningful return of the artist to his natural origins. From here he struck far-reaching connections with Oriental culture, including Indian Buddhism and Chinese Confucianism. Yet in the final analysis, Hausenstein insisted that Klee's historic sensibility as a European had kept him from reaching the goal of the path to the East. To him, Klee's hypothetical mixed origins symbolized an unresolved discrepancy between Europe and the Orient.

With great acuity, Hausenstein pinpointed the political conditions of Klee's subjectivist abstraction in the middle of German wartime culture: "Someone who has been militarized, someone on whom objectivity has been imposed, objectivity in that unbearable increase which was called organization and Ludendorff, or organization and Clemenceau and Foch, someone who was blackmailed into uniformed submission to a travesty of collectivism: that he should now snap back completely into the polar remoteness of subjectivity, is the most primitive of dialectical events."[32] Hausenstein's negative interpretation of the term "nonobjective"("*gegenstandslos*"), which drew on its alternative meaning in the German language as "pointless" or "invalid," was a stunning reversal of the originally optimistic understanding he had shared with Kandinsky before the war (see p. 47). At that time, abstract subjectivity had been tantamount to triumphant artistic freedom, not to resignation in retreat from a corrupt world. However, if Hausenstein now ignored those earlier ambitions, he grasped all the more accurately the changed significance whereby abstract art had found cultural acceptance in the last two war years. Klee in particular owed his success to the new connection between abstract transcendence and historical resignation. He had acknowledged this much in the conclusion of his text for *Creative Confession*, where he compared his art to a summer resort (see p. 136). In Hausenstein's book, such a claim was declared to be no more than a desperate response to historic emergency.

In the chapters of his book devoted to a chronological account of Klee's artistic development, Hausenstein did draw on Klee's autobiographical digest, often to the point of paraphrasing it sentence to sentence. However, he thereby did not transmit Klee's intentions, for he consistently ignored or altered all of Klee's statements focussed on progress, balance, construction, or synthesis,[33] so as to maintain his own view of Klee as a radically destructive postwar artist. The abundance of negative terms, such as "absurd," "anarchy," "illegitimacy," "irrational," "nihilism," "the nothing," "radical," "revolt," and "sabotage,"[34] was bound to recall to the reader the politicized, radical artists of the Munich revolution. In defiance of the city's counter-revolutionary catholicism, Hausenstein called Klee a "heretic" time and again. His poetic description of Klee's supposedly oriental appearance reads like this: "This man is not from here. The pallor of the long head is [really] the brown of an Arab, faded away in nordic basements. Does not this white man share with those dark ones the pointed beard below the chin, the blackness of hair growing into the forehead, the depth of the dark irises shining with oriental splendor, the bluish iridescence of the white skin . . ?"[35] Such a physiognomic characterization conjured up the antisemitic caricatures and published mugshots of the Munich revolutionary leaders Landauer, Toller, Axelrod, and Leviné (fig. 120).[36] Earlier, in 1919, crude attacks such as the postcard "from a German" published in *Der Weg* had compared those despised political figures to modern artists (see p. 194). In his first draft, Hausenstein had written unmistakably: "Does [Klee] belong to the totality of

Charakterköpfe aus der Räterepublik

Dr. Arnold Wadler
deportiert in Belgien Arbeiter,
ist während der Räterepublik
Wohnungskommissar

Eugen Leviné
der Diktator:
„Wir haben unsere Gewehre nicht
zum Spatzenschießen"

Tobias Axelrod
russischer Diplomat
und Vater der finanziellen
Maß- und Wegnahmen

Edelanarchist Erich Mühsam
Volksbeauftragter und Dichter

Max Levien
die Seele der Räterepublik

Ernst Toller
„Dichter und Held"

Gustav Landauer
Volksbeauftragter für „Volksaufklärung"

Niekisch
ehem. Lehrer und Vorsitzender
des Zentralrates

Dr. Neurath
Sozialisierungskommissar,
dessen Experimente den letzten Anstoß
zur Ausrufung der Räterepublik bildeten

Gandorfer
radikaler Bauernführer und
„Schweizerreisender"

Fig. 120. "Character Heads from the Council Republic"

231

the East, where something new grows from a revolution? Others attempt it here, in their own place. Who decides who is right?"[37] In the printed text, he prudently omitted this leading question, but his all-pervading associations of Klee's abstract art with anarchistic attitudes were left to stand.

The scathing cultural critique into which Hausenstein cast his book on Klee was at odds with Klee's own attempts to establish himself in the incipient democratic culture of the postrevolutionary Weimar Republic, which were culminating in his attempts to become a teacher of modern art. "Today, man and object continue to exist merely in their own ruins. A consistent painter must be a draughtsman today. . . . The painter-draughtsman who is to be consistent must draw and paint ruins."[38] A statement such as this was in contradiction to what Kairouan had meant for Klee himself: the achievement of a purely coloristic "pictorial architecture," as he called it in the transcription of his diaries just now.[39] In the years 1919 and 1920, when Hausenstein was working on his text, Klee embarked on "building" the medium of oil painting.[40] Since he was now finding more and more buyers for his works, he could count on selling such oil paintings, which were fetching more than double the price of his usual watercolors. Many of them were consolidated architectural compositions, the "synthesis of city architecture and pictorial architecture" which Klee had conceived on the Tunisian trip.

"He had never been a man of the profession: for it had been his nature to divine that doing nothing was man's noblest wisdom. What he did happened as if it were nothing, and what he formed represented nothing,"[41] wrote Hausenstein, in unwitting contradiction to an entry in Klee's diary from the year 1909, which the latter, in his transcript of 1921, copied or rephrased to read: "If with my things there arises at times a primitive impression, this [seeming] primitiveness is explained by my disciplined reduction to a few [formal] steps. It is merely economy, and thus the ultimate professional experience. Therefore, the opposite of real primitiveness."[42] In the spring and early summer of 1920, such a contradiction was touching Klee's career objectives. Hausenstein's sentences read like literary elaborations of his published newspaper note against Klee's appointment to the Stuttgart Academy (see p. 217). All the while, Klee's negotiations with the Bauhaus were underway. Six months later, when he was appointed Bauhaus master, he was immediately ready to paint "severe" pictures for the purpose of instruction (see p. 250). Within another six months, he started the meticulous longhand transcription of his systematic *Pictorial Form Instruction,* on which he henceforth based his teaching (see p. 251). Contrary to what Hausenstein had written, Klee was "a man of the profession."

Zahn

In 1920 Klee's dealer, Hans Goltz, was aggressively pushing modern art on the booming market, resolutely disavowing any of the compromised political implications of expressionism that had emerged the year before. In January

1920, he reissued his house journal, *Der Ararat*, under a new designation: "The Ararat, which heretofore appeared as a political broadsheet, will from now on stand up for the New Art."[43] For Goltz, the depoliticization of his journal meant no longer using it for propagating his own conservative convictions. Recognizing the market possibilities of modern art with heretofore conventional, low-budget audiences, he was the first and only modern art dealer to advertise in *Der Kunsthandel*, a conventional trade journal for the high-quality reproductions business.[44]

In his contract with Klee of October 1, 1919, Goltz had committed himself "to hold a collective exhibition of the works of Mr. Klee in the spring of 1920, and to further to the best of his ability the success of this exhibition through appropriate propaganda, and particularly to issue a catalog in the form of a brochure with at least 20 reproductions."[45] For this catalog, which appeared as a special issue of *Der Ararat* for the opening of the Klee exhibition in May 1920, the artist furnished an autobiographical text, which was, however, different from, and much shorter than, the one he had written for Hausenstein.[46] It concluded with a self-congratulatory statement: "The great success fell into his lap like a ripe fruit. He enjoys it in the silence of his industrious withdrawal. Dreaming, creating, playing the violin."[47] Sometime in 1920, Klee drew a straightforward illustration of this statement, which he turned into a watercolor the following year, *The Man under the Pear Tree* (fig. 121). Just as in his number-tree landscape of 1918 and 1919 (see pp. 143, 203, figs. 75, 114), Klee's key metaphor of the growing, fruit-bearing tree as a symbol of his creative work was here adapted to the market situation. In a literal rendering of the autobiographical text, the artist appears comfortably seated on the ground, without as much as reaching up to the branch lowered by the heavy fruit which is about to drop from it into his open hands.[48]

Moreover, *Der Ararat*'s editor, Leopold Zahn, wrote a full-scale monograph entitled *Paul Klee: Life, Work, Spirit*, which appeared one month later in Berlin. The title of the book included the term "spirit," the code word for art-critical detachment from revolution already advanced in Kuno's editorial program for the *Münchner Blätter* of January 1919 (see p. 157). Zahn based his survey of Klee's career on the same autobiographical text he had printed verbatim in the exhibition catalog. In addition, Klee provided him with extensive excerpts from his diaries covering the years 1902–5, which Zahn printed in an appendix. Finally, both book and catalog carried as a motto a calligraphically handwritten text by the artist (fig. 1): "On this side I am not at all comprehensible. For I reside just as well with the dead as with the unborn. Somewhat closer than usual to the heart of creation. And still by far not close enough."[49] The facsimile was labelled "from the diaries." However, the transcript of the diaries does not contain the handwritten text, and thus the designation means at best that Klee had elaborated the statement from thoughts he had first formulated there.[50] The diary source given for the motto made Klee's otherworldly public posture appear to be the result of introspective, solitary meditation. Like Hausenstein, Zahn utilized Klee's text

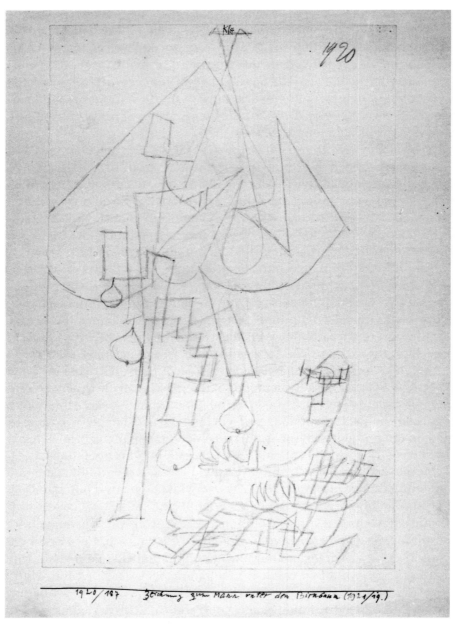

Fig. 121. *Drawing for the Man under the Pear Tree*
(*Zeichnung zum Mann unter dem Birnbaum; 1920, 187*)

234

published in *Creative Confession,* but, unlike Hausenstein, he faithfully conveyed Klee's ideas: "Klee the spiritual man, the cognitive man, ponders the infinite actuality of the supernatural, which becomes finite in the terrestrial; as he contemplates visible reality, he experiences the dynamics, the energy, the rhythmics, the harmony, and the melody as emanations of a cosmic potency."[51] "Klee the spiritual man" was the opposite of Hausenstein's "ruin-painter," a philosophical magnification, as it were, of von Sydow's mystic clairvoyant (see p. 202). Klee's own sentence "On this side I am not at all comprehensible" sidestepped Hausenstein's characterization of him as a historic figure. Zahn, on the contrary, introduced his book with a quotation "from the speeches and parables of Tschuang-Tse," which equated Klee's artistic conception to the Chinese Tao:[52] "Nan Po-Tse-Kuei said to Nü Yü: 'You are old and yet your face is like that of a child. How is that possible?' Nü Yü replied: 'I have learned Tao.'"[53] Thus Hausenstein's "European of 1914 and 1919" was transformed into Zahn's timeless sage of the Far East.

Zahn's quotation from the Chinese tale was especially apt since it served to solve a problem which had troubled the image of Klee's singular child-likeness, that is, the problem of a verifiable artistic quality indispensable for any public acceptance of his work. Throughout the following years, critics who were not ready to respond to the aesthetic claims of Klee's abstraction continued to raise the charge of childishness against him. Däubler in 1918 had already defended Klee against this charge (see p. 116), and now Zahn, elaborating on a passage from *Creative Confession,* advanced an even more profound formula of synthesis: "Is it just the playful fantasy of unknowing childlikeness that has filled the leaves of the cosmic picture book . . . ? Or is it manly wisdom, overcoming the reality of appearances, which has given form to the cognition of last things? Childlike fantasy and profound wisdom are here not opposites, but complements."[54]

Klee's Choice

When Zahn's book appeared in June 1920, Hausenstein had barely finished writing his own. Apparently Klee informed him about the parallel venture only at the last moment, at the end of May.[55] Hausenstein sent him a long, angry reply: "I openly confess to you: it is a surprise which pains me in the highest degree, that you have given your consent to a publication which was meant to compete with mine. The group Westheim-Kiepenheuer-Goltz methodically sabotages me, and it is a matter of course that Mr. Zahn, who recently in *Der Ararat* fired off a polemic against me, falsifying the truth and extremely rude in tone, will act in the sense of this trust."[56] Hausenstein was referring to Zahn's note "Apostata" in the April issue of *Der Ararat,* where the author had ridiculed Hausenstein's deeply felt public lecture disavowing expressionism (see p. 227 and note 13). And he concluded: "Mr. Westheim and his people do not want me to be the first to write on Klee. This glory must be reserved for the combine Kiepenheuer-Goltz-Westheim, etc. Of

course it matters nothing to the business engineers of the new art that I stood up for you at a time when Mr. Zahn was still wrapped in his diapers, and when standing up for you still required special courage."[57] It is unknown whether Goltz indeed wished to forestall Hausenstein's ambitious book with Zahn's speedy publication. Zahn, in his uncritical but straightforward text, indeed underscored just those principles of Klee's art which Goltz had been able to observe as succeeding with the public in the past three years. If, on the other hand, the dealer was familiar with Hausenstein's ambivalent pronunciations on Klee since 1914, he could hardly expect whatever he might write now to be advantageous for Klee's business interests. The words with which Hausenstein, in his letter to Klee, characterizes Goltz's business connections—"trust," "combine," "business engineers of the new art"—reveal that he was conscious of a market competition at issue here. "Under any circumstances it was of course clear that a second book on Klee could not only be factually superfluous, but perhaps even detrimental to you and in any event not without concern to me."[58] Did Hausenstein really believe that his characterization of Klee as a nihilistic draughtsman of ruins could help the painter's chances of success in the Weimar culture of reconstruction better than Zahn's faithful retelling of Klee's constructive ideal of a reconciliation between opposites? He sidestepped the question with the assurance: "You can, dear Mr. Klee, act quite without worry. It is not you who needs Mr. Goltz, Mr. Kiepenheuer and [the] others, but it is the others who need you."[59] Klee, who had for four years lived through the uncertainties of making a career in the modern German art world, must have remained skeptical toward Hausenstein's prophecy of his economic independence.

On June 2, 1920, Klee answered Hausenstein with a short, delaying note in which he merely attempted to reassure the author that his book would "have no match as a piece of writing."[60] Meanwhile, he prepared a long letter of justification which he took so seriously that he drafted it into the "supplementary manuscript." On June 6, he mailed the amended fair copy. Here Klee defended himself at great length against the charge of "an intrigue" and declared his neutrality of opinion vis-à-vis the various publications being written about him. Finally, he acknowledged: "The fact that Goltz on the whole disliked you as a critic appeared self-evident and harmless to me. I for my part was seeking and am seeking a neutral attitude in this commotion. I paint, he markets and advertises."[61] Klee may have intended to assuage Hausenstein by calling Zahn's book, and another one just being written by von Wedderkop, "advertising," but the distinction implied that he could not see Hausenstein's work as supportive of his career. In spite of his professed detachment from those other book projects, his cooperation in their making gave them the appearance of having been authorized. They were, in fact, the first proclamations of the public posture which dealers and critics elaborated for Klee under his own supervision.

As for Hausenstein, Klee left him in no doubt that he did not expect to find himself adequately represented in his book: "May I again emphasize

that I expect from your book something fundamentally different, that is to say, a work with artistic qualities of its own, or quite simply a work of fiction. (You yourself called it after all a kind of novel) [see p. 227]. I will only embody an historical aspect for this work. You will emerge quite strongly as the author in the first place, and that is my conviction that [in this venture] I rather than you will be the one who serves."[62] Klee seems to have suspected that Hausenstein would use the extensive autobiography he had sent him—it was several times as long as that for Zahn—merely in order to make him appear as "an historical aspect" of Hausenstein's own argumentation. At this time, of course, he did not yet know the text, but had formed his assessment of what Hausenstein was going to write about him merely "by conclusions from your last works," as he wrote in the draft of the letter. Since November 1919, when Hausenstein had sent him the published note of protest against his coveted appointment to the Stuttgart Academy (see p. 218), the growing discrepancy of their views must have become clear to him. For Klee to insist on the discrepancy meant to make it clear that he had reached equal standing with Hausenstein. Hence, in one of his dialectical reversals, Klee ventured to speculate that he as the subject of the book might "serve" its success, rather than the book "serving" the success of his art. This was Klee's final emancipation from the art critic on whom he had counted for support since 1914.

When Hausenstein, around Christmastime 1920, sent Klee an advance copy of *Kairuan,* Klee limited himself to a curt note of thanks and to an offer of a watercolor as a gift of exchange.[63] In early April 1921, Hausenstein seems to have asked him finally to write what he thought of the book, but Klee only replied with an evasive postcard.[64] It was the last time he ever wrote to Hausenstein.

Airplane Crash and *Angelus Novus*

During the years 1919 and 1920, at the pinnacle of his public success, Klee returned several times to the antithetical depiction of flights and crashes which he had derived from his experiences at the military airfields and made into images of his artistic self-reflection. No less than three such pictures were reproduced full-page in Zahn's monograph.[65] Another, the great drawing *Airplane Crash (Fliegersturz;* 1920, 209; fig. 122)[66] is the first straightforward representation of the subject in his oeuvre, almost four years after his first note of an airplane crash at the Schleissheim airfield (see p. 82). The drawing, which Klee transposed into a watercolor by way of an oil tracing, is composed of numerous small, more or less distorted rectangles linked by diagonals and crosses where they overlap. In the center they are arranged in a clearly recognizable configuration which suggests a vertically crashing German fighter aircraft with its steel-tube frame, rectangular canvas surfaces, and diagonal wire reinforcements (fig. 56). The tenuous balance of movements which, according to Klee's evolving theory of painting,[67] constitutes any pictorial composition has here been extended into a counterplay be-

Fig. 122. *Airplane Crash* (*Fliegersturz;* 1920, 209)

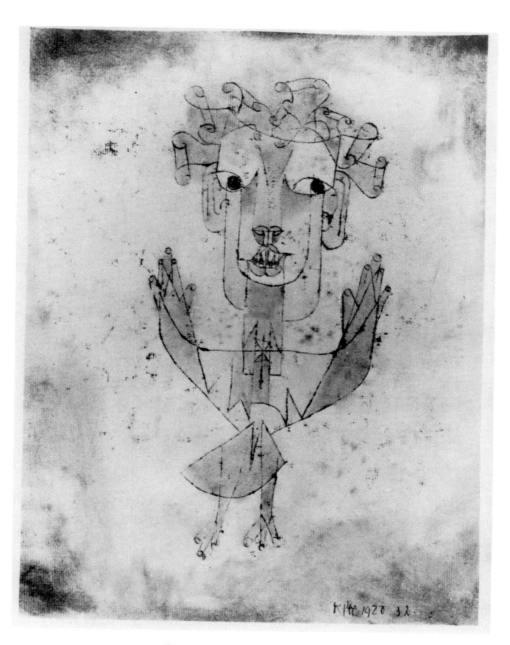

Fig. 123. *Angelus Novus* (1920, 32)

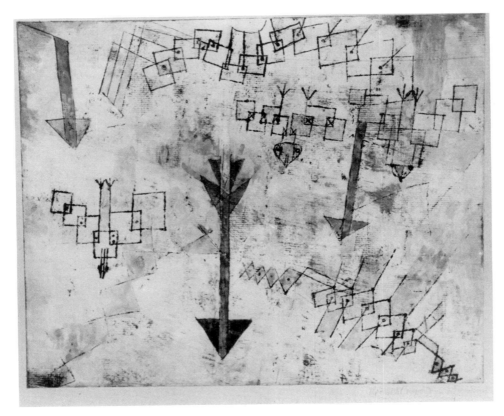

Fig. 124. *Descending Birds and Air Arrows*
(*Herabstossende Vögel und Luftpfeile*; 1919, 201)

tween disintegration and interconnection, that is, between subject and form. The image of the airplane is itself ambiguous here, since the two forward wheels may also be perceived as the eyes of a bird, and the tripartite ends of the inner frame as its claws. This formal equation between animal and machine, between organism and mechanism, was a general concern of Klee's at this time, as evident in the *Twittering Machine* from the same year.

In the drawing *Bird-Airplanes* of 1918 (fig. 77), Klee had already established a formal equation between bird and airplane. Like *Airplane Crash*, this drawing formed part of his large working collection, the "special class," which he rated most successful and retained for his own further reference. He no doubt consulted the earlier drawing when he made the later one. Its three figures anticipate the one birdlike airplane of *Airplane Crash*, where the title no longer evokes the ambiguity of organism and mechanism. Since 1917, Klee had made a whole series of pictures with such birds falling downward head-on (figs. 52, 57, 59, 64, 65, 68), several of them in the form of paper airplanes (fig. 60), indestructible, childish counterparts of the crashing machines (see p. 113). Only in 1920 did it become apparent how he had started with the imaginary antithesis, and how he had subsequently worked his way back to the historical experience which had triggered the theme.

Abstraction never meant a renunciation of the representational mode, although Klee on occasion did work that bordered on the nonrepresentational. What it meant, according to the diary entries of early 1915 which Klee was just now recasting into literary form, was a subjective representation by way of contrast, ostensibly far removed from its theme, and only to be deciphered as a counterstatement. The metaphor of flying away from reality links this principle with the related imagery of the two pictures discussed here. In the watercolor *Descending Birds and Air Arrows* (1919, 201; fig. 124) the transition to the clarified wartime memory is already on its way. It is based on an oil tracing of *Bird-Airplanes,* but the profile bird and the asymmetrical, organic variants in the shape of the left-hand frontal bird have been omitted, and the crashing bird in the middle has been replaced by a huge, solid arrow flanked by two smaller ones. These are airplane arrows, anti-personnel weapons showered over moving infantry columns on the ground. Klee has repeatedly explained how, in his way of working, any pictorial content emerges only at the end of a self-sufficient formal composition process.[68] To the extent that such content is based on experience, one must conclude, it comes from memory, of which the artist remains unconscious as he concentrates on form. With the subject of airplane crashes, the process lasted several years. Klee articulated his dated war experience with increasing clarity through successive repetitions. As he had projected in his programmatic diary entries of early 1915, abstraction was not meant to obliterate historical reality in exchange for pure invention, but to preserve it by antithesis as a surreptitious memory.

Angelus Novus (fig. 123), also from 1920, can be seen as a pendant to *Airplane Crash.*[69] Klee transposed the original drawing through the same oil tracing technique into the watercolor soon to be purchased by Walter Benjamin. Unlike traditional angel figures, this one has no wings but is extending his arms, of which the hands with five fingers can be recognized.[70] The outer contours of the arms are drawn straight down to the hip, without any indication of a joint below the shoulders. The wings they suggest do not grow from behind the shoulders independent of the arms, but appear to be extended by the arms themselves. The inner lines leading from the fingers inward and downward to the body can be read as wires or strings. The "new angel," then, is a "flying man," as Klee had written in 1902 (see p. 48), with artificial, mechanical wings. Ever since Leonardo and Swedenborg, the idea of flight by means of artificial wings or flying machines had been compared to the flight of angels.[71] Klee's figure appears to be standing in *contrapposto,* perhaps ready to take off, but since there is no ground line, he may also be viewed as motionless and hovering, neither ascending nor descending.

The theme is the same as in *The Hero with the Wing* of 1905 (fig. 27). Yet with the *Angelus Novus,* the effort to fly succeeds. Given the continuity of Klee's thinking, the picture must refer to the self-assured diary entry of 1915 where he had formulated this idea and which he was just now recasting into literary form. It may be taken as an image of the artist's exaltation, by means

of abstraction, into a spiritual counterworld.[72] Taken together, *Angelus Novus* and *Airplane Crash* denote the interrelated antithetical concepts of abstraction and historical experience in the polarized mode which was the premise of Klee's writing at this time (see p. 144).

The Call to the Bauhaus
The Appointment

On October 25, 1920, Klee received a telegram from Walter Gropius offering him the position of master at the Bauhaus, a state art school. His year-long quest for an academic appointment, a failure in Stuttgart, was at last fulfilled. At this point, Klee's career in the Weimar Republic was assured, but it was also launched on a double, potentially contradictory course. On the one hand were his increasing sales success on the art market and his corresponding prestige with the art public as a leading modern master; on the other, his teaching, and beyond that, his public visibility at an institution whose socially ambitious program was aimed at freeing modern art from its isolation as an exhibition commodity and at integrating it with the technology and lifestyle of society as a whole. In the first track Klee detached himself into a nonpolitical, cultural realm removed by now from the attacks to which modern art had been subject in the years before the war, yet economically, he exposed himself to the vicissitudes of the free market, whose fluctuations were now exacerbated by the pricing uncertainties of inflation. In the second track, Klee attained the economic security of a state employee, yet politically, he remained exposed to a continuing public controversy from which he had hoped to remove himself after the failure of the Munich revolution. This controversy became all the more trenchant since the Bauhaus, in the political democracy on which it was founded, had become accountable to public opinion. Thus, in both tracks of his career, Klee remained subject to uncertainty: in the first, through inflation, in the second, through politics. His first two years at the Bauhaus were a learning process which brought that lesson home to him.

In the short term, the appointment seemed advantageous enough. The real income of state employees, measured by various purchasing-power indexes and compared to 1913, had been on the rebound ever since the salary reform for the civil service was enacted in April 1920. It happened to rise over the 100 point in 1921,[73] the year Klee started his Bauhaus job. Klee's contract of appointment has not yet been found,[74] but it is more than likely that it resembled in its most important stipulations the contracts which the Thuringian government concluded with Gropius in 1919 and with Kandinsky in 1922. Accordingly, Klee would have been granted a three- or four-year tenure without possibility of cancellation on the state's part and a salary paid out in quarterly installments at the end of the first month and supplemented by a regular, adjustable inflation allowance.[75] Thus Klee was joining a social group which, through their secure and indexed income, paid, moreover, in advance,

benefitted the most from inflation when compared to the self-employed middle class, the social group to which he had belonged before and who were the main losers.[76].

The reasons that prompted Gropius and the Bauhaus faculty to offer Klee the post have not been clarified thus far. The ideas Klee had laid out in his letter to Kubin of May 12, 1919, in line with the arts school reform program of the Bavarian Council Government correspond to what had already been printed in the memoranda and manifestos of the Working Council for Art in Berlin in early 1919 (see p. 178). Gropius, chairman of that artists' group since March 1, 1919, drew on its program for his founding manifesto of the Bauhaus, published in April 1919. Klee, through his involvement in the reform initiatives promoted first by the Council of the Fine Artists of Munich and then by the Action Committee of Revolutionary Artists, probably knew texts of Berlin's Working Council, or even the Bauhaus manifesto itself, when he wrote his letter to Kubin.[77] The Bauhaus program, devised for a state institution under a parliamentary government, seemed to promise the solution to the problems Klee thought insoluble at the moment when he wrote the letter and when the Munich revolution had come to nothing. Gropius, in turn, may have been aware of Klee's agreement with his program before approaching him. Thus, the appointment, when it was finally made, would seem to have been the logical fulfillment of a long-standing convergence of interests and convictions. It is in this sense that Gropius, in his letter to Klee following the cable, wrote: "For a year now I have been waiting for the moment when I would be able to issue this call to you. I assume you more or less know what we have started here."[78] Six months earlier, Klee's failed appointment at Stuttgart, which was publicized in the national art press,[79] had highlighted the case for academic reform with which he was associated.

Unlike Munich and Stuttgart, Weimar should have presented no problem to the fundamental restructuring of the teaching of art, about which Gropius and Klee seem to have been in agreement. Gropius's memorandum of January 25, 1916, on the program for the prospective school was practical, technical, economical, and industry-oriented, but it was not modernist at all. Likewise, his printed Bauhaus program of April 1919 followed traditional thinking, dressed up but not affected by some leftist and expressionistic rhetoric.[80] It was not this program, approved by the local goverment authorities on the recommendation of Wilhelm von Bode in Berlin, which brought art-political attacks upon the Bauhaus after December 1919, but Gropius's intransigent policy of hiring exclusively expressionist artists.[81] Thus, the Bauhaus controversies of 1920 were a matter not of substance but of style. They ended in the breakaway of the provisional Hochschule für Malerei (Academy for Painting) on September 20, 1920, to which the three former academy professors on the Bauhaus faculty were reassigned, with the result that two of the vacancies were offered to Klee and Schlemmer six weeks later. On April 4, 1921, the old academy was formally reestablished as Staatliche Hochschule für bildende Kunst (State Academy for Fine Art). Ten days

later, Klee began his Bauhaus teaching.[82] Thus, it was not in order to fulfill the Bauhaus's far-reaching technical, economic, and social ambitions that Klee the renowed modernist was brought in, but as a result of the academic, and potentially political, polarization between traditional and modern art. And although Klee was assigned the supervision of the bookbindery, the course he began to teach was, as Franciscono has aptly put it, an end in itself.[83]

Itten's Initiative

Conflicting claims have been advanced as to whether it was Gropius or Itten who first proposed Klee as a Bauhaus master.[84] A decision on this point will help to clarify the nature of the contribution Klee was expected to make. To what extent was it his concurrence with Gropius's antiacademic, craft-oriented, and modernist Bauhaus program as suggested by Klee's letter to Kubin, to what extent was it his concurrence with Itten's pedagogical emphasis on childlike immediacy and Far Eastern mysticism, as suggested by the presentation of Klee in Zahn's monograph? The improbable connection of utopian left-wing art politics and childhood had already been promoted by the Working Council for Art, the forerunner of the Bauhaus program.[85] Thus, initially, the question was not a matter of alternatives, but of emphasis. It only became a question of alternatives in 1921, when Itten was on his way out at the Bauhaus and Klee, conversely, was in the ascendancy. However, initially it was Itten who promoted Klee's appointment.

On November 1, 1920, three days after Gropius's telegram and letter, Itten wrote a two-page follow-up letter urging Klee to accept. Here he explained the circumstances that had provided the opening and the prospect for a modernist closing-of-ranks at the institution: "If we replace the two masters [i.e., the former academy professors Klemm and Engelmann] with two modern, like-minded artists, I believe Weimar will become a center of the most intensive artistic work in the sense of progress, and unassailable by the forces of reaction."[86] If Itten wrote this letter on the initiative of Gropius and the faculty, it was no doubt because he was the only one of them who knew Klee personally.[87] According to Itten's later recollections, he first visited Klee in Munich in early summer of 1916, on his way to Vienna.[88] He came to see him for the second time at a crucial intersection of both artists' careers, in the last days of May 1919, when Itten stopped over in Munich on his way to Weimar for negotiations on the Bauhaus appointment he had just been offered, and when Klee was lying low in fear of the occupation authorities, ready to leave for Switzerland. In a letter of June 1, 1919, Itten reported: "In Munich I went to see Klee. We spoke no more than thirty words. He played Bach and I listened. Then a heartfelt handshake and goodbye. The day after tomorrow I shall be seeing him again."[89] If the first day of the visit was limited to music, the second must have been devoted to business. The two artists agreed on a collection of Klee's works which Itten was to take with him to Weimar and Vienna in order to select from it some works for

eventual acquisition.[90] In July, one of Itten's students in Vienna purchased two more drawings.[91] On October 15, about two weeks after Itten had moved to Weimar, and ten days before the opening of Klee's exhibition in Stuttgart which was to promote his appointment to the academy there (see p. 213), Klee wrote to Itten that some of Itten's students had visited him: "I have great interest in your Weimar mission. When your students visited here, we talked a lot about you."[92] Possibly the students, whom Klee does not name, were those who were following their teacher from Vienna to Weimar, where they made up the core enrollment of his course.[93] They may have stopped over with Klee in Munich just as Itten himself had done four and a half months earlier. They may even have been among those students whom Gropius, in his written offer to Klee a year later, described as "glowing" at the thought of his arrival.[94] Whatever the specific circumstances, at the moment when Itten joined the faculty, he had already established a link with Klee on which he was able to rely a year later when he wrote to back up Gropius's offer. The one-year period during which Gropius, according to the offer, had had Klee's appointment on his mind, had in fact begun with Itten's tenure.

In 1915 and 1916 Itten had worked at Stuttgart as a close friend of Schlemmer, in common allegiance to their professor Adolf Hölzel,[95] as a successor to whom Schlemmer had proposed Klee. The Bauhaus offer to Schlemmer and Klee in tandem confirms that Itten was a driving force behind it. Just as in Klee's case, he followed up Gropius's letter to Schlemmer with one of his own, to which Schlemmer answered, on November 4, 1920, with hesitations prompted by the Stuttgart affair: "I have become frightened of the public sphere, the notoriety acquired in Stuttgart has done me more harm than good in artistic respects. . . . Has Klee accepted already? After the Stuttgart experience, I am sure he will."[96]

Itten's interest in Klee and his art can be pinpointed through the three works by Klee which he kept from the collection he took with him to Vienna. They were *Chosen Boy* (1918, 115; watercolor), *Primordial Creatures* (1918, 195; wash drawing), and no title (1918, 197; drawing with watercolors).[97] The selection combines, in an almost programmatic fashion, the artistic concerns of precultural creativity, childhood mystique, primordial origins, and abstraction, all concerns that Itten at this moment shared with Klee. On February 3, 1917, for example, Itten had noted in his artistic diary a thought about primordial creation out of an interaction between good and evil which word for word recalls Klee's statements of July 10, 1917 (see p. 100) and of early November, 1918 (see p. 135).[98] An undated poem by Itten, written perhaps as early as 1919, might be read as an evocation of the *Chosen Boy*:

> "Be human like the child
> Unrestrained self-realization
> Be solitary like the monk
> Exercizing the abstinence of the humble spirit
> Be knowing like the sage
> Powerful clarity of measured, prudent action."[99]

It is on the basis of such thoughts that Itten, on November 28, 1919, delivered a formal invocation to his students which concluded not unlike Klee's essay in *Creative Confession:* "That our play become work and our work become celebration and our celebration become play—this seems to me to be the highest accomplishment of human activity. To shape the play of forces inside us—outside us—into a festive action by way of self-oblivious work—this means to create in the children's way."[100] Thus, if Itten was the driving force behind Klee's appointment to the Bauhaus, it was Klee's reputation for child-like immediacy of form and imagination, not his involvement in the politics of progressive art instruction, which, aside from his general distinction as a leading German modern artist, made for his specific appeal.

Childhood versus Professionalism

However, the difference between the ironic self-detachment of Klee's *Chosen Boy* and the dead-serious enthusiasm of Itten's poem "Be human like the child" suggests a difference between the two artists which became relevant in their diverging careers as Bauhaus masters. In November 1919, the same month that Itten delivered his invocation about art as child's play to his Bauhaus students, the opponents of Klee's appointment at Stuttgart expressly singled out the "playful character" of his art as too idiosyncratic to be taught in an art school (see p. 192). That Klee should have suppressed just then the explicit correlation of art and childhood in the revision of his essay on graphic art, as it went to press for *Creative Confession* (see p. 212), shows that he was by now aware of a critical ambivalence in the seemingly childlike traits of his work on which his newly won success with the public was founded to a con-siderable extent. Art critics now generally admired those childlike traits, partly in literal observance of what could be read in the *Blaue Reiter* almanac of 1912. Grünthal, for example, had written in his essay on Klee in *Der Weg* of February 1919 (see p. 163): "Life appears muted, undifferentiated, in *cosmic wholeness*. What has never been heard or seen before, rises, becomes real, in an *unbroken* soulfullness, such as only wide open *children's eyes* are capable of seeing. . . . Something like this is, of course, opposed in *absolute* polarity to the conceptual-conventional, trivially 'natural' reality of bourgeois adults."[101] Nevertheless, more important critics who wrote about Klee remained con-scious of the critical ambivalence noted by the artist himself. They did extol childlike immediacy of perception and imagination as his distinct artistic qualities, but also insisted, as already Däubler had done in 1918, on assur-ances that his works were aesthetically reflective, not naive. Thus, in his monograph, Zahn reaffirmed: "Childlike fantasy and profound wisdom are here not opposites, but complements."[102] Until the end of the Weimar Re-public, Klee's apologists time and again were careful to strike just this bal-ance. In a way, they were stating the obvious: that the seemingly childlike simplicity of Klee's figurations resulted from a deliberate reduction which not only did not impair his sophistication of form, but actually enabled him

to realize it. However, they failed to perceive that the elementary purity of form, from which Klee wished to start afresh, presupposed a radical attitude of cultural critique, provocatively stated by means of simplistic imagery. That is why critics not receptive to the aesthetic qualities of Klee's abstraction continued to raise the charge of childishness against him.

Soon, however, even critics sympathetic to modern art found the balance between childlike spontaneity and formal refinement claimed by Klee and his admirers to be contradictory and suspect. E. H., the reviewer of the big Klee exhibition at the Goltz Gallery in Munich in May 1920, admitted that "one took pleasure in this seemingly childlike cast of mind," but also professed to be weary of the constant repetition, of "the machinery . . . whereby the richness of genuine children's art has been replaced."[103] At about the same time Willi Wolfradt stated with trenchant clarity what he called "The Paul Klee Case": the contradiction between the yearning for transcultural immediacy in postwar art and the establishment of modernism in a traditional art world complete with museums, professorships, and great masters. Wolfradt was ready to grant that Klee's art was a legitimate and necessary "descent of hypercomplication to childlike primitivism," but he concluded that for just this reason Klee "was more noteworthy as an anti-artist than as an artist."[104] Thus, Klee's cultural critique of the prewar years was being turned against him as soon as he was about to establish himself as one of the great masters and professors of modernism.

Klee may have been aware of the potential contradiction between the values of childlike ingenuity and artistic self-reflection much earlier than this. In the clear copy of his diary, the passage about "the ultimate professional experience," dated to 1909, addresses the contradiction.[105] Whether or not this text in its present form was already written in 1909, the reflection it contains was crucial for the problems Klee was facing at the time of the rewriting.

Klee's Starting Point in the Bauhaus Curriculum

When Klee started in April 1921 to teach at the Bauhaus, he joined a program of art instruction that derived in part from prewar traditions of art pedagogy for children.[106] This assumption of a professorial role on the part of a modern artist who had started out with a challenge to all art instruction in the name of children's art was the end result of the increasing attention being given to the artistic activity of children since the turn of the century. In 1901, the German art education movement had already vindicated children's spontaneous drawing and painting as a relevant artistic activity, even if only as a preliminary stage toward the more accomplished art of adults. In 1908, Kerschensteiner, in a programmatic speech at the founding congress of the German Werkbund, had called for an art pedagogy founded on children's natural development as he conceived of it, not only in elementary and high schools, but also in arts and crafts schools. In the years immediately before and during

the war, Cizek and Itten in Vienna taught art to children as a spontaneous formal and expressive activity, and it was Cizek who eventually adopted some of these principles for adult art instruction. After the war, Cizek and Itten taught abstract art classes in the belief that it could facilitate a spiritual regeneration. Thus, when Itten, a trained professional educator, devised his preliminary course at the Bauhaus, with its emphasis on unbridled creative immediacy, he was able to draw on an established tradition of art education for children. Franciscono has stressed that the foundation of Itten's Vorkurs

> did not come primarily from orthodox sources of professional art education but rather from the liberal Rousseau-Pestalozzi-Fröbel-Montessori reform tradition of child education, which had as a basic tenet that education is essentially the bringing out and developing of inherent gifts through a guided process of free and even playful activity and self-learning. This tenet . . . is, above all, behind Itten's famous intention to "liberate the student's creative powers" and to retrain him from the beginning by means which initially included bypassing the intellect in order to reach what is conceived to be his natural unlearned creative center.[107]

Klee's reputation must have appeared to fit well into this pedagogical concept. By May 1920, a hostile critic of his exhibition at the Goltz Gallery had couched the customary charge of childishness in new terms, comparing Klee's watercolors with "certain Fröbel games of children (assembling motley paper chips in all possible forms)."[108] But, when Klee conceived his own Bauhaus course in the spring of 1921, he was ready to exchange random regression to play for systematic progress to achievement. With this new approach, he was in time to match Gropius's directive of October 13, 1920, which made theory courses compulsory in order to correct what the Bauhaus director perceived to be "chaotic" in the students' work.[109] In a carefully devised sequence of steps, Klee's course rose from an elementary stocktaking of form to a systematic exploration of color composition by analogy to musical counterpoint, based, it seems, on Fux's fundamental musical counterpoint manual *Gradus ad Parnassum* (1725). The stated goal of that manual had been "to work out a method similar to that by which children learn, first letters, then syllables, and finally how to read and write."[110] The point was not natural expression, but natural order, and, in the final analysis, natural discipline. Thus, the variety of pedagogical traditions on which Klee drew for his teaching enabled him to link his earlier interest in the "primordial origins of art" with a controlled introduction into laws of form proceeding from the elementary to the complex.

On January 10, 1921, Klee arrived in Weimar in order to familiarize himself with his new workingplace. The detailed reports he wrote home to his wife about his first experiences and activities are full of statements, descriptions, and implicit or express judgments revealing with how much quiet self-assurance he was taking charge. Three days after his arrival, Klee had organized his atelier and was able to paint for the first time. Only two days

later was he given a tour of the school. Most of that tour was devoted to observing Itten's teaching.[111] What Klee wrote about it to his wife amounts to a "territorial demarcation" like the one he had drawn toward Franz Marc in 1915 and 1916. On entering Itten's class where the preliminary course was about to begin, he observed on the walls experimental form assemblages produced by the students. His characterization of these objects as "bastards of savages' art and children's toys"[112] reads like the hostile attacks on expressionist art that Walden had reprinted in *Der Sturm* in 1913 and had countered with the title-page reproduction of Klee's own provocative drawing *Belligerent Tribe* (see p. 71, fig. 43).[113] Now Klee revoked his earlier enthusiasm for just this combination, which in his *Blaue Reiter* review of 1912 he had located "in the ethnographic museum or at home in the nursery (don't laugh, reader)."[114] If he expected his wife, if not to laugh, at least to smile at the expression "bastards of savages' art and children's toys," he was at variance with the admonition he had just transcribed with few changes into the fair copy of his diaries. By distancing himself from his own earlier posture, he was only being consistent with his altered correlation of children's art to modern art.

Klee's subsequent account of Itten in action, as the latter was conducting his preliminary course, exposes the perceived discrepancy between the professed artistic ideal of unbridled spontaneity and the disciplinarian behavior of the teacher: "The master controls the work, has individual students expressly repeat it for him, controls their postures. Then he conducts their work by beating the time, then he has them stand up and go through the same exercise. It seems a sort of body massage is being intended, in order to school the machine to function intuitively."[115] Klee's understated but merciless satirical comparison of Itten's enactment of natural art-making to a functioning machine is aimed at the oppressive conduct of elementary form instruction. To that contradiction, Klee must have been all the more sensitive since he was himself moving away from unguided spontaneity and toward conscious discipline in his approach to elementary form. By contrast to Itten's, his discipline did not touch the person but was focussed on the object. The patient methodological detachment, cast into a satirical mode of pedantry, which Klee cultivated for his own teaching posture, was surely a response to Itten's serious, forced intensity, all the more a deliberate antithesis since it was directed against the perceived similarity of goals which had prompted Itten to bring Klee to his side. Klee's descriptions of how Itten postured in his teaching are unabashedly sarcastic. After Kubin and Marc, this was the third modern artist better established than Klee and helping him along at a critical juncture of his own career from whom he detached himself in return, making allies into imaginary contrast figures.[116]

Klee began his work at Weimar with a strict sense of priorities. "Weimar hustle and bustle does not exist for me. I work, all the time talking to no human being."[117] For the Compositionsprakticum, as he had labelled his upcoming course in the announcement on the bulletin board, he worked out a

series of "show pictures" (*Musterbilder*), watercolors with systematically superimposed wash layers.[118] Three times in a row in his letters he called these watercolors "severe," resuming the term he had used in 1918 for the watercolor *The Dream,* which he had painted "in opposition" to Hausenstein (see p. 130).[119] Now he was in a position to disprove that critic's doubts about his teaching capabilities (see p. 217). When the day of the first lecture came, Klee was ready with ten such watercolors,[120] which he handed around and analyzed together with the students. Consistent with his year-long aspirations, he had made his own art a general paradigm.[121]

Epilog

"Scenes in the Department Store"

Klee's initial contribution to the Bauhaus curriculum in the spring term of 1921 was consistent with the current tendency of that curriculum as a whole, noted by Franciscono, to move away from shopwork and technical knowledge toward picture-making and theory.[1] Moreover, according to Franciscono, Klee's course contained nothing to indicate "the slightest interest in architecture *per se.*"[2] Klee's first full year's course, which started in November, 1921 and ended in December 1922 and which is recorded verbatim in a notebook under the title *Bildnerische Formlehre (Pictorial Form Instruction)*, is also devoid of any reference to the social issues addressed in the original Bauhaus program.

Yet if technical, architectural, and social concerns were lacking, economic ones were not. They become apparent in a summary of the relationships and transitions between the three levels Klee was used to distinguish in his progressive buildup of pictorial form, which is entitled "Scenes in the Department Store" (fig. 125):

Measure

Patron: 1. Merchant, give me a bucket full of this merchandise! The merchant measures and demands 100 marks. Patron: (Good).

2. Now, merchant, give me the same bucket full of this other merchandise. The merchant measures and it costs 200 marks. Patron: (why twice as much?)

Weight

Merchant: Because this other merchandise is twice as heavy. (The patron sees the point and pays). Patron: 3. Now, merchant, give me from a third merchandise of the same weight! The merchant weighs and it costs 400 marks. Patron: (why twice as much?)

Pure *Quality* (unweighable)

Merchant: Because this third merchandise is twice as good, more durable, much more tasty, more in demand, more beautiful (the Patron

Montag den 26. Juni 1922 ⟨ R. 5. ⟩

eine (Scenen im Waarenhaus)

Maass und Gewicht		reine Qualität (imponderabel)
KU: 1. Kaufman gib mir einer Eimer voll von dieser Waare! Der kaufman misst und verlangt 100 Mark. KU. (gut) 2. Nun Kaufman, gib mir den selben Eimer voll von dieser andern Waare. Der Kaufman misst und es kostet 200 Mark KU: (warum doppelt so viel?)	KA: Weil diese andere Waare doppelt so schwer ist. (Der Kunde sieht ein und bezahlt) KU. 3. Nun Kaufman gib mir ebenso schwere dritte Waare! Der Kaufman wägt und es kostet 400 M KU (warum doppelt so viel?)	KA Weil diese dritte Waare doppelt so gut ist. viel (haltbarer, schmackhafter,) begehrter, schöner (Der Kunde schwankt)
Linie Lineare Wertung: länger, kürzer	Ton (helldunkel) Tonale Wertung: heller, dunkler schwerer, leichter	Farbe Farbige Wertung: Begehrter, schöner, besser, zu sättigend erkältend, zu heiss, hässlich

Fig. 125. "Scenes in the Department Store" ("Scenen im Warenhaus"),
from *Bildnerische Formlehre*

149

Die Wertung der Farbe ist also keine feststehende, sondern rein imaginär. Ist es zu heiss sehnt man sich nach grün-blau, ist es zu kalt, sehnt man sich nach gelb-rot. Die Nachfrage kann wechseln. der Geschmack kann wechseln.

wavers). Measure refers to the realm of *line*: linear evaluation: longer, shorter, coarser and finer. Weight refers to the realm of *tonality* (light and dark). Tonal evaluation: brighter, darker, heavier, lighter.

Pure quality refers to the realm of *color*. Color evaluation: more in demand, more beautiful, better, too saturating, cooling, too hot, ugly, too sweet, too sour, too beautiful!"[3]

These "scenes in the department store" define the progressive, systematic elaboration of artistic quality by analogy to an increase in commodity value, where "pure quality" is equated with "more in demand." They are a far cry from the idealistic renunciation of a market orientation on the part of artists which Gropius, in a speech of early October 1919, had proclaimed as germane for both their artistic self-sufficiency and their socially responsible re-integration into society. The Bauhaus director had held out to prospective students the example of "oriental" craftsmen who "sit between the doors of their stalls and work. When a stranger asks about the price of their wares, they answer in a sullen monotone, for they are in love with their work, do not want to let themselves be disturbed and even part unwillingly from their finished work. For them, making money, selling is only a necessary evil."[4] Franciscono has duly noted the contradiction between this posture and the tenet of the German arts and crafts movement that the beauty of form achieved by artistic quality work should increase the market value of the product,[5] all the more so since Gropius had emphatically magnified just this tenet in a programmatic speech of spring 1919, to suit Germany's postwar economic emergency: "Good work, that is: every shred of raw material . . . must be multiplied in value through the *highly-qualified work of the crafts or industry* and also, above all, through *the inimitable character of form.*"[6] Three and a half years later, when Klee delivered his lecture, the Bauhaus students had already been officially conditioned to perceive their work in just these terms. Gropius's memorandum of February 3, 1922, entitled "The Viability of the Bauhaus Idea," had inaugurated a turn to commercial work-shop production which became fully operative in the course of the year.[7] Its results were first presented to the public in the exhibition of products by "Bauhaus apprentices and journeymen" in April and May 1922.[8] Thus, students were prepared to understand Klee's "scenes in the department store" in terms of the commercial value-increase to be achieved by the artistic beautification of products for sale.

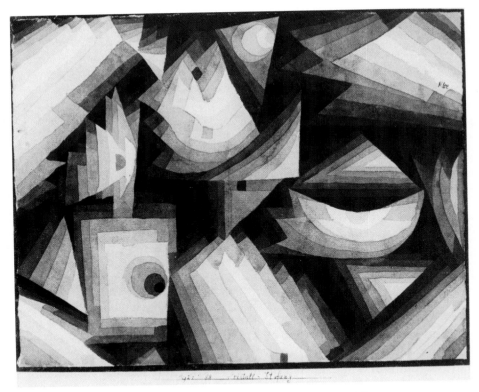

Fig. 126. *Crystal Scale* (*Kristall-Stufung;* 1921, 88)

Klee had started his course by defining the key term "analysis" in straightforward commercial terms: "For example, some medical prescription finds a large market because of its outstanding efficacy. The manufacturer's ensuing good business makes other manufacturers curious, and they bring a specimen to the chemist for him to make an analysis. He has to proceed methodically in order to dissolve the prescription into its components."[9] Chemical analysis and market analysis converge in this comparison. Although in Klee's principled generalizations the term "analysis" is detached from any specific application, it pertains to the work of the painter: "In our business enterprise (*Betrieb*) the motivations of the analysis are, of course, different. We do not do analyses of works we would like to copy."[10] The distinction of art from other products pertains to the preservation of originality, not to market value. And here, Klee was able to draw on his well-tested experience of the art market during the preceding seven years of his career. The geometric progression of prices, from 100 to 200 to 400 marks, by which Klee, always bent on counting regularly, distinguishes between the three basic levels of form, recalls the three categories of net prices for his work, which was stipulated in his general sales contract with Goltz of October 1, 1919 (see p. 208): "For the time being Mr. Klee will keep the net prices for paintings at 800 marks for the individual piece, the net prices for watercolors

at 200 to 500 marks according to the kind of work (*Art der Arbeit*) for the individual piece. The net prices for drawings Mr. Klee establishes at a level not below 150 marks apiece."[11] Of the three price ranges, that for watercolors is the crucial one. *Art der Arbeit* refers to the varying complexity of techniques which Klee applied to them, from the casual wash on a drawing to the protracted layering of shades. As a result, it is here that Klee reserved for himself the greatest pricing flexibility, which he tied to his own assessment of the work expended. And it is this price scale corresponding to technical complexity which the "scenes in the department store" apply to the basic build-up of form. The dazzling, "severe" watercolors such as *Crystal Scale* (fig. 126),[12] which Klee had produced for the purpose of teaching, cast essential ideals of his career into this commercial mode. From a symbol of intransigent withdrawal, deeply hidden within the "bleeding" rock (see p. 41), the crystal had been turned into a shiny showpiece placed up front in the jewelry section of his imaginary department store.

When Klee delivered this lecture to his students, on June 26, 1922, the contract with Goltz must have been on his mind, for its tentative expiration date was five days later. According to §8, Klee had the right to cancel it by registered letter before July 1, 1922; otherwise it was to remain valid for another two years. Klee did not cancel.[13] The contract's stipulation about the guaranteed correlation between artistic quality, levels of workmanship, and commercial value must have impressed him so much that he transfigured it into the essence of his pedagogical theory. The figures he used in his demonstration were those of 1917. In the course of the steadily progressing inflation between October 1919 and March 1920, Klee had refrained from adjusting them upward as the contract would have permitted him to do, with the result that his work was steadily depreciating (see p. 209). It remains an open question whether he did raise them after January, when the sales entries in his oeuvre catalog break off. However, between March 1920 and July 1921, when the German mark stabilized within a range of 9 to 18 compared to the gold mark of 1913,[14] any adjustments cannot have been more than index fluctuations. And when depreciation resumed in August 1921, with the index rising from 20.07 to 75.62 where it stood in June 1922, Klee was contractually positioned to apply the multiplicator as he saw fit. Thus he remained in a frame of mind to conceive of basic price differences as meaningful classifications of quality, that is, to fix his progressions of artistic complexity on the German prewar principle of *Mark gleich Mark*.[15] And the contract with Goltz must have appeared to him, even more clearly than in October 1919, as a guarantee for the artist's control over the market value of his work. Hence he made it the model not merely of artistic quality, but of artistic work itself.

In retrospect, this text from *Pictorial Form Instruction* confirms the market orientation of Klee's work, which has been traced throughout this book. Far from being detrimental for an assessment of Klee's art, such an observation only shows how accurately its historical deployment expressed what modern art was meant to convey, namely, the live identity of the mod-

ern artist. And for Klee's comprehensive, accurate attention to reality, the identity of the artist was circumscribed not just by his imagination, but by his life, including the material conditions of his work. For this reason, the basic contradiction between freedom and security in the capitalist economy did not escape Klee's self-reflection. He concluded to his class: "The evaluation of color is therefore not constant, but purely imaginary. If it is too hot, one longs for green-blue, if it is too cold, one longs for yellow-red. Demand may change, taste may change."[16] Klee's "purely imaginary" definition of color was thus founded on the recognition of economic uncertainty. At the highest level of achievement, art was no longer free, but subject to change.

As it happened, Klee delivered his lecture about the German mark as the measure of artistic quality in the very month when the German inflation was starting to spiral out of control and to turn from an agent of economic productivity into one of economic crisis. This moment came in June 1922 with the piling up of the French rejection of any change in the reparation agreement, the J. P. Morgan committee's insistence that reparations had to be changed to make possible an American loan, and finally, and most critical, the assassination of Walther Rathenau. The mark went from 272 to the dollar on June 1 to 318 on the 12th when the Morgan report came out, and from 332 to 355 on the day of the assassination (June 24). On June 30 it hit 374, and the next day 401. By July 31 it was 670 and by the end of August 1,725. Speculation in favor of the mark by foreigners (and some Germans) had been completely reversed.[17] Was Klee's Bauhaus lecture such a speculation? It remains an open question how the career Klee had secured for himself at this point stood up to the economic reversals of the following years.

"From the Museum, We Were Watching"

Economic and political reflections went together. Two days after the lecture, on June 28, 1922, Klee wrote to his wife about the installation of the summer exhibition of Thuringian artists in the Weimar Museum:[18] "Yesterday there was a big demonstration here of the workers with red banners. From the Museum, we were watching."[19] Far from being an unconscious avowal of yet another detachment of the modern artist from the political conflicts of his time, this private comment reveals, with dead-pan irony, Klee's awareness about the perils of confrontations that would not go away. The scenery of the marching workers with their red banners may have recalled to him the march of those "reservists in Munich chanting stupidly" who at the turn of 1914–15 had bolstered his revulsion against, fear of, and eventual withdrawal from the war (see p. 49): "The letters in the history book turned real. Old picture-sheets confirmed."[20] After making his career through war and revolution, Klee had experienced that political reality catches up with modern art no matter how resolute its self-confinement. Turning back into the museum, he observed: "Thedy's and Gugg's pictures bring a certain qualitative note into the department on the right."[21] Thedy was the conser-

vative former Bauhaus master who had led the secession of the old academy professors, reestablishing the Weimar art academy in response to rightist political pressure, and Gugg was the first new appointment to that academy, coming in along with Klee and Schlemmer on the other side.[22] What Klee was saying was that in the meeting of both sides at their common exhibition, artistic quality in "the department on the right" was lower than in his own, which he refrained from locating either within the building or within the political spectrum. Was he recalling his defiant report "In those rooms, my *abstracta* come off as very telling" from the New Munich Secession spring show of 1915, where he had claimed to be enacting a silent political provocation with his pictures (see p. 39)? Or was he recalling his political statement made by means of the lone *Young Proletarian* in the New Munich Secession show of June 1919 (see p. 186)? The report from the Weimar show of June 1922 may again have been meant to suggest his own confidence in the stand that he was taking, but it is also a resigned acknowledgment that the political confrontation between right and left had penetrated the museum. And, as Klee had told his students two days earlier in the matter of artistic quality, "demand may change, taste may change." The changes in the offing were not just of taste but of ideology, and not just changes but threats. It was possible for Klee the modern artist to adjust to changes as long as they were merely a matter of market competition. But, as he had found out, political conditions were out of reach for his initiatives. It would be trivial to state in hindsight that therefore Klee's career, at the moment when he had attained all of his goals, was far from being secure. It is perhaps more to the point to recognize that Klee's self-awareness, which for him was tantamount to artistic maturity, extended to historical self-reflections whose sensitivity allowed no feeling of security at the moment of accomplishment.

Notes

Introduction

1. Cf. T. J. Clark, *Image of the People* (London, 1973), p. 15.
2. *Tagebücher*, no. 725, p. 229, November 1905: "Leb wohl gegenwärtiges Leben das ich führe. Du kannst so nicht bleiben. Vornehm warst Du. Reiner Geist. Still und einsam. Leb wohl Ehre beim ersten öffentlichen Schritt." Cf. Haxthausen 1981, pp. 96–97.
3. I have lifted this sentence out of a letter from Charles Haxthausen, who has also influenced the following remarks.
4. For the change of attitudes involved, see Haxthausen 1981, pp. 372–28.
5. Cf. the sustained, trenchant critique of K. Badt, "Zur Bestimmung der Kunst Paul Klees," *Jahresring 64–65* (Stuttgart, 1964), pp. 123–36, which went unheeded in subsequent literature until it was taken up by Kühn 1986, pp. 28–29.
6. G. Feldman, "Gegenwärtiger Forschungsstand und künftige Forschungsprobleme zur deutschen Inflation," in Büsch and Feldman 1978, pp. 3–21, esp. p. 5.
7. Editors, "Inflation und Wiederaufbau in Deutschland und Europa 1914 bis 1924: Ein Forschungsprojekt," in Feldman et al. 1982, pp. 1–21, esp. pp. 19–20.
8. Feldman, in Feldman et al. 1982, p. 11.
9. H. Mommsen, discussion remark, in Büsch and Feldman 1978, p. 275.
10. Werckmeister 1981, pp. 179–97 ("Die neue Phase der Klee-Literatur").
11. Glaesemer 1976, p. 8.
12. In the two concluding volumes, published in 1979 and 1984, Glaesemer has twice changed course.
13. B. Witte, *Walter Benjamin—Der Intellektuelle als Kritiker* (Stuttgart, 1976), p. 40.
14. Ibid., p. 57.
15. Werckmeister, review, 1987.
16. Haxthausen 1981, pp. v ff.
17. Haxthausen, 1981, pp. 97 ff., has given the most extensive account of the diaries prior to this critical reassessment.
18. Geelhaar 1979.
19. *Briefe* 1:414, to Lily Stumpf, 12 April 1904: "in der Absicht, es später einmal als Material zu einer Selbstbiographie zu verwenden." Cf. Geelhaar 1979, p. 249.
20. Geelhaar 1979, p. 251.
21. *Tagebücher*, pp. 284–85.
22. The mistranslation "Creative Creed," by which Klee's contribution to the collection of essays published under the title *Schöpferische Konfession* has become known in the English-speaking literature, would actually mean the opposite: the recital of an authoritative set of beliefs by a faithful follower. Perhaps the mistranslation

has been so readily accepted because writers on modern art were eager to submit to Klee's remarks as an authoritative statement on what modern art was meant to be. In such a misreading, Klee would appear, not as a penitent laying his soul bare to the community, but as a church father who formulated a creed for others to follow. This may be suggestive of Klee's canonization in modernist culture, but it is at odds with the original intention of the text.

23. Geelhaar 1976, p. 7.

24. Geelhaar 1976, p. 15.

25. *Der Ararat*, 1920, p. 3, reprinted in von Wedderkop 1920, p. 16; Klee ed. Geelhaar 1976, p. 140: "Der grosse Erfolg fiel ihm wie eine reife Frucht in den Schoss. Er freut sich seiner in der Stille einer arbeitsreichen Zurückgezogenheit. Träumend, schaffend, geigespielend."

26. Cf. Hohl 1982, pp. 149 ff.

27. Cf. W. Schmidt, "Gesellschaftskritische Aspekte in Klees Werken," in *Paul Klee: Vorträge der wissenschaftlichen Konferenz* (Dresden, 1986), pp. 6–10, esp. p. 6: "Es geht darum, die Kunst Paul Klees nicht nur als privates Lebenszeugnis . . . zu verstehen, sondern darüber hinaus—trotz starker subjektiver Brechungen—als Äusserung zu historischen Prozessen und als Reflexion auf objektive Vorgänge der Gesellschaft." The published contributions to the conference are not, however, in compliance with this postulate.

Chapter 1

1. *Kunst und Künstler* 13 (1914–15):43, 44–45, 52–53.

2. "Der Kunsthandel während des Krieges," *Der Kunstmarkt* 12, no. 8 (November 30, 1914):29: "Angebot wie Nachfrage haben so gut wie ganz aufgehört, und man entsinnt sich keiner Zeit einer nur annähernd ähnlichen Stille des gesamten Kunsthandels."

3. "Stattgehabte Auktionen," *Der Cicerone* 6, no. 7 (April 1914):272–73.

4. Holtfrerich 1980, pp. 193–94.

5. C. Ule, "Die Künstler im Deutschen Befreiungskriege!" *Der deutsche Künstler* 1, no. 5 (August 15, 1914):49–50.

6. G. Jahn, "Der Krieg und die Künstler," *Der deutsche Künstler* 1, no. 6 (September 15, 1914):61–62.

7. E. Daelen, "Das Schweigen der Musen," *Der deutsche Künstler* 1, no. 7 (October 15, 1914):67–68.

8. E. Daelen, "Wirtschaftspolitik und Kunststadt," *Der deutsche Künstler* 1, no. 9 (December 15, 1914):83–85. Cf. A. Dobsky, "Der Krieg und die Zukunft der deutschen Kunst" (reprinted from the biweekly *Volkstümliche Kunst*), *Der Kunsthandel* 6, no. 10 (October 1914):181–82.

9. Munich, Städtische Galerie im Lenbachhaus, Gabriele Münter-Stiftung, letter from Klee to Kandinsky, August 18, 1914: "Was mich betrifft, möchte ich jetzt einesteils lieber dort sein, denn trotz allem—die Zeit hat eine gewisse Grösse. Dass sie vom Standpunkt unserer weiteren Bestrebungen reactionär scheint ist wohl schmerzlich . . . Aber wer weiss ob der nationale Aufschwung Deutschlands uns nicht auch wieder Mittel bringt (Mut und Geld von Seiten der Förderer und Verleger) zu denen unter dem Druck der letzten Jahre der Mut gefehlt hat. . . . Und es war ein Fehler, nicht mehr mit einem Krieg der Grossmächte fortwährend zu rechnen. Es war eine Art Verweichlichung."

10. Ibid.: "Mein Wunsch nach Deutschland jetzt zurückzukehren, wird mir in diesen Tagen wahrscheinlich in Erfüllung gehn, aber nicht in der ausgedachten

freien Form, sondern unter dem Zwang der fortgesetzten Mobilmachung. Ich gehöre dem bayr[ischen] Landsturm 1. Aufgebot an. Da ich nie militärisch eingeübt wurde, steht mir wohl eine verspätete Rekrutenschule bevor. Ich werde es aber von der ironischen Seite zu nehmen und zu würdigen wissen."

11. Letters of Lily Klee to Maria Marc, Nuremberg, Nachlass Marc, Prod. 11, August 6, 1914: "Mein Mann erwartet täglich seine Einberufung"; August 10, 1914: "Mein Mann ist noch nicht einberufen da er zum Landsturm gehört"; August 28, 1914: "Mein Mann hat sich heute auf der Deutschen Botschaft stellen müssen und wurde ärztlich untersucht und zur Landsturmrolle eingetragen. Muss aber einstweilen noch nicht gehen. Vielleicht bald"; September 15, 1914: "Mein Mann ist noch nicht einberufen"; September 24, 1914: "Mein Mann ist noch nicht einberufen. In den ersten Tagen des Oktober kehren wir heim—ev[entuell] 2. 3. od[er] 4. Oktober spätestens."

12. Bern, Nachlass-Sammlung Paul Klee: "War für ein Glück das sein wird, wenn die schreckliche Zeit vorüber ist. Was kommt nachher? Ich glaube eine grosse Entfesselung der inneren Kräfte, die auch für die Verbrüderung sorgen werden. Also auch grosse Entfaltung der Kunst, die jetzt in verborgenen Ecken stecken muss." Cf. Haxthausen 1981, p. 420.

13. Bern, Nachlass-Sammlung Paul Klee, Sonderegger correspondence, no. 25: "Doch alles wird vorüber gehen, und wohl im gewünschten Sinn, dass die ruhige Zentralmacht unerschüttert bleibt. Dann geschieht den andern auch nicht viel mehr, als dass ihnen ein langer Frieden diktiert wird. Und den brauchen wir, einen unbedrohten Frieden, sonst nichts."

14. Lankheit 1976, pp. 147–48.

15. F. Marc and W. Kandinsky, *Briefwechsel* (Munich, 1983), pp. 266–67: "In den ersten sehr schlimmen Vogesenkämpfen konnte ich oft Traum und That nicht trennen. . . . Und oft dachte ich an Ihre Bilder, die mich wie die Formeln eines solchen Zustandes begleiteten. . . . mein Herz ist dem Krieg nicht böse, sondern aus tiefstem Herzen dankbar, es gab keinen anderen Durchgang zur Zeit des Geistes." Cf. Lankheit 1976, p. 267.

16. Ibid., p. 44: "Ich selbst *lebe* in diesem Krieg. Ich sehe in ihm sogar den heilsamen wenn auch grausamen Durchgang zu unseren Zielen; er wird die Menschen nicht zurückwerfen, sondern Europa *reinigen*, 'bereit' machen."

17. Marc 1978, pp. 158 ff.

18. "Das geheime Europa," Marc 1978, pp. 165, 163: "dieser Grosskrieg ist ein europäischer Bürgerkrieg, ein Krieg gegen den inneren, unsichtbaren Feind des europäischen Geistes"; "[er ist] das uralte Mittel des Blutopfers" zur "Heilung unsrer europäischen Krankheit."

19. Ibid., p. 164: "des wütenden und unwürdigen Nationengekläffs."

20. Nuremberg, Nachlass Marc, IC, Prod. 17: "Kandinsky traf ich in Rorschach, durchaus nicht deutsch gesinnt."

21. Ibid.: "Wie sich Ihr Geist der unerhörten Veränderung frischweg anpassen konnte habe ich den kl[einen] Aufsätzen entnehmen können die mich Ihre Frau lesen liess.

Eigentlich sind doch wir gerade gegenwärtig hart betroffen worden in unseren zartesten Hoffnungen. Sie aber ersetzen den Verlust durch die kühnsten Erwartungen. Und wie wenige Deutsche sind wir doch noch—und trotzdem?! Nun haben wir noch August Macke verlieren müssen. . . .

Dazu muss ich die ungeheuren Sensationen die Sie haben missen. Alles in Form v[on] Lektüre aufnehmen. Wenn morgen in allen Zeitungen stände es sei nicht wahr, kein Krieg, gar nichts—ich müsste es auch glauben.

Also beneide ich Sie!"

22. Macke und Marc 1964, p. 196; Marc 1978, pp. 156–57: "Das Blutopfer, das die erregte Natur den Völkern in grossen Kriegen abfordert, bringen diese in tragischer, reueloser Begeisterung. Die Gesamtheit reicht sich in Treue die Hände und trägt stolz unter Siegesklängen den Verlust."

23. Nuremberg, Nachlass Marc, no. 4: "wenn der Krieg sich glücklich entschieden hat sind wir dann doch vielleicht weniger einsam als es Dir jetzt vorkommt."

24. Since the oeuvre catalog is unpaginated, individual references cannot be given.

25. Entry number 128, *Befestigter Ort;* 132, *Frühstück mit der Deutschen Flagge;* 133, (*betonierte Anlage*); 140, *Gedanken an die Schlacht;* 141, *Gedanken an den Aufmarsch;* 162, *Eroberungsmaschine;* 166, *Der Krieg welcher das Land verwüstet* (Giedion-Welcker 1961, pp. 48–49); 167, *Der Deutsche im Geräuf* (Glaesemer 1973, p. 228, fig. 530); 172, *Tod auf dem Schlachtfeld;* 173, *Krieg in der Höhe* (Glaesemer 1973, fig. 533); 178, *Vorzeichen schwerer Schicksale* (Osterworld 1975, fig. 128); 179, *Der Krieg schreitet über eine Ortschaft* (Geelhaar 1975, pl. 34); 219, *Abstrakt kriegerisch.*

26. Cf. Droste 1979, p. 409.

27. Gollek 1982, p. 159, fig. 206.

28. Munich, Gabriele Münter-Stiftung: Klee, letter to Kandinsky from Berne, October 1, 1914: "Wir reisen am nächsten Sonntag nach München zurück."

29. Entry number 166, *Der Krieg welcher das Land verwüstet;* 167, *Der Deutsche im Geräuf;* 178, *Vorzeichen schwerer Schicksale;* 179, *Der Krieg schreitet über eine Ortschaft.*

30. *Der Cicerone* 7, nos. 5–6 (March 1915), p. 129: "München. Die Ausstellung 'Der Krieg', welche der Salon 'Neue Kunst', Hans Goltz, vor einiger Zeit eröffnete, umfasst jetzt folgende Namen: Bechstein, Caspar, Caspar-Filser, Eberz, Grossman, Hegenbarth, Klee, Klemm, Nymann, Oppenheimer, Pellegrini, Sewald, Schnarrenberger, Schülein, Thum, Unold u. a. m."

31. Hoffmann 1977, pp. 93 ff.

32. *Im Schützengraben,* 1914: T. Grochowiak, *Ludwig Meidner* (Recklinghausen, 1966), p. 115.

33. Entry number 18, no title, watercolor, (*abstr. Compos.*); 49, *Abstraction eines Motivs aus Hammamet;* 88, *abstracter Apparat f. Statik;* 99, ⟨?⟩ *Kubin* ⟨*plastisch abstract*⟩; 117, ⟨*abstract Garten Dämmerung*⟩; 118 ⟨*abstract Garten Dämmerung*⟩; 119, ⟨*Abstraction nach 1914 114*⟩, later inscribed *Motorisches einer Landschaft;* 201, *Zwei Vignetten* (a) *Der bevorzugte Baum,* (b) *abstracte;* 218, *abstract, farbige Kreise durch Farbbänder verbunden;* 219, *abstrakt kriegerisch.*

34. Portfolio *1914,* by René Beeh, *Hinter den Heeren,* by Erich Thum, *Kämpfe,* by Josef Eberz, and *Die Opfer,* by Hermann Ebers.

35. T. Mann, "Gute Feldpost," *Zeit-Echo* 1 (1914–15): 14–15, esp. p. 15.

36. Reed 1977, pp. 253–54.

37. *Zeit-Echo* 2 (1915–16): 2 (retrospective quotation of the program of 1914).

38. T. Däubler, "Die Führer," *Zeit-Echo* 1 (1914–15): 34.

39. Kornfeld, 1963, no. 62. The title *Schlachtfeld* appears on none of the extant prints.

40. Nuremberg, Nachlass Marc, no. 5, November 22, 1914: "Die ersten Nummern der neuen kl[einen] Kriegsmilchkuh mehr milchgeiss 'Kriegs Echo' oder 'Zeitecho' hat Dir Deine Frau geschickt. Ich sollte dafür als erstes eine Vignette zu einem zieml[ich] abstracten Gedicht von Däubler zeichnen. . . . Als schon 5000 Exemplare gedruckt waren, bekamen die Herausgeber Angst, wahrscheinlich dass man die harmlose Sache als hochverräterische Franzosenkunst nehmen würde, was die Abonnenten ablehnen müssten." Added at the bottom: "die 5000 wurden eingezogen und Nr. 3 ohne mich nochmals gedruckt."

41. Ibid.: "So rein zur Opposition wäre es ja ganz spassig, aber dazu sind die Bilder wieder zu gut."

42. Ibid., IIC, no. 29, December 11, 1914: "Ich hoffte immer schon, dass Dir der Geist dieser guten Gesellschaft auf die Dauer doch zu buntscheckig wird,—was thust Du auch in diesem Notstandszirkel?"

43. Marc, letter to Albert Bloch, from Hageville, November 22, 1914; New York, Guggenheim Museum, Klee Archive: "Die neue Secession ist schon sehr übel,— Maria sandte mir 2 Nummern des Zeit-echo, das vor allem in seiner Graphik schon trostlos ist, so eine Art Wohltätigkeits-ausgabe für notleidende malende Nicht-Combattanten, unter dem scheinheiligen Deckmantel von moderner Kunst. Mich ärgert immer, dass Klee bei der Gesellschaft mittut, die seine Gutmütigkeit, sein 'weites Herz' nur ausnutzt; denn er gehört mit keinem Strich seiner Arbeit dahinein."

44. Nuremberg, Nachlass Marc, no. 6, December 16, 1914: "Ich legte [Stein] gegenüber das Hauptgewicht darauf, keine Konzessionen machen zu müssen. . . . Ich bin deswegen [inserted: "künstlerisch"] nicht weniger isoliert, habe aber praktisch einen garantierten Anhalt."

45. Ibid.: Stein "weiss ebenso gut dass die Ehre eines Redakteurs [added on top of the line: "heute," added below the line: "schon jetzt"] darin liegt, links stehende Leute zu lancieren."

46. Zeit-Echo 1 (1914–15): 92. G. Trakl, Dichtungen und Briefe, ed. W. Killy and H. Szklenar, vol. 1 (Salzburg, 1969), p. 160.

47. See note 33. Thanks to Charles Haxthausen's criticisms, I am here reversing my earlier interpretation of the lithograph as a literal illustration of Trakl's text (Werckmeister 1981, p. 14).

48. G. Trakl, Dichtungen und Briefe, ed. W. Killy and H. Szklenar, vol. 2 (Salzburg, 1969), pp. 736–37: "im hiesigen Spital wegen Geistesstörung (Dement. praec.) in Behandlung stand, am 2. November nachts einen Selbstmordversuch durch Coccainvergiftung . . . unternommen hat und trotz allermöglichen ärztlichen Hilfe nicht mehr gerettet werden konnte. Derselbe starb am 3. November um 9 h abends."

49. Ibid., p. 737: "im k[aiserlichen] u[nd] k[öniglichen] Garnisonsspitale in Krakau fürs Vaterland gestorben."

50. M. Buber, "Das Gleichzeitige," Zeit-Echo 1:90–91.

51. M. Scheler, "Krieg und Tod," Zeit-Echo 1:95.

52. A. Kolb, "Briefe an einen Toten," Zeit-Echo 1:102.

53. Bern, Kunstmuseum, Hermann und Margrit Rupf-Stiftung; reproduced in the catalog Der frühe Klee (Baden-Baden, 1964): "was für ein Unglück für uns alle ist dieser Krieg, und insbesondere für mich, der ich Paris so viel verdanke und geistige Freundschaft mit den dortigen Künstlern pflege. Wie wird man nachher sich gegenüberstehn. Welche Scham über die Vernichtung auf beiden Seiten!"

Chapter 2

1. Report from Munich, Der deutsche Künstler 1, no. 10 (January 15, 1915): 97.

2. "Bevorstehende Auktionen," Der Kunstmarkt 12, no. 19 (February 5, 1915): 73. Cf. also A. Dobsky, "Kriegsbetrachtungen über Kunst und Kunsthandel," Der Kunsthandel 7, no. 5 (May 1915): 81–84, referring as far back as Christmas 1914. For reasons which are still unclear, Kunst und Künstler waited until its December issue to come out with the cautious statement: "On the art market, slight stirrings occur again. Dealers are testing the public's urge to buy with this or that offer, and the results are better than one could expect if one makes allowance for present conditions"; Kunst und Künstler 14 (1915–16): 211.

3. "Der deutsche Kunstmarkt im Kriege," *Der deutsche Künstler* 2, no. 1 (April 15, 1915): 3: "Wie das ganze Wirtschaftsleben, beginnt auch der Kunstmarkt sich in erfreulicher Weise wieder zu beleben. Nachdem die grossen Kunstauktionshäuser ihre Versteigerungen wieder angekündigt haben, mehren sich die Anzeichen einer Gesundung des Marktes. Überall übersteigt bereits die Nachfrage das Angebot. . . . Der regen Nachfrage kommt es natürlich sehr zugute, dass die Geldflüssigkeit überhaupt augenblicklich und zum Teil gerade infolge des Krieges ziemlich gross ist, und dann auch der Umstand, dass das Geld in diesem Jahre ganz und gar im Lande bleibt." Cf. also "Die Lage des Kunstmarkts," *Der Cicerone* 7, nos. 5–6 (March 1915): 127.

4. Rösler 1967, pp. 48 ff., 65; Feldman 1966, p. 116.

5. G. Walther, "Die Kunstkritik nach dem Kriege," *Der deutsche Künstler* 2, no. 3 (June 15, 1915): 17–18; G. Jahn, "Kunstkritik, Kunstmode und Kunstmarkt," ibid., pp. 25–26. Cf. A. Dobsky, "Deutsche Kriegskunst," *Der Kunsthandel* 7, no. 3 (March 1915): 54; H. Rosenhagen, "Die deutsche Kunst und ihre Feinde," ibid., no. 10 (October 1915): 189–93; A. Dobsky, "Kriegseindrücke vom Kunsthandel," ibid., no. 12 (December 1915): 241–44.

6. P. Fechter, "Bestätigung des Krieges," *Zeit-Echo* 1, no. 17 (1915): 261–63.

7. A. Behne, "Organisation, Deutschtum und Kunst," *Zeit-Echo* 1, nos. 23–24 (1915): 361–65.

8. Postcard of 29 December 1914: "Briefe von Paul Klee an Alfred Kubin," 1979, p. 86: "An den Krieg bin ich jetzt schon ganz gewöhnt. Er regt mich nicht mehr an. Ich bin ganz bei mir, irgendwo, jenseits unten, aber sehr lebendig."

9. H. Hartog, "Franz Marc und Heinrich Kaminski," *Neue deutsche Hefte* 22 no. 1 (1975): 68–93.

10. Nuremberg, Nachlass Marc, I C, January 14, 1915: "Ich muss mich über Klee wundern—er arbeitet so ruhig u[nd] gelassen weiter u. sehr gut, finde ich, nur ganz im selben Fahrwasser. Aber ich habe das Gefühl, für dieses Fahrwasser ist kein Krieg von Einfluss, es fliesst weitab vom Schauplatz der Kämpfe. Kommt es nun auch zum guten Ziel? ist ihm der richtige Weg vorgeschrieben, den es fliessen muss—ganz gleich ob mit ob ohne Krieg? ich glaube es fast. Aber es ist *merkwürdig*."

11. Ibid., January 19, 1915: "Merkwürdig ist Klee—. . . er fand Deinen Artikel II sehr schön—und sagte dann—er hätte *garkeinen* derartigen Gedanken;—es freut ihn sehr, dass jemand sie hat und schreibt! . . . Ihn berührt der Krieg innerlich überhaupt nicht. . . . Um so merkwürdiger, weil er künstlerisch so ganz sicher u. sehr reich empfindet."

12. Ibid., March 15: "Dass der Krieg auch nur den geringsten Einfluss auf den Geist der Menschen haben soll, leugnet er [sc. Kaminski], wie Klee."

13. Ibid., April 11, 1915: "Ich verstehe Klee ja auch nicht—einesteils diese Intelligenz—und andernteils diese Unklarheit."

14. Ibid., April 26, 1915: "Klee ringt nicht—quält sich nicht—leidet nicht."

15. Ibid.: "Er arbeitet *sehr* viel u[nd] ich halte es nicht für ausgeschlossen, dass er mal ein paar gute Sachen macht. Zum reinen grossen Schaffen wird er nicht kommen—er hat eben seine Grenzen!"

16. Cf. *Der Cicerone* 7, nos. 7–8, (April 1915): 160.

17. G. Wolf, "Die Neue Münchner Secession," *Die Kunst für Alle* 30 (1914–15): 278–80, esp. p. 278: "Die Frühjahrsausstellung der Neuen Münchener Secession, die in den Räumen des von einem vorwiegend konservativen Kunstpublikum besuchten Kunstvereins durchaus am falschen Platze war, stand an Bedeutung und Wert weit hinter der ersten Veranstaltung des Vereins im Sommer 1914 zurück. . . . Die Kunst, die sich in der Neuen Münchener Secession konzentriert, ist problematisch; zumindest ein sehr stattlicher Bruchteil der hier vereinigten Künstler hat seine Anregungen

und die entscheidende Richtung von den jüngsten Franzosen und Russen erhalten, und wir sind heute, wo wir uns bei allen Dingen äusserer und innerer Kultur wieder unseres Deutschtums erinnern, ganz und gar abgeneigt, derartige Vorbilder als nachstrebenswert gelten zu lassen."

18. H. Esswein, "Frühjahrsausstellung der Neuen Münchner Secession," *Deutsche Kunst und Dekoration* 36 (1915–16): 77–83, esp. p. 77: "entfesselte einen Entrüstungssturm mit Protestlisten, Lärmszenen und Schmähschriften. Zeitiger als bei ihrer Eröffnung bekanntgegeben worden, musste die Ausstellung geschlossen werden."

19. Wolf, "Die Neue Münchner Secession," p. 280: "Weder Klees phantastisch-pointillistische Kompositionen noch . . . können den Eindruck des Wohlgefallens bei einem normal empfindenden Kunstfreund auslösen."

20. Esswein, "Frühjahrsausstellung der Neuen Münchner Secession," p. 83: "Verfehlt wäre es, dem Terrorismus dieser Gegner irgendwelche Zugeständnisse zu machen, noch verfehlter aber, ihn durch die polemische Betonung der extremsten Note unserer neuzeitlichen Kunstbestrebungen herauszufordern."

21. Postcard from Klee to Kubin, March 13, 1915, "Briefe von Paul Klee an Alfred Kubin," 1979, p. 86: "Esswein tut irgendwie überlegen und blamiert sich sehr."

22. Ibid.: "Ich habe mich speciell mit der historischen Tat, jetzt 'Feindeskunst' zu veröffentliche[n], bewusst in die Brust gegriffen. Meine Abstracta machen sich in jenen Räumen sehr vielsagend."

23. After Wolf, "Die Neue Münchner Secession," p. 278: "Nachschleicher der Kunst unserer Feinde."

24. "Diese sinnlose Anmassung weisen wir zurück, die Beschimpfungen prallen an uns ab.

Als Deutsche Künstler, die wie alle anderen Bürger ihren Pflichten [?] dem Staate gegenüber in jeder Hinsicht nachkommen, haben wir von altersher ein vererbtes Recht auf geistige Freiheit. [text unreadable] Freiheit des Künstlers anzutasten[?] und ihn bevormunden zu wollen vergebens sein.

Wir sind von unseren Bestrebungen überzeugt, und deutsch ist, dass wir dafür kämpfen und uns nicht beirren lassen.

Wir arbeiten weiter.

März 1915.

Die Neue Münchener Secession."

25. For 1915, 75, see Glaesemer 1973, p. 237, no. 561; cf. *Paul Klee: Das Frühwerk 1883–1922* (Munich, 1979), p. 424, no. 285.

26. Postcard from Klee to Kubin, March 13, 1915, "Briefe von Paul Klee an Alfred Kubin," 1979, p. 86: "Das ist alles furchtbar wichtig trotz der grossen Zeit."

27. *Tagebücher,* pp. 365–66: "951 Man verlässt die diesseitige Gegend und baut dafür hinüber in eine jenseitige, die ganz ja sein darf.

Abstraction.

Die kühle Romantik dieses Stils ohne Pathos ist unerhört.

Je schreckensvoller diese Welt (wie gerade heute), desto abstrakter die Kunst, während eine glückliche Welt eine diesseitige Kunst hervorbringt. Heute ist der gestrige-heutige Übergang. In der grossen Formgrube liegen Trümmer, an denen man noch teilweise hängt. Sie liefern den Stoff zur Abstraktion. . . .

Ich meinte zu sterben, Krieg und Tod. Kann ich denn sterben, ich Kristall?

ich Kristall.

952 Ich habe diesen Krieg in mir längst gehabt. Daher geht er mich innerlich nichts an.

Um mich aus meinen Trümmern herauszuarbeiten musste ich fliegen. Und ich flog.

In jener zertrümmerten Welt weile ich nur noch in der Erinnerung, wie man zuweilen zurückdenkt.

Somit bin ich 'abstract mit Erinnerungen.'"

28. Haxthausen 1981, p. 423.

29. Nuremberg, Nachlass Marc, Klee letters, no. 9, June 8, 1915: "Ich habe einmal für ein naives Schweizer Publikum geschrieben, aber aus rein praktischen Gründen. Was etwa sonst in Tagebüchern steht hat rein biographischen Wert."

30. Ibid., no. 7, February 3, 1915: "Für mich ist ein Krieg eigentlich nicht mehr notwendig gewesen, aber vielleicht für die Andern alle die noch so zurück sind. Bei mir hatte sich das Gegenwärtige schon verbissen und zerstört. . . . Es gab nur ein Heil, sich von dieser Welt abzuwenden. Abstraction. Rückfälle stehen uns nicht so schlecht an, dass man sie gewaltsam vermeiden müsste. Man war Kind und hat seine Erinnerungen dran."

31. Marc 1982, p. 30.

32. "Der hohe Typus" (unpublished), Marc 1978, pp. 168 ff.

33. Marc 1978, pp. 185 ff.

34. Nuremberg, Nachlass Marc, Klee letters, no. 8: "Deine Aphorismen haben schon starke Wirkungen ausgeübt, ehe sie die zur Herausgabe definitive Gestalt erlangt haben. Ich fand drin eine Menge geglückter Gedanken und dichterischer Stücke dass ich nur wünschen kann Du möchtest bald Musse und Distanz finden sie zu vollenden. Es wird mir dann auch mehr als jetzt möglich sein das was sie zu mir passendes sagen zu bestimmen. Sicher sehr viel."

35. Marc 1978, pp. 187–88: "9. Vom ersten Moment des Kriegsausbruches an war mein ganzes Sinnen darauf gerichtet, den Geist der Stunde aus ihrem tosenden Lärm zu lösen. Ich verstopfte mein Ohr und suchte dem Kriegsgespenst in den Rücken zu sehen. Alle Zeichen des Krieges stritten wider mich. Sein Gesicht blendete mich, wohin ich mich wandte. Der Denker meidet das Gesicht der Dinge, da sie niemals das sind, was sie scheinen."

36. Ibid., p. 209: "85. Im grossen Krieg stand in irgend einer Stunde und Sekunde jedes Herze einmal, ein kleines einziges Mal ganz still, um dann mit leisem neuen Pochen wieder langsam aufzuhämmern der Zukunft entgegen. Das war die heimliche Todesstunde der alten Zeit."

37. Ibid., p. 193: "25. . . . Viele, die die innere Glut nicht haben, werden frieren und nichts fühlen als eine Kühle und in die Ruinen ihrer Erinnerungen flüchten."

38. Ibid., p. 211: "90. Wie schön, wie einzig tröstlich zu wissen, dass der Geist nicht sterben kann. . . .

Dies zu wissen macht das Fortgehn leicht.

Ich singe mit Mombert:

'Nur einen Flügelschlag möcht ich thun,

Einen einzigen!'"

39. Nuremberg, Nachlass Marc, no. 8, letter from Klee to Marc, April 28, 1915: "ich kann eben so gut diejenigen bewundern, die schweigend hinweggingen [corrected from "hingingen"] und jetzt nicht mehr sind, als denen recht geben die ihr Leben zu anderen Kämpfen erhalten wollen. Dementsprechend bin ich bereit jedes Schicksal auf mich zu nehmen, nicht gerufen zu werden, oder die grösste Hölle mit anzusehn oder zu erleiden."

40. *Briefe*, 1:768, to Lily Klee, Berne, July 30, 1911: "Gestern hab ich den Professor Lotmar aufgesucht. . . . Er hat auch auf dem Gebiet der Kunst ein Streben nach Modernität gezeigt, das mir neu war. Natürlich nicht auf dem direkten Weg (angesichts des Kunstwerks), sondern mehr durch Gelehrte. er findet auch den Privatdozenten Worringer hier, den mir Michel schon erwähnt hat, sehr beachtenswert. Der ist für die Distanz von Natur und Kunst, betrachtet Kunst als eine Welt für sich, ist nicht der Meinung, dass die Primitiven zu wenig gekonnt haben usw. Alles für

mich längst Errungenschaft, aber als wissenschaftliche Äusserung hocherfreulich."

41. Cf. Werckmeister, "From Revolution to Exile," 1987, pp. 39 ff.

42. Ibid., p. 41.

43. W. Kandinsky and F. Marc, *Briefwechsel* (Munich, 1983), p. 136.

44. Geelhaar 1972, pp. 24 ff.; cf. also, critically, Peg Weiss, *Kandinsky in Munich* (Princeton, 1979), pp. 158 ff.; Haxthausen 1981, pp. 424–25.

45. *Tagebücher*, p. 365, no. 951.

46. W. Worringer, *Abstraktion und Einfühlung*, 4th ed., unchanged (Munich, 1916), pp. 19–20, 134–35.

47. *Kandinsky: 1901–1913* (Berlin, 1913), p. xii.

48. W. Kandinsky, *Schriften* 1 (Berne, 1980), pp. 51–59, esp. p. 57: "Für mein damals noch vollkommen unbewusstes Gefühl kleidete sich die höchste Tragik in die höchste Kühle, also sah ich, dass die höchste Kühle die höchste Tragik ist. Und das ist die kosmische Tragik, in der das Menschliche nur ein Klang ist, nur eine einzige mitsprechende Stimme, und in der das Zentrum in eine Sphäre verschoben wird, die sich dem Göttlichen nähert."

49. "Zur Kritik der Vergangenheit," Marc 1978, pp. 117–18: "Alles ist eins. Raum und Zeit, Farbe, Ton und Form sind nur Anschauungsweisen, die der sterblichen Struktur unsres Geistes entstammen. . . . Der Tote kennt nicht Raum und Zeit und Farbe, oder nur soweit er in der Erinnerung der Lebenden noch 'lebt.' Er selbst ist erlöst von allen Teilempfindungen. Mit dem Tode beginnt das eigentliche Sein, das wir Lebende [sehnsüchtig] unruhevoll umschwärmen wie der Falter das Licht."

50. "Ich bin die Klippe, die nicht sterben kann," quoted by Lankheit 1976, p. 141.

51. Klee, *Tagebücher*, p. 292, no. 925, last, undated entry for the year 1913.

52. W. Hausenstein, *Die bildende Kunst der Gegenwart* (Stuttgart and Berlin, 1914), p. 308: "Seine Zeichnungen sind der letzte überhaupt noch graphisch materialisierbare psychologische Rest sinnlicher und mehr noch übersinnlicher Erlebnisse. Die Handschrift gewinnt dabei die äusserste Verdünnung, das Objekt gewinnt in der Zersetzung die äusserste Durchsichtigkeit. . . . man hat das Gefühl einer bis zur Kindlichkeit sublimen Verderbtheit, die aber keinen Moment im Stofflichen bleibt, sondern sich sofort mit grösster Intensität in künstlerische Anschauung umsetzt und das verwischteste Erlebnis mit einer Handschrift von namenloser, dennoch präziser Erotik niederzuschreiben weiss. Begriffe wie Dekadenz sind hier sinnlos: die Intensität und die Schärfe der Form überwindet zuletzt jegliche Zerrüttung."

53. Ibid., p. 307.

54. Ibid., p. 278.

55. W. Hausenstein, "Für die Kunst" (Ende 1914), *Die neue Zeit* 33, no. 1 (1914), pp. 154–60; reprinted in *Zeiten und Bilder* (Munich, 1920), pp. 143–51, esp. p. 148: "Die Funktion des Künstlers hört im Krieg auf. . . . Er fühlt, wenn er einigermassen ehrlich ist, das es zum Krieg kein sogenanntes ästhetisches Verhältnis gibt."

56. *Zeiten und Bilder*, p. 151: "Der Krieg ist etwas ungeheuer Gegenständliches. Die Kunst, mit der wir bis an die Schwelle des Kriegs gegangen waren, war nicht gegenständlich. Wir lebten im Sommer 1914 in einem Augenblick, in dem die Kunst zu einer—so schien es—unerhört abstrakten Formalität gediehen war. Die Erlebnisse des Künstlers waren nicht minder heftig und minder innig als je. Aber die Erlebnisse wurzelten ganz in der von allem greifbar Substanzartigen fast losgelösten spekulativen Formanschauung. . . . jeder Affekt, jede Situation übersetzte sich in reine formale Aequivalente. . . . Wird der Krieg die Überlieferung aufheben?"

57. W. Hausenstein [text without title], *Zeit-Echo* 1, no. 14 (1915): 212–15, esp. pp. 212–13: "Werden Krieg und Kunst in eine zu unmittelbare Verbindung gebracht, so werden sie polar. . . . Aber es hatte keinen Sinn und keine Würde, sondern war im äussersten Mass hilflos, wenn Künstler, die das erkannten, . . . ihr Leben gegen das Ereignis des Kriegs . . . abzuschliessen suchten, als gäbe es heute überhaupt einen

giltigen Gedanken, der gegen den Krieg aufkommen könnte, und als wären sie Pfleger dieses Gedankens."

58. Rosenthal 1975; for the modern European tradition of the motif, see Ingold 1978, pp. 337ff., without reference to Klee.

59. *Tagebücher,* p. 155, no. 425, June 22, 1902: "Ein fliegender Mensch!"

60. "Von der Natur mit einem Flügel besonders bedacht, hat er sich daraus die Idee gebildet, zum Fliegen bestimmt zu sein, woran er zu Grunde geht."

61. No. 585, January 1905, *Tagebücher,* p. 198: "Dieser Mensch, im Gegensatz zu den göttlichen Wesen, mit nur einem Engelsflügel geboren, macht unentwegt Flugversuche. Dass er dabei Arm und Bein bricht, hindert ihn nicht, seiner Flugidee treu zu bleiben.

Der Kontrast seiner monumental-feierlichen Haltung zu seinem bereits ruinösen Zustand war festzuhalten."

62. *Tagebücher,* no. 956, pp. 366–68, early 1915: "Was anfangs der Krieg mir sagte, war mehr physischer Natur: Dass Blut in der Nähe floss. Dass der eigene Leib in Gefahr kommen konnte, ohne den die Seele einmal nicht! Die blöd singenden Reserven in München. Die bekränzten Opfer. Der erste am Ellbogen umgekrempelte Ärmel, die Sicherheitsnadel dran. Das eine lange bayrischblaue Bein, zwischen zwei Krücken weit ausschreitend.

Die Verwirklichung des Buchstabens im Geschichtsbuch. Die Bestätigung alter Bilderbogen."

63. M. Beckmann, *Briefe im Kriege 1914–1915* (Munich, 1984), p. 13, October 3, 1914.

64. Entry number 10, *Kriegshafen;* 11, *Kristallinische Erinnerung an die Zerstörung durch Marine;* 12, *Das angreifende Schiffchen;* 16, *mit dem Belagerungsgeschütz* (Glaesemer 1973, fig. 549); 25, *Gebäude des Friedens ⟨Symbol⟩;* 55, *Schiffsarsenal ⟨normale Perspektive⟩;* 87, *Ansicht der schwerbedrohten Stadt Pinz ⟨kriegskartonartig⟩* (Geelhaar 1975, pl. 37).

65. Cf. Werckmeister, review 1987, pp. 66–67, 70.

66. Undated postcard from Gersthofen to Herwarth Walden, April 1917 (Sturm-Archiv, Blatt 9): "Das Blatt nach dem Sie fragen ist eine Lithographie die ich zu Anfang des Kriegs im Auftrag von Goltz machte. Die Herausgabe verzögerte sich bis zum letzten Herbst oder Winter, aus welcher Zeit die Hand-Kolorierung stammt."

67. M. Franciscono, "Paul Klees kubistische Graphik," in Glaesemer 1975, pp. 46–56, esp. pp. 48ff.

68. They were 1914, 32 *St. Germain (Abends etwas Provencestimmung);* 1914, 15, *Park;* 1914, 130, *Häuser und reife Felder.* Note in the oeuvre catalog: "Verkauf an Dr. Probst (Februar 1915)."

69. *Tagebücher,* p. 369, no. 959, undated: "Dr. Hermann Probst besitzt einige meiner Aquarelle und liebt sie scheints recht sehr. Auf seine Anregung hin hatte Rilke eine kleine Kollektion von mir zugestellt bekommen und brachte sie mir persönlich zurück."

70. Letter of 23 February 1921 from Rilke to Wilhelm Hausenstein, after Huggler 1967, p. 197, n. 1: "1915 brachte mir Klee etwa 60 seiner Blätter—farbige—ins Haus und ich durfte sie monatelang behalten; sie haben mich vielfach angezogen und beschäftigt, zumal Kairouan, das ich kenne, darin noch zu gewahren war." Rilke thus does not even mention Klee's drawings.

71. They were 1913, 161, *Ein Stückchen Eden;* 1913, 173, *Alte Stadt.*

72. The two were 1915, 151, *Drei Araber,* and 1915, 101, *⟨Auf eine Skizze aus Sidibuo Said zurückgreifend⟩.*

73. Bürgi bought 1915, 164 A 1, *Unterer Stockhornsee;* 1915, 165 A 2, *Oberer Stockhornsee;* 1915, 166 A 3, *Stockhornsee (trübes Wetter);* 1907, 22, *Strasse in der Hirschau.*

74. The oil was 1915, 163, *Abstract-architectonisches kl. Ölbild ⟨mit der gelben und blauen Kugel⟩*.

75. Postcard of April 29, 1915: "Briefe von Paul Klee an Alfred Kubin," 1979, p. 87: "Diese Tage besuchte mich Ihr engerer Landsmann Rilke. . . , um Aquarelle zu sehn; ich freute mich sehr darüber. Dieser Mann gehört ja nicht wie Däubler in unsern Kreis, und wenn ihm doch meine Kunst etwas sagt, so darf ich ihn schon zu meinem Publikum zählen, und ein kl[eines] Publikum aus feinen Köpfen ists, was ich mir wünsche."

76. Macke and Marc 1964, p. 205: "Ich liebe heute alle Menschen, deren Herz mit unserem Leben und mit dem Schicksalswillen dieses Krieges mitzittern. . . . Es gibt merkwürdigerweise doch auch viele, die ängstlich alles meiden, was ihre Seele in den Krieg hineinziehen könnte, die 'Neutralen' im Lande."

77. Nuremberg, Nachlass Marc, postcard from Marc to Klee, October 23, 1914: "Lieber Klee, gib Du mir wenigstens die Hand u[nd] lass uns brüderliche Freunde werden, über dem Grab dieser andern guten."

78. Reed 1977, pp. 215 ff.

79. Marc 1982, p. 50, letter to Maria Marc, March 17, 1915: "wie eine Vorahnung des Krieges."

80. Lankheit 1970, p. 218, no. 682. In *Franz Marc, Skizzenbuch aus dem Felde*, 2d ed. (Berlin, 1956), p. 6, Lankheit compares the composition with Leonardo's *Battle of Anghiari*.

81. Nuremberg, Nachlass Marc, Marc letters, no. 32.

82. In a postcard of April 18 to Lily Klee, Marc acknowleges his "laziness to write"; Nuremberg, Nachlass Marc, Marc letters, no. 33.

83. Nuremberg, Nachlass Marc, Klee letters, no. 8: "Vielleicht wird das ein im Feld stehender Krieger rätselhaft finden, wie man [added: "jetzt"] aquarellieren und violinieren kann. Und ich finde beides so wichtig! Überhaupt das Ich! Und die Romantik!"

84. Nuremberg, Nachlass Marc, Marc letters, no. 34: "Aber die Gewissensfrage—die Frage nach der Sache, nach dem Wesentlichen—bleibt doch die letzte und unumgängliche Frage, nicht Dein 'Ich und die Romantik'! . . . Wie soll man nur dieses Ichtum, diese Wurzel unserer europäischen Unreinheit und Unfrömmigkeit ausreissen?"

85. Ibid.: "Wo das Ich wichtig genommen wird, wichtiger als die *Sache,* da ist schlechte, unreine Kunst. Der Künstler ist Werkzeug und schafft selbstlos . . . die Alten nannten es Inspiration, Entrücktsein . . . und steht hinter seinem Werk, wie der Evangelist hinter dem Evangelium."

86. Nuremberg, Nachlass Marc, Klee letters, no. 9: "Was mein 'Ich und die Romantik' betrifft will ich nicht weiter unklug sein und Dinge sagen die falsch klingen können. Natürlich meine ich das göttliche Ich als Centrum. Es ist dies Ich für mich das einzige Zuverlässige, und mein Vertrauen zu anderen beruht auf den gemeinsamen Gebietsteilen. Dein Kreis und meiner schienen mir relativ erheblich viel gemeinsames zu haben. Etwa so: [drawing] und ich glaubte mich drauf verlassen zu können bis ich Angst bekam. Nun bin ich wieder ganz beruhigt."

87. F. Hebbel, *Tagebücher,* no. 2207: "Das Verhältnis der meisten Menschen zueinander = [figure of intersecting circles]." Thanks to Christian Geelhaar and Wolfgang Kersten, both of whom have pointed this passage out to me.

88. Cf. Marc and Macke 1964, pp. 181 ff.

89. Albert Bloch, "Kandinsky, Marc, Klee—Criticism and Reminiscence," 1934 lecture quoted in Lankheit 1976, p. 126.

90. F. S. Levine, "Iconography of Franz Marc's Fate of the Animals," *Art Bulletin* 58 (1976): 269–77.

91. *Kreise ⟨freiere und gebundener⟩.* The title has been entered into the oeuvre

catalog in pencil, hence perhaps at a later time, together with the owner note "Marc."

92. Cf. the transcription of that title in *Tagebücher,* p. 362, no. 937, August 1914.

93. Geelhaar 1979, p. 247.

94. Marc 1982, pp. 66–67: "Ich bin noch mehr als je in die Blumen u[nd] Blätter verliebt. . . . Mit Menschen kann man fast nie so verkehren; da stossen immer die Ich's aufeinander; am wenigsten vielleicht noch bei Klee."

95. *Tagebücher,* p. 370, no. 961, emphasis added: "Dein Kreis und mein Kreis schienen mir verhältnismässig viel gemeinsames Gebiet zwischen sich zu haben. Und ich verliess mich felsenfest darauf, weil ich doch die letzte Einsamkeit fürchtete. Nun bin ich nach einer vorübergehenden Erschütterung wieder ganz beruhigt."

96. Nuremberg, Nachlass Marc, Marc letters, no. 36: "Sei sicher: unsere Kreise schneiden sich noch immer erheblich. Deine bildl[iche] Darstellung davon ist aber zu starr. Man muss sich die Kreise in Wirbeln und Bahnen vorstellen, mit nötigen zeitweisen Entfremdungen, Durchkreuzungen, Zerteilungen u[nd] z[u] Zeiten auch schöne [added: "romantische"] Verfinsterungen. Unsere Sonne bleibt immer das *göttliche* Ich als Centrum."

97. *Tagebücher,* p. 372, no. 962: "Das verdammte Habit . . . begann ich nun richtig zu hassen. . . . Die feldgrauen Sachen hingen wie ausgedrücktes Gedärme zum Trocknen im Freien."

98. Marc 1982, p. 83: "warum es uns so auf die Nerven geht, wenn wir jemand sehen, der so thut, als ginge ihn der Krieg, auch als Ereignis, gar nichts an."

99. *Tagebücher,* p. 372, no. 962: "brennende Gärungen."

100. Marc and Macke 1964, p. 216.

101. *Tagebücher,* p. 374, no. 964, November 15: "Ich bin nicht sicher, ob er nun der Alte war oder nicht."

102. Marc 1982, p. 137: "Aber ich wehre mich unablässig gegen die herrschende Gedankenlosigkeit, den Krieg als solchen so zu hassen."

103. Ibid., p. 138, letter to Maria Marc, February 4, 1916: "Krieg als natürliche *Folge* u[nd] insofern als gerechte, unausbleibliche Sühne."

104. Ibid., p. 145, letter to Maria Marc, February 22, 1916: "Mein Blick hat sich *längst ganz vom Krieg abgewendet.* Mein Wesen sucht allerdings nicht die Indifferenz von Klee u[nd] Campendonk zu gewinnen."

105. *Tagebücher,* p. 374, no. 965, March 1916: "er kannte nun meine Abneigung zu theoretisieren."

Chapter 3

1. Rösler 1967, p. 70.

2. Ibid., pp. 137–38.

3. Feldman 1966, pp. 117, 120.

4. *Kunst und Künstler* 14 (1915–16): 517: "Geld scheint ja in Deutschland jetzt keine Rolle zu spielen. Der Gesamterfolg der Auktion, der von Optimisten mit 600,000 M. veranschlagt war, brachte noch reichlich 100,000 M. mehr. . . . Kriegsgewinnstanlage spielt dabei kaum mit."

5. *Kunst und Künstler* 15 (1916–17): 200; cf. A.L.M., "Die Versteigerung der Sammlung Hirth," *Der Cicerone* 13, no. 11 (December 8, 1916): "Die Auktion ergab das überraschend hohe Gesamtergebnis von eineinhalb Millionen Mark. . . . Der Mangel an Zufuhr wirkt auch auf den Kunstmarkt preissteigernd, und wer jetzt Ware hat, kann ausverkaufen, um damit zu räumen."

6. E. Herold, "Bilder, die man im Ofen bäckt," *Der Kunsthandel* 10, no. 7 (July 1918): 99–100, esp. p. 99.

7. "Zur Besteuerung des Kunstbesitzes," *Der Cicerone* 13, no. 17 (January 21,

1916): 70; "Der Kampf gegen die Besteuerung von Kunstwerken," ibid., no. 21 (February 18, 1916): 88; "Die Künstlerschaft gegen die Kunstwerke in der Kriegsgewinnsteuer," ibid., no. 33 (May 12, 1916): 152.

8. "Die ernste Kritik," *Der Sturm* 6, nos. 15–16 (November 1915): 87. The critic had attacked "die Faselei, der Krieg habe mit dem Expressionismus nicht nur nicht aufgeräumt, sondern seine Richtigkeit schlechthin und mit ungemeiner Schlagkraft gezeigt, erfüllt und bewiesen." Walden retorted: "Aber mit Krieg wird weder für noch gegen Kunst etwas bewiesen."

9. T. Däubler, *Der neue Standpunkt* (Dresden-Hellerau, 1916).

10. *Tagebücher,* p. 374, no. 965, March 1916: "1916. Ein Schicksalsjahr.... Am 4. März fiel mein Freund Franz Marc bei Verdun. Am 11. März wurde ich als Rekrut von 35 Jahren zum Militärdienst eingezogen."

11. Ibid., p. 376.

12. Letter of February 8, 1916 to Kubin: "Briefe von Paul Klee an Alfred Kubin," 1979, p. 87.

13. Roethel 1971, p. 113 (fig.).

14. Vishny 1978, p. 236.

15. Geelhaar 1979, p. 248.

16. *Tagebücher,* pp. 383–84, no. 971, March 17, 1916. On April 16, Klee moved to another place; see p. 390, no. 993.

17. Ibid., p. 385, no. 975.

18. *Briefe,* 2:798: "Ich habe gestern Violin gespielt bis spät.... Heut nachmittag mal ich vielleicht. Natürliche Scheu hält mich bis jetzt davon zurück, ich muss mich auch erst auf einen leichteren 'Gelegenheitsstyl' einstellen."

19. *Tagebücher,* p. 387, no. 982: "Hie und da spiel ich Geige. Vor d[em] Malen hält mich grosse Scheu ab." Cf. *Briefe,* 2:798, to Lily Klee, March 28, 1916.

20. L. Schreyer and Nell Walden, *Der Sturm: Ein Erinnerungsbuch an Herwarth Walden und die Künstler aus dem Sturmkreis* (Baden-Baden, 1954), p. 261.

21. Berlin, Sturm-Archiv: "Ich nehme also die Tragik der Miniatüre mit vermehrter Last auf mich und ermässige die Nettopreise *von 100 Mark an aufwärts* um *20 %.*"

22. *Tagebücher,* p. 387, no. 982. See *Briefe,* 2:798, to Lily Klee, March 29, 1916.

23. *Briefe,* 2:802, to Lily Klee, April 4, 1916.

24. Letter of April 10, 1916: "Briefe von Paul Klee an Alfred Kubin," 1979, p. 90: "der da in der Kolonne schwergestiefelt abgebräunt und bestaubzuckert mittrottet."

25. *Briefe,* 2:816, to Lily Klee, May 19, 1916: "Ich muss ihm dann noch Ersatz schicken, da er noch mehr Verkäufe machen möchte." See *Tagebücher,* p. 394, no. 995d.

26. *Briefe,* 2:816, 819, 820, to Lily Klee, May 19, May 26, June 9, 1916. See *Tagebücher,* pp. 396–97, nos. 997, 998.

27. *Tagebücher,* p. 456, no. 1112, April 5, 1918.

28. Nuremberg, Nachlass Marc, Prod. 16.

29. "Franz Marc†," *Frankfurter Zeitung,* March 7: "Franz Marc ist gefallen!... Seinen jungen Ruhm hat er nicht lange überlebt. Denn erst am Anfang dieses Winters, anlässlich einer Berliner Sturm-Ausstellung, entdeckte man, was viele Jahre nicht erkannt werden sollte, in den Bildern Franz Marcs: die Phantasie und Seele eines *echtdeutschen* (auf deutsch soll der Nachdruck liegen) Künstlers."

30. "Frank Marc im 'Fegefeuer des Krieges," *Frankfurter Zeitung,* 2d morning edition, March 9, 1916: "Was er dort innerlich erlebte, hat er in einem Aufsatze 'Im Fegefeuer des Krieges' niedergelegt."; "Im Fegefeuer des Krieges," *Frankfurter Nachrichten,* March 9, 1916, with the same preamble.

31. Marc and Macke 1964, p. 212: "Walden ist für mich ein bis jetzt leider notwendiges Übel."

32. H. Walden, "Franz Marc" [Nachruf], *Der Sturm* 6 (1916): 133; reprinted in Walden 1918, pp. 7–8: "Wie das Wunder durch Dich auf die Erde kommt, die nun entzaubert und verwundert ist: mit grossen erstaunten Kinderaugen nun in die Welt sieht, die sich über den Augen aller Kämpfer wölbt. Sichtbar nur für grosse, erstaunte Kinderaugen. Künstler und Kinder finden, was sie suchen. Sie sehen, sie hören, sie fühlen. Sie springen im Tal, sehen die Berge, hören die Stimme und fühlen Gott. . . . der Vogel dort erhebt sie und sie sind eins mit der Erde, weil sie sich in der Welt fühlen."

33. Sturm-Archiv, Blatt 1: "Sollte man nicht im Sturm wieder etwas bringen? Aber etwas Neues von 1915. Es ist die Fülle vorhanden."

34. Cf. Werckmeister, "From Revolution to Exile," 1987, pp. 42 ff.

35. On May 24, Klee, in a postcard to Walden, expresses himself "sehr erfreut" about his continuing sales, hopes "für die Zukunft Gutes" and claims six author's copies of the *Sturm* issue with his drawing; Sturm-Archiv, Blatt 3.

36. The following argument was suggested to me by Wolfgang Kersten.

37. Marc, "Im Fegefeuer des Krieges" (fall 1914), ed. Lankheit, pp. 158–59: "wir können nicht denken. Wir können nur primitiv erleben; unser Bewusstsein schwankt oft zwischen zwei Fragen: ist dieses tolle Kriegsleben nur ein Traum, oder sind unsre Heimatgedanken, die uns manchmal streifen, der Traum? Eher scheint beides ein Traum zu sein, als beides wahr. . . . also liegen wir wohlgeborgen unter dem Zenith der grossen Geschosskurve. . . . Wir schlafen in unsre Mäntel gehüllt. . . . Nun ist ein jeder für sich und kann träumen."

38. Thanks to a meticulous critique of Charles Haxthausen, I have expanded this section of my original text and significantly altered my conclusions.

39. Changes of titles:

Watercolors

1914
102 [pencil:] ~~mit d. braunen Spitzen~~ Parkkomposition
111 ~~Erinnerung eines Erlebnisses~~ Orientalisches Erlebnis
119 [pencil:] ⟨~~Abstraction nach 1914 114~~⟩ Motorisches einer Landschaft
127 [pencil:] ~~mit d. 3 braunen Dreiecken~~ [no title]
141 ~~Gedanken an den Aufmarsch~~ Geordnetes Pathos

1915
31 [pencil:] ⟨~~Lustig?~~⟩ Lachende Gotik
70 [pencil:] ~~Durchleuchtungen (orange-blau)~~ Komposition transparenter Orange und Blau
72 [pencil:] ~~Durchleuchtungen (rot u. grün)~~ Komposition transparenter rot-grünblau
103 [pencil:] ⟨im Sinn von 87, 91–93, etwas gegenständlicher, mit der Strassenwendung⟩ Villenort mit der Wegwendung
116 [pencil:] ⟨~~kleine schwarze tür~~⟩ Schwarz und verschiedene Rot
118 [pencil:] ⟨mit dem blauen [drawing of a triangle] (~~Himmels~~ = [drawing of an inverted triangle]
131 [pencil:] ⟨nach e. Impr. beim Milchhäusl⟩ Restaurationsgarten
173 ~~Composition~~ [pencil:] ⟨freier als Beispiel 143⟩ tonig Architektur der Höhe bläulich rötlich
178 Neuer Stadtteil [pencil:], ⟨~~aus den Tagen in Frybourg~~⟩ französische Schweiz
181 [no title] Mit dem gelben [drawing of square] in der Mitte
219 ⟨~~mittelalterliche Stadt~~⟩ Stadtkomposition
223 ⟨Stadt ~~emporwachsend, sich verdüsternd~~⟩ nach der Höhe sich fortsetzend

224 ~~⟨orange-ultrm.blau grünviolett umdämpft kl. orange Gestirn⟩~~ Komposition orange und blau mit dem kleinen Gestirn

230 ⟨Vorstadtbildchen im grossen koloristischen Stil⟩ [pencil, later:] Ausschnitt einer Stadt Ausschnitt einer Stadt

Paintings

1913

122 (B) Kakteen ~~hinter Butzenscheiben~~

Drawings

1909

69 Blick ~~vom~~ am Atelier ~~in der Feilitzstrasse (Schneeschmeize)~~

40. Kröll 1968, who, however, does not deal with the issues raised here and generally does not relate the significance of Klee's titles to the public response to his work at any given time in his career.

41. P. Paret, *The Berlin Secession* (Cambridge, Mass., 1980), p. 240.

42. Klee has pasted the printed list of pictures from the catalog of the Sturm exhibition into his oeuvre catalog. The sales are marked near the titles of the individual works in the oeuvre list itself, and only some are also marked in the actual lists of Klee's current sales. It follows from both these entries that 1915, 190 and 1915, 45 were sold before July; 1915, 178 in July; and 1914, 1 and 1914, 5 in October.

43. Sturm-Archiv, Blatt 5: "Möge es so weiter gehn (woran ich gar nicht mehr zweifle)."

44. See the characterization of this style by Glaesemer 1976, pp. 34–35.

45. For example, 1914, 119, 141; 1915, 103, 178, 230.

46. Hagen, Karl-Ernst-Osthaus-Archiv, No. F2/422, Blatt 1.

47. Hagen, Karl-Ernst-Osthaus-Archiv, No. F2/422, Blatt 2: "Ich freue mich, in Ihrer Sammlung vertreten zu sein und will daher ausnahmsweise auf Ihren Vorschlag (Zeichn[ungen] und Aquarell 5 Blätter—300 Mark) eingehen."

48. They were 1914, 140 *Gedanken an die Schlacht,* which in the oeuvre catalog is marked, inexplicably, "Verkauf durch Goltz Jan. 1918"; 1915, 183; 1915, 192, *Mit den 4 Reitern;* 1915, 212, *Landung in Salonik;* 1916, 10.

49. Thus, 1915, 183, *Pflanze, tonig, gelblich belebt;* 1916, 10, *violett-gelber Schicksalsklang mit den beiden Kugeln.*

50. Since this title in the oeuvre catalog is written in pencil, it is possible that it was entered after the watercolor had been retitled for the second showing.

51. Only the early oil painting *Kakteen und Tomaten* (1912, 169) was sold to Wolfskehl, a personal acquaintance and admirer of Klee's. The note "verkauft" entered for three watercolors of 1915 clearly refers to the later sale, noted under 1917 as "Verkäufe der M. Neuen Secession in Frankft. a. M. (lt. Frl. Weeber)."

52. I.e., 1915, 223 ~~⟨Stadt emporwachsend, sich verdüsternd⟩~~ Wachstum der Häuser Aquarell 200 brutto

1915, 131 [pencil:] ~~⟨nach e. Impr. beim Milchhäusl⟩~~ Restaurationsgarten Aquarell 150 brutto

1915, 175 [pencil:] ⟨schweres Pathos⟩ [in summer exhibition 1916 of New Munich Secession still entitled *Abstraktes Aquarell*] 250 brutto

53. Since this is one of the titles written in pencil in the oeuvre catalog, it is hard to say when the watercolor was given its definitive title.

54. This is all the more important since in the oeuvre catalog the watercolor is entered next to two others with the word "pathos" in their titles: 175 ⟨schweres Pathos⟩, 176 ⟨nicht ganz schweres Pathos⟩, 177 ⟨leichtes Pathos, abstract⟩. All three entries are in pencil.

55. See her account of the planning in her letter to Gabriele Münter, in Kandinsky and Marc, *Briefwechsel*, p. 282.

56. Munich, Gabriele Münter-Stiftung, postcard of January 17, 1917: "Die Gedächtnisausstellung . . . war ein künstlerisches Ereignis u. brachte Frau Marc auch grossen materiellen Erfolg."

57. Letter from Klee to Maria Marc, May 24, 1916: Nuremberg, Nachlass Marc, Prod. 12.

58. Ibid.: "Dass die Neue Sec[ession] einen Katalog mit e[inem] Vorwort biographischen Charakters zu ihrer Marc Ausstellung anfertigt, ist doch eigentlich selbstverständlich, wenn es auch nicht höflich war, sich nicht mit Ihnen zu besprechen. Nun hat ja Piper Sie orientiert und Sie können sich mit ihm leicht besprechen was Ihnen recht ist und was nicht. Ich habe nur den Auftrag erhalten, zum Ausstellungs Katalog ein biographisches Vorwort zu schreiben von höchstens 6 Druckseiten. Natürlich tu ich das gern und hoffe, von Ihnen, wenn es nötig sein sollte, unterstützt zu werden. Da Piper schrieb, dass er sich an Sie gewendet habe, hielt ichs nicht für notwendig, Sie zu informieren."

59. Nuremberg, Nachlass Marc, letter from Maria to Franz Marc, April 11, 1915: "Ich verstehe Klee ja auch nicht—einesteils diese Intelligenz—und andernteils diese Unkarheit." Ibid., June 25, 1915: "Die Münter . . . denkt doch wenigstens, im Gegensatz zu Klee's." Ibid., August 29, 1915: "Ich bin sicher, dass Klee's durch ihre gänzliche Gefühllosigkeit, mit der sie sich gegen den Krieg wappnen, in einen geistigen Stillstand geraten, der ihnen nie mehr grosse Schritte erlaubt."

60. Ibid., letter from Klee to Maria Marc, July 17, 1916: "Wenn Ihnen der Hausensteinsche Aufsatz gut gefällt stehe ich gern zurück. Erst tat es mir etwas leid, nun aber sehe ich ein, dass ich mir an dieser Stelle einen gewissen Zwang hätte antun müssen."

61. Quoted after K. Lankheit, ed., *Franz Marc im Urteil seiner Zeit* (Cologne, 1960), pp. 89 ff.: "Der Maler, der in diesem Frühjahr als bayerischer Artillerieleutnant gefallen ist, war nicht ein Freund des Mars. Aber noch weniger war er ein Künstler in jenem engen Sinn, der die Schöngeistigen von der allgemeinen Zeitgeschichte abschliesst und sie der empfindsamen Pflege des Reizenden überlässt."

62. Nuremberg, Nachlass Marc, letter from Klee to Maria Marc, July 17, 1916: "und werde dann meine jetzt angefangene Sache Walden überlassen."

63. Geelhaar 1979, p. 247.

64. *Tagebücher*, p. 383, no. 970, March 16, 1916: "Manchmal fällt mir das Wort Marc ein, ich bin betroffen und sehe etwas einstürzen."

65. Ibid., p. 399, no. 1007, July 1916: "Schiesserei genauer. Ernsthafte Gefechtsübungen."

66. Geelhaar's attempt (1979, pp. 255 ff.) to clarify the relationship between the three versions in which this text is extant should be revised. The earliest one is that written in ink in the current diary, fol. 523–24, not, as Geelhaar thinks, the shorter, sketchy one jotted down in pencil on the facing empty verso pages, fols. 522 ff. The latter version does not even mention Marc, but is an excerpt of only the passages on Klee himself. It is from this excerpt that Klee later developed the lengthier version of the supplementary manuscript, which likewise deals only with himself. Only such a sequence of the three texts would make sense, for Klee would hardly have started his catalog preface about Marc with a self-description pure and simple, only to expand it later by the comparison with his friend. It was on the contrary Klee's habit to develop self-representations from comparisons with his friends. Moreover, his model had been Walden's Marc obituary (see below). The version of the supplementary manuscript is inscribed "für Zoff," not "für Zahn," as Geelhaar, p. 257, reads. Zahn would certainly have used this text just as he did the diary entries which Klee excerpted for

him at the end of the supplementary manuscript. Wolfgang Kersten has ascertained that "Zoff" most likely refers to the writer Otto Zoff (1890–1963), whose book *Der Winterrock* appeared in 1921 from the Georg Müller publishing house in Munich. Zahn featured him in *Der Ararat* 3 (August–September 1921): 250. It is not known what Zoff may have intended to do with Klee's text.

67. *Tagebücher*, p. 400, no. 1008: "Als ich einmal von mehreren Malen in Fröttmanig die Munitionsanstalt bewachte kamen mir etliche Gedanken über Marc u[nd] seine Kunst. Das Kreislaufen um ein paar Munitionsmagazine war so recht geeignet sich mit Musse zu versenken. Tags stimmte eine fabelhafte Hochsommerflora außerdem noch besonders farbig und nachts und vor Sonnenaufgang spannte sich über mir und vor mir ein Firmament das die Seele in grosse Räume dahinzog."

68. Ibid.: "Wenn ich sage, wer Franz Marc ist, muss ich zugleich bekennen, wer ich bin, denn vieles, woran ich Teil nehme, gehört auch ihm."

69. "Franz Marc, wüssten sie, wie der Künstler sie liebt, diese Blinden, denen er das Licht gibt, alles Feuer würde sie selber verzehren, ehe es den Menschen frisst, der allein und nur, ihnen allen Vater und Mutter, Geliebter und Geliebte ist."

70. "Menschlicher ist er, er liebt wärmer, ausgesprochener. . . . Kein Wunder dass er mehr Liebe fand. Edle Sinnlichkeit zog wärmend ziemlich viele an. . . . Meine Liebe ist religiös."

71. "Ihm schien die Erde, ihm redeten die Tiere, die Wälder und die Felsen.

Ihn zog der Mensch nicht an, den er ausziehen musste. Der erst hinter den Dingen stand. Er sah die Dinge an sich, die Andere sich erst aufbauen müssen. Er stand vor den Felsen und die Felsen fügten sich ihm. Er wandelte zwischen den Bäumen und der Wald umstellte sich ihm."

72. "Zu den Tieren neigt er sich menschlich. Er erhöht sie zu sich. Er löst nicht sich zuerst als zum Ganzen zugehörig auf um sich dann nicht nur mit Tieren, sondern auch mit Pflanzen und Steinen auf einer Stufe zu sehn."

73. "Sein Reich ist nicht von dieser Welt. Aber die Erde war ihm heimisch. [Künstler und Kinder] . . . sind eins mit der Erde, weil sie sich in der Welt fühlen. Dir war die Erde heimisch, aber Dein Reich ist in der Welt."

74. "In Marc steht der Erdgedanke vor dem Weltgedanken."

75. "Der Erdgedanke tritt [sc. bei mir] vor dem Weltgedanken zurück." This is an addition in the pencilled version of the text.

76. "Wie das Sein durch Dich Glühenden glüht. / Wie ich Dich liebe, Franz Marc. / Wie Du mir entgegenglühst / Wie ich Dir entgegenglühe."

77. "Meine Glut ist mehr von der Art der Toten oder der Ungeborenen."

78. "Künstler und Kinder finden, was sie suchen. Sie . . . fühlen Gott. . . . Dir, Künstler Gottes."

79. "Ich suche nur bei Gott einen Platz für mich, und wenn ich zu Gott verwandt bin . . ."

80. "Ich suche hierin einen entlegeneren, schöpfungsursprünglicheren Punkt, wo ich eine Art Formel ahne für Tier, Pflanze, Mensch, Erde, Feuer, Wasser, Luft und alle kreisenden Kräfte zugleich."

81. Letter of Lily Klee to Walden, March 15, 1916, Sturm-Archiv, Blatt 25.

82. Klee's correspondence with Walden does not refer to the project.

83. Geelhaar 1972, p. 25.

84. "In Marc steht der Erdgedanke vor dem Weltgedanken (ich sage nicht, dass er sich nicht hätte dahin entwickeln können, und doch: warum starb er dann?)."

85. *Tagebücher*, pp. 232–34, nos. 744–45, January 1906: "Mir träumte ich erschlug einen jungen Mann, und hiess den Sterbenden einen Affen. [Der] Mann war empört, er liege doch in den letzten Zügen. Desto schlimmer für ihn, antwortete ich, dann kann er sich nicht mehr hinaufentwickeln!"

86. W. Benjamin, *Gesammelte Schriften*, 2, pt. 1 (Frankfurt, 1977), p. 367 ("Karl Kraus," 1931).

87. As suggested to me by Charles Haxthausen.

88. "Der Übergang der Zeit bedrückte ihn, die Menschen sollten mit ihm gehen. Weil er selbst noch Mensch war und ein Rest von Ringen ihn fesselte. Der letzte Zustand, wo das Gute noch Gemeingut war, das bürgerliche Empire, kam ihm beneidenswert vor."

89. Munich, Bayerisches Kriegsarchiv, Kriegsstammrollen 7762, R. J. R. 2, Ers. Batl., 1. Kompanie Nr. 2428:
"11. III. 16
2. Landw. Inf. Reg. Landshut Rekr. Dep.
20. 7. 16 z E/R. I. R. No. 2 1. E . . . Kp.
11. 7. [error!] 16 z. Fliegerers. Abteilung Schleissheim vers. lt. Brig. Verf. v. 9. 8. 16 No. 33667."
I have been unable to locate Brigade Order No. 33667, which would presumably clarify the circumstances of Klee's transfer.

90. *Tagebücher*, p. 404, no. 1012, July 1916: "Als ich längst zu Haus schlief und es mir gut zu gefallen begann bei diesem Truppenteil wurde einmal plötzlich auf dem Exercierplatz während der Rast bei einer der unzähligen Gefechtsübungen mein Name gerufen. Hier! Sofort zum Bataillonsarzt, zuerst zum Feldwebel.

Mir kam das gleich ziemlich bedeutsam vor. Der Feldw[ebel] empfing mich sehr aufgeräumt. Wollens nicht fliegen? Ich? Ja, Sie haben sich doch zu den Fliegern gemeldet! Verzeihung Herr Feldwebel ich weiss nichts davon! Nun, damit Sie sich auskennen, wir haben Eana g'meldet."

91. Ibid.: "Grüss Gott Klee, lassen sich's gutgehn! Auch die anderen Chargen schmunzelten. Der Schreiber schüttelte mir lächelnd die Hand."

92. M. Pulver, "Erinnerungen an Paul Klee," *Das Kunstwerk* 3, no. 4 (1949): 28–32, esp. pp. 23–24; reprinted, slightly expanded, in L. Grote, *Erinnerungen an Paul Klee* (München, 1959), pp. 18–26.

93. Letter of Klee to Osthaus, August 31, 1916, Hagen, Karl-Ernst-Osthaus-Archiv, No. F27422: "In meiner militärischen Laufbahn ist eine Veränderung erfolgt, ich wurde plötzlich, wahrscheinlich als zweifelhaft 'K. V.', nach Schleissheim zur Flieger Ersatz Abt[eilun]g versetzt und bin jetzt da auf der Werft tätig."

94. *Tagebücher*, p. 405, no. 1013, undated: "Nun nachdem wir uns sicher fühlten waren wir nicht nur Maler mehr, sondern Kunstmaler. Wir erregten damit etwas Kopfschütteln. Nur der Kompagnieschreiber war erfreut. Wir würden jetzt gerade eine Arbeit bekommen, an der wir unsere Kunst erproben könnten."

95. Ibid., p. 406, no. 1018, October 23, 1916: "Zwei Wandtafelgestelle lasiert. An Aeroplanen alte Nummern ausgebessert, neue vorn hinschabloniert."

96. Ibid., pp. 406–7, no. 1021: "Habe heute den kaputten Aeroplan aufräumen helfen, auf dem 2 Flieger vorgestern ihr Leben liessen. Übel zugerichteter Motor etc. Ganz stimmungsvolle Arbeit? . . . Dann hab ich wenigstens das Erlebnis mit der gestürzten Maschine gehabt." Cf. *Briefe*, 2:831, to Lily Klee, November 10, 1916.

97. *Tagebücher*, p. 406, no. 1018, October 23, 1916: "Gerücht vom Exercieren gegen 4 Uhr aufgetaucht. Dann den günstigen Moment erwischt und aus der Kolonne entwischt. Dadurch hübsch Zeit gewonnen. Ob Folgen, wird sich zeigen.

Ich war bis jetzt biederer Rekrut, zahm und gehorsam. Dafür Urlaubsverpatzung. Konsequenz: kein biederer Rekrut mehr. Die Kolorierung der Litho f[ür] Goltz in Angriff genommen." Cf. *Briefe*, 2:830, to Lily Klee, October 23, 1916.

98. *Tagebücher*, p.407, no. 1021a, early November 1916(?): "'Sonst geht's mir gut', immer auf militärische Tücken gefasst. Aber es wird schon wieder die Zeit für eine Compensation kommen . . . Werde heute abend (Samstag) arbeiten, etwas Petroleum ist da und ein warmes Zimmer."

99. *Briefe*, 2:829, to Lily Klee, October 12, 1916: "einen kleinen Urlaub."

100. Hagen, Karl-Ernst-Osthaus-Archiv, No. F 2/1162, letter from Goltz to the Folkwang Museum, October 9, 1916: "In meinem Verlage erscheint eine neue Originallithographie von Paul Klee Erobertes Fort. . . . Paul Klee, dessen Bedeutung immer weiteren Kreisen offenbar wird, gehört zu den Künstlern, die unbekümmert um Anfeindung und Missverstehen ihren Weg gehen."

101. Kornfeld 1963, no. 68.

102. *Schriften*, ed. Geelhaar, p. 108: "Zerstörung, der Konstruktion zuliebe?"; cf. Werckmeister, review, 1987, p. 66.

103. Nuremberg, Nachlass Marc, Klee letters to Maria Marc, no. 7: "Lange dauert dieser Zustand der Zerstörung, Gründlich geht man [added: "darin"] vor, um: schliesslich heil zu sein."

104. Ibid., no. 8: "Sie haben entschieden dass Franz nicht länger im Soldatengrab liegen soll, besonders da es unter Umständen auch noch der allgemeinen Zerstörung anheim fallen kann. Wie viel Kraft ist doch in Ihnen, dass Sie es unternahmen. Herzlichen Dank noch insbesondere für die schönen Zeichnungen. Wie gut dass noch Hoffnung ist etwas Positives zu schaffen und nicht nur Zerstörung überall."

105. Klee began to develop this set of motifs as early as 1913, in response to Marc's "cosmic" imagery; cf. Naubert-Riser 1978, p. 53.

106. According to Faust 1974, pp. 35 ff., the words "Mond, Sonne, Stern, Gestirn, Himmel, kosmisch" occur by far most frequently in the titles of works from the years 1914–20, the second of eight periods which the author has distinguished for statistical, not historical reasons.

Chapter 4

1. Feldman 1966, pp. 391 ff.

2. The ordinary budget, as distinct from the war budget, projected a deficit already for 1916; Holtfrerich 1980, p. 114.

3. Rösler, 1969, pp. 109–10.

4. P. C. Witt, "Finanzpolitik und sozialer Wandel in Krieg und Inflation 1918–1924," in H. Mommsen, D. Petzina, and B. Weisbrod, eds., *Industrielles System und politische Entwicklung in der Weimarer Republik* (Düsseldorf, 1974; paperback edition, 1977), pp. 395–425, esp. pp. 408 ff.; Holtfrerich 1980, p. 103.

5. *Kunst und Künstler* 15 (1916–17): 245: "Die Versteigerung . . . übertraf mit ihrem Gesamtresultat von nahezu anderthalb Millionen Mark alle Erwartungen. . . . Die grossen Händler, denen die Einfuhr sehr erschwert ist und die Mangel an Ware in diesen höchst kauflustigen Zeiten fürchten, 'hamsterten' förmlich, ohne Rücksicht auf normale Preishöhen"; cf. also "Die Versteigerung der Sammlung von Kaufmann" [on December 4], *Der Cicerone* 10, nos. 1–2 (January 1918): 24.

6. *Der Kunstmarkt* 15, no. 1 (October 5, 1917): 5; cf. *Der Kunsthandel* 9, no. 11 (November 1917): 241.

7. *Der Cicerone* 9, nos. 13–14 (July 1917): 260; A.L.M., "Kunstauktion und Marktwert," *Der Kunstmarkt* 14, no. 37 (June 15, 1917): 229–31; W.K., "Versteigerung der Galerie Flechtheim," ibid., pp. 231–32.

8. *Kunst und Künstler* 15 (1916–17): 591.

9. A. Mayer, "Kunsthandel und Krieg," *Der Kunsthandel* 9, no. 1 (January 1917): 1–3, esp. p. 3: "Es hat sich erwiesen, dass die in jeder Hinsicht ganz frisch beginnenden Sammler den *neuesten Tendenzen* viel mehr zugetan sind und modernste Kunst viel leichter kaufen als solche, die durch schon früher betätigtes Interesse etwas 'voreingenommen' sind."

10. *Kunst und Künstler* 15 (1916–17): 346–47.

11. Nell Walden 1963, p. 22.

12. *Kunst und Künstler* 15 (1916–17): 197.

13. See the perceptive conclusions in "Versteigerung der Sammlung Kaufmann," *Der Kunsthandel* 10, no. 1 (January 1918): 2–5, esp. pp. 2–3.

14. *Kunst und Künstler* 15 (December 1917): 197.

15. E. Müller-Wulckow, "Die Sammlung Kirchhoff in Wiesbaden," *Das Kunstblatt* 1 (1917): 102–9, esp. pp. 102, 109.

16. E. Waldmann, "Der Krieg und die Bilderpreise," *Kunst und Künstler* 15 (1916–17): 376–84, esp. p. 378: "Woran liegt nun dieses starke Überwiegen der Nachfrage gegenüber dem Angebot? Einmal an dem . . . Zustand, dass die Kunst vielen ein Bedürfnis geworden ist. Man sucht geistige Erholung im Verkehr mit Kunstwerken, vielleicht auch Vergessen. Es scheint, dass man in den Stunden, die man mit Kunst zubringt, den Jammer des Krieges und den Wahnwitz dieser Zeit vergisst." Cf. L. Brieger, "Die Zukunft der Kunst," *Der Kunsthandel* 9, no. 10 (October 1917): 209–10.

17. Reed 1977, pp. 209 ff., 222.

18. *Tagebücher*, p. 426, no. 1043, January 9, 1917: "Wir sprechen, planen ein Buch und Geschäfte."

19. Vogel 1980, p. 327. This article gives an exhaustive, well-documented account of the training school and of Klee's service there.

20. *Der Sturm* 7, no. 11 (1916–17): 125: 1915, 157, *Gefangene Tiere*; 1915, 63, *Tierseelen*; p. 127: 1915, 234, *Drama in der Kuhwelt*; 1916, 48, *Schiffe, ein Schiff, Bastard*.

21. *Mondaufgang*, 1913, 57; as Wolfgang Kersten has pointed out to me, the sexual significance appears more clearly if the drawing is seen in sequence with those adjacent in the oeuvre catalog: *Listige Werbung*, 1913, 56, and *Versuchung eines Polizisten*, 1913, 58 (Glaesemer, 1:213, fig. 497). It thus suggests the sexual sentiment associated with the moon in several pieces of Schoenberg's *Pierrot Lunaire*.

22. Werckmeister, "From Revolution to Exile," 1987, pp. 42 ff.

23. *Tagebücher*, p. 431, no. 1060.

24. Ibid., p. 432, no. 1062: "Walden verkaufte einiges . . . Ein Artikel Däublers im Börsencourier wurde mir zugesandt. Die Ausstellung sei erschütternd, die Vertiefung in letzter Zeit unglaublich." Cf. *Briefe*, 2:850.

25. *Tagebücher*, p. 432, no. 1064, February 14, 1917.

26. Ibid., p. 433, no. 1066: "Meine Berliner Ausstellung wird ein finanzieller Erfolg. Walden kauft für 800 und ausserdem sind 12 Blätter für 1830 Mark verkauft. Sage zweitausendsechshundert und 30 Mark." Cf. *Briefe*, 2:853.

27. *Tagebücher*, p. 434, no. 1068: "Die letzten Verkäufe bei Walden betragen 540 M., der erste Verkauf den er meldete, war 290 M, also sind es jetzt 3460 M. Gott sei Dank, dass man nicht auch noch Geldsorgen hat!" See *Briefe*, 2:858.

28. A second one, brought to my attention by Charles Haxthausen, was published in the *Vossische Zeitung*, no. 105 (February 27, 1917), morning edition, by Franz Servaes, their regular art critic: "Im 'Sturm' darf man sich neuerdings den Kopf und beinahe auch die Gesichtsnerven über Paul Klee zerbrechen. Man hat den Eindruck einer sog [enannten] 'feinen Natur', die aber nicht aus noch ein weiss; die zu vornehm ist, das auszuführen, was ihr vorschwebt; sich darum mit vagsten Andeutungen begnügt und den noch nicht ganz wie Espenlaub Sensitiven leider unverständlich bleibt."

29. T. Däubler, "Paul Klee und Georg Muche im Sturm," *Berliner Börsen-Courier* 49, no. 68 (10 February 1917): 5: "Paul Klee ist nach Marcs Tod der bedeutendste Maler der expressionistischen Richtung. . . . Seine Ausstellung ist geradezu erschütternd; es ist unglaublich, wie sehr er sich noch in der letzten Zeit vertieft und entwickelt hat." I am grateful to Christian Geelhaar for a copy of this text.

30. Behne 1917, p. 168: "Paul Klee liebt die Sternenwelt, und jede seiner Zeichnungen, jedes seiner Bilder berührt weither die Sterne. . . . Dass wir einen Künstler haben von dieser Ehrlichkeit, dieser Treue zu den Sternen, das ist ein grosses Glück!"

31. Werckmeister 1981, pp. 138–47.

32. *Feurige Kapelle*, 1913, 53.

33. Werckmeister, "From Revolution to Exile," 1987, pp. 42 ff.

34. Walden 1917, p. 17: "Zeit des Kunstglücks."

35. Ibid.: "Es ist eine glückliche Zeit, in der wir leben."

36. T. Däubler, "Acht Jahre 'Sturm,'" *Das Kunstblatt* 1 (1917): 46: "Die stilbildende Richtung der letzten Generation ist zugleich bilderhaltend: eine Bewegung zurück zur Ordnung . . . Dabei steht das Ich gebieterisch in der Welt seiner Träume und Verwirklichungsabsichten. Keine Flucht aus der Wirklichkeit, sondern ein Sichtbarmachen des Transzendenten und Gegebenen: dies ist die neue Metaphysik."

37. W. Pastor, "Politik im Dienste des Kunsthandels," *Der Kunsthandel* 9, no. 11 (November 1917): 225–26.

38. Postcard from Tzara to Klee, November 16, 1916, Bern, Nachlass-Sammlung Paul Klee.

39. *Dada*, no. 1 (1917), last unnumbered page: "Ihr Zweck war, . . . den Künstlern aus kriegführenden Ländern die Möglichkeit zur Verständigung zu geben. Politik und Kunst sind verschiedene Dinge. Kunst wirkt rein und moralisch, wenn sie intensiv und direkt dem Beschauer Freude gibt."

40. Photocopy of the manuscript in Bern, Paul Klee Stiftung.

41. W. Jollos, "Paul Klee (in der 'Sturm'-Ausstellung der Galerie Dada)," *Neue Zürcher Zeitung*, no. 670 (April 17, 1917), first evening edition.

42. Sturm-Archiv, Blatt 13: "Über den Sturm als Zeitschrift möchte ich noch sagen, dass er als Schrift für die Werdenden ganz ausgezeichnet ist, aber nicht mehr als Vertreter des schon Feststehenden Neuen. Ihr Sturm ist grossenteils nur das Beiblatt der Zeitschrift, die ich wünsche. Alles bedingt Gute, was Sie oft genug und mit Recht veröffentlichen, wäre da an seinem Platz. Alles polemische des litterarischen Teils würde sich da auch besser ausnehmen. Leider muss ich auch gegen den Namen protestieren, der schon veraltet ist. Wir haben jetzt kulturell schon Weltfrieden, ein Sturm scheint unser Glaubensbekenntnis nur den ältern Herrn. (Also wieder das Polemische Gebiet)."

43. Ibid.: "Der positive Teil der Zeitschrift erforderte eine Ausstattung für alle Möglichkeiten. Verschiedene Papiere für alle Reproduktionen. (Original und photomechanisch). Das unerhört neue *die Farbe* dürfte in keiner Nummer fehlen."

44. *Fünf Jahre Goltz Verlag München: Die graphischen Werke*, catalog (Munich, 1917), p. 10: "In seiner bizarr romantischen Weise, die das Erleben rein subjektiv seelisch durch ein Gefüge von Linienzeichen, durch Runen gleichsam, wiedergibt, hat hier Paul Klee ein 'Kriegsblatt' geliefert. Dem, der eindringen will, vermittelt es eine tiefe Anschauung. Eine scheinbar regellose Vielheit von Kreisen und Strichen ohne gegenständlichen Sinn vollzieht doch das Wunder, die ganze Turbulenz der Kriegszerstörung als eine Gesamtstimmung darzustellen. Sonne, Mond und Sterne leuchten über der Zerstörung und geben dieser Stimmung den Aufschwung zum Hoffen auf das Ende."

45. See p. 75. On March 21, Klee noted in the oeuvre catalog three pictures as "Ersatzsendung (für Verkf. in Frankft. durch die Münchner Neue Secession) nach Wiesbaden Kunstverein."

46. Klee priced two watercolors of 1914 at 400 marks each, one oil painting of 1915 at 600 marks.

47. Only one watercolor was priced at 200 marks, two others at 300 marks each.

48. Nell Walden 1963, p. 58: "Franz Marc fiel im März 1916, und die Preise seiner Bilder stiegen."

49. G. J. Wolf, "Münchner Sommerausstellungen, II, Die Münchner Neue Secession," *Die Kunst für Alle* 34 (August 1, 1915): 426–33, esp. p. 432: "Klee setzt seine ziellosen kunstgewerblichen Prismen-Experimente fort"; cf. idem, "Ausstellung der Münchner Neuen Secession," ibid. 35 (August 21–22, 1916): 424–32, esp. p. 425.

50. K. Mittenzweig, "Ausstellung der 'Neuen Sezession' München 1917," *Deutsche Kunst und Dekoration* 41 (October 1918): 108–9, esp. p. 109: "oder in den Kompositionen Paul *Klees,* in denen zwar ein gut Teil Spielfreudigkeit des Kindes steckt, das bunte Scherben zur Mosaik reiht, in denen aber doch die Grenze zwischen Bild und dekorativer Füllung verkannt ist und schliesslich ein einmaliges Rezept immer weiter verfolgt wird."

51. *Briefe*, 2:878, to Lily Klee, September 27, 1917.

52. Geelhaar (1979, p. 248) even thinks that Klee may have intended it for eventual publication, just as the text on Marc. In rewriting the subsequent discussion of this text from the earlier German version, I have especially benefitted from Charles Haxthausen's criticisms.

53. *Tagebücher,* p. 440, no. 1081, July 1917: "Wir forschen im Formalen um des Ausdrucks willen. . . . Die Philosophen haben eine Neigung zur Kunst, anfangs war ich erstaunt, was sie alles sahen. Denn ich hatte nur an die Form gedacht, das Übrige hatte sich von selber ergeben. Das erwachte Bewusstsein dies[es] Übrigen hat mir indessen viel genützt und grössere Variabilität im Schaffen ermöglicht. Ich konnte sogar nun wieder zum Illustrator von Ideen werden, nachdem ich mich formal durchgerungen hatte. Und nun sah ich gar keine abstracte Kunst mehr. Nur die Abstraction vom Vergänglichen blieb. Der Gegenstand war die Welt, wenn auch nicht diese sichtbare."

54. Cf. Geelhaar 1974, pp. 35 ff.

55. *Briefe,* 2:876: "Die Zeit ist nicht leicht, aber voller Aufschlüsse. Ob meine Kunst bei gelassenem Weiterleben auch so schnell emporgeschossen wäre wie anno 16/17?? Ein leidenschaftlicher Zug in der Verklärung ist doch mit Produkt des äußeren Erlebens."

56. *Tagebücher,* p. 444, no. 1082: "Ein leidenschaftlicher Zug nach Verklärung hängt doch wohl mit der grossen Veränderung der Lebensführung zusammen."

57. Ibid., p. 381, no. 1079, July 10, 1917: "Gestern abend konnte ich gut malen. Ein Aquarell in der Art der Miniatüren entstand, nichts Neues aber eine gute Erweiterung der Serie.

Neues bereitet sich vor, es wird das Teuflische zur Gleichzeitigkeit mit dem Himmlischen verschmolzen werden, der Dualismus nicht als solcher behandelt werden, sondern in seiner complementären Einheit. Die Überzeugung ist schon da.

Das Teuflische guckt da und dort schon wieder hervor und kann nicht unterdrückt werden. Denn die Wahrheit erfordert alle Elemente zusammen.

Wie weit sich dies jetzt schon unter nur teilweise günstigen Umständen verwirklichen lässt ist fraglich. Doch kann auch der kürzeste Moment, wenn er gut ist, ein dahin gesteigertes Dokument hervorbringen." Cf. the more tentative version in the letter to Lily Klee, Gersthofen, July 10, 1917, *Briefe,* 2:873: "Neues bereitet sich vor, es muss das Teuflische zur Gleichzeitigkeit mit dem Himmlischen verschmolzen werden. Der Dualismus nicht als solcher behandelt werden, sondern in seiner complementären Einheit. Die Überzeugung ist da, das Teuflische guckt da und dort hervor und kann nicht unterdrückt werden, denn die Wahrheit erfordert die Berücksichtigung aller Elemente, das Kunstwerk aller zusammen."

58. M. Rickards, *Posters of the First World War* (New York, 1968), figs. 96, 99, posters by Max Mandel and Julius Gipkens (undated). Cf. Hoffmann 1977, p. 264, with figure.

59. *Tagebücher,* p. 442, no. 1081a, August 1917:
"Weil ich kam erschlossen sich Blüten

Die Fülle ist ringsum weil ich bin
Zum Herzen zaubert meinem Ohr
Nachtigallsang.
Vater bin ich allem,
Allen auf Sternen,
Und in letzten Fernen."

60. Cf. Felix Klee 1960, p. 141; C. Giedion-Welcker, *Paul Klee* (Stuttgart, 1954), p. 39; eadem 1961, p. 49; Ingold 1978, p. 259.

61. Vogel 1980, p. 330.

62. *Tagebücher*, p. 445, no. 1084, September 24, 1917: "weil ich photograph-ischer Stellvertreter von Baumann war, und bei einem Absturz die Aufnahme hätte machen müssen." Cf. *Briefe*, 2:877–78.

63. *Briefe*, 2:884: "Ich war gestern und heut recht productiv, arbeitete wie alt-gewohnt, nur in der Schublade. Für die Schule war's ein Unglückstag, früh stürzte einer und brach sich Verschiedenes, nachmittags fiel einer aus grosser Höhe zu Tod (Leutnant Geuth). Guten Appetit für die morgige Sonntagsfliegerei. Mich geht's ja nichts an, ich sitze hier warm und sicher."

64. "Sitze ja warm und sicher und kenne im Innern keinen Krieg."

65. *Tagebücher*, pp. 448–49, no. 1094, November 28, 1917: "Der neue Kreis nennt sich die Dresdener Gesellschaft, in Hannover heisst es Kestnergesellschaft, in Frankfurt Neue Vereinigung, in München Das Reich. Ueberall dieselben empor-schiessenden Pilze der neuen Zeit. . . . Eine Genugtuung scheint für mich jedenfalls draus hervorzugehn: eine vollständige wirtschaftliche Selbständigkeit. Nicht dass nun alle Hindernisse aufhören werden. Der Geist braucht sie ja!" Cf. *Briefe*, 2:888.

66. Gersthofen, September 4, 1917 (Sturm-Archiv, Blatt 16): "und zwar, so bald Sie wollen! Vielleicht ist es sogar möglich, eine Kollektion im Herbst und eine zweite im Frühjahr zu zeigen. Bitte antworten Sie mir bald."

67. Gersthofen, October 8, 1917 (Sturm-Archiv, Blatt 17): "leihweise zum Stu-dium." The watercolors are listed in the oeuvre catalog.

68. T. Däubler, "Berliner Kunstsalons," *Berliner Börsen-Courier* 50 (December 7, 1917): 5: "So nennt [Klee] ein ganz besonders melodisch empfundenes Aquarell 'Drei schlagende Nachtigallen', oder ein anderes 'Die schwarze Nachtigall.'" I am grateful to Christian Geelhaar for a copy of this review.

69. Däubler, in *Das Kunstblatt* 2 (1918): 25.

70. In the oeuvre catalog, the word *Berg* in the original title *Berglandschaft* has been struck out and *Vogel* written above it. Next to it a note in different handwriting reads: "verkauft Walden Dez. 17." It is therefore not quite certain whether Klee changed the title only at the time of the show.

71. Sturm-Archiv, Blatt 10, May 14, 1917: "Als dritte Frage möchte ich noch wissen wie es mit unserem Album steht."

72. Sturm-Archiv, Blatt 21, January 19, 1918: "Was diese Originale betrifft so bitte ich nun, keine zu verkaufen (2 sind schon weg glaube ich) da ich ein Original Album zusammenstellen möchte."

73. These are the drawings reproduced in the album: from 1913, 41 *Krieger-ischer Stamm;* 53 *Feurige Kapelle;* 57 *Mondaufgang;* 100 *Selbstmörder auf der Brücke;* 134 *Der Mord;* 138 *Ein Engel überreicht das Gewünschte;* from 1914, 112 *Schöp-fungsvorfeier;* 113 *Akrobaten;* 162 [title *Eroberungsmaschine* omitted]; 200 *Leiden-schaftliche Pflanzen;* from 1915, 2 *Der Zauberer;* 23 *Der Herr ist mein Hirt;* 30 *Neues Land;* 59 *Artisten;* 63 *Tierseelen;* 106 *Traum zu Schiff;* 110 *Spuck* [sic]; 112 *Orien-talische Melodie;* 113 *Todessprung;* 132 *Abgeschiedene von einem gedeckten Tisch an-gezogen;* 234 *Drama in der Kuhwelt;* and from 1916, 18 *Schiffe, ein Schiff, Fisch, Bastard.*

74. The drawing was also reproduced in *Der Sturm* of February 1917 (see note 20), the only one of five whose title was omitted.

75. Sturm-Archiv, Blatt 14: "Die Reproduktion der Zeichnungen im Album würde gewinnen, wenn der Ausschnitt des Zeichnungspapiers vom Passepartout etwas unterschieden werden könnte dadurch dass man einen *ganz leichten* gelblichen Ton verwenden würde, genau nach dem Original."

76. In the second edition, which appeared c. 1923, Klee's suggestions were observed: the drawings were printed on a yellowish half-tone block and on glossy art paper.

77. Sturm-Archiv, Blatt 20: "Mein Album scheint noch nicht herausgekommen zu sein. . . . Es liegt mir sehr an diesem Bilderbuch."

78. Sturm-Archiv, Blatt 21: "Was mein eigenes [Bilderbuch] betrifft, so habe ich es mir allerdings nicht so dürftig vorgestellt (als Ausstattung). . . . Aber wenn dies alles nicht möglich ist, so muss man sich eben mit einer solchen Kriegsausgabe begnügen. Vielleicht wäre es gut, das auch zu vermerken, wenn es nun nicht mehr Zeit ist, auf bessere Verhältnisse zu warten."

79. M. Slevogt, *Kriegstagebuch* (Berlin, 1917).

Chapter 5

1. [G.] J[ahn], "Die geplanten Kunstausfuhrerschwerungen und die Interessen der Künstlerschaft," *Der deutsche Künstler* 4, no. 11 (February 15, 1918): 85–87, esp. pp. 85–86: "die ausserordentliche Geldflüssigkeit, die die Kriegswirtschaft mit sich brachte. Von zahlreichen Händlern und Industriellen wurden bei der Veräußerung der vorhandenen Warenbestände wie bei der Herstellung und dem Vertrieb kriegsnotwendiger Waren z[um] T[eil] unerhörte Gewinne gemacht, die nur schwer untergebracht werden konnten. Die Anlagemöglichkeiten in der Industrie und im Handel waren gering. Von den Industrieunternehmungen konnten aus Mangel an Maschinen, Rohstoffen und Arbeitskräften nur die für unmittelbaren Kriegsbedarf erweitert werden und im Handel beschleunigte sich der Kapitalumlauf infolge der erhöhten Nachfrage bei verringerter Produktion und zusammengeschmolzenen Vorräten ganz wesentlich. Da die Kriegsanleihen die Gewinne nicht völlig aufnahmen, konnte ein gesteigerter Luxus getrieben werden. . . . so traten Kriegsgewinnler auch auf Kunstauktionen als Bieter und Käufer auf, teils, um sich allen Ernstes Sammlungen anzulegen, teils um ihre Gewinne in Wertgegenständen zu verstecken und dadurch insoweit der Besteuerung zu entgehen oder auch um gelegentlich damit Spekulationsgewinne machen zu können."

2. G. Jahn, "Kriegskonjunkturen," *Der deutsche Künstler* 4, no. 8 (November 15, 1918): 157–59: "Eine ganze Anzahl diesjähriger Sommerausstellungen hat über die Maßen gut abgeschnitten und Verkaufsumsätze erzielt, wie sie kaum je auf Ausstellungen dagewesen sind. An der Spitze unter ihnen marschiert auch in diesem Jahre wieder die Münchener Glaspalast-Ausstellung, die an Verkäufen rund 1,960,000 Mark auf der Habenseite buchen konnte, eine in der Geschichte der Münchener Ausstellungen bisher unerreichte Summe, die alle früheren Abschlüsse, auch den vorjährigen, bisher höchsten, in den Schatten stellt."

3. *Kunstchronik und Kunstmarkt* 54, n.s. 30, no. 6 (November 22, 1918): 120: "Am 9. November, als die Wirren der Berliner Revolutionstage einsetzten, wurde die Grosse Berliner Kunstausstellung in der Akademie der Künste geschlossen. Sie sollte ursprünglich bis zum 17. November dauern. Der wirtschaftliche Erfolg war diesmal besonders gross."

4. Rösler 1967, pp. 79, 112, 130.

5. "Stimmen zum Luxussteuer-Gesetz und die neue Bundesratsverordnung

vom 2. Mai 1918," *Der Kunsthandel* 10, no. 5 (May 1918): 67–69; F. Szkolny, "Die Steuer auf Kunstwerke," ibid. 10, no. 6 (June 1918): 81–82.

6. "Die künftige Steuer auf Kunstwerke," *Der deutsche Künstler* 5, no. 2 (May 10, 1918): 112–13.

7. See the auction report with commentary in *Kunst und Künstler* 16 (1917–18): 322, dated May 1, 1918.

8. *Kunst und Künstler* 16 (1917–18): 406, July 1, 1918.

9. "Zur kommenden Besteuerung der Kunstwerke," *Der deutsche Künstler* 5, no. 3 (June 15, 1918): 120.

10. *Briefe*, 2:894: "kamen ernstere Gedanken, beeinflusst von der grimmigen Schneewüste und chaotischen Finsternis, die da regierte. . . . Kyrie eleyson war mein Leitmotiv. . . . Das Crucifix stand schwarz und unfreundlich zur Rechten"; cf. *Tagebücher*, p. 450, no. 1098, January 3, 1918.

11. Sturm-Archiv, Blatt 20: "Ausser dem einen Verkauf hat sich scheints nichts mehr ergeben. Es scheinen die Preise etwas hoch gefunden zu werden. Aber das macht nichts. Ich bin mit dem Resultat jetzt schon zufrieden, und kann nur begrüssen dass kein Ausverkauf stattgefunden hat diesmal. Wenn ich so viel verdiene als ich jetzt in dieser schweren Zeit brauche um den Meinen das Dasein zu erleichtern und dabei für mich und für spätere Zeiten eine Kollektion reservieren kann ist mir das viel lieber, als zu sehr in Mode und Spekulation hineinzugeraten."

12. "Briefe von Paul Klee an Alfred Kubin," 1979, p. 92: "Die schwere Zeit hat meine Production im ethischen Sinn stark beeinflusst. Das Religiöse ist ganz zum Durchbruch gekommen."

13. G. F. Hartlaub, "Die Kunst und die neue Gnosis," *Das Kunstblatt* 1 (1917): 166–79, esp. p. 168: "Zweifellos besteht heute ein halb bewusstes, halb unbewusstes Bestreben, . . . eine innigere Verschmolzenheit des religiösen und aesthetischen Vorstellens . . . zu erneuern."

14. Ibid., pp. 166 ff.: "Das Spiel mit allzu direkten Analogien zu mittelalterlicher Mystik (ja selbst zu mittelalterlicher Kunst!) ist gefährlich . . . Dort haben wir es mit den Äusserungen eines geschlossenen Bewusstseins zu tun, gewissermaßen mit den mystisch-ästhetischen Emanationen eines solchen festen Glaubenskernes. . . . Aber Transzendentalismus als Stimmung, Strebung, Weltgefühl ist noch nicht Religion—am allerwenigsten auf der ästhetischen Ebene."

15. Ibid., pp. 176–77.

16. G. F. Hartlaub, "Ausstellung: Neue religiöse Kunst," *Das Kunstblatt* 2 (1918): 190.

17. *Briefe*, 2:902, to Lily Klee, January 31, 1918: "Heut sprach mich im Bureau ein Leutnant Oesterreicher an, ein netter Mann, der mir schon lange gut gefällt. Er wollte etwas von mir sehn. Ich konnte ihm aber nur die Reproduktion im 'Kunstblatt' zeigen. Ich schnitt dann gleich die Frage der Weltanschauung an, und er entpuppte sich als ein ganz wohlunterrichteter Mensch. Wir kamen dann auf religiöse Fragen und auf den Krieg als Verwirklichung des Zusammenbruchs Europas. Erstaunlich für einen technischen Officier und Flieger!"

18. The photograph reproduced here, Munich, Bayerisches Hauptstaatsarchiv, Abteilung IV, Kriegsarchiv, BS III K 8d, Nr. 371 rot, Bild Nr. 219, and first published by Vogel 1980, p. 360, fig. 6, was actually not taken by Klee, but by Baumann, to document the fatal crash of Private Georg Schmitt on March 8, 1918.

19. *Tagebücher*, p. 454, no. 1106, February 21, 1918: "Gestern hatten wir . . . Dienst wie sonst mit zugehörigem Bruch. . . . Diese Woche hatten wir 3 Tote, einer vom Propeller derschlagen, zwei derhutzten sich aus der Luft. Ein vierter sauste gestern mit Krach, Splitter-Riss und Schurf auf das Dach der Werft. Zu tief geflogen, an einer Telegraphenstange hängengeblieben auf dem Werftdach einmal aufgehupft, überpurzelt und verkehrt liegengeblieben wie ein Trümmerhaufen. Ein Gerenne

von allen Seiten, im Nu das Dach schwarz von Monteurkitteln. Tragbahre, Leitern. Der Photograph. Ein Mensch rausgelöst und bewusstlos fortgetragen. Gellendes Schimpfen gegen Zuschauer. Kinoeffekt 1. Güte." Cf. *Briefe*, 2:907, to Lily Klee, February 21, 1918.

20. Thürlemann (1982, pp. 17–40) offers an inconclusive semiotic analysis of this picture.

21. The configuration is the same as in *Copulation in the Air* (1912, 129 A) and *The Poisonous Animal* to be discussed below, p. 153, fig. 81; cf. Geelhaar 1972, pp. 54 ff.

22. *Tagebücher*, p. 234, no. 748, January 1906: "Traum. Ich flog nach Haus, wo der Anfang ist. Mit Brüten und mit Fingerkauen begann es. Dann roch ich was oder schmeckte was. . . . Käme jetzt eine Abordnung zu mir, und neigte sich feierlich vor dem Künstler, dankbar auf seine Werke weisend, mich wunderte das nur wenig. Denn ich war ja dort, wo der Anfang ist. Bei meiner angebeteten Madame Urzelle war ich, das heisst so viel als fruchtbar sein."

23. Walden, *Einblick in die Kunst* (Berlin 1917), pp. 5, 9.

24. Walden, *Expressionismus: Die Kunstwende* (Berlin, 1918), pp. 72–73, 76.

25. Däubler, *Das Kunstblatt*, 1918, p. 25.

26. H. Bloesch, "Ein moderner Graphiker," *Die Alpen* 6 (1912): 264–72, reprinted in H. C. von Tavel, "Dokumente zum Phänomen 'Avant-garde'. Paul Klee und der moderne Bund in der Schweiz 1910–1912," *Beiträge zur Kunst des 19. und 20. Jahrhunderts* (Schweizerisches Institut für Kunstwissenschaft, Jahrbuch 1968–69; Zurich 1970), pp. 69–116, cf. pp. 97–98. Cf. Werckmeister 1981, p. 125.

27. W. Hausenstein, *Die bildende Kunst der Gegenwart* (Stuttgart and Berlin, 1914), p. 306.

28. Däubler, *Das Kunstblatt* 2 (1918): 25: "Die obere Einfachheit ist erreicht!"

29. Ibid., p. 24: "Wenn man nämlich solche scheinbar unbeholfenen Arbeiten . . . eingehend betrachtet, so kann man bald feststellen: hier ist nichts kindlicher Versuch geblieben! Im Gegenteil: die geringsten Zufälligkeiten sind ausgeschieden; alles was Klee gibt, muss vollgekonnte männliche Kunst genannt werden." Also p. 25: "nur beim Maler, der wie ein Kind im Mannesalter schaut, kann es gelingen."

30. Quintavalle 1972, p. 5, fig. 4, 7.

31. Werckmeister 1981, pp. 138–47.

32. Glaesemer 1976, p. 455, no. 68.

33. *Briefe*, 2:911, to Lily Klee, March 19, 1918: "Am Bahnhof Augsburg kaufte ich Zeitungen und fand die Besprechung Hausensteins über die graphische Ausstellung der Neuen Sezession. Das Wunder einer Würdigung meines Schaffens hat sich erfüllt." Cf. the slightly changed transcription in *Tagebücher*, pp. 455–56, no. 1109.

34. Klee, *Briefe*, 2:885–86, to Lily Klee, Gersthofen, November 15, 1917.

35. *Münchner Neueste Nachrichten* 71, no. 141 (1918): 2, quoted after Klee, *Schriften*, p. 175: "Das Urteil ist vollkommen persönlich gemeint; es verpflichtet niemand. Zumal bleibt die Einschätzung Klees sich bewusst, dass sie eine irgendwie allgemeingültige Urteilsnorm weder geben kann noch will; seine Zeichnung ist so subjektiv und so voll von grundsätzlich Problematischem, dass sie objektiv-allgemeinen Kunstmassstäben gegenüber unmöglich geltend gemacht werden kann."

36. W. Hausenstein, *Über Expressionismus in der Malerei* (Berlin, 1919); for the date of writing, see the postscript, p. 76.

37. Ibid., pp. 46–47: "Prozess . . . des Untergangs und der Neuentstehung"; about Klee see, in addition, pp. 34–35, 45 ff., 51.

38. W. Kandinsky, *Rückblicke* (Berlin, 1913), p. xxxviii, about *Composition VI*: "Ein grosser, objektiv wirkender Untergang ist ebenso ein vollständig und im Klang abgetrennt lebendes Loblied, wie ein Hymnus der neuen Entwicklung, die dem Untergang folgt."

39. Hausenstein, *Über Expressionismus* (see note 36), p. 51.

40. *Tagebücher*, p. 456, no. 1112, April 5, 1918: "Bei Richter soll auch wieder ein Zeitschriftenpilz emporschiessen. Im Auftrag von Däubler hat er sich schmeichel-rednerisch (quasi Honorarersatz) an mich gewendet. Zugleich Erweiterung meiner Ausstellung daselbst." Cf. *Briefe*, 2:914, to Lily Klee, April 5, 1918.

41. *Tagebücher*, p. 457, no. 1116, April 21, 1918: "Ach dass man nur Mensch ge-worden ist, halb Gesindel und nur halb Gott. Ein tragisch reiches tiefsinniges Schick-sal. Möge sein ganzer Gehalt einmal geformt als Dokument vor mir liegen. Dann kann ich in Ruhe dem schwarz-leeren Moment entgegensehen."

42. Klee changed 1915, 117, (*Städtische Darstellung*) to *Kleine Stadthäuser*; 1917, 13, (*Dorfartig, Häuser, 2 Rinder*) to *Dorf*; 1917, 5 *Heitere Architekturen* to *Heiteres Städtebild*; 1915, 70 *Durchleuchtungen (orange-blau)* to *Komposition Transparenter Orange und Blau*. However, he also changed 1915, 229, (*Was ein Mädchen unwissend mit sich bringt*) to *Mädchen*, that is, in the opposite direction.

43. T. Däubler, "Paul Klee," *1918: Neue Blätter für Kunst und Dichtung* 1 (May 1918): 11–12, esp. p. 12: "Da schlägt eine Nachtigall: rosa Verliebtheiten weiten sich unglaublich zart und behutsam. Melancholisierendes Lila tönt nach, stirbt entbläu-lichend ab. Wieder ein Schlag! Entschieden-Rosa. . . . Noch ein rascheres Schlagen! Eine andere Nachtigall? Es kam so hell, dass die goldgrünen Frühlingszweige sicht-bar glimmten. . . . Es war ein Nachtigallenschlag!"

44. *Tagebücher*, p. 461, no. 1122, June 3, 1918: "Der Aufsatz Däublers kurz, er versucht auf meiner Musikalität aufzubauen, und verbreitet ausserdem meinen inter-nationalen Ruhm als Violinvirtuos. Engagements erster Konzertinstitute werden die nächste Folge sein. Ich werde aber zurücktelegraphieren: Feldgrau verhindert." Cf. *Briefe*, 2:922, to Lily Klee, June 3, 1918, without the last sentence.

45. *Tagebücher*, p. 461, no. 1122, June 4, 1918; *Briefe*, 2:923 to Lily Klee, June 4, 1918.

46. *Tagebücher*, p. 461, no. 1124, June 28, 1918.

47. *Briefe*, 2:925, to Lily Klee, July 8, 1918. Klee sold the two top pictures for 500 rather than 600 marks.

48. *Briefe*, 2:926, to family Hans Klee, July 8, 1918. At this time, only four water-colors had been sold.

49. Entry number 101 *Landschaft mit fliegenden Vögeln, einer v. Pfeil durch-bohrt*; 115 *Auserwählter Knabe*; 118 *Mit der herabfliegenden Taube*; 134 *Vogelflüge (horizontal und vertikal)*.

50. *Tagebücher*, p. 462, no. 1125, July 3, 1918: "Die Lerchen sind verstummt, hie und da huschen Schwalben schattenhaft über den Boden." However, since Klee painted the picture *Der Traum* (1918, 121) on August 17–18, 1918, the sequence of entries in the catalog cannot be taken to follow the sequence in which Klee com-pleted the works.

51. For this technique of Klee's, see Glaesemer 1976, pp. 150–51.

52. *Artisten* (1915, 59) and *Acrobaten und Jongleur* (1916, 66; Glaesemer 1973, p. 245, no. 590). For the theme, see Plant 1978, pp. 58–59.

53. Däubler, "Paul Klee," 1918, p. 26: "Wenn Klee Akrobaten zeichnet, so lässt er Erdenkinder wieder zu Sternbildern werden. Fast immer sind es zwei Figuren, die in der Kuppel arbeiten; denn dort oben, auf dem Trapez, soll der Mensch seine Gleichgewichtssehnsucht . . . erfüllt sehen. . . . Fliegen möchte der Mensch we-sentlich allein; allerdings auf ein Ziel zu. . . . aber eine sinnfällige Einsternung, als feste Punkte im All, können wir uns am ausgesprochensten paarweise erturnen. . . . Man muss [sc. Klees Farben] . . . durch stilistisches Jonglieren vorgaukeln."

54. Klee to Hausenstein, Gersthofen, May 22, 1918: Hausenstein papers, Mar-bach, Deutsches Literatur-Archiv, 66.2261.2. On July 8, 1918, Klee reported the plan to his family in Berne; Klee, *Briefe*, 2:926, to Ida und Mathilde Klee, Gersthofen, July 8, 1918.

55. London, Renée-Marie Parry-Hausenstein.

56. "Im Orient Frühling 1914 entwickelte ich—reichlich spät—meine Farbe. . . . Die Vergangenheit schien echter, die Zukunft deutlicher. Schlüsse vom Ich auf den Kosmos 1915. Positive Religiosität im Gegensatz zum pathetischen Element der Verneinung von früher (16/17). . . . Eine Vereinigung der verschiedenen selbständigen Kräfte zum Ganzen ist mein gegenwärtiges Wollen."

57. *Briefe*, 2:933: "Der Hausensteinsche Aufsatz, so schmeichelhaft er für mich ist, hat doch wieder eine Art Opposition in mir hervorgerufen, und ich malte ein streng organisiertes Stück *Der Traum*, eines meiner schlagendsten Blätter, auf grobes Papierleinen mit Gipsgrund. Wurde gleich weiss gerahmt und an die Wand gebracht. Erfüllte mich noch auf dem ganzen Heimweg vollständig." Compare the slightly different transcript in *Tagebücher*, p. 464, no. 1126a, August 19, 1918, where Klee calls the picture "ein streng organisches Stück."

58. *Tagebücher*, p. 464, no. 1126a, August 7, 1918. Cf. *Briefe*, 2:931, to Lily Klee, August 7, 1918.

59. *Tagebücher*, p. 464, no. 1126a, August 21, 1918; *Briefe*, 2:933, to Lily Klee, August 21, 1918. Cf. Kornfeld 1963, no. 61.

60. Letter of Edschmid to Klee, August 30, 1918, Bern, Nachlass-Sammlung Paul Klee.

61. Cf. Naubert-Riser 1978, pp. 81 ff.

62. *Briefe*, 2:936: "Mein Essay für Edschmid ist als erster Entwurf schon da. Nun ist es aber schwer, die hingeworfenen Gedanken zu überblicken und zu ordnen. Manches ist zweimal in verschiedener Richtung gesagt, und muss entsprechende Wahl getroffen werden." Cf. *Tagebücher*, p. 467, no. 1127, September 19, 1918.

63. Letter of Edschmid to Klee, October 17, 1918, Bern, Nachlass-Sammlung Paul Klee.

64. *Briefe*, 2:943: "bald fertig." "Der Aufsatz über Graphik wird jetzt fertig." Cf. *Tagebücher*, p. 469, no. 1131, November 3, 1918: "fast fertig." Cf. Geelhaar, in Klee 1976, p. 171.

65. Transcription and facsimile reproduction of the manuscripts in Glaesemar 1975, p. 6 ff.; Geelhaar in Klee 1976, p. 171 ff., figs. 51–58.

66. Glaesemer 1975, p. 6; Geelhaar (in Klee 1976, p. 171) does not distinguish between the stages; Cherci (1978, pp. 79 ff.) wrongly asserts that the text has essentially remained the same.

67. "Die Graphik lasse ich von Graphikern selbst machen. Sie sollen nur über Ihr Zeichnen schreiben."

68. "An sich zur Abstraction mit grösserem Recht führend, musste sie [sc. die Graphik] in unserem Zeitalter erhöhte Wertschätzung erfahren."

69. For the literary and autobiographical implications of this mode, cf. Naubert-Riser 1978, p. 89.

70. "Entwickeln wir, machen wir eine kleine Reise ins Land der besseren Erkenntnis. . . . Ein Fluss will uns Schwierigkeiten machen, und wir müssen uns eines Botes [sic] bedienen (Wellenbewegung), weiter oben wäre eine Brücke gewesen (Bogenreihe). . . . Wir durchqueren einen frischgepflügten Acker (Fläche von Linien durchzogen). . . . Korbflechter begegnen uns (Liniengeflecht). Ein Kindchen ist bei ihnen mit den lustigsten Locken (die Schraubenbewegung). . . . Ein Blitz am Horizont (die Zickzacklinie). Ober uns sieht man zwar noch Sterne (die Punktsaat)."

71. Cf. Naubert-Riser, pp. 60 ff.

72. "Über das Licht von Robert Delaunay," *Der Sturm* 3 (1913): 255–56; Klee 1976, pp. 116–17: "Solange die Kunst vom Gegenstande nicht loskommt, bleibt sie Beschreibung, Litteratur, erniedrigt sie sich in der Verwendung mangelhafter Ausdrucksmittel, verdammt sie sich zur Sklaverei der Imitation." Klee is here literally following Delaunay; see the French text in Klee 1976, p. 171.

73. "Ohne die Wahrnehmungsmöglichkeiten des Gesichtssinnes wären wir bei einer Successiv-Bewegung stehen geblieben, sozusagen beim Takt der Uhr."

74. "Das Werk entstand aus Bewegung, ist selber fest gelegte Bewegung (stereotyp) und wird aufgenommen in der Bewegung (Augenmuskeln)."

75. "*L'oeil* est notre sens le plus élevé"; Klee 1976, p. 170.

76. Naubert-Riser (1978, pp. 94–95) has identified the predominantly abstract watercolors 1917, 100 and 102–4 as the visual equivalent of the "excursion into the land of better knowledge." Klee painted them on extended outings near the Lech, which he also described in his diary (*Tagebücher*, pp. 442–44, no. 1082, September 9, 1917; Naubert-Riser 1978, p. 94, has misnumbered the passage).

77. Däubler, "Acht Jahre 'Sturm,'" *Das Kunstblatt* 1 (1917): 46.

78. *Tagebücher*, p. 467–68, no. 1128, October 2, 1918: "Keine Aufsicht, kein 'Licht auslöschen!' kein Wecken, nichts Militärisches ausser dem edlen Kostüm. . . . Viel Platz hab ich und einen schönen grossen Schrank ganz für mich allein.

Also ganz Arbeit! Das glänzende Licht mit 100 Kerzen! Also heran Du heiliger Geist! . . . Der psychologische Moment ist da." Cf. *Briefe*, 2:938–39, to Lily Klee, October 2, 1918.

79. *Tagebücher*, p. 468, no. 1128, October 2, 1918: "Nach Hause gehn wir dann, welch ein hymnisches Thema!"

80. *Briefe*, 2:942, to Lily Klee, October 30, 1918: "Ein merkwürdiger Moment, wie jetzt das deutsche Reich so ganz allein dasteht, bis an die Zähne bewehrt und doch so hoffnungslos. Ich sehe jetzt nur noch das Ende, und man muss hoffen, dass nach innen eine gewisse Würde bewahrt werde und der Schicksalsgedanke über den alltäglichen Atheismus Oberhand behält.

Vielleicht soll einmal ein Exempel statuiert werden, wie ein Volk eine Katastrophe ertragen soll. Nicht das Volk wird dabei handeln, sondern Instrument sein. Wenn es selbst die Sache in die Hand nimmt, geht es gewöhnlich zu, fliesst Blut und wird processiert. Das wäre banal."

81. *Tagebücher*, p. 469, no. 1130, October 30, 1918: "Was für ein Moment, wie jetzt das Reich so ganz allein dasteht, bis an die Zähne bewaffnet und doch so hoffnungslos.

Ob wohl auch die Hoffnung, dass noch innen Würde bewahrt werden möge und dass der Schicksalsgedanke über den alltäglichen Atheismus die Oberhand behalten werde zerschellen wird? Gelegenheit zu einem Exempel, wie ein Volk seine Katastrophe ertragen soll hätten wir ja jetzt. Wenn aber die Massen aktiv werden, was dann? Dann wird es sehr gewöhnlich zugehn, es fliesst Blut und was noch schlimmer ist: es gibt Prozesse! Wie banal!"

82. *Briefe*, 2:943.

83. "Kunst verhält sich zur Schöpfung gleichnisartig, sie ist ein Beispiel ähnlich wie das Irdische [corrected from: die Erde] ein kosmisches Beispiel bedeutet."

84. Klee, 1976, p. 174: "Die Einbeziehung der gutbösen Begriffe schafft eine sittliche Sphäre. Böse soll nicht triumphierender oder beschämter Feind sein, sondern am Ganzen mitschaffende Kraft."

85. Overmeyer 1982, p. 125.

86. "Dem entsprechend simultaner Zusammenschluss der Formen, Bewegung, Gegenbewegung, oder bei naiverer Auffassung der Gegenstände. (Koloristisch: Anwendung der Farbenzergliederung wie bei Delaunay)."

87. Cf. Naubert-Riser 1978, pp. 109 ff.

88. "Wo die Phantasie, von instinktiven Reizen beschwingt, uns Zustände vortäuscht die vollkommener sind als die Irdischen, all . . ."

89. "Wo die Phantasie, von *kläglich* instinktiven Reizen beschwingt uns Zustände vortäuscht die *irgendwie mehr ermuntern und anregen* als die *allbekannten* Irdischen." Emphasis added.

90. "Die Kunst . . . spielt mit den Dingen ein unwissend Spiel. So wie ein Kind im Spiel uns nachahmt, ahmen wir im Spiel den Kräften nach, die die Welt erschufen und erschaffen."

91. Klee 1976, p. 174: "Und dem Menschen sei sie eine Villegiatur, einmal den Gesichtspunkt zu wechseln, und sich in eine Welt versetzt zu sehn, die ablenkend nur Annehmlichkeiten bietet, und aus der er neugestärkt zum Alltag zurückkehren kann."

92. One watercolor was priced at 250 marks, nine at 300 marks, five at 400 marks, two at 500 marks. Three watercolors are not marked with any price. Here Klee did not price later works higher than earlier ones.

93. In the fall of 1915, Klee paid income tax on 400 marks only: *Briefe*, 2:801, to Lily Klee, April 3, 1916.

94. On the back endpaper of the fourth volume of his diaries, Klee has jotted down the figures of his income tax returns for the years 1913–18, as of October of each year. Under the heading "Beruf," he entered a single figure comprising the income from his wife's piano lessons and from his own sales: 1913: 1,500 marks; 1914: 2,000 marks; 1915: 1,900 marks; 1916: 2,000 marks; 1917: 2,500 marks; 1918: 3,100 marks. Since Klee seems to have invariably figured the income from his wife's piano lessons at 1,500 Marks, his own income appears as follows: 1913: none; 1914: 500 marks; 1915: 400 marks; 1916: 500 marks; 1917: 1,000 marks; 1918: 1,600 marks. Obviously, the figures Klee chose to declare are at variance with his real sales, but the sense of their fluctuation over the years approximately matches the table, if one allows for the delayed payments from the sales of 1917 (see below, note 97).

95. See the comparative wage and salary tables in Rösler 1967, p. 224.

96. Nell Walden 1963, pp. 21–22.

97. Berlin, Sturm-Archiv, Blatt 10, 12, 15, 16, 21.

98. Cf. Holtfrerich 1980, p. 15, table 1.

99. *Briefe*, 2:944: "grosser Betrieb von ankommenden Feldfliegerabteilungen. Haarsträubende Erzählungen, zum Teil vielleicht wahr, zum Teil erlogen. Doppelt gemütlich ist nun meine Bude, wenn draussen das Durcheinander herumlärmt."

100. *Tagebücher*, p. 470, no. 1132, November 19, 1918: "Haarsträubende Erzählungen vom Zusammenbruch draussen.

Doppelt friedlich ist nun meine kleine Bude mitten in dem Durcheinander."

101. This is the title in the oeuvre catalog. On the watercolor it merely reads: *Gedenkblatt*.

102. Glaesemer 1973, p. 63, nos. 169, 170.

103. Hoffmann 1977, pp. 135ff. Klee had dealt with the theme already in the watercolor 1918, 125, *Gedenkblatt mit dem eisernen Kreuz*.

104. Supplementary manuscript: *Tagebücher*, p. 503.

105. *Konstruktive Bindung von Erde und Himmel* (1918, 211), Glaesemer 1973, p. 268, no. 634.

106. *Vogel-Flugzeuge* (1918, 210).

107. G. Wissmann, *Geschichte der Luftfahrt von Ikarus bis zur Gegenwart*, 2d ed. (Berlin, 1965), pp. 343 ff.

Chapter 6

1. Holtfrerich 1980, pp. 180–81.

2. Ibid., pp. 198–99.

3. C. Kindleberger, "A Structural View of the German Inflation," in G. D. Feldman, et al., eds., *The Experience of Inflation: International and Comparative Studies. Die Erfahrung der Inflation im internationalen Zusammenhang und Vergleich* (Berlin and New York, 1985), pp. 10–32, esp. pp. 28–29.

4. G. D. Feldman, "The Historian and German Inflation," in N. Schmukler and E. Marcus, eds., *Inflation through the Ages: Economic, Social, Psychological and Historical Aspects* (New York, 1983), pp. 386–99, esp. pp. 390 ff.

5. P. C. Witt, "Staatliche Wirtschaftspolitik in Deutschland: Entwicklung und Zerstörung einer wirtschaftspolitischen Strategie," in Feldman, et al., eds., 1982, pp. 151–79, esp. p. 169. Cf. also G. D. Feldman, "The Political Economy of Germany's Relative Stabilization during the 1920/21 World Depression," ibid., pp. 180–206.

6. G. D. Feldman, discussion remarks, in O. Büsch and G. D. Feldman, eds., *Historische Prozesse der deutschen Inflation 1914 bis 1924: Ein Tagungsbericht* (Berlin, 1978), p. 62; W. Abelshauser, "Inflation und Stabilisierung: Zum Problem ihrer makroökonomischen Auswirkungen auf die Rekonstruktion der deutschen Wirtschaft nach dem Ersten Weltkrieg," ibid., pp. 161–74, esp. pp. 163–64; S. A. Schuker, "Finance and Foreign Policy in the Era of the German Inflation: British, French, and German Strategies after the First World War," ibid., pp. 343–61, esp. p. 351.

7. G. Schmidt, discussion remarks, ibid., p. 365; H. Rupieter, discussion remarks, ibid., p. 373.

8. Quoted in "Aus dem Kunsthandel," *Der Kunsthandel* 11, no. 1 (January 1919): 10–11, esp. p. 10: "Auf keinem anderen Gebiet des kaufmännischen und industriellen Wesens haben sich die Folgeerscheinungen des Umsturzes so stark und einschneidend bemerkbar gemacht, wie auf dem der Kunst. Während in den Wochen vor Ausbruch der Revolution schon die alten Kriegshochkonjunkturpreise nicht mehr zu halten gewesen waren, setzte seit dem 9. November überhaupt jedwedes Interesse für alle Arten von Kunstwerken von seiten des kaufkräftigen Publikums völlig aus. Genau wie in den Antiquitätengeschäften zeigen sich auch in den Verkaufsläden moderner Kunstwerke keine Käufer mehr."

9. Ibid., p. 10: "Wir halten diese Anschauung für viel zu pessimistisch. Wohl war in den ersten vierzehn Tagen seit Beginn der politischen Umwälzung das Interesse der Käufer auf dem Kunstmarkt, wie auf allen anderen Gebieten, stark erlahmt. Aber die neuesten Versteigerungen haben wiederum lebhaften Zuspruch gefunden, und es wurde sowohl alte wie neue Kunst zu achtbaren Preisen verkauft, wenn auch sogenannte Rekordpreise nicht mehr auftraten."

10. L. Brieger, "Deutscher Kunst-Katzenjammer," *Der Kunsthandel* 11, no. 2 (February 1919): 17–18.

11. Cf. G., "Die Versteigerung der Sammlung Vincent Mayer, Freiburg, bei Cassirer in Berlin," *Kunstchronik und Kunstmarkt* 55, n.s. 31, no. 4 (October 24, 1919): 70–72.

12. W. Seitz, "Leipziger-Messe-Allerlei," *Der Kunsthandel* 11, no. 11 (November 1919): 166–67: "Jeder Tag bringt Mahnungen um Auslieferung, und man sitzt und sinnt und rührt sich, um die Produktion zu steigern und gut unter die Konsumenten zu verteilen."

13. Syndikus F. Hansen, "Der Kunsthandel als Objekt der Luxussteuer," *Der Kunsthandel* 11, no. 10 (October 1919): 152–53.

14. P. C. Witt, "Finanzpolitik und sozialer Wandel in Krieg und Inflation 1918–1924," in H. Mommsen, D. Petzina, B. Weisbrod, eds., *Industrielles System und politische Entwicklung in der Weimarer Republik* (Düsseldorf, 1974; paperback edition, 1977) 1:395–425, esp. pp. 414 ff.

15. As quoted in "Grosse Berliner Kunstausstellung 1919," *Der Kunsthandel* 11, no. 9 (September 1919): 137.

16. F. Hansen, "Der Kunsthandel auf der internationalen Frankfurter Messe," *Der Kunsthandel* 11, no. 11 (November 1919): 167–68.

17. L. Brieger, "Jahresbilanz," *Der Kunsthandel* 11, no. 12 (December 1919): 186–87, esp. p. 187: "Die wahrhaft schlimmen Folgen des Krieges für unseren Kunstmarkt werden sich . . . erst später zeigen, wenn vielleicht einmal in einigen Monaten

die Zwangsvaluta kommen und deutsches Geld dann wieder an Wert gewinnen wird."

18. Corrinth 1920, p. 60: "neuzeitlich-ewigen Kommunismus allen erblühender Leiber."

19. G. Albrecht, et al., *Lexikon deutschsprachiger Schriftsteller* (Leipzig, 1967) 1:226–27.

20. Corrinth 1920, pp. 85–86: "Zur Sperrung der fünf grossen Strassen türmten . . . Barrikaden aus Droschken, Trams und gefällten Bäumen hoch, hinter denen des Messias Jüngerinnen waffenlos (und doch, alalà, wie bewaffnet!) des männlichen Ansturms harrten.

Jetzt, wie klimmende Stiefel schon heraufwuchteten—auf die Wälle schossen die hunderttausend glühenden, in begeisterter Ekstase himmlischer Schönheit überleuchteten Königinnen, . . . bogen ihrer Leiber unendliche Grazie dem Ansturm verheissend zu, rissen—o weisse tapfere Hände—seidene Oberkleider fetzend zu Öffnungen und wiesen ihrer prangenden schwellenden Brüste rundliche Verführung."

21. "Dieses . . . Exemplar . . . des zu Märzende 1918 entstandenen . . . Werkes." My thanks go to Wolfgang Kersten for bringing this dedication to my attention.

22. *Briefe* 2:943–45, letters of November 3, December 2, and December 12, 1918, which however only refer to negotiations with the publisher, not to the project.

23. See Klee's letter to Kubin of January 1, 1920 (see p. 224).

24. Glaesemer, 1:263 ff.

25. Note in the oeuvre catalog: "An Dr. v. Sydow Leipzig Inselstr. 25." This collection comprised 45 works ranging from 1904 through 1918, of which von Sydow purchased three (two from 1916, one from 1918). He returned the rest in May 1919: "zurück bis auf drei verkaufte Blätter Mai 1919."

26. Corrinth 1920, p. 5: "Voll von revolutionärer Paradoxie sind diese Zeichnungen Paul Klees! . . . Es lebe die Revolution, die lebenspendende! Es lebe die Erotik, die lebenspendende!! . . . Denn: liebten wir nicht in ihm Den, der unserer reinen Seelenhaftigkeit reinsten Spiegel schliff?: fern von der Welt wiegten wir uns im Rhythmus der Linien und der Stimmung der Entsagung. Und nun: dynamischer Lebenswille. . . . Nur unproduktive Naturen ertragen das Dauer-Leben der Resigniertheit. Die expressionistische Welt-Zeit beflügelt sicher solche Verweltlichung. . . . Ihre Zauberstäbe sind die Revolution und die Erotik."

27. Glaesemer, 1:254–58, is the only account of the illustrations in the scholarly literature.

28. "Kritik der bourgeoisen Gesellschaft": This sentence does not occur in the fair copy of the diaries, *Tagebücher*, p. 177, no. 514, July–September 1903, only in the excerpt made for Leopold Zahn, ibid., p. 523.

29. Corrinth 1920, pp. 46–47: "die Leiber endlich erlösten Frauentums, das Jahrhunderte in Bürgerkerkern verschmachtete Entfesselte, rasten sie in toller Entzückung."

30. Ibid., p. 45: "Tapfre Hand: bald reckte sie, Bombenlegerin, sich zerbröckelnden Barrikaden auf, Bresche zu sprengen. Bankierstochter, übereilig, hinwarf sich."

31. H. Hess, *George Grosz* (London, 1974), p. 78, pl. 61.

32. In interpreting the drawing as Klee's own invention, Glaesemer (1:255–56) has missed out on the manifest sexual violence of both text and illustration: "Über der Szene schwebt ruhig und Sehnsucht weckend der Mond. Nicht die Kräfte des Mannes, sondern kosmische Mächte treiben den Körper zu einer sich wie rasend drehenden Bewegung an."

33. *Das Frühwerk* 1979, p. 470, no. 359. Klee has cut off a strip from the upper border and glued it together with an additional piece of drawing to form the drawing *Der Fisch*, 1918, 185, Bern, Paul Klee Foundation (Glaesemer, 1, no. 683). Glaesemer (1:255) misreads the title as "komisch-revolutionär" and misinterprets the drawing accordingly.

34. Glaesemer, 1:256, without reference to the earlier version.

35. *Erste Grosz-Mappe*, sheets 1, 5; *Kleine Grosz-Mappe*, sheets 2, 5, 14 in A. Dückers, *George Grosz: Das druckgraphische Werk* (Berlin, 1979), pl. 49–55.

36. Corrinth 1920, p. 58: "D-Züge donnerten, unablässig, Erwachende zum Paradies."

37. W. Nerdinger, "Fatale Kontinuität: Akademiegeschichte von den zwanziger bis zu den fünfziger Jahren," in T. Zacharias, ed., *Tradition und Widerspruch: 175 Jahre Kunstakademie München* (Munich, 1985), pp. 179–203, esp. pp. 180–81.

38. H. Urban, "Ein Rat der bildenden Künstler Münchens," *Der deutsche Künstler* 5, no. 9 (December 15, 1918): 166–67.

39. *Münchner Neueste Nachrichten* 71 (1918), no. 580; published in K. L. Ay, *Appelle einer Revolution: Dokumente aus Bayern zum Jahr 1918/19* (Munich, 1968), Appendix 10: "Neben dem provisorischen Zentralparlament und dem in der Regierung verkörperten revolutionären Vollzugsausschuss sollen alle einzelnen Verbände und Berufe ihre eigenen Angelegenheiten in voller Öffentlichkeit erörtern können. Wir wollen die bisherigen Organisationen parlamentarisieren. . . . Das Deutsche Theater zu München soll der Sitz dieses *Nebenparlamentes* sein. Beamten-, Lehrer- und Privatangestelltenorganisationen, die freien Berufe, das Handwerk, der Handel und die Industrie, alle sollen sich zu Räten zusammenfinden und in diesen freien Parlamenten ihre Angelegenheiten unabhängig und selbständig erörtern, ihre Wünsche und Anregungen sowohl im Zentralparlament, wie in der Regierung zur *Geltung* bringen."

40. E. Kolb, "Rätewirklichkeit und Räte-Ideologie in der deutschen Revolution von 1918/19," in E. Kolb, ed., *Vom Kaiserreich zur Weimarer Republik* (Cologne, 1972), pp. 164–84.

41. *Arbeitsplan des Rates der bildenden Künstler Münchens*, section 10, copy submitted to the Bavarian Ministry of External Affairs on February 8, 1919, Munich, Bayerisches Hauptstaatsarchiv, MA 92225: "Die Künstlerschaft muss aus ihrer unpolitischen Haltung herauskommen. Wenn Forderungen der Kunst und der Künstlerschaft volkstümlich werden und im Volkswillen Ausdruck finden sollen, muss die Künstlerschaft an der gesamten politischen Arbeit aktiven Anteil nehmen. Manche von uns, vielleicht die meisten, werden sich sträuben, ein so wenig anreizendes Gebiet zu betreten, allein es geht nicht anders. Es ist nicht das Recht, sondern die Pflicht des einzelnen, seinen Anteil am Gesamtwillen der Nation durch Mitarbeit zu beweisen. Es müssen Künstler ins Parlament, aber nicht nur, um bei den seltenen Kunstdebatten sachverständig Stellung zu nehmen, sondern um sich an der ganzen politischen Arbeit mitzubeteiligen."

42. "Die Kunstpflege des Volksstaates, dem mit dem Zusammenbruch des alten Systems gerade auf diesem Gebiet eine Reihe wichtiger, fördernder Arbeiten zufallen, behält als ihr Ziel im Auge, dass die Kunst nicht Luxus- und Ausnahmezustand sein darf, dass sie vielmehr das ganze Volk und das tägliche Leben durchdringen, nicht einzelnen, sondern allen erreichbar sein soll"; A. L. Mayer, "Vor Kunstreformen im Volksstaat Bayern," *Kunstchronik und Kunstmarkt*, November 29, 1918, pp. 136–39, esp. p. 139, quoted after Nerdinger, "Fatale Kontinuität", p. 180.

43. Nerdinger, "Fatale Kontinuität," p. 180.

44. This follows from a letter of the Bavarian Minister for Education and Culture to the president of the newly elected Arbeitsausschuss bildender Künstler (Working Committee of Fine Artists) of July 22, 1919, Munich, Bayerisches Hauptstaatsarchiv, MA 92225, which states that contrary to the earlier council, the new committee is not supported by the New Munich Secession.

45. Exhibition catalog *Neue Münchener Secession, 4. Ausstellung* (Munich, 1918), p. 9: "Schriftführer: Gustav Jagerspacher, Paul Klee, z. Zt. beim Heer."

46. Nerdinger, "Fatale Kontinuität," p. 181; idem, ed., *Richard Riemerschmid: Vom Jugendstil zum Werkbund* (Munich, 1982), p. 512; Hoffmann 1979.

47. R. Kuno, "Die Saturnalien des Krieges," *Münchner Blätter für Dichtung und Graphik* 1 (1919): 4–6, esp. p. 5: "Sicher scheint das eine: Wie der Krieg sich als der Bringer eines ganz anderen Schicksals herausgestellt hat, als alle meinten, die betriebsam waren, ihn heraufzuführen—ganz ebenso dürfte die Revolution zu einer ganz anderen Entfaltung der Ideen werden, als alle diejenigen glauben, die heute die Ideen zu repräsentieren und ihre Verwirklichung zu meistern glauben. Die Revolutionspsychose hat kaum so viele Tage gedauert, wie die Kriegspsychose Wochen gedauert hat."

48. Ibid.: "Die Revolution war zunächst ein Sklavenaufstand der Gehorchenden, eine antimilitaristische Revolution. . . . es wider die Natur ist, ein Volk vier Jahre lang in den widersinnigen Befehlsturm der militärischen Hierarchie einzuspannen."

49. Ibid.: "uns bleibt nur eines: auf der Wacht sein und an den Geist glauben. Denn das ist unser Schicksal."

50. H. Johst, "Die Tragödie der Zeit," *Münchner Blätter für Dichtung und Graphik* 1, no. 1 (1919): 14–16, esp. p. 16: "das Schlagwort von der Politisierung des Geistigen."

51. See also *Kopf Jongleure,* 1916, 46 (D. Chevalier, *Klee* [Paris, 1971], p. 27), showing four decapitated jugglers juggling with their own severed heads.

52. K. Bock, "Voran!" *Der Weg,* no. 2 (February 1919), p. 10: "Es ist an der Zeit, dass die Revolution eine Revolution, eine Reformation schaffe. Die Stunde schreit nach der Politik der Sache. Ein misslich Tun ist es, an die selbständige Kraft des Geistes zu glauben. . . . Politiker des Geistes sind ein fruchtloser Begriff; die Diktatur . . . allein erzwingt wahre Politik."

53. Ibid.: "Mag Einer stehen, in welchem Lager er will, unter dem stürmischen Zwang der Notwendigkeit entgeht er dem Sozialismus nicht."

54. See Hausenstein's article "Kunst und Revolution," *Ostern 1919* (Potsdam and Berlin, 1919), pp. 25–40.

55. E. Grünthal, "Paul Klee," *Der Weg,* no. 2 (February 1919), p. 6: "Substanzlose Seelenhaftigkeit harter, schmerzhaft harter Gegenstände mit äusserst empfindsamen Fingerspitzen erfasst, kurz vor unwiederbringlichem Entgleiten in auflösendes Sichverlieren. Sichtbar noch, aber kaum festzuhalten: wie Schaumblasen, die bei brüsker Näherung schon platzen. Klee darf sich ihrer bemächtigen, denn er umfängt sie liebend und liebt unsäglich zart, mit kindlicher Scheu, fast nur im Traum."

56. *Das Tribunal: Hessische radikale Blätter,* nos. 8–9 (1919).

57. *Das Tribunal,* nos. 8–9. Thanks to Wolfgang Kersten for pointing this out to me.

58. W. Jollos, "Paul Klee," *Das Kunstblatt* 3 (1919): 225–34; H. von Wedderkop, "Paul Klee," *Der Cicerone* 12 (1920): 527–38.

59. Lisbeth Stern, "Bildende Kunst," *Sozialistische Monatshefte,* Year 25 (1919), vol. 52, pp. 293–96, esp. p. 294 ("Klee").

60. A. Behne, "Kunstwende," *Sozialistische Monatshefte,* Year 24 (1918), vol. 51, pp. 948–49, as quoted by Olbrich 1986, p. 15.

61. C. Corrinth, "Heimkehr," *Münchner Blätter für Dichtung und Graphik* 1, no. 2 (1919): 17–18. The story tells of a soldier with radical socialist convictions who after the war returns to his lover. She recalls to him their common prewar designs of "conspiracy, upheaval, new order, freedom, humanity, redemption!" But now the soldier wants no more of this: "'Time?—Eternity!—Action?—Nothing greater than a smiling prayer! and silent absorption (*Versenkung*): so that I will become new, spiritual, and graced: human being (*Mensch*)!" He pronounces this new conviction "while outside the streets are raging, red pennants are exulting in the evening." Corrinth's quick turn to spiritual absorption was consonant with the editorial line which the editor Kuno had summarized with the sentence "to stand guard and believe in the

spirit." Its explicitly antirevolutionary meaning was all the more obvious since it was presented as the conversion of a radical soldier returning from the front, the typical member of the revolutionary soldiers' councils at that time.

62. H. Johst, "Der Schöpfer," *Münchner Blätter für Dichtung und Graphik* 1, no. 2 (1919):38:

"Was deines Geistes uferloser Drang
 Sich je erkühnte als Gedanke
 —Jetzt ohne Hemmung, ohne Schranke
 Ist es die Welt!—
 Es sprang
 Aus Schöpferwollust Deiner Phantasie
 Es wurde ihr und dir zum Bilde—*Vieh!*"

63. H. Hansen, "Revolutionäre Künstler," *Der Weg*, no. 3 (March 1919), p. 6:
"Was tun unsere Künstlerkommissionen? Sie stellen sich auf den Boden der Revolution. Jeder aus ihnen ist eifrig auf Namen und Geldbeutel bedacht. . . .
Was ist Revolution?
Umsturz—Empörung.
Was ist Kunst?
Revolution—
Revolution!"

64. Although the March issue of *Der Weg* only appeared "with more than one month's delay, because of the various political upheavals in Munich," as stated in the publisher's note.

65. A. Mayer, "Revolution und Kunst," *Münchner Blätter für Dichtung und Graphik* 1, no. 4 (1919):64: "Wir haben in der Kunst seit 15 Jahren die stärkste Revolution, eine Weltrevolution der Kunst. . . . dass Künstler stets die grössten Revolutionäre gewesen sind. . . . Dabei ist es bemerkenswert, dass die meisten dieser Künstler als Menschen ganz auf dem Boden der jeweiligen Gesellschaftsordnung standen, korrekte, ja beinahe spiessige Bürger waren. . . . Ihre alles bewegende Kunst war unpolitisch."

66. Ibid.: "Wohl mag es die ernste Absicht der neuen Machthaber sein, die Kunst noch mehr zu fördern als bisher, die Stellung des Künstlers zu heben und zu festigen, aber dies alles hat mit der Kunst selbst im Grunde nichts zu tun."

67. Hoffmann 1982, p. 23.

68. Bern, Nachlass-Sammlung Paul Klee: "Sehr geehrter Herr! Der Arbeitsausschuss des Rats der bildenden Künstler hat, um die Vertretung der fortschrittlichen Kräfte zu stärken, die Herren Karl Caspar, Jos. Eberz, Alex. Kanold, *Paul Klee*, Richard Seewald und die Architekten Biber und Oskar Scharff kooptiert. Wir bitten Sie, im Interesse der wirklichen Freiheit der Kunst, die einer solchen Vertretung unter den jetzigen Umständen notwendig bedarf, die Wahl anzunehmen und Ihre Mitarbeit zuzusagen.
Mit vorzüglicher Hochachtung
I. A. Max Unold
Schwind Str. 29/IV

Wir bitten Sie, zur nächsten Sitzung, Montag 14. 4. nachm. 5 Uhr, im Künstlerhaus, Eingang Hoftor, bestimmt zu erscheinen."

69. A printed copy can be found in Munich, Bayerisches Hauptstaatsarchiv, MA 92225.

70. "Sehr geehrter Herr Schäfler [sic],
Der Aktionsausschuss revolutionärer Künstler möge ganz über meine künstlerische Kraft verfügen. Dass ich mich dahin zugehörig betrachte ist ja selbstverständlich, da ich doch mehrere Jahre vor dem Krieg schon in der Art produzierte, die

jetzt auf noch breitere öffentliche Basis gestellt werden soll. Mein Werk und meine sonstige künstlerische Kraft und Erkenntnis stehen zur Verfügung!

Mit bestem Gruss

Ihr Klee."

Aachen, Estate of Fritz Schaefler. My thanks go to Justin Hoffmann for bringing this document to my attention. On December 2, 1918, Klee had already responded to Schaefler's request to participate in an exhibition at the I. B. Neumann Gallery in Berlin; letter in Aachen, Estate of Fritz Schaefler.

71. L. Coellen, "Die neue Kunst," *Münchner Neueste Nachrichten,* no. 161 (April 9, 1919), quoted after Weinstein 1986, p. 196: "Ehe die politische Revolution war, war die Revolution der Kunst. Lange bevor das Ende des Weltkrieges dem Geist der neuen Zeit politisch die Bahn frei gemacht hat, war dieser Geist in der neuen Kunst lebendig geworden. Das ist es, was heute das werktätige Volk wissen muss, dass die jungen Künstler und die junge Kunst seine Bundesgenossen sind. . . .

Die neue Kunst jubelt der Weltrevolution zu. Sie weiss, dass nun auch der Tag ihres eigenen Sieges gekommen ist."

72. Werckmeister, "From Revolution to Exile," 1987, p. 40.

73. "Revolutionäre Künstler," *Mitteilungen des Vollzugsrats der Betriebs- und Soldatenräte,* April 15 and 16, reprinted in M. Gerst, *Die Münchner Räterepublik* (Munich, 1919), pp. 63–64; cf. Weinstein 1986, pp. 203–4.

74. Washington, Library of Congress, Reese Collection, Copy of minutes of the session. My thanks go to Justin Hoffmann for providing me with a copy of this document.

75. Ibid: "Vorschlag: Klee in den Aktionsausschuss aufzunehmen, wurde angenommen."

76. Washington, Library of Congress, Reese Collection, quoted by Hoffmann 1982, p. 24, note 16.

77. The following point was brought home to me by Charles Haxthausen.

78. *Verhandlungen des provisorischen Nationalrates des Volksstaates Bayern im Jahre 1918/1919,* I–III (Munich, 1919).

79. Munich, Staatsarchiv, Staatsanwaltschaft München, No. 2242/II, Blatt 120, exhibit in Toller's trial.

80. Hoffmann 1982, p. 22.

81. Quoted from Hoffmann 1982, p. 22: "Die Geistigkeit einer abstrakten Kunst (siehe Ausführungsprogramm) bedeutet die ungeheure Erweiterung des freiheitlichen Gefühls des Menschen. . . . Die Kunst im Staat muss den Geist des gesamten Volkskörpers widerspiegeln. Kunst . . . soll . . . jedem einzelnen und keiner Klasse gehören. . . . Solche Arbeit verbürgt dem Volke höchsten Lebenswert."

82. Ibid.

83. Ibid., p. 23.

84. Willett 1978, pp. 34 ff.

85. Hoffmann 1979, p. 31: "Die Herren sprachen im Namen des Expressionismus, meldeten die Ansprüche der Neuen Kunst an und der von ihr ergriffenen jungen geistig-revolutionären Generation."

86. H. Esswein, "Die Sommerausstellung der Neuen Sezession III," *Münchner Post* 33, no. 158 (July 10, 1919), quoted after Weinstein 1986, p. 207: "Der Kuriosität halber mag erwähnt werden, dass Paul Klee von den Kunstdiktatoren der Rätezeit als Graphik-Lehrer an der Münchner Kunstgewerbeschule in Aussicht genommen war."

87. Nuremberg, Germanisches Nationalmuseum, Archiv für Bildende Kunst, ZR ABK 816, Riemerschmid Papers, B 197.

88. "Ich komme nun zu der Gruppe von Gegnern idealer Art, welche die intensivsten Gegner der Akademie sind, ich meine die Vertreter der allerjüngsten Richtung, die ich hier der Bequemlichkeit halber als *Expressionisten* oder *Futuristen*

bezeichnen will. . . . So gut ich es verstehe, dass überzeugte Anhänger einer Richtung alles ins Werk setzen, um dieselbe zur Geltung zu bringen, so würde man sich doch eine schwere Verantwortung aufbürden, . . . wenn man . . . in künstlerischen Dingen äussere Umstände wie z. B. *die momentane Verteilung der politischen Machtfaktoren* als *Zwangsmittel* für Erreichung künstlerischer Zwecke hereinziehen würde."

Chapter 7

1. Weinstein 1986, p. 211, and references there.

2. Munich, Staatsarchiv, Staatsanwaltschaft München I, No. 2242/I, fol. 124, report by police officer Konrad Walch of Toller's capture on June 4: "Neben der Reichl'schen [sic] Wohnung befindet sich auch ein Arbeitszimmer des Kunstmalers Klee—Näheres und Wohnung nicht bekannt. In diesem Zimmer fanden sich verdächtige Sachen nicht vor."

3. "Die Fugen der Türe waren durch Zeichnungen und Bilder verdeckt. Kunstsachverständige Kriminalbeamte erkannten sofort, dass hinter diesen Bildern etwas 'steckt.'" Quoted by W. Kehr, "Die Münchner Bildproduktion der Jahre 1918/19 als Gegenstand eines Seminars der Münchner Kunstakademie," in D. Halfbrodt and W. Kehr, eds., *München 1919: Bildende Kunst/Fotografie der Revolutions- und Rätezeit* (Munich, 1979), pp. 5–20, esp. p. 8.

4. P. Klee, *Briefe*, 2:952, to Lily Klee, June 11, 1919: "Das Schiff nach Romanshorn konnte ich nicht mehr erwischen, das Schiff nach Rorschach 1,10 sehr knapp. Sonst hätte ich in Lindau bleiben müssen bis 4 Uhr. Meine Nerven waren etwas unruhig, und ich machte, dass ich möglichst rasch über die Grenze kam. Es ging alles ganz glatt."

5. Ibid., p. 955, to Lily Klee, June 24, 1919: "Es scheint, wir haben Frieden, besser für mich."

6. Ibid., p. 957, to Lily Klee, June 28, 1919: "Drittens die Haussuchung! Was wollen die bei mir? Bilder anschauen, die sie doch nicht schön finden??"

7. This was over three weeks later than he had planned, according to the letter of May 12, 1919, to Kubin, quoted in the following note, where Klee writes that he will go on a three-week trip starting June 11.

8. "Briefe von Paul Klee an Alfred Kubin," p. 93: "Ich war nicht fähig gewesen die verschiedenen Ansätze zu Briefen so weit fertig zu machen dass Sie Freude drangehabt hätten. Auch diesen 'Brief' schicke ich Ihnen erst heute zu, am (10. Juni) Vorabend meiner 3 wöchigen Schweizerreise."

9. Ibid.: "Es war ein richtiges Trauerspiel, ein erschütternder Zusammenbruch einer im Grunde sittlichen Bewegung, die aber, im Überdrang falsch einsetzend, sich von Verbrechen nicht rein halten konnte.

So wenig dauerhaft diese kommunistische Republik von Anfang an schien, so gab sie doch Gelegenheit zur Überprüfung der subjektiven Existenzmöglichkeiten in einem solchen Gemeinwesen. Ohne positives Ergebnis war sie nicht. Natürlich eine zugespitzte individualistische Kunst ist zum Genuss durch die Gesamtheit nicht geeignet, sie ist kapitalistischer Luxus. Aber wir sind doch wohl mehr als Kuriositäten für reiche Snobs. Und das was an uns irgendwie darüber hinaus Ewigkeitswerten zustrebt, das würde im kommunistischen Gemeinwesen eher Förderung erfahren können. . . . wir würden die Ergebnisse unserer Erfindertätigkeit dem Volkskörper zuleiten können. Diese neue Kunst könnte dann ins Handwerk eindringen und eine grosse Blüte hervorbringen. Denn Akademien gäbe es nicht mehr, sondern nur Kunstschulen für Handwerker."

10. See W. Pehnt, *Die Architektur des Expressionismus* (Stuttgart, 1973), p. 109.

11. "Kunst und Volk müssen eine Einheit bilden. Die Kunst soll nicht mehr Genuss weniger, sondern Glück und Leben der Massen sein," "Ein neues künstlerisches Programm," reprinted in *Arbeitsrat für Kunst 1918–1921,* catalog (Berlin, 1980), p. 87.

12. M. Pechstein, "Was wir wollen," in L. Meidner and M. Pechstein, eds., *An alle Künstler* (Berlin, 1919), p. 19.

13. *Arbeitsrat für Kunst 1918–1921,* p. 87.

14. G. J. Wolf, "Kunst und Revolution," *Die Kunst* 39 (1918–19): 217–20.

15. T. Tautz, "Die Kunst und das Proletariat," *Münchner Neueste Nachrichten,* no. 161, April 9, 1919: "Kunst ist weder Luxus noch Vergnügen. Kunst ist Brot; der unterdrückte, leidende, endlich sich befreiende Mensch ist hungrig nach Wahrheit und Schönheit. Die Kunst ist allen Menschen zugänglich zu machen." Cf. Weinstein 1986, p. 197.

16. W. Nerdinger, *Richard Riemerschmid: Vom Jugendstil zum Werkbund, Werke und Dokumente,* catalog (Munich, 1982), pp. 508 ff.

17. "Also hat die Räte Republik auch für uns manche Erkenntnis gebracht. An eine praktische Durchführung ist nun erst recht nicht mehr zu denken. Wir sind kurz nach der ideellen Verdichtung auch noch nicht reif dazu."

18. "Lieber Kubin, vielleicht interessiert Sie das nicht so sehr, aber es hat mich zeitweise sehr beschäftigt."

19. "Dass ich deswegen von nichts wesentlichem abwich, würde Ihnen meine Secessions Kollection erweisen."

20. See L. Zahn, [memoir] in L. Grote, ed., *Erinnerungen an Paul Klee* (Munich, 1959), p. 31.

21. "Heraus aus dem Gefängnis des Schlagworts und der Phrase," signed "Der Ararat," *Der Ararat* 1, no. 3 (May 19, 1919): "Was im November 18 geschah, war ein Verbrechen an dem deutschen Volke. . . . Rettungstruppen."

22. Ibid.: "Wo ist heute noch die Grenze zwischen den Besitzenden und dem Proletariat zu ziehen? . . . Jede Nation wird stets aus Tüchtigen und Untüchtigen bestehen. Der Könnende und Wollende ist der Besitzer. Der Faule und Degenerierte muss sich ihm unterordnen. Eine andere Weltordnung gibt es nicht. Wo sie aufgerichtet wurde, traten die Zustände ein, die wir in München erlebt haben."

23. This dating is based on the numbering sequence in the oeuvre catalog—which, to be sure, does not necessarily record the day-by-day chronology in which Klee completed each one of his works—where the group is preceded by the watercolor "Mai," numbered 1919, 64. On the other end, the last work completed before June 19, when Klee left Munich, is *Junger Proletarier* (1919, 111), since it was exhibited in June in the New Munich Secession.

24. W. Kandinsky, *Über das Geistige in der Kunst,* 3d ed. (Bern, 1952), p. 84: "Blind gegen 'anerkannte' oder 'unanerkannte' Form, taub gegen Lehren und Wünsche der Zeit soll der Künstler sein. Sein offenes Auge soll auf sein inneres Leben gerichtet werden und sein Ohr soll dem Munde der inneren Notwendigkeit stets zugewendet sein."

For further analogies in the modernist tradition (Yeats, de Chirico), see Hohl 1982, p. 12.

25. Klee, *Briefe,* 2:908, to Lily Klee, February 28(?), 1918: "alles versinkt um mich, und gute Werke entstehen von selber vor mir. . . . Meine Hand ist ganz Werkzeug einer fernen Sphäre. Mein Kopf ist es auch nicht, was da funktioniert, sondern etwas anderes, ein Höheres, Ferneres, Irgendwo. Ich muss da grosse Freunde haben, helle aber auch dunkle. Das ist gleich, ich finde sie alle von grosser Güte." Cf. S. Ringbom, "Art in the Epoch of the Great Spiritual: Occult Elements in the Early Theory of Abstract Painting," *Journal of the Warburg and Courtauld Institutes* 29 (1966): 386–418, esp. pp. 412–13, on this passage, with reference to Klee's later claim that he had

nothing to do with theosophy; see below, p. 216, n. 130; W. Baumeister, [memoir] in Grote 1959, p. 37.

26. Huggler (1969, pp. 10–11) seems to have been the only author to have recognized this: "Fünf Blätter des Jahres 1919 geben die Situationen, in denen der nunmehr Vierzigjährige sich schaffend, als Künstler, mit bösem Spott ironisiert, indem er zugleich die schöpferische Tätigkeit in ihre verschiedenen Phasen zerlegt...; besonders scharf ist die Ironie über die *Versunkenheit.*" Huggler does not, however, touch with as much as a word the historical situation in which Klee found himself when he made the drawings.

27. The fantastic landscapes that were exhibited were 1917, 75; 1918, 80, 90, 93, 108, 112, 118, 150; 1919, 8, 40, 99, 104. The four narratives were 1918, 138, 139; 1919, 2, 98. And the abstract and constructive compositions were 1917, 52; 1919, 68, 69.

28. Gustav Pauli, "Reiseberichte," Hamburg Kunsthalle, Archiv 119a, July 9, 1917, quoted by Theda Shapiro, *Painters and Politics* (New York, 1976), p. 165.

29. M. Prosenc, *Die Dadaisten in Zürich* (Bonn, 1967), p. 95, with reference to H. Ball, *Die Flucht aus der Zeit,* (Munich and Leipzig, 1927), p. 170.

30. P. Bender, "Der Künstler und die Revolution," *Die Aktion* 8 (December 14, 1918): cols. 654–656, esp. col. 655. "Diese Krise ist zunächst wirtschaftlich; sie wird aber auch künstlerisch, da an Stelle des alten Publikums das Proletariat treten wird. Das Proletariat aber versteht die ... bürgerliche Kunst und Lebensgestaltung nicht und steht daher auch dem Künstler und Kunstwerk als einem charakteristischen Teilstück der proletariatsfeindlichen Klasse verständnislos oder gar feindselig gegenüber."

31. I. Boyd Whyte, *Bruno Taut and the Architecture of Activism* (Cambridge, 1982), pp. 144–45.

32. A. Behne, "Unsere moralische Krisis," p. 38: "Es bleibt uns also nichts anderes übrig als uns an die Proletarier zu wenden, das heisst an jene Menschen, die Besitz verschmähen, in denen das Gefühl tiefster Zusammengehörigkeit über alle Grenzen hin lebt."

33. *Der Cicerone* 11, no. 15 (August 1919): 497.

34. Hoffmann 1982, p. 22.

35. Klee, *Das bildnerische Denken,* p. 55, undated lecture text.

36. "Aufruf der Unbeteiligten," *Münchner Neueste Nachrichten,* May 19, 1919, quoted after C. Stölzl, "Unordnung und gedämpftes Leuchten: Ein Vorwort," in C. Stölzl, ed., *Die Zwanziger Jahre in München,* catalog (Munich: Stadtmuseum, 1979), pp. x–xxiii, esp. pp. xiiff.: "Es genügt nicht, ... vor einer harten Gewaltanwendung und einem frivolen Triumphieren in diesem furchtbaren Augenblick zu warnen, sondern wir halten es gerade jetzt für nötig, dass das Bürgertum ernst und ehrlich seinen Sinn darauf richtet, seiner Schicksalsgemeinschaft mit dem arbeitenden Volke innezuwerden. Dass es mit ihm die grundlegende Umwandlung der Gesellschaftsordnung beginnt."

37. Klee 1976, p. 174.

38. See above, p. 146, n. 2.

39. Oeuvre catalog numbers 1918, 80, 108, 118; 1919, 8, 40, 99.

40. Oeuvre catalog numbers 1917, 52; 1919, 68, 69.

41. My account is based on the following three publications by Karin von Maur: von Maur 1975; von Maur 1979; "Paul Klee und der Kampf um die Hölzel-Nachfolge in Stuttgart," in Magdalena Droste, ed., *Klee und Kandinsky,* catalog (Stuttgart, 1979), pp. 95–99; on additional material which Karin von Maur kindly sent me; and on the correspondence between Klee and Schlemmer, Stuttgart, Staatsgalerie, Schlemmer Archive, and Bern, Nachlass-Sammlung Paul Klee.

42. Letter of January 25, 1919, to Meyer-Amden, as quoted by von Maur 1979, p. 84.

43. Letter of April 30, 1919, to Meyer-Amden, as quoted by von Maur 1979, p. 353, note 306.

44. Von Maur 1979, p. 84.

45. Stuttgart, Schlemmer Archive: "Was nun eine Ausstellung meiner Werke in Stuttgart betrifft, so bin ich zwar stets dafür, meine Bilder weiteren Kreisen immer wieder aufs Neue zugänglich zu machen. . . . Anderseits muss ich mir sagen: Wer sich in den letzten vielsagenden Jahren um bildende Kunst ernsthaft gekümmert hat, wird doch ganz gut wissen, wer ich bin.

Ich könnte Ihnen ja zu Händen der für Sie in Betracht kommenden Personen, Stellen oder Behörden vielleicht einen Hinweis auf etliche Publikationen empfehlen. Wilh. Hausenstein. . . , Theodor Däubler . . . Oder verweisen Sie an Dr. Hausenstein persönlich als 'Sachverständigen', so komisch das vielleicht für's erste sich anhört."

46. Stuttgart, Schlemmer Archive: "dass meine Bereitschaft, in Stuttgart oder anderswo als Kunsterzieher zu wirken, in erster Linie altruistischen Motiven wie dem guten Willen zu helfen entspringt, sowie der Erkenntnis dass ich mich einer erspriesslichen Lehrtätigkeit mit gutem Gewissen auf die Dauer nicht werde entziehen können. . . . Nur eines bitte ich Sie nicht zu tun, nicht dran zu denken, dass beim Scheitern Ihres Planes irgendein Ehrgeiziges oder wirtschaftliches an mir davon betroffen würde."

47. He had given similarly vague hints of possible teaching opportunities in his letter requesting leave from the Gersthofen soldiers' council on December 16, 1918, reprinted in Felix Klee's edition of *Tagebücher* (Cologne, 1957), p. 419.

48. "Bericht des Referenten Stud. Schlemmer betr. die Berufung des Malers Klee an die Stuttgarter Akademie der bildenden Künste," dated July 7, 1919; copy in Stuttgart, Staatsgalerie, Oskar Schlemmer-Archiv, kindly brought to my attention by Karin von Maur.

49. "Bericht des Referenten": "der auf eine Anfrage sich bereit erklärte, eine Lehrstelle in Stuttgart anzunehmen und dieselbe andern bereits an ihn ergangenen Angeboten von Frankfurt und Weimar vorzuziehen. Die überall im Reich vor sich gehenden Neugestaltungen des Kunstschulwesens und die damit verbundenen Neuberufungen . . . lassen es als dringlich erscheinen, die Berufung *unverzüglich* vorzunehmen."

50. The minutes of the Bauhaus faculty (West Berlin, Bauhaus-Archiv) contain nothing about any earlier offer.

51. Letter of Gropius to Klee, October 29, 1920, Bern, Nachlass-Sammlung Paul Klee, quoted by Glaesemer, 2:10: "Schon seit Jahresfrist warte ich auf den Moment, diesen Ruf an Sie ergehen zu lassen."

52. See p. 178. In his letter of October 29, 1920, Gropius presupposes: "Ich nehme an, dass Sie ungefähr wissen, was wir hier begonnen haben."

53. "Bericht des Referenten": "Die Studierenden liessen sich bei der Wahl Paul Klee's davon leiten, dass ihnen derselbe *Autorität*, indem sie ihn als künstlerisch überlegenen vorbildlichen Geist anerkennen, aber auch *Kampfgenosse* zu sein vermag, indem er als Pionier der neuen Ideen sich restlos für dieselben einsetzt und damit das Streben und die Interessen der sich zu ihm bekennenden Studierenden zu vertreten gewillt ist."

54. Bern, Nachlass-Sammlung Paul Klee: "Ihr Brief war mir sehr wertvoll, weil Sie sich darin über die Auffassung Ihrer Lehrtätigkeit äussern. Einer der Hauptanwürfe gegen die wir Sie hier zu verteidigen haben ist nämlich, dass ein so erdfernverträumter Künstler wie Sie 'vermutlich' wären, schwerlich ein Lehrer wäre, der die moderne Sache mit dem in einer Stadt wie Stuttgart nötigen Nachdruck zu führen geeignet wäre. Nun—vielleicht ist die *sanfte* Art sogar die eindringlichere und die Agitation für die neue Kunst besorgen andre, an denen es in Stuttgart nicht fehlt. 'Spielerisch', 'feminin' sind weitere Worte des Zweifels."

55. Letter of Däubler to Klee from Berlin, March 12, 1919, Bern, Nachlass-Sammlung Paul Klee: "Ich sprach oft mit Gurlitt, auch neulich telephonisch, er scheint Sie langsam zu verstehen. Warum, lieber Klee, sollen Sie nicht auch einen guten Vertrag wie alle anderen Künstler haben? Bei Cassirer gehts leider nicht: dort wurden Sie noch nicht begriffen. Oder sind Sie mit Goltz irgendwie festgelegt: ich hoffe, das nein!" Klee jotted down on the letter the terms of his reply to Däubler: "bereit zu einem allgemeinen Vertrag mit Gurlitt."

56. Bern, Nachlass-Sammlung Paul Klee, letter from Flechtheim to Klee, June 3, 1919: "Da ich durch Herrn Uhde und auch Herrn Friege und Däubler höre, dass Sie keinen Kunsthändler haben, . . . so frage ich hierdurch an, ob Sie nicht geneigt sind, die Vertretung Ihrer Interessen mir zu übertragen." Thanks to Wolfgang Kersten for making this letter known to me.

57. Note by Klee on the original of Flechtheim's letter: "Mein Interesse am Vorschlag geäussert. Näheres erbeten."

58. Bern, Nachlass-Sammlung Paul Klee: "Ich habe eine Reihe Verträge mit Künstlern. Den einen gegenüber garantiere ich ein Mindest-Einkommen, ich bin dann nur [sic] mit einem grösseren Nutzen an ihren Malereien, Aquarellen und graphischen Arbeiten beteiligt; den anderen gegenüber garantiere ich keinen Betrag, ich bin dann nur mit einer kleinen Provision beteiligt."

59. Herbert Eulenberg, "Vorspruch," in *Ostern 1919* (Potsdam and Berlin, 1919), p. 3: "Kunst und Revolution! / Das passt vortrefflich zusammen."

60. W. Hausenstein, "Kunst und Revolution," in *Ostern 1919*, pp. 25–40, also printed in *Der Vorläufer: Sonderheft des neuen Merkur* 3 (1919): 115–27; reprinted in W. Hausenstein, *Zeiten und Bilder* (Munich, 1920), pp. 25 ff.

61. Hausenstein, in *Ostern 1919*, p. 35: "Es sind nicht die schlechtesten Künstler, die darauf verzichtet haben, den Moment der Revolution wahrzunehmen. Indem sie alles auf die Bedeutung der abgesonderten, in sich selbst ruhenden künstlerischen Leistung stellten, waren gerade sie als Künstler, wahrscheinlich auch als Menschen und als Elemente der Gesellschaft, radikaler als die andern, die das Heil von der eiligen Gründung künstlerischer Räte erwarteten. Räte: sie berühren nur das Gebiet des Mittelbaren. Die Macht im Staat ist für die Kunst das Mittelbare. Das Wesen der Kunst liegt im Unmittelbaren der Leistung von Fall zu Fall, von Person zu Person. Es bleibt Hauptsache, das Künstlerische zu tun, Nebensache das Kunstpolitische zu bearbeiten."

62. Bern, Nachlass-Sammlung Paul Klee, letter from Flechtheim to Klee, June 3, 1919: "Beigefalten übersende ich Ihnen mein Buch *Ostern 1919*."

63. Klee, *Briefe*, 2:957, to Lily Klee, June 28, 1919, and p. 959, to Lily Klee, July 6, 1919.

64. Bern, Nachlass-Sammlung Paul Klee, §1: "Ferner behält sich Herr Klee vor, für die Kunsthandlung Flechtheim in Düsseldorf eine Collektion seiner Werke zusammenzustellen, die dieser Firma zum kommissionsweisen Verkauf in der Wintersaison 1919/20 übergeben werden wird. Die Verrechnung aus dem Verkauf dieser Collektion geschieht durch Herrn Goltz. . . . Endlich verpflichtet sich Herr Goltz, nach besten Kräften dahin zu wirken, dass die Kunsthandlung [sic] Gurlitt in Berlin und Flechtheim in Düsseldorf ihr bisher für die Werke des Herrn Klee bekundetes Interesse beibehalten."

65. Munich, Staatsarchiv, Staatsanwaltschaft München I, no. 1915. After a short detention, Trautner was released on his own recognizance. He returned to Munich and on September 26, 1919, was condemned to five months in prison and payment of the costs. The imprimatur of the May–June issue of *Der Weg* gives "Berlin W. Kurfürstendamm 71/IV" as his address, although the publisher is still listed as A. Karl Lang Verlag, München-Pasing.

66. *Der Weg*, May–June 1919, p. 14: "Von einem Deutschen! Wehe Euch jüdi-

schen Schweinehunden! Euch Spartakisten! Nichtskönner! Spekulanten! Hunde! Gesindel! Wehe Euch, die Ihr das deutsche Vaterland und die deutsche Kunst ruiniert! . . . Dasselbe Gesindel wie Mühsam, Levien etc. und Konsorten. Kokoschka! Heckel! Kirchner! Eberz! Unold! Seewald! Dawringhausen [sic]!"

67. E. Grünthal, "Neue Sezession [sic] München," *Der Weg*, May—June, 1919, p. 2: "Alleräusserste Spitze des vorgetriebenen Keiles wird unbestritten *Klee* einnehmen. . . . Die kosmischen Dinge fängt er auf und formt mit *zwingender* Notwendigkeit eine transzendente Welt. So freundschaftlich bekannt muten diese farbig blühenden Rinnsale an, als ob wir sie schon einmal irgendwann gesehen hätten. . . . Das ist der Weg zum Sein hinter den Erscheinungen, zum ästhetischen Ding an sich."

68. K. Pfister, "Fünfte Jahresausstellung der Münchener Neuen Sezession," *Der Cicerone* 11, no. 13 (July 1919): pp. 411–12, esp. p. 411: "da es, von Generation zu wird: frühzeitig zu ermatten und aus dem radikalen Bewusstsein junger Jahre eine lebenslängliche Rente zu gewinnen."

69. G. J. Wolf, "Die Ausstellung der Neuen Münchner Secession 1919," *Die Kunst für Alle* 39 (August 21–22, 1918): 397–405, esp. p. 400: "Ich muss mich auch stets aufs neue fragen, ob . . . in den von den Leuten der Neuen Secession so hochgeschätzten Kompositionen Paul Klees tatsächlich 'das elementare Lebensgefühl, wo das Denken und Schaffen des Menschen noch einer religiösen Offenbarung gleicht', emporsteigt oder ob man es da etwa doch nur mit geistreichen Spielereien . . . zu tun hat." Cf. also K. Pfister, "Münchner Neue Sezession," *Deutsche Kunst und Dekoration* 45 (October 1919): 3–6; W. Wolfradt, "Münchner Neue Sezession," *Das Kunstblatt* 3 (1919): 253–54.

70. H. Esswein, "Die Sommerausstellung der Neuen Sezession III," *Münchner Post* 33, no. 158, July 10, 1919, quoted after Weinstein 1986, p. 348: "Unter den Phantasiekünstlern gilt Paul Klee als ein ganz besonderes Phänomen, ich finde nur, dass er eigentlich keine Phantasie hat, sondern Torheiten treibt wie ein Kind. . . . aber schliesslich ist dieser ganze Salon-Bolschewismus auch in der Kunst nur eine Spezialität für gebildetes Lumpengesindel."

71. *Münchner Blätter* 1, no. 6 (1919), subscription invitation at end of fascicle: "Keinem Werk werden wir die Aufnahme verwehren, weil es zu links, zu radikal wäre."

72. Ibid., pp. 129–30:
"Lausch auf, meine Seele, ob du nicht vernimmst
Eine Botschaft von oben!—O lasst,
Unsterbliche Berge, aus eurem Geheimnis hervorgehn
Mit Licht umkränzt den heiligen Sänger!

.

O unbekannter Geist! Steige herab von dem reinsten der Berge,
Bring uns die Freude herab
Von jungfräulichen Gipfeln, die im Scheine der Sterne erglänzen,
Von unerforschten Sitzen,
Von nie versiegenden Quellen, die unbewusst singen . . .
Aus den lautern Adern Eises, aus dem heiligen Schweigen
Der unbekannten Dinge . . .
Rufe ich dich herab, o reiner Geist."

73. It was copied after a drawing of his from the year 1913.

74. H. Schiebelhuth, "Für Lefherte," ibid., p. 138:
"Nachbluth zerfallener Zeit fiebert um Dich. Reden
Leichtfertiger Menschen rühren wie Handharfe Dein kindlich Herz.

.

Aber einmal wirst Du auch in den heiligen Säulenwäldern
Weinen, dass Gott herabkomme und die Steine erlöst,
Dankbar sein, wenn seine Hand Dir immer unsichtbar
Bessere Sternbilder aufbaut über dem Horizont."

75. E. O. Stählin, "Traum vom neuen Paradies," ibid., p. 140:
"Verwildrung, Seuchen, hungerndes Gestöhn,
Irrtum und Hohn, der Unvollkommenheit
Zerrüttetes Bewusstsein und die Schmach . . .

.
Wo bleibt ein Licht? Wer weiss wann Freude blüht.

.
Verkünderseelen flammen auf, die Rede
Magischer Menschen braust . . .

.
Die Erde lieben! Sternenwunder ahnen!"

76. E. von Sydow, "Paul Klee," ibid., pp. 140–44, esp. p. 144: "Der wahrhafte Psychograph, Seelenschreiber, Seelen-Entzauberer, Gottes-Verzauberer, hier ist er: Paul Klee!" Von Sydow republished this text in his book *Die deutsche expressionistische Kultur und Malerei* (Berlin, 1920), pp. 124–26.

77. Kühn (1986, p. 28), who likewise discusses the lithograph as a fitting illustration of von Sydow's text, does not draw this distinction.

78. Ibid.: "Er lauscht ganz reglos der inneren Stimme, die in ihm laut wird; wie zitternd flüstert diese Stimme: 'nimm spitzesten Bleistift zur Hand und zarteste Pinsel, rühre dich nicht, sondern warte, warte, bis sich deine Hand von selbst regt.'
. . . Und seine Augen erzählen von mystischen Praktiken,—wie oft muss er den Blick auf die andere Seite des Mondes zu richten versucht haben: so schaut nur ein Mensch, der aus der Entsagung subtilste Erkenntnis gewann. . . .
. . . Ob Klee bewusst so konzentriert? Er gibt wohl als kopiegetreuer Nachahmer das Anschauungsbild des inneren Zustandes seiner Seele wieder. Und auch den der Wirklichkeiten? Wahrscheinlich; denn ein Hellseher, der die Zeichnung 'Seelen Abgeschiedener nähern sich einem mit Gerichten besetzten Tisch' sah, rief verwundert: 'Genau so sehe ich diese Wesen auch!' Ist's eine allgemein menschliche Fantastik? Sind manchem Menschen wirklich Übersinnlichkeiten wahrnehmbar?"

79. The connection has been noted by Hohl (1982, p. 152).

80. K. Sch[effler], "Zur Klee-Ausstellung bei Fritz Gurlitt," *Kunst und Künstler* 18 (1919–20): 341: "Der von etlichen Hohenpriestern auf dem Angesicht Angebetete."

81. L. Meidner, *An alle Künstler,* quoted in T. Grochowiak, *Ludwig Meidner* (Recklinghausen, 1966), p. 149: "Stehen wir viel besser und gesicherter in der Gesellschaft als der Proletarier?! Sind wir nicht wie Bettler abhängig von den Launen der kunstsammelnden Bourgeoisie!"

82. C. E. Uphoff, "Künstler, Kunst, Sozialismus," *Der Cicerone* 11 (1919): 121–25, esp. p. 124: "Die Tatsache, dass die Kunst Luxusbedeutung hatte, bringt den Kunstschaffenden jetzt in Not. . . . So wird der Künstler gezwungen, mit einer Besitzlosigkeit zu rechnen, die ihn dem ärmsten Proletarier gleichstellt. . . . Der Künstler ist mir der geehrteste, dessen Werke in den Wohnstuben der Arbeitenden feinstes Verständnis und ehrfürchtig-liebevolle Hege findet."

83. J. A. Lux, "Der Künstler und die neue Zeit," *Die Kunst für Alle* 33 (March 1919): 357–60, esp. p. 357: "Der Künstler ist nicht Proletarier, auch wenn er kein Geld hat; er kann nicht schöpferisch werden durch Organisation, die immer nur ein Äusserliches, Materielles betrifft. Seine Seelenkräfte sind nicht nach aussen gewendet, wie die des Politikers oder Redners oder Demagogen; sie sind nach innen

gewendet, auf den Kern seines Wesens bezogen, aus dem er durch Konzentration, Verdichtung seine Werke schafft. Er ist immer in gewissem Sinne Autokrat und nicht Organisator."

84. Bern, Nachlass-Sammlung Paul Klee:

"§1. Herr Klee überträgt Herrn Goltz für die Dauer dieses Vertrages das Alleinverkaufsrecht hinsichtlich seines gesamten künstlerischen Werkes, soweit nicht in diesem Vertrage ausdrücklich Ausnahmen gemacht sind. Herr Goltz ist demgemäss während der Vertragszeit ausschliesslich befugt, alle von Herrn Klee fertig gestellten und für verkaufsreif erklärten Gemälde, Aquarelle, Handzeichnungen und graphischen Werke, sowie alle von Herrn Klee während der Dauer dieses Vertrages in Zukunft fertig gestellten und für verkaufsreif erklärten Werke zu verkaufen. . . .

§3. Als Vergütung erhält Herr Goltz die von ihm über die durch Herrn Klee festzusetzenden Nettopreise erzielten Überpreise. Als Nettopreis gilt diejenige Summe ohne jeden Abzug, die Herr Klee als zu erzielenden Nettopreis bezeichnet. Zunächst wird Herr Klee die Nettopreise für *Gemälde* auf dem Fusse von 800 M. für das einzelne Stück, die Nettopreise für *Aquarelle* je nach Art der Arbeit auf dem Fusse von 200–500 M. für das Stück halten. Die Nettopreise für Handzeichnungen setzt Herr Klee nicht unter 150 M. für das Stück an. Die Verkaufspreise bestimmt Herr Goltz nach freiem Belieben. . . .

§6. Herr Goltz garantiert Herrn Klee eine reine Mindesteinnahme aus dem von ihm selbst vermittelten Absatz seiner Werke in Höhe von 15,000.--Mk.—fünfzehntausend Mark—und verpflichtet sich, diese Garantiesumme ohne Rücksicht auf den Umsatzumfang des von ihm jeweils erzielten Absatzes in monatlichen Raten von 1,250.--Mk.—zwölfhundertfünfzig Mark—zahlbar je am 6. eines Monats zu entrichten."

85. According to Holtfrerich's (1980, p. 15) table, the inflation factor stood at 5.62 in October 1919, compared to 1.79 (average) for 1917.

86. Of this amount, Klee actually received only 8,242 marks, after "Ratenzahlungen und Provisionen" had been deducted.

87. Of this amount, Klee had to hand back 300 marks "ab f. Provision f. das an Campendonk verkaufte Gemälde zu 1500 M brutto (1200 netto)."

88. "Mitteilungen der Galerie und des Verlages Neue Kunst, Hans Goltz," *Der Ararat*, nos. 5–6 (March 1920), p. 43: "Die Verkäufe von Klees Werken steigern sich von Woche zu Woche, so dass es erlaubt ist, von einem Run auf Klee zu sprechen."

89. "Briefe von Paul Klee an Alfred Kubin," in *Paul Klee: Das Frühwerk*, p. 95: "Goltz arbeitet bis jetzt sehr gut. Ich bin sehr froh über diese Lösung. Gar keine Ausstellungssorgen mehr. Fast gar keine geschäftliche Korrespondenz mehr! Das ist sehr angenehm."

90. Ibid.: "Dass ich mich durch diese Erleichterung verpflichtet fühle zu einer Steigerung meiner Leistungen, das glauben Sie mir doch?"

91. K. Edschmid, ed., *Schöpferische Konfession* (Tribüne der Kunst und Zeit: Eine Schriftensammlung, XIII; Berlin, 1920), p. 6: "Gedruckt im Herbst 1919 in der Spamerschen Buchdruckerei in Leipzig."

92. See Naubert-Riser (1978, p. 87), who, however, does not distinguish between the two versions of the draft and discerns no change of focus in the published version.

93. Sequence of sections:

I. §1 from "Graphic Art," I; §2 from "Graphic Art," II

II. all from "Graphic Art," II

III. all from Graphic Art," III

IV. all from "Graphic Art," IV

V. all from "Graphic Art," V

VI. all from "Graphic Art," V ("ein paar Beispiele")

VII. all from last, unnumbered, one-column passage of "Graphic Art."

94. "Kunst gibt nicht das Sichtbare wieder, sondern macht sichtbar."

95. *Briefe*, 2:945, December 10, 1918: "Bildende Kunst ist nicht vom Sehen abhängig. Sie will allein sichtbar werden." *Tagebücher*, p. 471, no. 1134, December 10, 1918: "Bei der Kunst ist das Sehn nicht so wesentlich wie das Sichtbarmachen." This adaptation has been observed by Naubert-Riser (1978, p. 88).

96. "Das Reich der Malerei ist nicht nur von dieser Welt und das Unsichtbare sichtbar zu machen, mehr denn je ein Zweck der Kunst"; letter of Schlemmer to Mascha Luz, June 9, 1918, quoted in von Maur 1979, p. 72. The sentence recurs in Schlemmer's unpublished statement "Ein Hinweis" of 1918, published by von Maur 1979, pp. 333–34, esp. p. 334. Von Maur's conclusion that the analogy cannot have been prompted by an influence of one artist upon the other (1979, p. 73) is based on her erroneous assumption that the sentence already forms part of Klee's manuscript of November 1918, a time when he was not yet acquainted with Schlemmer.

97. "Im Anfang ist wohl die Tat, aber darüber liegt die Idee. Und da die Unendlichkeit keinen bestimmten Anfang hat, sondern kreisartig anfanglos ist, so mag die Idee für primär gelten. Im Anfang war das Wort, übersetzt Luther." On Klee's reassertion of the gospel reading against that of Goethe's *Faust*, see Naubert-Riser, 1978, pp. 102–3, note 3.

98. Naubert-Riser 1978, pp. 89, 102, 107, rightly observes that the text is in effect setting the premises of Klee's Bauhaus teaching.

99. Postcard from Edschmid to Klee, September 5, 1919, Bern, Nachlass-Sammlung Paul Klee.

100. *Schöpferische Konfession*, pp. 95–96: "In Parenthese: die Gedanken sind nicht im vielbeschrienen Atelier der Modernen geboren, sondern im Sattel und unter dem Dröhnen der Geschütze. Gerade, und nur diese dröhnende Wirklichkeit riss die erregten Gedanken aus der gewohnten Bahn der traulichen Sinneserlebnisse in ein fernes Dahinter, in eine höhere geistigere Möglichkeit als diese unmögliche Gegenwart."

101. *Schöpferische Konfession*, p. 97: "Ich habe nur eines auszudrücken: die Idee des Nordlichts."

102. *Schöpferische Konfession*, p. 48: "Voraussetzung des politischen Dichters (der stets irgendwie religiöser Dichter ist): ein Mensch, der sich verantwortlich fühlt für sich und für jeden Bruder menschheitlicher Gemeinschaft. Noch einmal: der sich verantwortlich fühlt."

103. *Schöpferische Konfession*, pp. 92–93: "Theorie, die das Wissen unterstützt und klärt, und Empfindung sind polare Gegensätze, die sich gegenseitig bedingen, ohne einander nicht auskommen können, sich brauchen, aber immer wieder abstossen.

Es müssen nicht alle Maler Theoretiker sein. Aber die weisesten freilich mussten sich alles sehr klar machen. Und diese sagen dann: Kunst ist eine Wissenschaft.

Auf dem Wege der vollen Erkenntnis der künstlerischen Mittel kann ein Ausbau zur höchsten künstlerischen Sensibilität erstrebt werden. . . .

Und nichts geschieht an den Akademien, dass die jungen Leute in der Malerei das lernen, wonach sie Sehnsucht haben: das Wesen der Malerei."

104. *Schöpferische Konfession*, p. 91: "Die Bildflächenwelt und ihre Lebewesen sind etwas ganz anderes als die Welt der Menschen, die Luft atmen und eines weiten Raumes bedürfen. Hier sind Irrtümer auszugleichen."

105. Von Maur 1975, p. 8.

106. Bern, Nachlass-Sammlung Paul Klee.

107. "Entwickeln wir, machen wir *unter Anlegung eines topographischen Planes* eine kleine Reise ins Land der besseren Erkenntnis."

108. "Die Kunst . . . spielt mit den Dingen ein unwissend Spiel. So wie ein Kind im Spiel uns nachahmt, ahmen wir im Spiel den Kräften nach, die die Welt erschufen und erschaffen."

109. *Schöpferische Konfession,* p. 122: "Die Kunst spielt mit den letzten Dingen ein *unwissend* Spiel und erreicht sie doch!"

110. ". . . wobei Abstracte Formen zu sinngemässen Gegenständen werdend oder reine Symbole bleibend wie Zahlen und Buchstaben geeint zu Symbolen des Kosmos werden, das heisst religiöser Ausdruck."

111. The following is an attempt to show the emendations embedded in the actual text of the draft, with the deletions set in brackets and the additions in italics: "⟨wobei⟩ *Aus* abstracte⟨n⟩ Form*elementen wird über ihre Vereinigung zu konkreten Wesen oder zu abstrakten Dingen* ⟨zu sinngemässen [korr. aus: sinnreichen] Gegenständen werdend oder reine Symbole bleibend⟩ wie Zahlen und Buchstaben ⟨geeint zu Symbolen des⟩ *hinaus ein formaler* Kosmos ⟨werden⟩ *geschaffen, der mit der grossen Schöpfung solche Ähnlichkeit aufweist, dass ein Hauch genügt, den* ⟨, das heisst religiöser⟩ Ausdruck *des Religiösen zur Tat werden zu lassen.*"

112. ". . . fort mit dem Alltag und fort mit den Geheimwissenschaften, sie sind hier fehl."

113. *"Man kann wohl noch vom Effekt und vom Heil vernunftmässig reden, die sie da ausübt, dadurch: dass* ⟨Wo die⟩ Phantasie, von ⟨kläglich instinctiven⟩ *instinktgeborgten* Reizen beschwingt, uns Zustände vortäuscht die irgend⟨wie⟩ *mehr ermuntern und anregen als die allbekannten Irdischen oder bewusst überirdischen.*"

114. "⟨Und dem Menschen sei sie eine⟩ *Auf Mensch! Schätze diese* Villegiatur."

115. "⟨Hier münde alle Kunst, die⟩ *In dieses stärkende Meer lass dich tragen, auf* ⟨breiten Ströme⟩ *breitem Strom* und auch *auf* ⟨die⟩ reizvolle*n Bächen, wie die* aphoristisch-vielverzweigte Graphik."

116. In the intervening months, Willi Baumeister had kept written contact with Klee; their correspondence is not yet available.

117. Unpublished eyewitness report by Gottfried Graf of 1931, quoted by von Maur 1979, p. 353, note 306.

118. Von Maur 1975, pp. 16–17, facsimile of the text, cf. p. 16; von Maur 1979, pp. 334–35, esp. p. 334: "Die Revolutionierung der Kunst, international und alle Künste gleichzeitig und gleichmässig erfassend, ging der politischen Revolution längst vor dem Krieg voraus. Die Kunst in ihrer Sensibilität und Geistigkeit schien das grosse Weltgeschehen vorauszufühlen, anzukündigen."

119. Von Maur 1975, p. 16: "So will es für den deutschen Expressionismus scheinen, dass er einer lichten Klarheit entgegengeht. Dämonie weicht mystischer Einfalt. Die Mystiker! Indien! Paul Klee, sei gegrüsst!"

120. O. Schlemmer, *Briefe und Tagebücher,* ed. Tut Schlemmer (Stuttgart, 1977), pp. 24–26: "In einem Minimum von Strich kann er seine ganze Weisheit offenbaren. So zeichnet ein Buddha. Ruhig, in sich ruhend, von keiner Leidenschaft bewegt, der unmonumentalste Strich, weil suchend und kindlich, um Grösse zu offenbaren. . . . Die Taten aller bedeutenden Menschen haben ihre Wurzel in einer einfachen, aber alles umfassenden Erkenntnis."

121. K. K. Düssel, "Um die Berufung Paul Klees," *Stuttgarter Neues Tagblatt,* no. 541, October 25, 1919, morning edition, p. 2.

122. Ibid.: "Als im November die Revolution kam und damit die Bahn frei schien für Erneuerungen und Reformen auf allen geistigen Gebieten, da ging auch an der Stuttgarter Akademie die Rede von allerlei Versprechungen und Zukunftsplänen."

123. Letter of Schlemmer to Klee, September 23, 1919, Bern, Nachlass-Sammlung Paul Klee.

124. Düssel, "Um die Berufung Paul Klees": "Die besondere Lehrbegabung

Klees ist freilich noch wenig erprobt. Wer aber Klee einmal gehört hat, wie er seinen Lehrberuf auffasst, der hofft viel von diesem Lehrer. Er hat kein festgenageltes Programm, aber er entwickelt die Grundsätze des idealen Kunstpädagogen: Achtung und möglichste Steigerung der künstlerischen Individualität des Schülers."

125. "Das Wesentliche für die Frage, ob man Paul Klee berufen soll, scheint mir aber doch, dass Klee als führende Persönlichkeit in der modernen Kunstbewegung anerkannt ist."

126. Von Maur 1979, p. 89.

127. H. Missenharter, "Expressionisten im Kunstverein," *Württemberger Zeitung*, October 30, 1919.

128. "Ist es ein freiwilliger oder ein unfreiwilliger Scherz, wenn Oskar Schlemmer . . . fordert, dass Paul *Klee* als Akademieprofessor für Kompositionslehre nach Stuttgart berufen wird? Was kümmert ihn die Akademie, die seiner innersten Überzeugung nach doch je früher, je besser abzuschaffen ist?"

129. "ist inzwischen aber, wie viele wurzellose, krankhafte Zeitgenossen, aus modischen Rücksichten, vielleicht auch in dilettantischer Phantasterei zur Theosophie übergegangen und malt jetzt, was immer noch das bequemste ist, abstrakt. Er setzt süsse Farbenquadrätchen nebeneinander, zeichnet auch einmal ein Sternchen oder ein Herzchen hinein, und macht gute Geschäfte damit."

130. Stuttgart, Staatsgalerie, Oskar Schlemmer-Archiv; von Maur 1975, p. 11: "Mit Theosophie habe ich mich nie beschäftigt."

131. Klee, *Briefe*, 2:882, to Lily Klee, October 14, 1917. As Wolfgang Kersten has pointed out to me, Klee's words "also ein Einführungskurs in die Theosophie" identify the book as Steiner's *Theosophie: Einführung in übersinnliche Welterkenntnis und Menschenbestimmung* (Berlin, 1904) with eight subsequent printings through 1918. Haxthausen (1981, pp. 473–74) assumes that as early as 1913, Klee may have followed Steiner in his pursuit of the equation between creative nature and the creative artist which is encapsulated in the term "Genesis."

132. *Briefe*, 2:906–7, to Lily Klee, February 21, 1918: "Das Schweigen des Doktor Steiner über mich ist leicht zu deuten, es kommt jedenfalls einer Ablehnung (mit Misstrauen vermischt, ganz wie bei mir) gleich."

133. Reproduced in von Maur 1975, pp. 10–11.

134. "Ad 5) Geschäftlich war [corrected from: bin] ich mit München durchaus niemals [corrected from: nicht] liiert, fast alle Verkäufe werden im übrigen Deutschland abgeschlossen. Aus geschäftlichen Gründen zieht man nicht nach München, der Kunstmarkt ist ursprünglich international, und jetzt zum mindesten national." Emphasis added in the English translation.

135. Bern, Nachlass-Sammlung Paul Klee: "Eine Stuttgarter Korrespondenz der 'Kunstchronik' meldet, es sei in Stuttgart eine Agitation im Gange, die den Münchner Graphiker und Maler Paul *Klee* an die Stelle Adolf Hoelzels, also an die Spitze der Stuttgarter Kunstschule zu bringen beabsichtige. Der Korrespondent tritt diesem Plan—soweit er an ihn glaubt—mit sachlichen Argumenten entgegen. In den M. N. N. ist der Kunst Klees wiederholt mit Worten tiefer Sympathie gedacht worden. Um so mehr besteht selbstverständlich die Verpflichtung, zu betonen, dass der Gedanke einer derartigen Berufung Klees durch und durch verfehlt wäre. Er wäre deshalb verfehlt, weil er am eigentlichsten Wert Klees, an der absoluten Subjektivität und Irrationalität seines Arbeitens (die nicht nur allem Lehrhaften entgegengesetzt, sondern beinahe aller Ausdeutung entzogen ist), geraden Wegs vorbeigeht. Man lasse Klee in der Sphäre, in der er einzig denkbar ist: in der Abseitigkeit seiner bedingungslos und ungehemmt persönlichen Phantasie und in der verborgenen Zauberwelt seiner Geige."

136. "Lieber Herr Klee, ich möchte diese Notiz morgen Donn. Abend in der

Zeitung bringen. Ich halte es für meine Loyalitätspflicht, Ihnen zuvor Kenntnis zu geben. Bitte rufen Sie mich heute Abend noch an: 32729.—Wann erhalte ich die Notizen für das Buch?

Herzlichst! Ihr Hausenstein."

137. W. Hausenstein, "Kunst und Revolution," in *Ostern 1919* (Potsdam and Berlin 1919), pp. 25–40.

138. London, Renée-Marie Parry-Hausenstein Archive: "Jedenfalls bin ich damit stets einverstanden, dass Sie öffentlich über mich alles sagen, was Ihrer Überzeugung entspricht.

Der Lebenslauf wird. Verzeihen Sie wenn ich Sie noch e[in] par Tage warten lassen muss.

Es handelt sich fast nur um innere Vorgänge und das gewissenhaft zu machen ist schwer."

139. Letter by Altherr, director of the academy, to Schlemmer, November 8, 1919, Stuttgart, Oskar Schlemmer-Archiv: "Die Arbeiten des Herrn Klee tragen im Ganzen einen spielerischen Charakter, verraten jedenfalls nicht den starken Willen zur Struktur und zum Bildaufbau wie er gerade von der jüngsten Bewegung mit Recht gefordert wird." Cf. von Maur 1979, p. 89.

140. London, Renée-Marie Parry-Hausenstein Archive.

141. "Diese Begründung wird ein kulturhistorisches Dokument bleiben, da sie ein Werturteil ausspricht, das sich übrigens im Gegensatz zu demjenigen Ihres Referenten befindet."

142. "Dessen Meinung, dass der Plan, Klee an eine Kunsthochschule zu berufen, gänzlich verfehlt wäre, kann ich eine Stelle aus einem Brief Klee's gegenüberstellen, die zur Genüge zeigt, wie sehr er eine Wirkungsmöglichkeit erstrebt."

143. Bern, Nachlass-Sammlung Paul Klee: "Sollen wir Revolution machen? Es wird sich eine kleine Minderheit zusammenfinden u[nd] die Akademie und Regierung wird ihre Macht zeigen und uns ausschliessen. Es wird ein aufreibender Kampf sein und viel verlorene Zeit. Dazu das brennende Verlangen zu arbeiten. Was raten Sie uns?"

144. Stuttgart, Oskar Schlemmer-Archiv: "Bleiben Sie Opposition, versuchen Sie eine Scheidung von offizieller und inoffizieller Kunst, wie sie in Berlin immer schon bestand, und wie sie auch in München besteht, nachdem die allgemeine Reaction wieder eingesetzt hat. Hier ist es sogar so weit, dass die ganze Neue Secession mit ihrem gar nicht radikalen Durchschnitt Opposition ist."

145. Letter of Bayerisches Staatsministerium für Unterricht und Kultus to the Arbeitsausschuss bildender Künstler, Munich, Bayerisches Haupt- und Staatsarchiv, MA 92225.

146. Klee notes in his following letter to Hausenstein of December 15 that he is returning both: Marbach, Deutsches Literatur-Archiv, 66.2261/7.

147. Marbach, Deutsches Literatur-Archiv, 66.2261/6: "Die Stuttgarter Angelegenheit ist für mich vollständig erledigt, und ich wüsste auch nicht, was die Öffentlichkeit noch damit anfangen soll. . . . Und für Sie ist sie vollends erledigt, da Sie ja die Berufung für verfehlt hielten. Für mich galt blos das eine: dass man nicht gegen [inserted: die] Schüler lehren soll. Da z. Zt. aber in Stuttgart gegen die Schüler gelehrt wird, und die selben Schüler sich, völlig frei, in ihrer Bedrängnis an mich gewandt hatten, konnte ich nicht nein sagen."

148. K. Schumann, "Kommunalpolitik in München zwischen 1918 und 1933," in C. Stölzl, ed., *Die Zwanziger Jahre in München,* catalog (Munich: Stadtmuseum, 1979), pp. 1–17, esp. p. 5.

149. Munich, Bayerisches Kriegsarchiv, Gruppenkommando 4, Bund 48, Akt 1: Presse: Verbot, Zensur, Überwachung; Bund 51, Akt 2: Rätesystem: Allgemeines,

Ausschüsse, Hochschulräte; Bund 53, Akt 12: Sicherheit München und Provinz; Bund 60, Akt 14–18: USPD Namentliche Listen; Bund 65, Akt 2–3, 6–10: Verdächtige Personen; Bund 66, Akt 4: Vereine und Körperschaften.

150. Munich, Bayerisches Kriegsarchiv, Gruppenkommando 4, Bund 53, Akt 12, Tk. Z. No. 1370:
"Die radikale Intellektuellenbewegung in München.

. . . Betrachtet man noch die wechselartigen Beziehungen von radikalen Strömungen in der Kunst selbst, also nicht im rein politischen Leben der Künstlerschaft, so beachtet man, das[s] beispielsweise an der Münchner Kunstakademie . . . von revolutionären Bewegungen relativ wenig zurückgeblieben ist. [Some group] . . . trachtet nach wie vor, den Expressionismus zu züchten (siehe die Leute um Scharff Unold usw.) die grosse Masse der Kunststudierenden betrachtet das Studium des Futurismus, Expressionismus jedoch lediglich als Selbstzweck und Vergleichsobjekt zu den alten noch jetzt tonangebenden Richtungen. . . . Die Abfärbung des künstlerischen Radikalismus auf die politische Gesinnung hat wohl vereinzelt hierselbst stattgefunden."

151. K. K. Löwenstein, "Mord der Moderne," *Münchner Blätter für Dichtung und Graphik* 1, no. 10 (1919): 160: "Woran endet die Moderne? Nicht an Krankheit, Schwäche, Alter und Auflösung. Nein! Ihr Ende ist Mord! . . . Die *Neue* hat die Moderne in Acht getan. Sie will sie bewusst und überlegt aus der Welt schaffen, nicht als einer Gegner, der überwunden, besiegt werden kann, sondern als einen Gezeichneten, der beseitigt werden muss."

152. A. Rimbaud, "Aus dem Sommer in der Hölle," ibid., pp. 180–84, esp. p. 184: "Die Weissen landen. Die Kanone kommt! Man muss sich taufen lassen, Kleider anziehen, arbeiten. Ich bekam ins Herz den Schlag der Gnade. Ach! ich hatte das nicht vorhergesehen!"

153. Ibid.: "Glück zu, rief ich, und ich sah ein Meer von Flammen und Rauch am Himmel; und links, rechts, alle Reichtümer flammend wie Milliarden Donner. Aber die Schwelgerei und die Kameradschaft der Frauen waren mir nicht erlaubt. . . . Ich sah mich einer erbitterten Menge, der Henkerrotte gegenüber . . . 'Priester, Professoren, Vorsteher, ihr seid im Irrtum, wenn ihr mich der Gerechtigkeit überliefert. Ich habe nie zu diesem Volk hier gehört . . . '"

154. Ibid.: "Ich liebe nicht länger das dumpfe Brüten. Wut, Ausschweifung, Narrheit, deren Fieber und Niederlagen ich alle kenne,—meine ganze Bürde ist abgeworfen. Stellen wir gelassen den Umfang meiner Unschuld fest."

155. Letter of Klee to Kubin, January 1, 1920, Briefe von Paul Klee an Alfred Kubin," p. 94: "Die tiefen Temperaturen meines Arbeitsraumes im Toller-Schlösschen."

156. Ibid.: "Neulich war ein junger Herr aus Russland da, es soll alles mit Übertreibungen wahr sein was man von dort hört." There follows an account of Kandinsky's good fortunes. "Er selber wird wenn es geht nach nicht bolschwistischen Ländern gehn. Man weiss dort ganz gut in welcher Lage die Räterepublik sich befindet, trotz des 'Sieges'. Wir in Deutschland wissen womöglich noch besser was Siege unter Umständen bedeuten. Hieran litten wir ja am wenigsten Mangel."

157. Ibid.: "Vielleicht kommen bald die Illustrationen zu Corrinth [sic] Potsdamerplatz heraus. . . . Diese Illustrationen habe ich dies Frühjahr gemacht. Die Dichtung ist nicht gerade besonders, aber ganz dankbar, und ich wollte ganz gern einmal etwas für den Müllerverlag machen. Vielleicht hat eine gewisse Souveränität mich vor Plattheiten bewahrt."

Chapter 8

1. P. Czada, "Grosse Inflation und Wirtschaftswachstum," in H. Mommsen, D. Petzina, and B. Weisbrod, eds., *Industrielles System und politische Entwicklung in der Weimarer Republik* (Düsseldorf, 1974; paperback edition, 1977), pp. 386–94; Holtfrerich 1980, p. 182; G. D. Feldman, "The Political Economy of Germany's Relative Stabilization during the 1920/21 World Depression," in G. Feldman, et al., 1982, pp. 180–206.

2. Holtfrerich 1980, pp. 207–8; G. Feldman, "Gegenwärtiger Forschungsstand und künftige Forschungsprobleme zur deutschen Inflation," in Büsch and Feldman 1978, p. 13 and discussion remarks, p. 63.

3. Sch., "Das Luxussteuergesetz," *Der Cicerone* 12, no. 19 (September 1920): 725.

4. "Ausverkauf," *Kunst und Künstler* 18, no. 5 (February 1920): 191: "Auf dem Kunstmarkte herrscht fieberhafte Bewegung. Unbesehen fast wird gekauft und überall fehlt es an Ware. Wohin mit dem Papiergeld? . . . Da erinnert man sich, dass Bilder, Graphik, Bücher und Antiquitäten Wertobjekte sind. Von schwankendem Kurswert zwar, aber vor der Hand doch von steigendem Kunstwert. . . . In den Ausstellungen prangt an jedem dritten Bild ein Zettel 'verkauft.' Und da es eine reaktionäre Kunst nicht mehr gibt, da jedermann modern malt und zeichnet, so wird der gestern noch verlachte Expressionist über Nacht zum Publikumskünstler und zum Kapitalisten."

5. O. Lindekam, "Kunst und Kunsthandel auf der Leipziger Frühjahrsmesse 1920," *Der Kunsthandel* 12, no. 3 (March 1920): 82–83.

6. F. Hansen, "Von der Kunst- und Antiquitätenschau auf der Frankfurter Messe," *Der Kunsthandel* 12, no. 5 (May 1920): 136–37, esp. p. 136.

7. Weinstein 1986, p. 71.

8. B. Rauecker, *Die Proletarisierung der geistigen Arbeiter* (Munich, 1920), p. 8.

9. Bern, Nachlass-Sammlung Paul Klee.

10. In a later letter of November 1919 (see below, p. 227) he announces that he is about to start writing.

11. Werckmeister 1982, pp. 80–81.

12. See his article "Kunst und Revolution," in *Ostern 1919,* pp. 25–40, quoted above, p. 193.

13. L. Zahn, "Apostata (Bemerkungen zu einem Vortrag Hausensteins)," *Der Ararat* 2, no. 7 (April 1920): 53: "Einer, dem es die 'Rechte' der Kunst verargte, dass er es mit der 'Linken' hielt, stand auf, sagte sich von der expressionistischen Irrlehre los, gestand seinen Irrtum, verbarg nicht seine Enttäuschung (die er auch auf andere sowohl politische wie gesellschaftliche Erscheinungen ausdehnte) und kehrte reueerfasst zum impressionistischen Glauben Meier-Gräfes zurück (woher er gekommen), aber als ein Hoffnungsbarer, der das Ende der Kunst überhaupt kassandrierte."

14. *Der Cicerone* 7, no. 14 (July 1920): 557 and no. 15 (July 1920): 587.

15. *Die Kunst in diesem Augenblick* (Munich 1920). A shorter article with the same title had already appeared in *Werden: Sonderheft des Neuen Merkur,* 1919, no. 3, pp. 115–27.

16. Ibid., pp. 49, 22, 44, 45, 46.

17. Hausenstein, *Kairuan,* p. 134: "Der Plan zu diesem Buch verdichtete sich im Lauf des Kriegs. Die Arbeit wurde 1919 begonnen. Das Manuskript wurde im Juni 1920 zu Ende gebracht."

18. Bern, Nachlass-Sammlung Paul Klee: "Ich habe mit Kurt Wolff heute einen Vertrag abgeschlossen über das Klee-Buch. Ich will es noch in diesem Jahre schreiben: es ist innerlich parat und muss eigentlich nur hergegeben werden. Aber in jedem Fall möchte ich nun baldigst Ihr ganzes Oeuvre mit Ihnen durchnehmen:

zur Auswahl der Bilder und zur Klärung einiger mir vielleicht nicht ganz heller Gedanken. Ich denke mir das Buch so: Sie werden in die Mitte gestellt, und um diese Mitte wird das Problem der Zeitkunst (und der Zeit) entwickelt. Das Buch wird vielleicht halb Roman werden.—Sie gaben mir einmal etliche Daten. Aber ich darf Sie vielleicht bitten, mir bald eine *möglichst ausführliche* Vita zu notieren, auch einiges Kommentatorische zu Ihrer Entwicklung und Ihrer Kunst im Einzelnan."

19. Marbach, Deutsches Literatur-Archiv, 66.2261/5, back of accompanying visiting card.

20. Ibid., 66.2261/6: "Bald erhalten Sie den Schluss der Vita."

21. Ibid., 66.2261/7, letter, Munich, December 15, 1919: "Schluss der biogr[aphischen] Scizze".

22. C. Geelhaar, "Journal intime" 1979, pp. 251–52.

23. For a comparison of both versions, see Werckmeister 1982, pp. 85 ff.

24. London, Renée-Marie Parry-Hausenstein.

25. Hausenstein, postcard to Klee of January 20, 1920, Bern, Nachlass-Sammlung Paul Klee: "Sie wollten mir noch einige kurze Bildanalysen schreiben."

26. Hausenstein, *Kairuan*, pp. 117–20.

27. Cf. Werckmeister 1982, pp. 83–84.

28. Hausenstein, *Kairuan*, p. 121: "Inhalt: die Art eines Europäers von 1914 und 1919, eines Europäers aus der Zeit des schrecklichsten aller Kriege; seine Art, die Welt zu erleben."

29. Ibid., pp. 89–90: "Aber nun, zwischen den anonymen Greueln des scheusslichsten aller Kriege, . . . da wurde es unmöglich, Ereignisse, Zustände, Gegenstände und Personen anders denn mit der Deseperation nihilistischer Instinkte anzusehn. . . .

In allem, was Geschichte, Ereignis, Mensch und Sache oder Gesinnung war, gab es unter diesen Umständen nichts, das gelten konnte. Die Welt war: nichts—abermals und schlimmer nichts. Nichts mit absurdem Gestänge von Organisation und Maschinen. Vielfältiges Nichts. . . . Das Menschliche zog sich zurück."

30. Ibid., p. 95: "Der Malerzeichner, der konsequent ist, muss Ruinen zeichnen und malen. Ihm wird allenfalls erlaubt, an der Romantik des Ruinenmalers teilzuhaben. . . . Ihm ist auch die Ironie des Geistes erlaubt, der sich keine Illusionen mehr gönnt."

31. "Ist zur Hälfte Schweizerin. (Basel) Ihre übrige Abstammung ist nicht völlig geklärt, sie kann über Südfrankreich orientalisch sein."

32. Hausenstein, *Kairuan*, p. 101: "Einer, der militarisiert worden ist, dem das Objektive oktroyiert wurde, das Objektive in jener unerträglichen Steigerung, die Organisation und Ludendorff oder Organisation und Clemenceau und Foch geheissen hat, einer, von dem man die uniformierte Konzession an eine Travestie des Kollektivismus erpresste: dass der nun vollends in die polare Entfernung der Subjektivität zurückschnellt, ist das primitivste der dialektischen Geschehnisse."

33. See Werckmeister 1982, pp. 85 ff., for detailed comparisons.

34. Hausenstein, *Kairuan*, passim: "absurd," "Anarchie," "Illegitimität," "irrational," "das Nichts," "Nihilismus," "radikal," "Revolte," "Ruinen," "Sabotage."

35. Hausenstein, *Kairuan*, p. 28: "Dieser Mensch ist nicht von hier. Die Blässe des hohen Kopfes ist das in nordischen Kellern ausgebleichte Braun eines arabischen Mannes. Hat der Weisse mit dem Dunklen nicht auch den zugespitzten Kinnbart, die Schwärze der einfach stirnwärts wachsenden Haare, die morgenländisch glänzende Tiefe der dunklen Augensterne, das bläuliche Leuchten des Weissen, das Wehen der Nüstern, die rassige Noblesse des ganzen Hauptes zusammen?"

36. D. Halfbrodt and W. Kehr, *München 1919* (Munich, 1979), pp. 139, 165, 177, 219–20.

37. London, Renée-Marie Parry-Hausenstein: "Gehört [Klee] zum Total des Ostens, wo aus einer Revolution sich etwas Neues bildet? Andere versuchen es hier, an ihrer Stelle. Wer entscheidet, wer Recht hat?"

38. Hausenstein, *Kairuan*, pp. 95–96: "Mensch und Ding existieren heute nur noch in ihren eigenen Ruinen. Der Maler, der folgerichtig ist, muss heute ein Zeichner sein . . . Der Malerzeichner, der konsequent ist, muss Ruinen zeichnen und malen."

39. Klee, *Tagebücher*, p. 340, no. 926f, April 8, 1914.

40. Autobiographical text: "das kleine Ölbild ausgebaut."

41. Hausenstein, *Kairuan*, p. 86: "Er war nie ein Mensch der Profession gewesen: denn ihm war in die Natur gelegt, zu ahnen, dass Nichtstun die edelste Weisheit des Menschen sei, und was er tat, geschah, als wäre es nichts, und was er bildete, stellte nichts dar."

42. Klee, *Tagebücher*, p. 294, no. 857, spring 1908: "Wenn bei meinen Sachen manchmal ein primitiver Eindruck entsteht, so erklärt sich diese 'Primitivität' aus meiner Disciplin auf wenige Stufen zu reduzieren. Sie ist nur Sparsamkeit, also letzte professionelle Erkenntnis. Also das Gegenteil von wirklicher Primitivität."

43. Advertisement in *Der Kunsthandel* 12, no. 2 (February 1920): 49: "*Der Ararat*, der bisher als politisches Flugblatt erschienen ist, wird von nun an für die Neue Kunst eintreten."

44. *Der Kunsthandel* 12 (1920): 22, 49, 92, 288.

45. Bern, Nachlass-Sammlung Paul Klee: "Er verpflichtet sich insbesondere, im Frühjahr 1920 eine Gesamtausstellung der Werke des Herrn Klee zu veranstalten und nach Kräften den Erfolg dieser Ausstellung durch entsprechende Propaganda zu fördern, insbesondere einen Katalog in Broschürenform mit mindestens 20 Abbildungen herauszugeben."

46. "Paul Klee: Eine biographische Skizze nach eigenen Arbeiten des Künstlers," reprinted in Klee, ed. Geelhaar 1976, pp. 137–40.

47. *Der Ararat*, 1920, p. 3, reprinted in von Wedderkop 1920, p. 16; Klee, ed. Geelhaar 1976, p. 140: "Der grosse Erfolg fiel ihm wie eine reife Frucht in den Schoss. Er freut sich seiner in der Stille einer arbeitsreichen Zurückgezogenheit. Träumend, schaffend, geigespielend."

48. Entry number 1920, 187. *Zeichnung zum Mann unter dem Birnbaum (1921/19)*. As late as 1928, Klee repeated the image in a drawing he offered his dealer of that time, Alfred Flechtheim, on the occasion of the latter's fiftieth birthday; see Frey and Kersten 1987, pp. 82ff., who, however, identify the seated man as Goltz, not Klee.

49. Zahn 1920, p. 4: "Diesseitig bin ich gar nicht fassbar. Denn ich wohne grad so gut bei den Toten, wie bei den Ungeborenen. Etwas näher dem Herzen der Schöpfung als üblich. Und noch lange nicht nahe genug."

50. See the analysis of Geelhaar 1979, pp. 255–56, and the interpretation of Hohl 1982, pp. 149ff.

51. Zahn 1920, p. 23: "Der geistige Mensch Klee, der erkennende, bedenkt die unendliche Wirksamkeit des Überirdischen, die sich im Irdischen verendlicht, erlebt, die sichtbare Wirklichkeit betrachtend, die Dynamik, die Energie, die Rhythmik, die Harmonie und die Melodie als Emanationen einer kosmischen Potenz."

52. Hausenstein, *Kairuan*, pp. 87ff., also referred Klee's work to Taoism.

53. Zahn 1920, p. 5: "Nan Po Tse-Kuei sagte zu Nü Yü: 'Du bist alt und doch ist dein Angesicht wie das eines Kindes. Wie geht das zu?' Nü Yü antwortete: 'Ich habe Tao gelernt.'"

54. Zahn 1920, p. 23: "Hat nur Spielphantasie unwissender Kindlichkeit die Blätter des kosmischen Bilderbuchs mit zarten Figuren und heiteren Farben gefüllt?

Oder männliche, Scheinwirklichkeit überwindende Weisheit Erkenntnis letzter Dinge gestaltet? Kindliche Phantasie und tiefe Weisheit sind hier nicht Gegensätze, sondern Ergänzungen."

55. His letter to Hausenstein is no longer extant.

56. Carbon copy in London, Renée-Marie Parry-Hausenstein: "Ich gestehe Ihnen offen: es ist für mich eine im höchsten Grade peinliche Überraschung, dass Sie zu einer als Konkurrenzarbeit gemeinten Publikation Ihre Zustimmung gegeben haben. Die Gruppe Westheim-Kiepenheuer-Goltz sabotiert mich methodisch und dass Herr Zahn, der kürzlich im Ararat eine die Wahrheit fälschende Polemik von äusserst ordinärer Form gegen mich losliess, nur im Sinne des Trustes handeln wird, ist selbstverständlich."

57. "Herr Westheim und seine Leute wollen nicht, dass ich zuerst über Klee schreibe. Dieser Ruhm muss dem Konzern Kiepenheuer-Goltz-Westheim etc. vorbehalten bleiben.

Dass ich für Sie eingetreten bin, als Herr Zahn noch in den Windeln lag, und als es noch einen besonderen Mut erforderte, für Sie einzutreten, ist den Betriebsingenieuren der neuen Kunst natürlich gleichgültig."

58. "Dass ein zweites Buch über Klee nicht nur sachlich überflüssig, sondern für Sie sogar vielleicht schädlich und mir jedenfalls nicht gleichgültig sein konnte, war doch unter allen Umständen klar."

59. "Sie können, lieber Herr Klee, ganz unbesorgt auftreten. Nicht Sie brauchen Herrn Goltz, Herrn Kiepenheuer und [die] anderen, sondern die anderen brauchen Sie."

60. Marbach, Deutsches Literatur-Archiv, 66.2261/10: "Am liebsten redete ich Ihnen alle Bedenken aus und verharrte ich auf meiner naiveren Auffassung, dass Ihre Arbeit konkurrenzlos sein wird als Schrift, aber dass eine andere Arbeit, wenn sie einigermassen ernsthaft ist, doch wohl ergänzend wirken kann."

61. London, Renée-Marie Parry-Hausenstein: "Dass Goltz Sie im Ganzen als Kritiker nicht mochte, schien mir selbstverständlich und harmlos.

Ich selber suchte und suche in diesem Getriebe eine neutrale Einstellung. Ich male, er vertreibt und macht Reclame."

62. "Darf ich nochmals betonen, dass ich mir von Ihrem Buch etwas Grundverschiedenes erwarte, nämlich ein Werk mit eigenkünstlerischen Qualitäten, oder ganz einfach eine Dichtung (Sie bezeichneten es doch selber als eine Art Roman.) In mir wird sich lediglich ein historisches Moment dazu verkörpern. Sie werden als Urheber sehr stark hervortreten und das ist meine Überzeugung dass eher ich dienen werde als Sie."

63. Marbach, Deutsches Literatur-Archiv, 66.2261/11, letter from Munich, January 9, 1921.

64. Hausenstein's letter is no longer extant. Klee wrote: "Wenn es einer Aufmunterung bedürfte, so wäre Ihr Brief sehr geeignet dazu. Ich wollte noch etwas abwarten, aber es will sich kein Ventil öffnen." Marbach, Deutsches Literatur-Archiv, 66.2261/12, postcard from Weimar, April 14, 1921. It is most likely that Klee refers to *Kairuan,* although he does not explicitly say so.

65. Zahn 1920, pp. 70, 73, 77: 1919, 55 *Hornklänge;* 1919, 206, *Abstürzender Vogel;* 1920, 2, *Luftkampf.*

66. 1920, 209: Glaesemer, 1:283, no. 680.

67. Klee, *Beiträge,* 1980, pp. 66ff.

68. Lecture in the Kunstverein at Jena, January 26, 1924: Klee, *Das bildnerische Denken,* pp. 88ff.

69. 1920, 69: *50 Werke von Paul Klee,* Auktionskatalog Kornfeld und Klipstein (Bern, 1975), no. 478, with reproduction.

70. It is strange that Benjamin never noted this in the texts he wrote about the picture.

71. J. Duhem, *Histoire des idées aéronautiques avant Montgolfier* (Paris, 1943), p. 28, and references.

72. Cf. P. von Haselberg, "Benjamins Engel," in P. Bulthaup, ed., *Materialien zu Benjamins Thesen "Über den Begriff der Geschichte"* (Frankfurt, 1975), pp. 337–56, esp. p. 353.

73. According to the statistics from Hamburg published by Holtfrerich 1980, p. 237, fig. 7, the 100 point was reached in February. In Bavaria, the point was reached, at least for the lower ranks of civil servants, in October; see A. Kunz, "Verteilungs-kampf oder Interessenkonsensus? Einkommensentwicklung und Sozialverhalten von Arbeitnehmergruppen in der Inflationszeit 1914 bis 1923," in Feldman, et al., 1982, pp. 347–84, p. 376. The overall figures for civil servants of the Reich show the highpoint for this rank at 96.80 in October 1921. In the other two categories, those of the middle and high tiers of the civil service, the recovery was less, but only to the degree that the salary differences between the three ranks were substantially leveled after the war.

74. Letter of Prof. Schädlich, Hochschule für Architektur und Bauwesen Weimar, Sektion Architektur, to Dr. Magdalena Droste, Bauhaus Archiv, Berlin, April 15, 1985, who says that the pertinent personnel files of several Bauhaus masters at the Staatsarchiv Weimar refer to but do not contain the contract.

75. Berlin, Bauhaus Archiv, Mappe 7,3:

§2. Herr W. Kandinsky erhält aus der Kasse des Staatlichen Bauhauses unter Vorbehalt jederzeitiger Änderung jährlich fünfunddreissigtausend Mark Grundbezug. Grundbezug und Teuerungszulage gelangen in vierteljährlichen je am Anfang des zweiten Monats im Quartal fälligen Teilbeträgen zur Auszahlung.

§3. Herrn Kandinsky steht jederzeit Kündigung in halbjährlicher Frist zu, wäh-rend für das Staatliche Bauhaus das Verhältnis bis 30. Juni 1925 unkündbar (ausser aus einem wichtigen Grund §626 B.G.B.) ist. Erstmalig kann zu diesem Termin und von da ab weiter gegenüber Herrn Kandinsky das Vertragsverhältnis mit halbjäh-riger Frist gekündigt werden. Die Kündigung ist nur für 1. April und 1. Oktober zulässig."

The contract with Gropius of April 1, 1919 (Bauhaus Archiv, Mappe 7,2) is simi-larly framed but stipulates a four-year tenure. It was amended by a *Nachtrag* on April 1, 1920, to include the inflation allowance.

76. Holtfrerich 1980, p. 268.

77. Franciscono 1977, p. 122; German version 1979, p. 17.

78. Letter from Gropius to Klee, October 29, 1920; Bern, Nachlass-Sammlung Paul Klee, quoted after Glaesemer 2:10: "Schon seit Jahresfrist warte ich auf den Mo-ment, diesen Ruf an Sie ergehen zu lassen. Ich nehme an, dass Sie ungefähr wissen, was wir hier begonnen haben."

79. O. Schlemmer, "Paul Klee und die Stuttgarter Akademie," *Das Kunstblatt* 4, no. 4 (1920): 123–24; [anonymous] "Aus Stuttgart wird uns geschrieben," *Der Kunstmarkt* 55, n.s. 31, no. 7 (November 14, 1919): 145–46.

80. Wingler 1975, pp. 29–30, and pp. 38 ff.: "ohne die klassentrennende An-massung, die eine hochmütige Mauer zwischen Handwerkern und Künstlern er-richten wollte!"

81. See Feininger's letter of June 27, 1919 (Wingler 1969, p. 43) and Hofmar-schall von Fritsch's memorandum of April 20, 1920, relating Wilhelm von Bode's dis-may about Gropius's unexpected turn to expressionism.

82. Wingler 1975, p. 14; Hüter 1976, pp. 26 ff.

83. Franciscono 1971, p. 171.

84. Wingler (1975, p. 250) credits Itten "essentially" with Klee's appointment. Wick (1982, p. 245, note 1) assumes that it was "probably" due to a "recommendation" by Itten.

85. Weinstein 1986, pp. 93–94. In his article "Werkstattbesuche. II. Jefim Golyscheff," *Der Cicerone* 11, no. 22 (November 1919): 722–26, A. Behne promoted the drawings of Golyscheff in terms of both childlikeness and proletarian simplicity and referred to Klee by comparison.

86. Bern, Nachlass-Sammlung Paul Klee, letter of Itten to Klee, November 1, 1920: "Wenn wir an Stelle der zwei eben genannten Meister noch zwei Moderne gleichgesinnte Künstler herberufen, so glaube ich dass Weimar ein Zentrum intensivster künstl[erischer] Arbeit wird im Sinne des Fortschrittes und uneinnehmbar von der Reaktion."

87. Däubler, who was in Weimar at that time, also recommended him. See his letter of November 4, 1920, to Klee, Bern, Nachlass-Sammlung Paul Klee: "Vorige Woche war ich in Weimar. Das Bauhaus interessiert mich sehr. Wir sind alle der Ansicht, dass Sie auch hinsollten; dann wäre alles vereint, was Zukunft verbürgen kann!" Behne, who has sometimes been credited with suggesting Klee, never met him until June 20, 1921; see *Briefe*, 2:980.

88. Rotzler 1972, pp. 28, 103. Itten wrote these recollections in October 1948. The visit must have taken place between June 1 and 8, when Klee was on home leave from military service at Landshut; see *Briefe* 2:820.

89. Itten, letter to Anna Höllering, Weimar, 1 June 1919, after Rotzler 1972, p. 65: "In München war ich bei Klee. Wir sprachen nicht dreissig Worte. Er spielte Bach und ich hörte zu. Dann ein herzl[icher] Händedruck und auf [?] Wiedersehen. Übermorgen bin ich wieder bei ihm."

90. The following account is based on Klee's notes in his oeuvre catalog.

91. Note in the oeuvre catalog: "Herr Singer, Schüler v[on] Joh[annes] Itten kaufte zwei Zeichnungen 1916, 45 und 1918, 14 zusammen 200 M."

92. Zurich, Annelise Itten Archive, letter of Klee to Itten, October 15, 1919: "Ich bin kein Briefschreiber aber deswegen ist mein Interesse für Sie und Ihre Weimarer Mission doch sehr gross. Wir sprachen viel über Sie, als Ihre Schüler sich hier einfanden."

93. Rotzler 1972, p. 400, note 105.

94. Letter from Gropius to Klee, October 29, 1920; Bern, Nachlass-Sammlung Paul Klee, quoted after Glaesemer, 2:10. "Die Schüler strahlen in dem Gedanken, dass Sie kommen könnten."

95. Von Maur 1979, 1:50.

96. Letter of Schlemmer to Itten, November 4, 1920, Zurich, Annelise Itten Archive: "Lieber Itten, es war mir eine nicht geringe Überraschung Deinen u[nd] einen Brief von Gropius vorzufinden. . . . Ich bin furchtsam vor der Öffentlichkeit geworden, das Bekanntwerden in Stuttgart hat mir mehr geschadet als genützt in künstlerischer Beziehung. . . . Hat Klee schon zugesagt? Ich glaube nach den Stuttgarter Erfahrungen sicher dass er es tun wird."

97. Entry number 1918, 115 *Auserwählter Knabe;* 1918, 195 *Urgeschöpfe;* 1918, 197 [no title].

98. Rotzler 1972, p. 49: "Am Anfang war das Nichts. Aus dem Gegensatz, durch den Gegensatz von Gut und Böse, Positiv und Negativ wird die Bewegung, entsteht die Eins. Aus Zwei wird Eins. Aus dem an und für sich ruhenden Guten und aus dem an und für sich ruhenden Bösen wird durch deren gegenseitige Spiegelung eine Anziehung und eine Abstossung, es wird die Bewegung."

99. Rotzler 1972, p. 74:
"Sei ein Mensch wie das Kind

inniger Kraft hemmungsloser Selbstauswirkung
Sei einsam wie der Mönch
demütigen Geistes Enthaltsamkeit übend
Sei wissend wie der Weise
massvoll besonnener Tat machtvolle Klarheit . . .”
Rotzler dates the group of poems to which this one belongs to the years 1919–23.

100. Rotzler 1972, p. 69: “Dass unser Spiel zur Arbeit und unsere Arbeit zum Fest und unser Fest zum Spiel werde—dies scheint mir höchste Vollendung des menschlichen Wirkens. Das Spiel der Kräfte in uns—ausser uns—in selbstvergessener Arbeit zur festlichen Tat gestalten—heisst gestalten nach Kinder Art.”

101. E. Grünthal, “Paul Klee,” *Der Weg* 1, no. 2 (February 1919): 6: “Leben erscheint in dumpfer Undifferenziertheit, in *kosmischer Ganzheit.* Unerhörtes, nie Erblicktes ersteht, wird wirklich in *ungebrochener* Seelenhaftigkeit, wie sie nur weitoffene *Kinderaugen* zu sehen vermögen . . . Freilich *absolut* polar liegt solches zur begrifflich-konventionellen, banal ‘natürlichen’ Wirklichkeit bürgerlicher Erwachsener.”

102. Zahn 1920, p. 23: “Hat nur Spielphantasie unwissender Kindlichkeit die Blätter des kosmischen Bilderbuches mit zarten Figuren und heiteren Farben gefüllt? Oder männliche, Scheinwirklichkeit überwindende Weisheit Erkenntnis letzter Dinge gestaltet? Kindliche Phantasie und tiefe Weisheit sind hier nicht Gegensätze, sondern Ergänzungen.” Zahn goes on to quote the sentence from *Schöpferische Konfession* quoted above, chap. 7, note 109.

103. E.H., in *Kunstchronik und Kunstmarkt*, n.s., 31 (1920): 725: “So ein Dutzend Kleescher Zeichnungen in irgendeiner Ausstellung konnte immer eine Art Erfrischung sein—nicht immer die beabsichtigte, man war froh, dem Allzuernstnehmen, wie es andere verlangen, enthoben zu sein; man freute sich an diesem scheinbar kindlich-naiven Gemüt. Klee hat die Gabe, einen zum wirklich naiven Schauen zu zwingen, . . . wie in einer Kinderstube den Anforderungen ihrer Beherrscher entsprechend, alles schön, wichtig und von einleuchtender Klarheit zu finden. Eine Zeitland kann man das! Die Massenhaftigkeit dieser Klee-Ausstellung lässt auch da zu tief in die Maschinerie blicken, mit der der Reichtum echter Kinderphantasie ersetzt worden ist. Raffinement ist dafür kein Ersatz.”

104. Wolfradt 1920, p. 2125: “Obwohl gewiss nicht einfach infantil (im Sinne der Psychiatrie), ist [Klee] die Landung der Hyperkompliziertheit in kindlicher Primitivität. Er mahnt, bei der unschuldigen und von Konventionen unbeeinträchtigten Phantasie und Farbenlust der Kinder in die Schule zu gehen. . . . Sein Schaffen (zu unbeschwert eigentlich, um es so zu benennen), ist eine erquickende Bresche in die Vorurteile des bürgerlichen Geschmacks. . . . Wenn dann aber der Träger dieser erlösenden Emanzipationsordre . . . von nicht wenigen Herolden und Kunstbörsianern unter die ersten Namen der Gegenwart gereiht, als überragende Künstlerpersönlichkeit gefeiert und seine Museumswürdigkeit und Kanditatur als Akademieprofessor propagiert worden ist, wird man auf die Verständnislosigkeit solcher Überschätzung des Künstlers Klee hinweisen müssen. . . . Klee ist erwähnenswerter als Anti-Künstler denn als Künstler.”

105. Quoted above, note 42.

106. The following account till the end of the paragraph is based on Franciscono 1971, pp. 183 ff. However, Wick (1982, pp. 231–33) rightly stresses the traditional, even academic form which Klee’s teaching actually took.

107. Franciscono 1971, pp. 180–81.

108. R. B., in *Münchner Zeitung*, May 21, 1920, reprinted in *Der Ararat*, no. 8 (July 1920), p. 80.

109. Franciscono 1971, p. 175.

110. Kagan 1977, p. 92, has shown how, through his use of Fux's counterpoint manual, Klee linked his interest in a totally regulated harmony of color composition with his interest in childhood as the origin of artistic creativity.

111. Postcard from Klee to Lily Klee, January 13, 1921, *Briefe*, 2:969: "Im Atelier bin ich so weit, dass ich heute zum ersten Mal malen konnte"; letter of Klee to Lily Klee, January 16, 1921, *Briefe*, 2:969 ff., esp. p. 970: "Gestern habe ich mich ganz dem Bauhaus gewidmet und mir den Betrieb erstmals zeigen lassen;" and see Wick 1982, p. 88.

112. Letter of Klee to Lily Klee, January 16, 1921, *Briefe* 2:970: "An der einen Wand stehn Gestelle mit Materialversuchsarbeiten. Die sehn aus wie Bastarde von Wildenkunst und Kinderspielzeug."

113. Cf. Werckmeister, "From Revolution to Exile" 1987, pp. 42 ff.

114. *Die Alpen* 6 (1912): 302, reprinted in Klee, ed. Geelhaar 1976, pp. 97–98: "Es gibt nämlich auch noch Uranfänge von Kunst, wie man sie eher im ethnographischen Museum findet oder daheim in der Kinderstube (lache nicht, Leser)." When Klee transcribed the review for his own use into his diary (*Tagebücher*, p. 322, no. 905, January–February, 1912) he left out or toned down the argumentative parts of the published version: "Es gibt nämlich noch Uranfänge von Kunst, wie man sie eher in ethnographischen Sammlungen findet oder daheim in seiner Kinderstube. Lache nicht, Leser! Die Kinder können es auch und es steckt Weisheit darin, dass sie es auch können! Je hilfloser sie sind, desto lehrreichere Beispiele bieten sie uns, und man muss auch sie schon früh vor einer Korruption bewahren. Parallele Erscheinungen sind die Arbeiten der Geisteskranken und es ist also weder kindisches Gebahren noch Verrücktheit hier ein Schimpfwort, das zu treffen vermöchte wie es gemeint ist."

115. *Briefe*, 2:970: "Der Meister kontrolliert die Arbeiten, lässt es sich von einzelnen Schülern extra vormachen, kontrolliert die Haltung. Dann kommandiert er's im Takt, dann lässt er dasselbe Exercitium stehend ausüben. Es scheint eine Körpermassage damit gemeint zu sein, um die Maschine auf das gefühlsmässige Funktionieren hin zu schulen."

116. Geelhaar, "Journal intime," 1979, p. 247.

117. Postscript to Felix Klee, April 19, 1921, *Briefe*, 2:976: "Weimarer Leben und Treiben gibt es für mich nicht. Ich arbeite, spreche die ganze Zeit keinen Menschen."

118. Letter to Lily Klee, April 14, 1921, *Briefe*, 2:974: "ausserdem schlage ich Compositionspracticum ans schwarze Brett." Compare the comments by Wick 1982, pp. 225–26.

119. Letter to Lily Klee, April 14, 1921, *Briefe*, 2:974: "Die neuen Sachen sind streng tonal, je durch Mischung von zwei Farben gearbeitet"; letter to Lily Klee, April 16, 1921, *Briefe*, 2:975: "Die Tonalität der letzten Aquarelle such ich jetzt auf zwei Farben streng aufzubauen . . . Und die Zeichnung geht streng mit der malerischen Form"; letter to Lily Klee, April 17, 1921, *Briefe*, 2:975: "In meinen streng rhythmischen tonalen Aquarellen fahre ich weiter."

He had already characterized his etching series *Inventions* of 1903–5 with the same term: *Tagebücher*, p. 207, no. 603, March–April 1905.

120. Letter to Lily Klee, May 13, 1921, *Briefe*, 2:977: "Dann gab ich zehn Aquarelle von mir herum und besprach sie eingehend auf ihre formalen Elemente und deren kompositionellen Zusammenhang hin. Ich war nur so unvorsichtig, das ganze Material zu verpulvern, so dass ich für nächsten Freitag erst wieder neue Musterbilder malen muss." The last sentence seems to suggest that the ten watercolors Klee handed around in this class were indeed expressly painted for the occasion.

121. Geelhaar (1972, pp. 23 ff.) has aptly surveyed Klee's Bauhaus teaching in terms of his earlier aspirations, often with pertinent quotes from the diary.

Epilog

1. Franciscono 1971, pp. 162–63.
2. Ibid., p. 241.
3. Klee, *Beiträge*, p. 78: "Szenen im Warenhaus" (transcription normalized):
Mass
Kunde: 1. Kaufmann gib mir einen Eimer voll von dieser Ware! Der Kaufmann misst und verlangt 100 Mark. (gut) Kunde: 2. Nun Kaufmann, gib mir den selben Eimer voll von dieser anderen Ware. Der Kaufmann misst und es kostet 200 Mark. Kunde: (warum doppelt so viel?)
Gewicht
Kaufmann: Weil diese andere Ware doppelt so schwer ist. (Der Kunde sieht ein und bezahlt) Kunde: 3. Nun Kaufmann gib mir ebenso schwere dritte Ware! Der Kaufmann wägt und es kostet 400 M. Kunde: (warum doppelt so viel?)
reine *Qualität* (imponderabel)
Kaufmann: weil diese dritte Ware doppelt so gut ist (viel schmackhafter, begehrter, schöner). (Der Kunde schwankt). [Mass] trifft ins Gebiet der *Linie*
Lineare Wertung: länger, kürzer
[Gewicht] trifft ins Gebiet des *Tons* (helldunkel)
Tonale Wertung: heller, dunkler, schwerer, leichter
[reine Qualität] trifft ins Gebiet der *Farbe*
Farbige Wertung: Begehrter, schöner, besser, zu sättigend, erkältend, zu heiss, hässlich, zu süss, zu herb, zu schön!"
4. "Die Handwerker sitzen vor der Tür ihrer Verkaufsstellen und arbeiten. Fragt sie der Fremde nach dem Preis einer Ware so geben sie nur mürrisch und eintönig Antwort, denn sie sind verliebt in ihre Arbeit, wollen sich nicht in ihr stören lassen und trennen sich auch ungern von ihrem Werk. Das Geldverdienen, der Verkauf ist für sie nur ein notwendiges Übel." Quoted after Franciscono 1971, p. 19; translation corrected.
5. Franciscono 1971, p. 19.
6. First published by Franciscono 1971, pp. 257ff., esp. p. 258: "Gute Arbeit dh.: jedes Stückchen Rohstoff, das wir im Lande besitzen oder für unsere letzten Pfennige einführen muss durch *hochqualifizierte Arbeit des Handwerks oder der Industrie* und vor allem auch durch *unnachahmliche Eigenart der Form* an Wert um ein Vielfaches gesteigert werden."
7. "Die Tragfähigkeit der Bauhaus-Idee," Wingler 1975, pp. 62–63 and p. 15.
8. Wingler 1975, p. 64.
9. *Beiträge*, p. 13: "Irgend ein Präparat z. B. findet grossen Absatz wegen seiner vorzüglichen Wirkung. Das gute Geschäft das der Fabrikant dabei macht macht andere Fabrikanten neugierig, und sie bringen eine Probe davon zum Chemiker, damit er davon eine Analyse macht. Er muss methodisch vorgehn um das Präparat in seine Bestandteile zu zergliedern. Das Rätsel lösen."
10. Ibid.: "In unserem Betrieb sind die Motive oder Beweggründe zur Analyse natürlich andere. Wir machen keine Analysen von Werken, die wir kopieren möchten."
11. Bern, Nachlass-Sammlung Paul Klee.
12. Geelhaar 1972, pp. 36–37, with color plate.
13. Klee cancelled the contract on June 18, 1925; letter of Goltz to Klee, June 22, 1925, Bern, Nachlass-Sammlung Paul Klee.
14. Holtfrerich 1980, p. 298.
15. O. Pfleiderer, "Das Prinzip 'Mark = Mark' in der deutschen Inflation 1914 bis 1924," in Büsch and Feldman 1978, pp. 69–82.
16. *Beiträge*, p. 79: "Die Wertung der Farbe ist also keine feststehende, sondern

rein imaginär. Ist es zu heiss, sehnt man sich nach grün-blau, ist es zu kalt, sehnt man sich nach gelb-rot. Die Nachfrage kann wechseln, der Geschmack kann wechseln."

17. C. Kindleberger, "A Structural View of the German Inflation," in G. Feldman et al., ed., *The Experience of Inflation: International and Comparative Studies. Die Erfahrung der Inflation im internationalen Zusammenhang und Vergleich* (Berlin and New York, 1985), pp. 10–32, esp. p. 28, and also p. 32; G. Feldman, "Gegenwärtiger Forschungsstand und künftige Forschungsprobleme zur deutschen Inflation," in Büsch and Feldman 1978, pp. 3–21, esp. p. 12.

18. Cf. von Maur 1979, p. 128.

19. Postcard to Lily Klee, June 28, 1922, *Briefe,* 2:985: "Gestern war hier grosser Demonstrationszug der Arbeiter mit roten Fahnen. Wir schauten vom Museum aus zu."

20. *Tagebücher,* no. 956, p. 368, early 1915: "Die Verwirklichung des Buchstabens im Geschichtsbuch. Die Bestätigung alter Bilderbogen."

21. Postcard to Lily Klee, June 28, 1922, *Briefe,* 2:985: "Die Bilder von Thedy und Gugg bringen eine gewisse qualitative Note in die Abteilung rechts."

22. Hüter 1976, p. 28.

Bibliography

Texts by Paul Klee

Tagebücher 1898–1918. Ed. W. Kersten. Stuttgart and Teufen, 1988.
J. Spiller, ed. *Paul Klee: Das bildnerische Denken.* 3d ed. Basel, 1971.
——. *Paul Klee: Unendliche Naturgeschichte.* Basel, 1970.
Schriften. Ed. C. Geelhaar. Cologne, 1976.
Briefe an die Familie. Ed. Felix Klee. 2 vols. Cologne, 1979.
"Briefe von Paul Klee an Alfred Kubin." *Paul Klee: Das Frühwerk 1883–1922,* pp. 80–97. Munich, 1979.
Beiträge zur bildnerischen Formlehre. Ed. J. Glaesemer. Basel and Stuttgart, 1979.

Secondary Literature

The following bibliography of the secondary literature is divided into two parts. The first is a complete survey of publications on Klee up to the year 1921, the limit of the time frame of this book. The second part is a critical selection of all documentary or scholarly publications up to the present which I consider to be relevant contributions to Klee scholarship, as opposed to an abundance of ephemeral contributions of no lasting importance.

The chronological arrangement is intended to make the historiographical progress of the Klee literature apparent, particularly its transition from criticism to scholarship, which began around 1972 with the work of Christian Geelhaar and Jürgen Glaesemer. Hence it deviates from the alphabetical arrangement of standard bibliographies intended solely to give complete bibliographical citations for abbreviated footnote references. Contrary to standard practice, the reader will locate entries by the year of appearance, and by alphabetical order of names or titles within each year.

1. Contemporary Critical Literature

1906
Gagliardi, E. "Schweizer Künstler auf der Münchner Sezession 1906." *Berner Rundschau,* no. 7 (1906).

1907
Der grüne Heinrich (Chur) no. 7 (1907).

1908
Lang, W. "Die Walze." *Die Schweiz* 12 (1908):418, 421.

<center>Bibliography</center>

1912
Bloesch, H. "Ein moderner Grafiker." *Die Alpen* 6, no. 5 (1912):264–72.

1914
Hausenstein, W. *Die bildende Kunst der Gegenwart,* pp. 307–8. Stuttgart and Berlin, 1914.
———. "Die Neue Münchner Secession." *Deutsche Kunst und Dekoration* 34 (1914): 321–36.
Rohe, M. K. "Die Neue Münchner Secession." *Die Kunst für Alle* 29 (August 15, 1914): 517–27.

1915
Meier-Graefe, J. *Entwickelungsgeschichte der modernen Kunst,* 3:666 ff. 2d ed. Munich, 1915.

1917
Behne, A. "Paul Klee." *Die weissen Blätter* 4 (1917): 167–69.
Caro, E. "Klee." In C. Brun, ed., *Schweizerisches Künstlerlexikon,* 4. Supplement, p. 261. Frauenfeld, 1917.
Däubler, T. "Acht Jahre 'Sturm.'" *Das Kunstblatt* 1 (1917): 46–50.
———. "Paul Klee und Georg Muche im Sturm," *Berliner Börsen-Courier* 49, no. 68 (February 10, 1917): 5.
Jollos, W. "Paul Klee (in der 'Sturm'-Ausstellung der Galerie Dada)." *Neue Zürcher Zeitung,* no. 670, April 17, 1917 (first evening edition).
Michel, W. *Das Teuflische und Groteske in der Kunst,* p. 33. Munich, 1917.
Mittenzwei, K. "Ausstellung der 'Neuen Sezession,' München 1917." *Deutsche Kunst und Dekoration* 41 (October 1917): 108–9.

1918
Däubler, T. "Paul Klee." *Das Kunstblatt* 2 (1918): 24–27.
———. "Paul Klee." *1918: Neue Blätter für Kunst und Dichtung* 1 (May 1918): 11–12.
Paul Klee. Sturm-Bilderbücher, no. 3. Berlin, 1918.
Walden, H., ed. *Expressionismus: Die Kunstwende,* pp. 82–87. Berlin, 1918.

1919
"Aus Stuttgart wird uns geschrieben." *Kunstchronik und Kunstmarkt* 55 (1919–20): 145.
Däubler, T., "Paul Klee." *Das junge Deutschland* 2 (1919): 101.
Grünthal, E., "Paul Klee." *Der Weg* 1 no. 2 (1919): 6.
Hausenstein, W., *Über Expressionismus in der Malerei,* pp. 34–35. Berlin, 1919.
Jollos, W. "Paul Klee." *Das Kunstblatt* 3 (1919): 225–34.
Michel, W. "Paul Klee." In H. T. Joel, ed. *Das graphische Jahrbuch,* p. 48. Darmstadt, 1919.
Pfister, K. "Münchener Neue Sezession: 1919." *Deutsche Kunst und Dekoration* 45 (October 1919): 3–6.
Stern, Lisbeth. "Bildende Kunst." *Sozialistische Monatshefte* 52 (1919): 293 ff.
Sydow, E. von. "Paul Klee." *Münchner Blätter für Dichtung und Graphik* 1 (1919): 141–44.
Wolf, G. J. "Die Ausstellung der Neuen Münchner Secession 1919." *Die Kunst für Alle* 39 (August 21–22, 1919): 397–405.
Wolfradt, W. "Münchener Neue Sezession" *Das Kunstblatt* 3 (1919): 253–54.

1920
Fechter, P. *Der Expressionismus,* p. 30. 2d ed. Munich, 1920.
Hartlaub, G. "Wie ich Klee sehe." *Feuer* 2 (1920–21): 239–40.
Kaiser, H. "Paul Klee." *Das hohe Ufer* 2 (1920): 14.

Meier-Graefe, J. *Entwicklungsgeschichte der modernen Kunst,* pp. 669–71. 3d ed., rev. Munich, 1920.

Pfister, K. *Deutsche Graphiker der Gegenwart,* pp. 27–28. Leipzig, 1920.

Schacht, R. "Paul Klee." *Freie deutsche Bühne* 1 (1920): 728–30.

Schlemmer, O. "Paul Klee und die Stuttgarter Akademie." *Das Kunstblatt* 4 (1920): 123–24.

Sydow, E. von. *Die deutsche expressionistische Kultur und Malerei,* pp. 124–26. Berlin, 1920.

Uhde, W. "Brief [to Edwin Suermondt on Klee]." *Die Freude* 1 (1920): 155–56.

Wedderkop, H. von. *Paul Klee.* Leipzig, 1920.

———. "Paul Klee." *Jahrbuch der jungen Kunst* 1 (1920): 225–36.

———. "Paul Klee." *Der Cicerone* 12 (1920): 527–38.

Wolfradt, W. "Der Fall Klee." *Freie deutsche Bühne* 1 (1920): 2123–27.

Zahn, L. *Paul Klee: Leben, Werk, Geist.* Potsdam, 1920.

———. "Paul Klee." *Valori Plastici* 2, nos. 7–8 (1920): 88–89.

1921

Das graphische Jahr Fritz Gurlitt, p. 77. Berlin, 1921 [biographical sketch].

Hausenstein, W. *Kairuan oder eine Geschichte vom Maler Klee und der Kunst dieses Zeitalters.* Munich, 1921.

Kolle, H. "Paul Klee." *Der Ararat* 2 (1921): 112–14.

2. Documentary and Art-Historical Literature

1948

Du 8, no. 10 (1948). Special issue on Klee, with contributions by A. Kuebler, M. Huggler, F. Klee, R. Bürgi, A. Zschokke, C. Halter, W. Ueberwasser, R. Thiessing, M. Frey-Surbek.

1949

Pulver, M. "Erinnerungen an Paul Klee." *Das Kunstwerk* 3, no. 4 (1949): 28–32.

1950

Haftmann, W. *Paul Klee: Wege bildnerischen Denkens.* Munich, 1950.

1952

Giedion-Welcker, Carola. *Paul Klee.* London, 1952; German edition, Stuttgart, 1954.

1954

Grohmann, W. *Paul Klee.* Stuttgart, 1954.

Zschokke, A. [Memoir]. *Rheinischer Almanach: Jahrbuch für Kultur und Landschaft* (1954)

1955

Hofmann, W. "Studien zur Kunsttheorie des 20. Jahrhunderts." *Zeitschrift für Kunstgeschichte* 18 (1955): 136–56.

1956

Schreyer, L. *Erinnerungen an Sturm und Bauhaus.* Munich, 1956.

1957

Petitpierre, Petra. *Aus der Malklasse von Paul Klee.* Bern-Bümpliz, 1957.

San Lazzaro, G. di. *Klee: A Study of His Life and Work.* New York, 1957; German edition, Munich, 1958.

1959

Grohmann, W. *Paul Klee: Handzeichnungen.* Cologne, 1959.

Grote, L., ed. *Erinnerungen an Paul Klee.* Munich, 1959.

Bibliography

1960

Gehlen, A. *Zeit-Bilder,* pp. 102–13. Bonn, 1960; 2d ed., 1965.

Huggler, M. "Die Kunsttheorie von Paul Klee." *Festschrift H. Hahnloser.* Basel, 1960.

Klee, F. *Paul Klee: Leben und Werk in Dokumenten, ausgewählt aus den nachgelassenen Aufzeichnungen und Briefen.* Zurich, 1960.

1961

Giedion-Welcker, Carola. *Paul Klee in Selbstzeugnissen und Dokumenten.* Hamburg, 1961.

Huggler, M. "Die Kunsttheorie von Paul Klee." *Festschrift Hans R. Hahnloser,* pp. 136–56. Basel and Stuttgart, 1961.

Winkler, E. "Paul Klee und die exakte Wissenschaft." In P. H. Diehl, ed., *Grenzen der Malerei,* pp. 78–85, 195–224. Vienna and Cologne, 1961.

1963

Kornfeld, E. W. *Verzeichnis des graphischen Werkes von Paul Klee.* Bern, 1963.

1964

Badt, K. "Zur Bestimmung der Kunst Paul Klees." *Jahresring 64/65,* pp. 123–36. Stuttgart, 1964.

1965

Hofstätter, H. H. "Symbolismus und Jugendstil im Frühwerk von Paul Klee." *Kunst in Hessen und am Mittelrhein* 5 (1965): 97–118.

1966

Ringbom, S. "Art in the 'Epoch of the Great Spiritual': Occult Elements in the Early Theory of Abstract Painting." *Journal of the Warburg and Courtauld Institutes* 29 (1966): 386–418.

1967

Kröll, Christina. *Die Bildtitel Paul Klees.* Ph.D. diss. Bonn, 1967.

Laxner, U. *Stilanalytische Untersuchungen zu den Aquarellen der Tunisreise 1914: Macke, Klee, Moillet,* Ph.D. diss. Bonn, 1967.

1968

Verdi, R. "Musical Influences on the Art of Paul Klee." *Museum Studies* 3 (1968): 81–107. For German version see 1973.

1969

Giedion-Welcker, Carola. *Paul Klee in Selbstzeugnissen und Bilddokumenten.* 5th ed., enlarged. Reinbek, 1969.

Huggler, M. *Paul Klee: Die Malerei als Blick in den Kosmos.* Frauenfeld and Stuttgart, 1969.

1970

Geelhaar, C. "Et in Arcadia Ego—zu Paul Klees 'insula dulcamara.'" *Berner Kunstmitteilungen,* no. 118 (1970), pp. 1–5.

Tavel, H. C. von. "Dokumente zum Phänomen 'Avantgarde'. Paul Klee und der moderne Bund in der Schweiz 1910–1912." In *Beiträge zur Kunst des 19. und 20. Jahrhunderts,* pp. 69–116. Schweizerisches Institut für Kunstwissenschaft, Jahrbuch 1968/69. Zürich, 1970.

1971

Engels, M. T. *Paul Klees docentenloopbaan aan de Staatliche Kunstakademie te Düsseldorf.* Catalog. Utrecht, 1971.

Fontaine, I. "Paul Klee: Six études inédites pour 'Candide.'" *La Revue de l'art,* no. 12 (1971), pp. 86–88.

Roethel, H. K. *Paul Klee in München.* Bern, 1971.

Bibliography

1972

Faust, M. "Diachronie eines Ideolekts: Syntaktische Typen in den Bildtiteln von Klee." *Zeitschrift für Literaturwissenschaft und Linguistik*, 2, no. 8 (1972): 97–109.

Geelhaar, C. "Paul Klee: 'Früchte auf Rot.'" *Pantheon* 30 (1972): 222–28.

Glaesemer, J. *Paul Klee: Die Kritik des Normalweibes: Form und Inhalt im Frühwerk.* Berner Kunstmitteilungen, nos. 131–32. Berne, 1972.

Quintavalle, A. C. *Paul Klee fino al Bauhaus.* Parma, 1972.

Strauss, E. *Koloritgeschichtliche Untersuchungen zur Malerei seit Giotto.* Munich, 1972.
"Zur Helldunkellehre Klees." pp. 121–33.
"Paul Klee: 'Das Licht und Etliches.'" pp. 113–20.

1973

Glaesemer, J. *Paul Klee Handzeichnungen*, vol. 1, *Kindheit bis 1920.* Bern, 1973.

Grebe, K. *Geboren am blauen Montag: Erinnerungen*, pp. 126–43. Pfullingen, 1973.

Teuber, M. "New Aspects of Paul Klee's Bauhaus Style." *Paul Klee: The Bauhaus Years, 1921–1931*, pp. 6–14. Catalog. Des Moines, Iowa, 1973.

Verdi, R. "Musikalische Einflüsse bei Klee." *Melos: Zeitschrift für neue Musik* 40 (1973): 5–22.

1974

Faust, M. "Entwicklungsstadien der Wortwahl in den Bildtiteln von Paul Klee." *Deutsche Vierteljahrschrift für Literaturwissenschaft und Geistesgeschichte* 48 (1974): 25–46.

Geelhaar, C. *Paul Klee: Progressionen.* Schriftenreihe der Paul Klee-Stiftung, no. 1, Bern, 1974.

———. *Die Vorgeschichte der Tunisreise.* Erlenbach-Zurich, 1974.

Glaesemer, J. "Paul Klees persönliche und künstlerische Begegnung mit Alfred Kubin." *Pantheon* 32 (1974): 152–62; slightly expanded and reprinted in *Paul Klee: Das Frühwerk*, 1979.

Glaesemer, J., ed., *Paul Klee: Das graphische und plastische Werk.* Catalog, Duisburg, 1974; reissued, Schriftenreihe der Paul Klee–Stiftung, no. 2, Bern, 1975.
Paul Klee, "Graphik," pp. 6–17.
J. Glaesemer, "Die Druckgraphik von Paul Klee, pp. 18–29.
M. Rosenthal, "'Der Held mit dem Flügel': Zur Metapher des Fluges im Werk von Paul Klee," pp. 30–38.
J. Glaesemer, "'Die Kritik des Normalweibes': Zu Form und Inhalt im Frühwerk von Paul Klee," pp. 38–46.
M. Franciscono, "Paul Klees kubistische Graphik," pp. 46–56.
C. Geelhaar, "Paul Klees druckgraphische Kleinwelt, 1912–1932," pp. 58–66.
J. Glaesemer, "Die Plastik von Paul Klee," pp. 68–75.

1975

Geelhaar, C. "Bande dessinée—Voltaire—Scénariste: Klee—Illustrateur de Candide." *L'oeil*, no. 237 (1975), pp. 22–27.

———. *Paul Klee: Zeichnungen.* Cologne, 1975.

Osterwold, T. *Paul Klee: Die Ordnung der Dinge.* Stuttgart, 1975.

Poling, C. *Bauhaus Color.* Catalog, Atlanta, Georgia, 1975.

Rosenthal, M. *The Arrow: A Microcosm in the Art of Paul Klee.* Ph.D. diss. University of Iowa, 1975.

Wingler, H. M., *Das Bauhaus.* 3d ed. Bramsche, 1975.

1976

Glaesemer, J. *Paul Klee: Die farbigen Werke im Kunstmuseum Bern.* Bern, 1976.

Mösser, A. *Das Problem der Bewegung bei Paul Klee.* Heidelberger kunstgeschichtliche Abhandlungen, n.s. 12. Heidelberg, 1976.

Pierce, J. S. *Paul Klee and Primitive Art.* New York, 1976. (Reprint of dissertation, Harvard University, 1961.)

Schlumpf, H. U. *Das Gestirn über der Stadt: Ein Motiv im Werk von Paul Klee.* Ph.D. diss. Zurich, 1969. (Partially published, Zurich, 1976)

1977

Arts Magazine 52, no. 1 (1977). Special issue on Paul Klee.

> A. Kagan. "Paul Klee's 'Ad Parnassum': The Theory and Practice of Eighteenth Century Polyphony as Models for Paul Klee's Art," pp. 90–104.
>
> Alessandra Comini. "All Roads Lead (Reluctantly) to Bern: Style and Source in Paul Klee's Early 'Sour' Prints," pp. 105–11.
>
> S. Ringbom. "Paul Klee and the Inner Truth to Nature," pp. 112–17.
>
> Sara L. Henry. "Form-Creating Energies: Paul Klee and Physics," pp. 118–21.
>
> M. Franciscono. "Paul Klee in the Bauhaus: The Artist as Lawgiver," pp. 122–27.
>
> J. S. Pierce. "Paul Klee and Baron Weltz," pp. 128–31.
>
> M. Roskill. "Three Critical Issues in the Art of Paul Klee," pp. 132–33.
>
> G. Schiff. "René Crevel as a Critic of Paul Klee," pp. 134–37.
>
> O. K. Werckmeister, "The Issue of Childhood in the Art of Paul Klee," pp. 138–51. German version, revised and enlarged in Werckmeister 1981, pp. 124–78.
>
> J. M. Jordan. "The Structure of Paul Klee's Art in the Twenties: From Cubism to Constructivism," pp. 152–57.
>
> Deborah Rosenthal. "Paul Klee: The Lesson of the Master," pp. 158–60.

Glaesemer, J., and M. Huggler. *Der 'Pädagogische Nachlass' von Paul Klee.* Bern, 1977.

Huggler, M. *Die Kunsttheorie von Paul Klee.* Schriftenreihe der Paul Klee–Stiftung, no. 3. Bern, 1977.

Mösser, A. "Pfeile bei Paul Klee." *Wallraf-Richartz-Jahrbuch* 39 (1977): pp. 225–35.

Svendsen, Louise A., ed. *Klee at the Guggenheim Museum.* Catalog. New York, 1977.

1978

Cherchi, P. *Paul Klee teorico.* Bari, 1978.

Naubert-Riser, Constance. *La création chez Paul Klee.* Paris and Ottawa, 1978.

Pierce, J. S. "Paul Klee and Karl Brendel," *Art International* 22, no. 4 (April–May 1978): 8–10.

Plant, Margaret. *Paul Klee: Figures and Faces.* London, 1978.

Rosenthal, M. "Paul Klee's 'Tightrope Walker': An Exercise in Balance." *Arts Magazine* 53, no. 1 (1978): 106–11.

Vishny, Michele. "Paul Klee and War: A Stance of Aloofness." *Gazette des Beaux-Arts* 120 (1978): 233–43.

Werckmeister, O. K. "Die neue Phase der Klee-Literatur." *Neue Rundschau* 89 (1978): 405–20. Revised and enlarged in Werckmeister 1981, pp. 179–97.

1979

Baumgartner, M. *Paul Klee und die Photographie.* Schriftenreihe der Paul Klee-Stiftung, no. 4. Bern, 1979.

Glaesemer, J. *Paul Klee, Handzeichnungen,* vol. 3, *1937–1940.* Bern, 1979.

Hohl, R. "Paul Klee und der Pariser Surrealismus." In *Neue Sachlichkeit und Surrealismus in der Schweiz 1915–1940,* pp. 147–60. Catalog. Winterthur, 1979.

———. "Paul Klee und seine Kunst." *Universitas* 34 (1979): 17–23.

Kagan, A. "Klee's 'Hommage à Picasso.'" *Arts Magazine* 53, no. 5 (1979): 140–41.

Osterwold, T. *Paul Klee: Ein Kind träumt sich.* Stuttgart, 1979.

Paul Klee: Das Frühwerk 1883–1922. Catalog. Ed. A. Zweite. Munich, 1979.

> [A. Zweite] Vorwort, pp. 9–15.
>
> Rosel Gollek. "Chronologie kultureller Ereignisse in München 1899–1920," pp. 16–19.
>
> C. Geelhaar. "Paul Klee: Biographische Chronologie," pp. 20–33.

M. Franciscono. "Paul Klee um die Jahrhundertwende," pp. 34–62.

J. Glaesemer. "Paul Klees persönliche und künstlerische Begegnung mit Alfred Kubin," pp. 63–79.

"Briefe von Paul Klee an Alfred Kubin," pp. 80–97.

C. W. Haxthausen. "Klees künstlerisches Verhältnis zu Kandinsky während der Münchener Jahre," pp. 98–130.

Regula Suter-Raeber. "Paul Klee: Der Durchbruch zur Farbe und zum abstrakten Bild," pp. 131–65.

O. K. Werckmeister. "Klee im Ersten Weltkrieg," pp. 166–226; revised and enlarged version in Werckmeister 1981, pp. 9–97.

J. M. Jordan. "Garten der Mysterien: Die Ikonographie von Paul Klees expressionistischer Periode," pp. 227–45.

C. Geelhaar. "Journal intime oder Autobiographie? Über Paul Klees Tagebücher," pp. 246–60.

Marianne L. Teuber. "Zwei frühe Quellen zu Paul Klees Theorie der Form: Eine Dokumentation," pp. 260–97.

Paul Klee: Das Werk der Jahre 1919–1933. Catalog. Ed. S. Gohr. Cologne, 1979.

M. Franciscono, "Paul Klee am Bauhaus—der Künstler als Gesetzgeber," pp. 17–28.

C. Geelhaar. "Moderne Malerei und Musik der Klassik—eine Parallele," pp. 29–42; enlarged and revised version, Geelhaar 1984.

Eva-Maria Triska. "Die Quadratbilder Paul Klees—ein Beispiel für das Verhältnis seiner Theorie zu seinem Werk," pp. 43–80.

S. Gohr. "Symbolische Grundlagen der Kunst Paul Klees," pp. 81–94.

P. Cherchi. "Paul Klee—Probleme der Einordnung," pp. 95–110.

P. Kirkeby. "Klee und die Wikinger," pp. 111–16.

W. Witrock. "Erläuterungen zu Klees graphischen Techniken," pp. 137–38.

Bibliographie, pp. 405–22.

Klee und Kandinsky. Catalog. Ed. Magdalena Droste. Stuttgart, 1979.

Magdalena Droste. "Klee und Kandinsky," pp. 9–22.

Paul Klee. "Wassily Kandinsky zu seinem 60. Geburtstag, 5. Dezember 1926," p. 23.

W. Kandinsky. "Paul Klee," p. 25.

Karin von Maur. "Paul Klee und der Kampf um die Hölzel-Nachfolge in Stuttgart," pp. 95–99.

1980

Kagan, A. "Paul Klee's 'Polyphonic Architecture.'" *Arts Magazine* 54, no. 5 (1980): 154–57.

Rosenthal, M. "The Myth of Flight in the Art of Paul Klee." *Arts Magazine* 55 no. 1 (1980): 90–94.

Vogel, R. "Paul Klee und die Fliegerschule 5 (Gersthofen) im I. Weltkrieg," *Jahresberichte 1978/79 des Heimatvereins für den Landkreis Augsburg,* pp. 327–67. Augsburg, 1980.

1981

Benincasa, C., ed. *Paul Klee: Opere 1900–1940 dalla collezione Felix Klee.* Catalog. Florence, 1981.

Haxthausen, C. W. *Paul Klee: The Formative Years.* New York and London, 1981. (Reprint of dissertation of 1976, with new introduction)

Tower, Beeke Sell. *Klee and Kandinsky in Munich and at the Bauhaus.* Ann Arbor, 1981.

Werckmeister, O. K. *Versuche über Paul Klee.* Frankfurt, 1981.

1982

Hohl, R. "Paul Klees Zwischenreich." In Therese Wagner-Simon and Gaetano Bene-

detti, eds., *Sich selbst erkennen: Modelle der Introspektion,* pp. 142–53. Göttingen, 1982.

Overmeyer, Gudula. *Studien zur Zeitgestalt in der Malerei des 20. Jahrhunderts: Robert Delaunay—Paul Klee.* Hildesheim, Zurich, and New York, 1982.

Thürlemann, F. *Paul Klee: Analyse sémiotique de trois peintures.* Lausanne, 1982.

Werckmeister, O. K. "*Kairuan:* Wilhelm Hausensteins Buch über Paul Klee." In E. G. Güse, ed., *Die Tunisreise,* pp. 76–93. Stuttgart, 1982.

Wick, R. *Bauhaus-Pädagogik,* pp. 216–248 ("Paul Klee") Cologne, 1982.

1983

Kagan, A. *Paul Klee: Art and Music.* London, 1983.

Naubert-Riser, Constance. "Paul Klee et la Chine," *Revue de l'art* (1984) no. 63, pp. 47–56.

1984

Benz-Zauner, Margareta. *Werkanalytische Untersuchungen zu den Tunesien-Aquarellen Paul Klees.* Frankfurt, 1984.

DeLamater, Peg. "Some Indian Sources in the Art of Paul Klee." *Art Bulletin* 66 (1984): 657–72.

1985

Geelhaar, C. "Paul Klee." In Karin von Maur, ed., *Vom Klang der Bilder: Die Musik in der Kunst des zwanzigsten Jahrhunderts,* pp. 422–29. Munich, 1985. (revised and enlarged version of article in *Paul Klee: Das Werk der Jahre 1919–1933,* 1979)

Glaesemer, J. *Paul Klee: Handzeichnungen,* vol. 2, *1921–1936.* Bern, 1984.

Jordan, J. *Paul Klee and Cubism.* Princeton, 1984.

Klee et la musique. Catalog. Paris, 1985.

> M. Franciscono. "La place de la musique dans l'art de Klee: une remise en cause," pp. 19–32.

> J. Glaesemer. "Paul Klee et Jacques Offenbach," pp. 169–78.

> W. Salmen. "Oeuvres orchestrales et musique de chambre inspirées par des tableaux de Paul Klee," pp. 179–84.

Paul Klee als Zeichner. Catalog. Berlin, 1985.

> W. Kersten. "Paul Klee: Chronologische Biographie," pp. 12–25.

> Magdalena Droste. "Wechselwirkungen—Paul Klee und das Bauhaus," pp. 26–40.

Verdi, R. *Klee and Nature.* London, 1984.

Vishny, Michele. "Paul Klee's Self-Images." *Psychoanalytic Perspectives on Art* 1 (1985): 135–68.

Werckmeister, O. K. *Paul Klee in Exile 1933–1940.* Catalog. Tokyo, 1985.

1986

Aichelle, K. P. "Paul Klee's Operatic Themes and Variations," *Art Bulletin* 68 (1986): 450–66.

Kersten, W. "Paul Klees Beziehung zum 'Blauen Reiter.'" In H.-C. von Tavel, ed., *Der Blaue Reiter,* pp. 261–73. Catalog. Berne, 1986.

Paul Klee: Vorträge der wissenschaftlichen Konferenz in Dresden, 19. und 20. Dezember 1984. Dresden, 1986.

> W. Schmidt. "Gesellschaftskritische Aspekte in Klees Werken," pp. 6–10.

> H. Olbrich. "Grosz/Herzfelde 1925—und die Schwierigkeit, Paul Klee als Bündnispartner zu begreifen," pp. 11–16.

> K. Weidner. "Paul Klee—Naturstudium und Formgesinnung," pp. 16–24.

> W. Schade. "Akouda," pp. 24–25.

> M. Kühn. "Klees Selbstdarstellungen bis 1920," pp. 26–29.

> P. Arlt. "'Hauptweg—Nebenwege': Zur Ikonographie eines Topos," pp. 30–32.

Irma Emmrich. "Paul Klee und Constantin Brancusi: Von der Heiterkeit des Archaischen," pp. 33–34.

C. Claus. "Subjektive Zwischenbemerkungen zu Paul Klee," pp. 34–36.

H. C. Wolff. "Paul Klee und die Musik," pp. 36–38.

H. Grüss. "Gedanken eines Musikhistorikers bei der Lektüre von Klees Tagebüchern," pp. 39–42.

F. Löffler. "Theodor Däubler sowie Ida Bienert und Klee," pp. 42–46.

Annegret Janda. "Paul Klee und die Nationalgalerie 1919–1937," pp. 46–51.

G. Regel. "Die Kunsttheorie Paul Klees in ihrer Funktion bei der Herausbildung seiner Bildersprache," pp. 51–55.

K. J. Winkler. "Über den Unterricht Paul Klees am Bauhaus," pp. 55–58.

G. Huniat. "Zu Klees Vortrag 'Über die moderne Kunst,'" pp. 59–61.

H. Schönemann. "Diesseits und jenseits des Gegenstandes—Paul Klees 'Abenteurer-Schiff' und 'Der bunte Dampfer' von Wolfgang Mattheuer," pp. 62–65.

A. Hüneke. "'Weg mit Zwitschermaschine & Paukenorgel!': Paul Klee und die Aktion 'Entartete Kunst,'" pp. 65–70.

B. Rosner. "Bemerkungen zum Zusammenhang von Persönlichkeitsstruktur und Eigenart des Werkes von Paul Klee," pp. 70–74.

Stutzer, B., ed. *Paul Klee: Spätwerke 1937–1940.* Catalog. Chur: Bündner Kunstmuseum, 1986.

B. Stutzer. "Paul Klee oder: Die neue Aktualität des Spätwerkes," pp. 9–18.

M. Baumgartner. "'. . . das Richtige als dazwischenliegend zu treffen.' Form als Inhalt im Spätwerk von Klee," pp. 19–29.

B. Stutzer. "Paul Klee 1933–1940," pp. 109–36.

1987

Lanchner, Carolyn, ed., *Paul Klee.* Catalog. New York: Museum of Modern Art, 1987.

Ann Temkin. "Klee and the Avant-Garde, 1912–1940," pp. 13–38.

O. K. Werckmeister. "From Revolution to Exile," pp. 39–64.

J. Glaesemer. "Klee and German Romanticism," pp. 65–82.

Carolyn Lanchner. "Klee in America," pp. 83–111.

Werckmeister, O. K. Review of J. Jordan, *Paul Klee and Cubism* and R. Verdi, *Klee and Nature. Kunstchronik* 40 (1987): 63–74.

Other Works Repeatedly Cited

Büsch, O., and G. Feldman, eds., *Historische Prozesse der deutschen Inflation 1914 bis 1924: Ein Tagungsbericht.* Berlin, 1978.

Corrinth, C. *Potsdamer Platz.* Munich, 1920.

Däubler, T. "Franz Marc." *Die neue Rundschau* 27 (1916): 564–67; reprinted in Lankheit 1960, pp. 81–85.

Feldman, G. D. *Army, Industry, and Labor in Germany, 1914–1918.* Princeton, 1966.

Feldman, G., et al., eds. *Die deutsche Inflation: Eine Zwischenbilanz.* Berlin and New York, 1982.

Gollek, Rosel. *Der Blaue Reiter im Lenbachhaus München.* 3d ed., rev. Munich, 1981.

Hoffmann, D., ed., *Ein Krieg wird ausgestellt.* Catalog. Frankfurt, 1977.

Hoffmann, J. "Der Aktionsausschuss revolutionärer Künstler Münchens," In D. Halfbrodt and W. Kehr, eds., *München 1919: Bildende Kunst/Fotografie der Revolutions- und Rätezeit,* pp. 21–76. Munich, 1979.

———. "Hans Richter und die Münchener Räterepublik." In *Hans Richter 1888–1976,* pp. 21–26. Catalog. Berlin, Zurich, and Munich, 1982.

Holtfrerich, C. H. *Die deutsche Inflation 1914–1923: Ursachen und Folgen in internationaler Perspektive.* Berlin and New York, 1980.

Hüter, K. H. *Das Bauhaus in Weimar.* 2d ed. Berlin, 1976.

Ingold, F. P. *Literatur und Aviatik. Europäische Flugdichtung 1909–1927.* Basel and Stuttgart, 1978.

Franciscono, M., *Walter Gropius and the Creation of the Bauhaus in Weimar.* Urbana, Chicago, and London, 1971.

Kandinsky, W., and F. Marc. *Briefwechsel.* Munich, 1983.

Lankheit, K. *Franz Marc: Katalog der Werke.* Cologne, 1970.

———. *Franz Marc: Sein Leben und seine Kunst.* Cologne, 1976.

Lankheit, K., ed. *Franz Marc im Urteil seiner Zeit.* Cologne, 1960.

Macke, A., and F. Marc. *Briefwechsel.* Cologne, 1964.

Marc, F. *Briefe aus dem Feld.* Ed. K. Lankheit and U. Steffen. Munich, 1982.

———. *Schriften.* Ed. K. Lankheit. Cologne, 1978.

Von Maur, Karin, *Oskar Schlemmer und die Stuttgarter Avantgarde 1919.* Beiträge zur Geschichte der Staatlichen Akademie der bildende Künste Stuttgart, 1. Stuttgart, 1975.

Von Maur, Karin. *Oskar Schlemmer: Monographie.* Munich, 1979.

Reed, O. P., Jr. *German Expressionist Art: The Robert Gore Rifkind Collection.* Los Angeles, 1977.

Rösler, K. *Die Finanzpolitik des Deutschen Reiches im Ersten Weltkrieg.* Berlin, 1967.

Rotzler, W. *Johannes Itten: Werke und Schriften.* Zurich, 1972.

Walden, H. *Einblick in die Kunst: Expressionismus, Futurismus, Kubismus.* Berlin, 1917.

———. *Expressionismus: Die Kunstwende.* Berlin, 1918.

Walden, Nell. *Herwarth Walden, ein Lebensbild.* Berlin, 1963.

Weinstein, Joan, *Art and the November Revolution in Germany 1918–1919.* Dissertation, University of California, Los Angeles, 1986.

Willett, J. *Art and Politics in the Weimar Republic.* New York, 1978.

Wingler, H. M. *Das Bauhaus.* 3d. ed., enlarged. Bramsche, 1975.

Archival Sources

Berlin-West, Preussische Staatsbibliothek, Sturm-Archiv Herwarth Walden, Mappe Paul Klee

Bern, Nachlass-Sammlung Paul Klee

London, Renée-Marie Parry-Hausenstein, Nachlass Wilhelm Hausenstein

Marbach, Deutsches Literatur-Archiv, Nachlass Wilhelm Hausenstein

Munich, Lenbachhaus, Gabriele Münter-Stiftung, Kandinsky correspondence

Nuremberg, Archiv für Bildende Kunst, ZR ABK 436, Nachlass Franz Marc

Index

Index

Index